MAKING
PHOTOGRAPHY
MATTER

MAKING PHOTOGRAPHY MATTER

A VIEWER'S HISTORY FROM THE
CIVIL WAR TO THE GREAT DEPRESSION

CARA A. FINNEGAN

UNIVERSITY OF ILLINOIS PRESS

Urbana, Chicago, and Springfield

First Illinois paperback, 2017
© 2015 by the Board of Trustees
of the University of Illinois
1 2 3 4 5 C P 5 4 3 2 1
∞ This book is printed on acid-free paper.

Printed and bound in Great Britain by
Marston Book Services Ltd, Oxfordshire

The Library of Congress cataloged the cloth edition
as follows:
Finnegan, Cara A.
Making photography matter : a viewer's history
from the Civil War to the Great Depression /
Cara A. Finnegan.
pages cm
Includes bibliographical references and index.
ISBN 978-0-252-03926-3 (hardcover : alk. paper) —
ISBN 978-0-252-09731-7 (e-book)
1. Documentary photography—United States—
History—20th century. 2. Documentary photography—
United States—History—19th century. 3. Photography—
Social aspects—United States. I. Title.
TR23.F548 2015
770.9'034—dc23 2014045920

PAPERBACK ISBN 978-0-252-08312-9

For all of my teachers, with gratitude

Contents

Illustrations

Acknowledgments

In the late stages of this project, I was diagnosed with a pretty serious illness. In the TV movie version of this story, the shocked and chastened workaholic realizes the error of her ways, acknowledges that she has misdirected her best years by focusing too much on her job, takes up yoga, escapes death, and discovers what really matters. Now, I am all for yoga, and escaping death is great, but I have to confess that this was not my experience. The need to temporarily set aside my work in order to attend to my health produced the opposite response: I couldn't wait to get back to work. Not only because I love my work, but also because the people with whom I work are phenomenal human beings. My cancer experience reinforced something I had always known intellectually but had never before felt so viscerally: that I have amazing friends and colleagues near and far, people who care not only about the life of the mind but about the life in the rest of me, too. For that reason and for so many others, this is a long list of acknowledgments.

At the University of Illinois Press, Kendra Boileau saw potential in the original project and extended an advance contract. Danny Nasset helped me navigate reviews and bring the book to completion. He also patiently waited when illness delayed my work for nearly a year. Many thanks also to the smart and efficient production and marketing staff at the press, including Marika Christofides, Tad Ringo, Jennifer Holzner, and Jill R. Hughes. Thanks to Amy Murphy for a detailed, efficient index. Two anonymous reviewers engaged

deeply with two drafts of the manuscript, identifying its weaknesses and helping me to build upon its strengths. I am immensely grateful for their insistence that I keep pushing to make this project better. A huge thanks also to Dennis Sears of the University of Illinois Rare Book and Manuscript Library, who saved the day in the midst of a big image emergency.

This book more or less became a coherent project during a 2006–2007 sabbatical year as the William S. Vaughn Visiting Fellow at Vanderbilt University's Robert Penn Warren Center for the Humanities. My year in Nashville was, to put it simply, divine. Center director Mona Frederick and my colleagues in the "Between Word and Image" fellows group offered valuable engagement with the earliest versions of the ideas in this book. Many thanks to my "fellow fellows" Carolyn Dever, Gregg Horowitz, Teresa Goddu, Robin Jensen, Kevin Leander, Ellen Levy, Richard McGregor, Catherine Molineux, and Paul Young. Beloved friends Bonnie Dow and John Sloop—amazing scholars, both—welcomed me and always made sure I ate and drank well.

The University of Illinois supported this project with an Arnold O. Beckman Award from the Campus Research Board; recurring Humanities, Arts, and Social Sciences (HASS) funding; and discretionary funds associated with my appointment as a Conrad Humanities Professorial Scholar. I am grateful for the university's ongoing commitment to humanities research. In the Department of Communication the leadership of Barb Wilson, the late Dale Brashers, Dave Tewksbury, and John Caughlin has always modeled the best of what we like to call "the Illinois way": work hard and care about each other. During much of the period I was writing this book, I held administrative appointments in the department, first as a course director and most recently as director of graduate studies. Many thanks to Grace Giorgio, the staff of CMN 111–112, and the incomparable Mary Strum for helping me keep those trains running on time. I also had the great fortune to have multiple generations of research assistants work with me on this project, including George Boone, Courtney Caudle Travers, Troy Cooper, Kassie Lamp, Daniel Larson, Marissa Lowe Wallace, Sabrina Marsh, Julius Riles, and Jillian Klean-Zwilling. Many thanks to each of them.

I presented earlier versions of these ideas on the University of Illinois campus at the Center for Writing Studies, the Lincoln and Cultural Value symposium, and the Modern Art Colloquium. Off campus I received invitations to share my work with colleagues and students at Penn State, University of Wisconsin–Madison, Carnegie Mellon University, Northwestern University, University of Texas, University of Georgia, and University of Alabama. I also presented parts of the project at conferences at Syracuse University, University of Pittsburgh, Indiana University, Rochester Institute of Technology, the Alta

Conference on Argumentation, and the Rhetoric Society of America. I thank Anne Demo, Diane Hope, Rosa Eberly, Dana Cloud, Janis Edwards, Christa Olson, Gordon Hutner, Terri Weissman, Lester Olson, Robert Hariman, and James Wynn for these invitations and for many productive conversations. Parts of chapter two appeared in a 2005 *Rhetoric & Public Affairs* essay and an early version of chapter three appeared in a 2009 piece in *POROI*. Thanks to editors Martin Medhurst and John Nelson for guidance on those earlier publications. Other colleagues who shared their insights and friendship include John Murphy, Debbie Hawhee, Vanessa Beasley, John Lucaites, Ned O'Gorman, Michael Shaw, Jenny Greenhill, Rachael DeLue, Jordana Mendelson, Nancy Abelmann, Jenny Rice, Amy Young, James Jasinski, Jennifer Mercieca, Rob Asen, Chuck Morris, Dan Brouwer, Jim Aune, Ray McKerrow, Brad Vivian, Grace Giorgio, Greg Goodale, Tom Goodnight, Vincent Pham, Robin Jensen, Jiyeon Kang, Jennifer Jones-Barbour, Kassie Lamp, David Cisneros, Jeremy Engels, Stephen Hartnett, Sue Zaeske, David Zarefsky, Kirt Wilson, and Michael Leff.

My spouse, John Murphy, came into my life at just the moment when I needed love and joy and dogs and cats. This outstanding colleague and critic's fingerprints are all over this manuscript in ways that made it so much better. If life really is a marathon, John Murphy, then I am grateful to be running this stretch of it alongside you.

The spirit of my doctoral advisor, Tom Farrell, hovers over this book. Although Tom died before we were able to have any meaningful conversations about the project, his ideas about what rhetoric is and how it works continue to inform and inspire me. If anyone would enjoy a project that spans the rhetorical spectrum from war, death, and poverty to ghosts, family pictures, and P. T. Barnum, it would be most certainly be Tom.

Viewers Reading Photographs

Studies of photography's historical viewers are rare, and with good reason. It is not easy to access the experiences of historical viewers. The critic seeking to account for such experiences inevitably runs up against the problem that the act of viewing typically leaves no discursive traces.[1] To say the least, this puts one at a loss for evidence. David Freedberg outlines the core problem: "How can one say anything at all about popular response and popular attitudes to images in history in the absence of living witnesses?"[2] I address this critical dilemma by using my training as a scholar of rhetoric to seek out and analyze the public discursive traces of people's responses to their photographic encounters. I argue that it is within these documented encounters between viewers and photographs that we may come to understand the complex and historically specific relationships that shape viewers' participation in photography.

Focusing on the period between the Civil War and the Great Depression—a period when photography became a dominant medium of cultural life—I study discourse produced by viewers in response to specific photographs they encountered in public. In the cases I examine, viewers left evidence of their responses in newspaper and magazine articles, letters to the editor, trial testimony, books, speeches, photographs, and comment cards left at an exhibit. My analysis shows how engagement with photography in the late nineteenth and early twentieth centuries helped viewers negotiate emergent anxieties and crises of U.S. public life. I argue that encounters with photography fostered in

viewers a rhetorical consciousness—that is, "a manner of thinking that invents possibilities for persuasion, conviction, action, and judgment."[3] As we shall see, viewers performed that rhetorical consciousness not only by describing or analyzing the photographs they encountered but also by mobilizing a sophisticated (though often implicit) rhetorical repertoire that grounded their arguments about war, empire, national identity, child labor, citizenship, and economic depression. Part of the goal of this project is to identify and elaborate features of that repertoire.

Before going further, let us take a more detailed look at the viewer responses that I take up here:

In October 1862 *Harper's Weekly* published engravings of photographs made after the Battle of Antietam, thus displaying images of the battlefield dead to Americans for the first time. Although the magazine's readers did not see actual photographs in print yet (that came later, with the rise of halftone in the 1880s), the knowledge that the engravings were based on actual photographs made real and graphic the losses of war. At about the same time, a photographer in Boston claimed to be able to conjure the spirits of dead loved ones and make them appear alongside the grief-stricken subjects of photographic portraits. Such new and previously unimaginable images of death (and the afterlife) forced viewers to directly encounter the grief and trauma of the Civil War. In their responses to such images, viewers made sense of these new and troubling photographs by writing texts that highlighted the role of imagination in photographic viewership and acknowledged the capacity of photography to produce *presence* in the face of profound, and often permanent, absence.

In November 1895 *McClure's* magazine published a newly discovered photograph of Abraham Lincoln as a young man. *McClure's* invited a handful of its readers to comment on the photograph's publication. Although the photograph was new, the mythic man was not. Thirty years after Lincoln's death, when some Americans were anxious about the fate of American identity in an age of dawning empire, Lincoln's photograph forced viewers to reconcile their beliefs about an iconic figure with this new visual information. They did so by arguing that the photograph revealed Lincoln's superior moral character and, by extension, the nation's. The letter writers made sense of the portrait of the younger Lincoln by invoking photography's capacity to communicate *character*.

In 1912 author and political gadfly T. R. Dawley Jr. published a heavily illustrated book called *The Child That Toileth Not*. By the turn of the

twentieth century, visual fictions of childhood—grounded in beliefs about citizenship and anxieties about the future of the "white race"—had come to dominate political debate. In response to what he viewed as a one-sided visual debate about child labor, Dawley used both his own photographs and those made by Lewis Hine for an anti–child labor group to argue that child labor was in fact good for children. In a time when the value of a healthy childhood was becoming politically more important, Dawley problematically but shrewdly made sense of the working child's role as proto-citizen by activating photography's capacity for *appropriation*.

In April 1938 an already Depression-weary nation was in the midst of the "Roosevelt Recession," a new and severe economic downturn. The Farm Security Administration (FSA) mounted an exhibit of its documentary work as part of the First International Photographic Exposition in New York City. At the invitation of FSA organizers, more than five hundred viewers left responses to the exhibit on comment cards at the exit. The exhibit's unexpected photographs of rural poverty and depression struck viewers as a stark contrast to the commercial spectacular of the exposition. Those who left comments addressed the photographs' overwhelming documentation by inserting themselves into the stories the photographs told. In a time of economic anxiety, commenters made sense of the FSA's photographs of rural poverty by managing photography's capacity to mobilize *magnitude*.

The events I examine stretch across photography's first one hundred years and address four periods of political and social upheaval in the United States: the "republic of suffering" during and after the Civil War; the dawn of U.S. empire and the closing of the frontier at the end of the nineteenth century; early twentieth-century debates about citizenship, race, and child labor; and the economic, political, and social strains of the Great Depression.[4] Each instance I explore posed for viewers a particular reading problem that needed to be confronted and navigated. In the case of battlefield and spirit photography, viewers were forced to confront the stark novelty of photographs that pictured death (and perhaps even the ghostly afterlife) in a time of national upheaval. The Lincoln portrait forced viewers to reconcile a newer but younger and enigmatic Lincoln with the mythologized man represented thirty years after his death as the very embodiment of American national identity. Photographs and other frequently circulated visual representations of the "priceless" children of white, well-off Americans in the early twentieth century posed a reading problem for T. R. Dawley, whose political commitments to child labor required him to devise shrewd ways to visualize working-class children as worthy of citizen-

ship. And finally, viewers of the FSA's 1938 exhibit faced the reading problem of how to engage photographs picturing real-time conditions of poverty and want in the midst of a commercial spectacular devoted to the consumption of photography.

Although I might have explored situations other than or in addition to these, my goal is not to offer a comprehensive history of photographic viewership during this period. What I do instead is explore cases that reveal how viewers responded to the various reading problems posed by specific public encounters with photographs. Despite their distinct historical contexts, each case illustrates that photography's viewers possessed an implicit but distinct and readily available repertoire for talking about photography. That repertoire, emerging from viewers' recognition of photography's capacity to produce presence, communicate character, activate appropriation, and manage magnitude, helped viewers make sense of the photographs they were viewing and grapple with the reading problems posed by particular images. My focus on viewers means I am not offering a history of photography as a medium, a technology, or an art, but rather elaborating a *rhetorical* history that considers how photography animated particular ways of seeing and habits of response among viewers.[5]

Photography, Public Life, and Historical Viewers

The seeds of this project were planted during work on my 2003 book, *Picturing Poverty: Print Culture and FSA Photographs*, in which I studied how Depression-era photographs produced by the U.S. government's Farm Security Administration were mobilized in three different magazines to picture poverty. In that project I focused primarily on the reproduction and circulation of the FSA's images. During my work I came across the well-known story of the "skull controversy," in which FSA photographer Arthur Rothstein was accused in 1936 of misrepresenting photographs he made of a bleached cow's skull he had found in South Dakota. As I examined the various responses to Rothstein's actions that circulated in the press, I became fascinated by the assumptions about photography that grounded the discourse of the controversy. The public arguments of those participating in the controversy made explicit a variety of typically implicit assumptions about the nature and functions of photography.[6] These assumptions suggested to me that there was value in studying viewership and response, and I began to question how one might develop rhetorical histories of photographic viewership. In particular I wondered how viewership and response might work in situations outside of those

4

times when controversy makes implicit assumptions explicit.[7] This book is my answer to that question.

Conceived rhetorically, photography may be understood as an art of the contingent, a visual habit of picturing social, political, and cultural life. Studying photography rhetorically does not mean treating photographs as objects of pure evidence with fixed meanings nor merely as supplemental illustrations to texts. Neither does it mean treating photographers as intentional orchestrators of those supposedly fixed meanings. Rather, it means attending to what elsewhere I have called the "eventfulness" of the photographic encounter: to images' *specificity* as rhetorical documents in the contexts in which they are produced and reproduced and to their *fluidity* as they circulate across space and time.[8] It is this combination of situatedness and contingency that prompts Ariella Azoulay to argue that photography is best thought of as an *event*, one that can never be reduced to its component parts of camera, photograph, photographer, subject, or viewer.[9] I contend that it is precisely the eventfulness of photography that makes it ripe for rhetorical study.

Rhetorical scholarship on photography, when it is done especially well, explores how photography visualizes the world we live in, shapes our perceptions of ourselves and others, guides our experiences of public life, and even constitutes us as citizens. On these topics the work of four authors on U.S. photography deserves particular mention. Alan Trachtenberg's *Reading American Photographs*, a foundational text in the history and interpretation of U.S. photography, argues that photographs "become history when they are conceived as symbolic events in a shared culture," and furthermore that "what an image shows depends on how and where and when, and by whom, it is seen."[10] Throughout his work Trachtenberg deftly shows how early photography functioned not only as a mass medium, a technology, and an art, but also as a *rhetoric*: a metaphor, an image, an idea.[11] He urges scholars to study the history of photography not only by studying its images as rhetoric but also by studying its rhetoric about images—that is, its "history of picturing photography in the medium of language."[12]

Communication and rhetoric scholars Barbie Zelizer and coauthors Robert Hariman and John Lucaites have studied how photojournalism of the twentieth and early twenty-first centuries built public memory and shaped our collective cultural and political experiences in the United States. Focusing primarily on images of unsettling or violent events produced by photojournalists for consumption as news, Zelizer argues that journalism historians' attention to "the fact and actuality of photographic depiction" has left underdeveloped our sense of photographs' relationships to emotion, contingency, and imagination,

three concepts that inevitably shape viewers' responses to photographs.[13] This is especially problematic, Zelizer points out, because emotion, contingency, and imagination intersect with photography in a dynamic fashion: "Images regularly travel across circumstances that are transformative, sometimes playful and hypothetical, and often internally contradictory. This means that an image's meaning relies not on individualistic whims but on fundamental collective impulses on hand to help people make sense of what they see."[14] In short, we cannot study photographs without engaging the interpretive communities surrounding them.

In their study of the highly visible roles that certain twentieth-century photographs have played in American culture, *No Caption Needed: Iconic Photographs, Public Culture, and Liberal Democracy*, Hariman and Lucaites offer a rich and compelling articulation of the power of photography in American public culture. They argue that particular images they term "iconic photographs" ("the images that you see again and again in the historical tableaus of the visual media"[15]) provide emotional and deliberative resources that enable their viewers to navigate the complexities of public life. Performing rich compositional analyses of famous photographs such as Dorothea Lange's "Migrant Mother," Joe Rosenthal's flag raising at Iwo Jima, and others, and exploring subsequent circulation of those same images via a seemingly limitless procession of appropriations and parodies, Hariman and Lucaites refute those who persist in claiming that visual rhetoric denigrates, rather than enriches, public culture: "Instead of seeing visual practices as threats to practical reasoning or as ornamental devices . . . we believe they can provide crucial social, emotional, and mnemonic materials for political identity and action."[16]

I share with Trachtenberg, Zelizer, and Hariman and Lucaites an appreciation for the complex role photographs play in public culture. Throughout my work I have framed photography as a site where social knowledge must be put to work in order to engage with images and puzzle out their structures and meanings in particular historical contexts.[17] Yet while this work addresses multiple facets of photography's eventfulness, it does not attend in detail to the rhetorical practices of historically specific viewers. While these authors (and I in some of my earlier work) lay claim to the capacities of photographs to invite particular interpretations, the readings they tend to privilege are their own. For example, when Trachtenberg articulates his interest in "the question of how we make sense of what we see," there is some slippage in the "we" that he invokes.[18] At times the "we" refers to historical viewers of photographs, but for the most part it turns out that the (skilled, profoundly talented) person doing the reading of the American photographs of the title is Trachtenberg himself.

As a result, photography's historical viewers are only tangentially addressed in the book.[19] Furthermore, although Hariman and Lucaites study circulation and offer numerous examples of appropriations of iconic photographs, the appropriations themselves typically are not studied as rhetorical responses by specific viewers in particular situations; rather, they are presented mainly to illustrate more general public uptake of the images and ultimately serve as further evidence for the iconicity of the originals. If, following Azoulay, we conceive of the "event" of photography as what involves the camera, photographer, photograph, subject, and viewer in endless and always incomplete relation, then we may conclude that even those photography critics and historians who embrace these complex relations still tend to ignore the latter, thus leaving open the question of historical viewership.

Indeed, such work may leave a lingering impression that only critics are qualified to make critical arguments about photographs. By contrast, this project complicates an easy distinction between critical reading and viewing, illustrating in multiple ways how photography's historical viewers have constituted themselves as critical interpreters of photography. In embracing the agency of viewers, I take up Leah Ceccarelli's call for rhetorical critics to "explore all available evidence of reception to a work" in order to more richly "locate meaning in the interpretations of audiences."[20] Of course, I too am a critic. As Bonnie Dow points out, doing "audience-centered work" does not mean erasing the critic, but rather acknowledging the critic's agency as a selector and interpreter of texts.[21] Thus this project might best be described, to use Alan Trachtenberg's formulation, as a series of "close readings of close readings" in which I privilege viewership by assembling, interpreting, and evaluating a series of texts produced by photography's viewers.[22]

The Challenge of Studying Photography's Viewers

In taking up the rhetorical traces of viewers' encounters with particular photographs, I seek to avoid the extremes of conceptualizing viewership as, on the one hand, merely idiosyncratic and anecdotal or, on the other hand, an inevitable product of "the system" that leaves no room for the agency of individual viewers.[23] My study privileges the agency of viewers; it is interested in, as W.J.T. Mitchell puts it, "what people liked to look at, how they described what they saw, how they understood visual experience."[24] Karlyn Kohrs Campbell defines agency as the "capacity to act, that is, to have the competence to speak or write in a way that will be recognized or heeded by others in one's community."[25] Viewers are not passive spectators with no capacity for agency.

Jacques Rancière, for example, points out that the spectator "observes, selects, compares, interprets. She links what she sees to a host of other things that she has seen," to a "common sense" or "community of sensible data."[26] With regard to photography specifically, Ariella Azoulay agrees: "Photography has become a means of viewing the world, and the citizen has become a well-trained spectator, capable of reading what is visible in photographs."[27] While here Azoulay writes primarily about contemporary photography, the point still holds: if we are willing to reconstruct and enter into the interpretive communities in which viewers of the past lived and moved, then we too may access these viewers' repertoires for engaging photography.

Such analysis poses a methodological challenge, however, because it requires the critic to reconstruct the ways audiences at different historical moments viewed and interpreted images and invites us to try to understand the various social, cultural, and political imaginaries that shaped their social knowledge, that "common sense," community-based knowledge that we draw upon to navigate daily life.[28] Vision and visual practices are historically situated, so it is no secret that people respond differently to images in different places and times; as Michael Ann Holly puts it, "The viewer of today not only sees things in a different way but also sees different things."[29] While such an observation might seem obvious enough, what may be less obvious is what differences those differences make in our understanding of the role of photography in the history of U.S. public life. The critic of historical viewers thus takes on a particular burden. Studying photographic viewership rhetorically requires special attention to the historically specific interpretive communities from within which photography's viewers encounter photographs and build their critical interpretations of them.

Making Photography's Viewers Matter

The viewers whose rhetorical practices I study in this book encountered photographs that addressed national anxieties and crises that animated public life in the period between the Civil War and the Great Depression. Each of the cases I study offers insight into the variety of ways that historical viewers used their social knowledge to navigate the reading problems posed by war photographs, spirit photographs, presidential portraits, child labor images, and pictures of poverty. Each example highlights a different way that viewers solved those reading problems by activating a rhetorical repertoire that recognized photography's respective capacities to produce presence, communicate character, activate appropriation, and mobilize magnitude. In producing pub-

lic arguments designed to help them navigate national anxieties and crises of the period, viewers also articulated the ways that photography itself could be mobilized to address those crises. If, following Thomas Farrell, we conceive of rhetoric as "the art, the fine and useful art, of making things matter," then this is a book about how viewers made photography matter, how they understood and mobilized its potential for addressing anxieties and crises of U.S. public life.[30] By showing how photography's viewers recognized the contingency of photographic interpretation, mobilized their social knowledge, and constituted themselves as active participants in the event of photography, I, in turn, make photography's viewers matter.

The Presence of Unknown Soldiers and Imaginary Spirits

Viewing National Grief and Trauma in the Civil War Era

> It was in evidence that persons had been
> honestly deceived by their imaginations.
>
> —"Home and Foreign Gossip,"
> *Harper's Weekly*, May 15, 1869

In the fall of 1862 Oliver Wendell Holmes learned his son had been shot in the neck at the battle of Antietam.[1] Upon receiving the news at home in Boston, the poet, medical doctor, Harvard University professor, writer, and photography enthusiast commenced a journey by train and wagon to find him. Antietam was the bloodiest action of the Civil War, costing more than six thousand American lives in just two days of fighting; another fifteen thousand soldiers were wounded.[2] Holmes eventually found his son, the future Supreme Court justice Oliver Wendell Holmes Jr., safe and recovering from a wound that was less severe than originally thought. Holmes Sr. reflected on his experience in an essay published in the December 1862 issue of *Atlantic Monthly* called "My Hunt After the Captain."[3] Writing of his visit to the battlefield just days after the fighting concluded, he wrote:

> We stopped the wagon, and, getting out, began to look around us. Hard by was a large pile of muskets, scores, if not hundreds, which had been picked up and were guarded for the Government. A long ridge of fresh gravel rose

before us. . . . Other smaller ridges were marked with the number of dead lying under them. The whole ground was strewed with fragments of clothing, haversacks, canteens, cap-boxes, bullets, cartridge-boxes, cartridges, scraps of paper, portions of bread and meat. I saw two soldiers' caps that looked as though their owners had been shot through the head. In several places I noticed dark red patches where a pool of blood had curdled and caked, as some poor fellow poured his life out on the sod.[4]

In telling his story of visiting the battlefield, Holmes writes as a kind of camera, offering the reader verbal snapshots of the tragic visual spectacle he encountered.

On December 10, 1862, a newspaper called the *Boston Investigator* noted the appearance of the December issue of *Atlantic Monthly* and pronounced it "very able." "Among the many admirably written articles," the *Investigator* commented, was the essay titled "My Hunt After the Captain."[5] Yet at the same time that it praised Holmes's photographic prose, the *Boston Investigator* was embroiled in a skirmish over what it viewed as a much less savory photographic practice. Since early November two spiritualist newspapers, New York's *Herald of Progress* and Boston's *Banner of Light*, had been publicizing the discovery of so-called spirit photographs by one William H. Mumler of Boston. An amateur photographer and engraver by trade, Mumler claimed to have produced photographic portraits with an added bonus: not only was the sitter represented, but a ghostly spirit hovering around the sitter would sometimes appear as well. And sitters, the spiritualist newspapers tantalizingly reported, frequently recognized those spirits as loved ones long dead.

Claiming to be no spiritualist himself, Mumler passed along news of his discovery to a friend, who in turn shared it with the spiritualist papers. In its issue of the first of November 1862, the *Herald of Progress* announced, "We have been placed in possession of an account of events transpiring in Boston, which give promise of opening to the world a new and most satisfactory phase of Spiritual Manifestations."[6] According to sources in Boston, the first "spirit photograph" was a self-portrait of the photographer that included the form "of a young girl apparently sitting in the chair, which appeared on developing the picture, greatly to the surprise of the artist."[7] Speaking with a photographer friend, Mumler was told that it was likely the glass he used had not been cleaned properly before exposure, thus leaving a latent, older image on the plate. Mumler accepted this explanation and repeated it when showing the image to friends. But on one of those friends, "who I knew was a Spiritualist," Mumler decided to play a little joke: "I therefore showed him the picture, and

with as mysterious an air as possible, but without telling an untruth, which Mr. P. T. Barnum calls 'drapery,' I stated to him 'that this picture was taken by myself when there was no visible person present but myself.'"[8] Mumler signed the back of the resulting *carte de visite* with the following winking message: "'This photograph was taken of myself, by myself, on Sunday, when there was not a living soul in the room beside me—'so to speak.' The form on my right I recognize as my cousin who passed away about twelve years since.'"[9]

The *Herald of Progress* was not quick to embrace the new discovery as absolute proof of spirits made visible. Yet it wrote suggestively, "This singular freak in chemical art, if it be no more, or the new manifestations of spirit power, if it be such, commands most earnest attention and inquiry."[10] Indeed, the newspaper continued to pay close attention; during the next six weeks the *Herald of Progress* published no fewer than ten articles on the question of spirit photography. The curious discovery spread quickly to non-spiritualist newspapers around the country as well, which noted with some amusement the apparent ability of Mumler "to produce photographs of spirits around his human sitters," spirits who had been "recognized as friends that once lived on earth."[11] Soon Mumler found himself in the spirit photography business. Boston's own spiritualist paper, *Banner of Light*, maintained a tone similar to that of the *Herald of Progress*. Dr. A. B. Child wrote, "We have been assured for months by our spirit friends that in due time the mundane world would be startled by this new phase of spirit power; but we were not prepared to receive it so soon, and are yet in doubt that the manifestation is entirely legitimate. We shall investigate further ere we give a decided opinion in the matter."[12]

But the *Boston Investigator*, which had admired Holmes's battlefield narrative and advertised itself on its masthead as "devoted to the development and promotion of universal mental liberty," was not quite so diplomatic. In late 1862 and early 1863 the paper wrangled in print with the spiritualist newspapers in an effort to debunk Mumler's spirit photography.[13] A writer named "Veritas" criticized the "dogmas of Spiritualism," observing that the appearance of spirit photography seemed to be just another in a long line of deceptive spiritualist performances:

The mediums multiply among us like the frogs of Egypt and set themselves up for teachers in morals, theology, science, and philosophy. They twitch, jerk, close their eyes, and saw the air with their arms, while they get off a large amount of cant and twattle about "the spheres" and other matters of which they know nothing whatever. . . . And in view of these things you and I, Mr. Editor, have often said, "*What next?*" Well, the next, the last, wonder

is these "spirit photographs," which I pronounce a transparent, unmitigated humbug from beginning to end.[14]

Readers appreciated the muckraking stance. A reader named "N. G.," who signed his letter "yours against all humbugs," wrote: "Mr. Editor: Your useful INVESTIGATOR is very much needed to counteract the superstitions of the day."[15]

It is not known whether William Mumler and Oliver Wendell Holmes ever met in person, but their paths would cross the following summer in the pages of *Atlantic Monthly*. In a now canonical essay on photography called "Doings of the Sunbeam," Holmes would write of his experience of seeing photographs of the battlefield of Antietam and would excoriate the practice of spirit photography as an exploitation of the grief of the bereaved. While a number of scholars have engaged Holmes's writing on the Antietam images and fewer have noted the same essay's attack on spirit photography, no one has read these two commentaries together.[16] Yet they are intimately related. The public conversation about spirit photography in the 1860s cannot be separated from the public experience of Civil War photography. Both summon the ghost of national trauma. I observed in the introduction that this book examines how Americans constituted themselves as agents of photographic interpretation. Although viewers could not yet view actual photographs in newspapers or magazines (that would not come for another two decades), spirit photographs and photographs of dead soldiers nevertheless shaped these citizens' experience of national life. Those who did not directly encounter photographs, or even engravings of them, frequently encountered public conversations about them in print. Such texts transformed readers into viewers through a translational process of virtual witnessing.[17] Through newspaper stories, magazine articles, popular writings on photography, and even trial transcripts, citizens routinely encountered Civil War–era accounts of viewing.

This chapter examines close readings of photographs of the battlefield dead at Antietam, published accounts of photographs of unknown soldiers, and public commentary and trial transcripts related to the practice of spirit photography. Such photographs posed considerable reading problems for viewers who were unaccustomed to the idea of photographic representations of death and the afterlife. In a time of national crisis, grief, and trauma, viewers made sense of such images by drawing on their recognition of photography's capacity to produce *presence*. Presence, as described by Chaim Perelman and Lucie Olbrechts-Tyteca in *The New Rhetoric* and elaborated by a variety of scholars, may best be understood as an effect of discourse that "acts directly on our sensibility." Presence brings before an audience an idea—an image—of

what is absent in ways that enhance its value.[18] Its "strongest agency," Louise Karon notes, "is that of the imagination."[19] Presence thus has a decidedly affective quality; Karon describes it as an ambiguous but "felt quality of the audience's consciousness."[20] John Murphy similarly observes that "presence possesses a kind of magical quality. . . . An auditor 'feels' the argument; it almost seems to be in the room."[21] In this way presence may be understood not only as affective but also as visual, even sensual. A variety of visual and verbal strategies may be mobilized to produce presence; Perelman notes that amplification, aggregation, and playing with time are predominant ways to evoke presence for audiences.[22] Techniques for generating presence are especially essential when the need arises to evoke "realities that are distant in time and space."[23] Photography as it was practiced during and just after the Civil War offered profound resources of presence for its consumers.

Photography's capacity to collapse time and space is well understood, of course; as Roland Barthes writes, "Every photograph is a certificate of presence."[24] What is pictured was once there, in the frame, to be photographed. And it persists in that presence, even with the passage of time. In the Civil War era, grieving families, war widows, and others with dead or missing loved ones embraced photography's capacity to offer presence in the midst of profound and often permanent absence. Small, treasured portraits could place lost or absent ones literally into the hands of family members to provide comfort, cue memory, and ease grief. In public contexts, photographs and engravings of the battlefield dead published in magazines and newspapers or displayed in the home or gallery space made war painfully present for viewers separated by time and space from loved ones in harm's way. Even more dramatically, the mysterious appearance of the apparent spirits of deceased family and friends in photographic portraits seemingly erased the most permanent of absences; here photography's capacity for presence seemed even to surmount death itself. During a period in which the collective grief of the "republic of suffering" vividly animated public life, those who read both war and spirit photographs recognized the medium's capacity for producing presence in the face of the most traumatic of absences.[25]

Photographing the Civil War

Writing about the aftermath of the Civil War, Jackson Lears remarks, "Wars have a way of staying in the mind. Scenes of unimaginable carnage cannot be casually shrugged off; visceral fears and rages cannot be easily forgotten."[26] Lears is not writing about photography specifically, but certainly the ability to

visualize war and carnage made the Civil War present in the minds of Americans for decades. While the American Civil War was not the first war—or even the first American war—to be photographed, it was the first whose images widely circulated in public.[27] By the time Holmes's account of the search for his son appeared in December 1862, other Americans had had their own chances to view the battlefield at Antietam. Photographs made immediately after the battle circulated as album cards and appeared as engravings in magazines like *Harper's Weekly*. Notably, the photographs of Antietam were the first images that featured the battlefield dead. William Frassanito observes, "Antietam was the first battlefield in American history to be covered by cameramen before the dead had been buried. It was the . . . scenes showing human wreckage that thrust the Antietam series into the public limelight like no other series before or after."[28] Photographers working for Mathew Brady, heralded by the *New York Times* in 1862 as the nation's "leading photographic artist," made the Antietam pictures. The *Times* wrote that since 1861, Brady's photographs of battlefields, camp life, and Union leaders had provided "us all a real service, in divers [*sic*] ways, by this work of his, undertaken so courageously, and carried forward so resolutely. It is no holiday business this taking the likeness of 'grim-visaged war.'"[29] Despite this praise, Brady did not physically make the Civil War photographs credited to him in the press; today we might consider his role as more akin to a producer of a film than its director or cinematographer. Yet an image branded "photo by Brady" carried public weight in the 1850s and 1860s. His biographer Robert Wilson asserts, "Brady saw immediately the potential for photography to record firsthand the history of the Civil War and did more than any other person to make a visual historical record of the war happen."[30]

Mathew Brady began his photography career at the age of twenty-two when in 1844 he opened a daguerreotype studio in New York City. He soon became a successful practitioner of photographic portraiture, opening subsequently larger galleries in New York and, by 1858, in Washington, D.C.[31] In the 1840s and 1850s Brady created and marketed what he called his "gallery of illustrious Americans," portrait photographs of the leading military, political, and literary figures of the day. Brady's portraits were displayed at his studios, where visitors could wander among the images of "'Lecturers, Lions, Ladies, and Learned Men'" and in their faces see traits worth emulating.[32] (I discuss Brady's gallery and the rhetoric of portraiture in more detail in chapter 2.) "More than any other American," argues Alan Trachtenberg, Brady "shaped the role of the photographer as a national historian, one who keeps records of the famous and the eminent, as well as the run-of-the-mill citizen."[33] By the dawn of the Civil War, "Brady stood at the pinnacle of contemporary fame."[34]

D. Mark Katz asserts that "Brady was adamant in his desire to photograph the war."[35] He sought immediacy: to get photographs of the action before the public (and for sale) as quickly as possible. Yet the action itself was difficult to photograph; equipment was cumbersome and photographers had to obtain permission to access the battlefields. For this reason the vast majority of extant Civil War photographs are images far from the scene of battle: photographic portraits sent home by soldiers to loving families; quotidian images of camp life; landscapes of battlefields long cleared of the dead; and portraits of generals and other notables.[36] Furthermore, most Civil War photographs record Union activities. As Keith F. Davis explains, "The Union blockade of Southern ports and the region's accelerating economic crisis severely curtailed photography in the fledgling Confederate nation and created many unfortunate gaps in the visual record of Confederate forces."[37]

Despite the *New York Times*'s declaration that Brady was the most important photographer of the war, there is little evidence that Brady himself made any battlefield photographs during the war. As was the case with his prewar photography, Brady considered an image his (and copyrighted it as such) if he had been present when the image was made or if he had provided the equipment to make the image.[38] Immediately after the war began, Brady and his Washington gallery manager, Alexander Gardner, trained twenty assistants who commanded wagons carrying photographic equipment, each essentially a "movable darkroom."[39] Gardner also obtained military credentials, which enabled him to work for the U.S. government as a photographer; his early work in the war found him photographing for Allan Pinkerton and the Secret Service.[40] Throughout the early months of the war, Brady's photographers chronicled military operations throughout Virginia.

By the time they arrived at the Antietam battlefield, in the third week of September 1862, Gardner and his assistant James Gibson had accumulated months of experience in the field. Frassanito, who chronicles in detail the photographs made by the two men at Antietam, states that it is not clear when they arrived at the scene of the battle, though it was well before the bodies of the dead were cleared from the area.[41] Gardner and Gibson made a total of ninety-five exposures at Antietam. Most were taken within a few days of the battle, and a couple of dozen were made later, in early October, when President Abraham Lincoln visited the area.[42] The majority of the images were stereo negatives made with a twin-lens camera. In addition to offering audiences the possibility of three-dimensional stereoscopic views of the battlefield, stereo negatives could also be printed as single images to be collected into sets and sold cheaply. Stereo cards were incredibly popular by the beginning of the war;

people put them into albums and viewed them in their homes using a binocular viewer called a stereoscope. Oliver Wendell Holmes Sr., in fact, introduced what became the most popular and easy to use of these in 1861.[43] Apart from their more flexible commercial possibilities, Gardner and his photographer colleagues also made stereo negatives because the stereo camera was easier to use in the field. The new photographic technology of the stereo camera and the new commercial product of the carte de visite emerged at precisely the right time. Photographers "went to war knowing that they would have at their disposal not only a ready-made mass market enthusiastically awaiting their products but, of equally vital concern, that they would be able to supply that demand with images that could be reproduced in unlimited quantities at a price almost everyone could afford."[44]

Gardner and Gibson's photographs of the Antietam battlefield highlighted key locations of the battle. Northern readers keeping up with the details of Antietam in newspapers and magazines would come to recognize names like Dunker Church, Burnside Bridge, and the so-called Bloody Lane, a scene of such carnage that battlefield accounts describe it as literally "choked with human corpses."[45] The content of the photographs was similar to earlier visual coverage of the war, with one significant difference: in addition to deceptively bucolic scenes depicting now-empty sites of battle and images of soldiers gathered in camp, Gardner and Gibson also photographed corpses (primarily Confederate soldiers) that had not yet been buried. William Frassanito estimates that roughly one-third of the photographs made by Gardner and Gibson at Antietam depict dead bodies.[46] Arriving before all of the dead had been buried, the two men photographed the dead where they had fallen, where they had been gathered in groups in preparation for burial, and after they had been placed in mass graves hastily dug to dispose of their rotting corpses.

Of the Antietam photographs James McPherson writes, "For the first time in history, the graphic and grisly sight of bloated corpses killed in action could be seen by those who never came close to the battlefield."[47] Yet as powerful as the photographs appear in retrospect, it is important to remember that the vast majority of the public would not have seen the images as photographs, but as engravings. Joshua Brown observes, "For the northern public during the civil war . . . the engravings in the illustrated press—almost 6000 cuts by one estimate—though they were at times based on photographs, outweighed in their accessibility and immediacy the comparatively expensive photographic albums and cards."[48] In the case of Antietam, Brown is right that most Northerners would not have seen the photographs of Gardner and Gibson *as photographs*

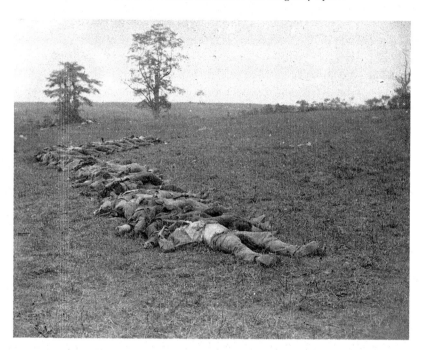

Bodies of Confederate dead gathered for burial, Antietam, 1862. Library of Congress.

unless they chose to purchase a set of album cards sold by Brady. They would have encountered them in print as engravings. Yet print culture was important not only as an outlet for circulating engravings but as a mechanism for translation of the experience of viewing the photographs themselves. That is, although the photographs were not widely seen in public as photographs, readers of newspapers and magazines did encounter accounts written by viewers who *had* seen the photographs. Those who authored such accounts sought to communicate their experience of viewing these unprecedented images of the war dead. Written accounts of such photographic encounters, I suggest below, served as translational mechanisms enabling those who had seen no images, or seen only engravings, to vividly experience the presence of the war.

"A Terrible Fascination": Making Antietam Present

The October 18, 1862, issue of *Harper's Weekly* featured engravings made from Gardner and Gibson's photographs at Antietam. Like all Brady photog-

raphers' work, the two-page spread was credited solely to "Mr. M. B. Brady." Titled "Scenes on the Battlefield of Antietam," the display of eight images is dominated by a large landscape image of two Union soldiers, rifles in hand, approaching the stone bridge over Antietam Creek. The remaining seven smaller images border the larger image on the top and sides; five of these feature human corpses. *Harper's* eschewed individual image captions in favor of several paragraphs introducing the series as a whole. Of a picture of the infamous Bloody Lane, where Gardner and Gibson photographed a Union burial detail presiding over a wide trench full of the bodies of dead soldiers, editors wrote, "Lying transversally in its depths, where they have evidently fallen in attempting to cross, are piles of rebel dead, many of them shoeless and in rags."[49] *Harper's* observed of another engraving, "A new-made grave occupies the centre of the picture, a small head and foot board, the former with lettering, defining its limits. Doubled up near it, with the features almost distinguishable, is the body of a little drummer-boy who was probably shot down on the spot."[50] For viewers of the engraving reproduced in the magazine, it is unlikely that the features of the young boy would be remotely "distinguishable," much less "almost" so. Thus *Harper's* is not so much describing what readers would see in the engravings as it is describing the experience of viewing the photographs. Just as Holmes sought to communicate to readers of the *Atlantic* his experience of seeing the battlefield at Antietam, so too *Harper's* describes for viewers what they would see if they were looking at the photographs. In order to accomplish the goal of making the battlefield present, *Harper's* must first put the viewer in relationship to the photographs rather than the engravings.

Turning to the magazine's comments about another of the engravings, we see this kind of translation displayed most clearly. Of a Gardner photograph of Confederate corpses lying next to a fence, *Harper's* writes, "Minute as are the features of the dead, and unrecognizable by the naked eye, you can, by bringing a magnifying glass to bear on them, identify not merely their general outline, but actual expression. This, in many instances, is perfectly horrible, and shows through what tortures the poor victims must have passed before they were relieved from their sufferings."[51] As with the "almost distinguishable" face of the drummer boy, here *Harper's* describes not the engraving, but the experience of viewing the photograph. Only the photograph is sharp and clear enough to enable engagement with the "features of the dead." Keith Davis makes a similar point, observing that while the photographs themselves were "shockingly expressive," in the *Harper's* Antietam feature "none of this detail was apparent in the printed illustrations. Perhaps it was sufficient to evoke the well-known descriptive power of photography in the minds of the

readers, allowing each viewer to imaginatively interpret these bland transcriptions of the originals."[52]

Yet *Harper's* hints that even the viewer of the photograph needs additional help with those features that are "unrecognizable by the naked eye"; recall the size of the stereo images is quite small, requiring one to bend over and look closely. The editors suggest engagement with the photograph using a magnifying glass, which enables the viewer to see into the images, not merely "their general outline." With the aid of this viewing device, one may see "actual expression" and witness the "perfectly horrible" anguish on the faces of the dead; the dead become more vividly present. The engravings thus are not a vehicle for communicating the content of the photographs themselves (though they do that to some degree); rather, they run parallel to a textual description that describes for viewers the experience of looking at the actual photographs.

At roughly the same time that readers encountered engravings of Gardner and Gibson's photographs in *Harper's* and the accompanying textual translations, Mathew Brady exhibited Antietam photographs in his gallery in New York. In a remarkable review of the exhibit, an unidentified *New York Times* reporter got straight to the painful, tragic point: "The living that throng Broadway care little perhaps for the Dead at Antietam, but we fancy they would jostle less carelessly down the great thoroughfare, saunter less at their ease, were a few dripping bodies, fresh from the field, laid along the pavement."[53] Noting the tendency for the war to seem far away, consisting of lists of strangers "in the morning paper at breakfast," the author observed, "we forget the horrible significance that dwells amid the jumble of type. . . . Each of these little names . . . represents a bleeding, mangled corpse."[54] While the bodies themselves would prompt the jostling and careless to "saunter less" and notice more, for this author the photographs function as a suitable substitute. The writer recognizes that the photographs collapse time and space in ways with the potential to make the carnage present.

Just as the writer of the *Harper's* piece translated the viewing experience for readers, so too this anonymous *New York Times* reviewer invited readers to put themselves in the place of the crowds at Brady's exhibit at the New York gallery: "Crowds of people are constantly going up the stairs; follow them, and you find them bending over photographic views of that fearful battle-field, taken immediately after the action."[55] In addition to translating the experience of viewing photographs for the reader, this account also gives the reader a chance to view the viewers. Writing in the second person, the author places the reader right in Brady's gallery: "You will see hushed, reverend [*sic*] groups standing around these weird copies of carnage, bending down to look in the

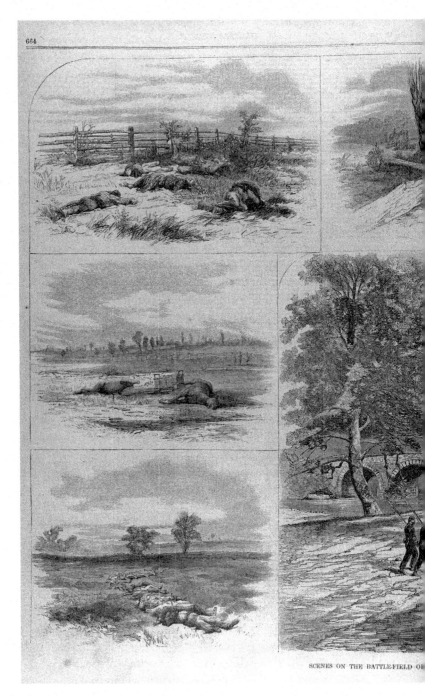

SCENES ON THE BATTLE-FIELD OF

Engravings of Gardner and Gibson Antietam photographs, *Harper's Weekly*, October 18, 1862, 664–65. Courtesy of the Rare Book and Manuscript Library, University of Illinois at Urbana-Champaign.

PHS BY MR. M. B. BRADY.—[SEE PAGE 665.]

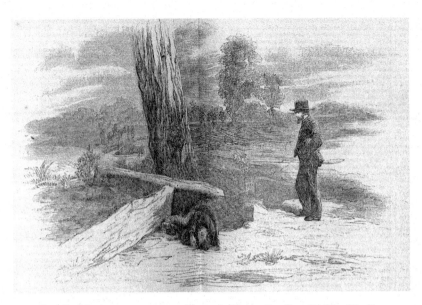

Detail of Antietam engravings, *Harper's Weekly*, October 18, 1862, 664–65. Courtesy of the Rare Book and Manuscript Library, University of Illinois at Urbana-Champaign.

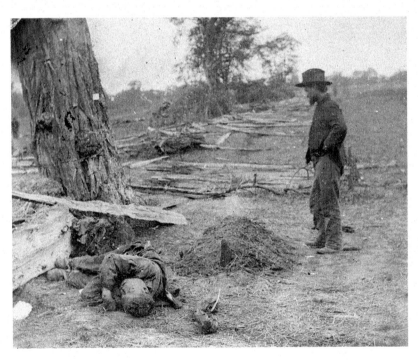

Federal buried, Confederate unburied where they fell, Antietam, 1862. Library of Congress.

pale faces of the dead, chained by the strange spell that dwells in dead men's eyes."[56] Gone is the jostling and the carelessness, replaced by hushed reverence and photographs that seem to cast a spell; the viewers are "chained" by the spell cast by the "dead men's eyes." Here is presence figured as dangerous and magical, capable of enslaving the viewer who chooses to look.

But the writer does not leave the photographs aside to focus on viewers. He also brings the reader with him to view the photographs. The photographs, the author writes, "have a terrible distinctness" such that people should not want to view them. And yet, "on the contrary, there is a terrible fascination about it that draws one near these pictures, and makes him loth [sic] to leave them." The writer paints a picture of active, engaged viewership, of viewers desiring to access that terrible distinctness for themselves, even using tools that create more presence: "By the aid of the magnifying glass, the very features of the slain may be distinguished."[57] Like *Harper's*, the *New York Times* reviewer emphasizes how active viewer engagement can be fostered by the use of an instrument to clarify and magnify the sharp details in the small images.[58] Indeed, writers on photography regularly noted the role a magnifying glass could play in enabling viewers to see into the stereo images more closely. In an 1859 essay on stereography, Oliver Wendell Holmes Sr. said the stereo photograph provided such clarity that one could "look at the two faces with a strong magnifier, and you could identify their owners, if you met them in a court of law."[59]

Yet there is within these close readings anxiety that such distinctness might tragically backfire. The *New York Times* reviewer imagines what might happen if the magnifying glass were actually to produce recognition of one of the subjects of the photographs: "We would scarce choose to be in the gallery, when one of the women bending over them should recognise a husband, a son, or a brother in the still, lifeless lines of bodies, that lie ready for the gaping trenches. . . . How can this mother bear to know that in a shallow trench, hastily dug, rude hands have thrown him."[60] In a moment of sheer imagination, the writer invites readers into Brady's gallery, puts a magnifying glass into the reader's hands, and asks viewers to imagine the very real possibility of recognition: the "terrible distinctness" of the photograph (a three-dimensional image, recall) might make a loved one present. By putting the reader in the gallery at precisely the moment when focused, but perhaps detached, viewership becomes an exciting, three-dimensional, horrific moment of identification, the reviewer asks readers not only to imagine their own response to the photographs, or to the woman who might recognize a loved one, but also to imagine grief itself. For despite the vivid quality of these pictures of war, the writer observes, one thing

"has escaped photographic skill. It is the background of widows and orphans, torn from the bosom of their natural protectors by the red remorseless hand of Battle. . . . All of this desolation imagination must paint—broken hearts cannot be photographed."[61] While the photographs make war more vivid and real by collapsing space and time to make the war dead present with viewers, there are limits to what they can depict.

The reviewer laments the photographs' inability to picture "the background of widows and orphans" and in doing so seems to signal the limits of presence. If photography cannot picture broken hearts, then we have reached our limit. But note that the reviewer himself, in imagining the scene of recognition, extends those limits of presence for his readers. Recall Louise Karon's claim that the "strongest agency" of presence "is that of the imagination."[62] The photographs and the scene of their encounter in the gallery prompt the writer's imagination in ways that make grief present to his audience. When the writer imagines a mother's grief and shock, and by extension asks his readers to do the same, he seeks to cultivate empathy and constitute his audience as a grieving community against the backdrop of national trauma. Thus, despite his own claims otherwise, the writer's close reading of the Antietam photographs works not only to make present the war dead but also to make more present the grief of those left behind.

Holmes writes of a similar sense of imagination in "My Hunt After the Captain." When Holmes stops at a hospital and looks for his son after Antietam, he imagines that each man he sees might be the lost captain: "as the lantern was held over each bed, it was with a kind of thrill that I looked upon the features it illuminated. Many times as I went from hospital to hospital in my wanderings, I started as some faint resemblance—the shade of a young man's hair, the outline of his half-turned face—recalled the presence I was in search of. The face would turn towards me, and the momentary illusion would pass away, but still the fancy clung to me."[63] In a scene that is something of the obverse of the *New York Times* writer's imaginary woman in Brady's gallery, Holmes wishes for a specific presence: he hopes to recognize one of these wounded men as his lost son. Thrilling at the possibility but ultimately failing, Holmes did not realize that his son was already making his winding journey back to Boston while Holmes Sr. searched the battlefield.

The Brady crew's images of Antietam were compelling and they sold. In addition to the gallery exhibit, by October 1862 Brady had issued the photographs as album cards and stereo views as well. The Antietam series of stereo cards continued to sell well late into the war.[64] Katz observes that its popularity was a direct result of Gardner and Gibson's arrival in time to photograph the

dead: "The views taken during the Battle of Antietam proved to Gardner that photographs of the dead commanded the public's attention and translated into sales and profits."[65] Perhaps it comes as no surprise, then, that when it came time to photograph at Gettysburg, "nearly 75 percent of his Gettysburg series focused on the bloated corpses of soldiers and horses."[66] Yet Brady biographer Robert Wilson contests the claim that images of dead bodies are what fueled the popularity of Civil War photography. Because "images of dead bodies were taken on so few occasions," Wilson concludes that they "did not really have a great deal of popular or commercial appeal."[67]

Both Katz and Wilson may be too narrowly focused on the photographs themselves. As we have seen, it was not necessarily viewers' encounters with the actual photographs that shaped their experiences of the Antietam images. Rather, through their encounters with commentary on the Antietam photographs and engravings, readers became virtual witnesses to the new and strange practice of war photography. The photographs made war present to viewers who were invited to "see" the images through writers' eyes. Furthermore, as I explore below, photography participated in the war in ways beyond chronicles of camp life and visualizations of the battlefield dead, producing other compelling moments of presence as well.

Recognizing Unknown Soldiers after Gettysburg

Newspaper accounts frequently mentioned photographs found among the personal effects of the dead. Photographs recovered from bodies of identified dead would be gathered up along with other personal effects and returned to families, sometimes by local pastors or other representatives who traveled to battlefields for that purpose. In the summer of 1864, for example, the *North American and United States Gazette* of Philadelphia reported that one Reverend John Montieth of the Euclid Street Presbyterian Church in Cleveland, Ohio, had traveled with the Christian Commission "to the army."[68] He returned, "bringing with him from the front . . . money, eight watches, and a large number of daguerreotypes and photographs of the mothers, sisters, sweethearts, etc., of soldiers, taken in large part by himself personally, from the dead and the dying, to be transferred to the hands of their friends at home."[69] In many cases it was these personal effects themselves that enabled identification of unknown soldiers. A March 1864 article in the *Boston Daily Advertiser* noted the completion of the long, arduous process of disinterring the Union dead from hastily dug graves and reinterring them in the National Cemetery at Gettysburg.[70] Observing that around one thousand of the Union soldiers

reburied were unknown and therefore "deposited in that part of the inclosure [*sic*] set apart for those unrecognized," the newspaper noted that some unknown soldiers had been identified thanks to personal effects: "Many of the unknown bodies have since been recognized, their names having been discovered from letters, photographs, medals, diaries, clothing, and other things found upon their corpses."[71]

No unknown soldier story is more famous than that of Amos Humiston. It is a complex story of photographic recognition, Civil War–era celebrity, media circulation, and, sadly, the economic exploitation and dashed dreams that public visibility frequently brings.[72] Humiston, a married father of three and sergeant with the 154th New York, died unknown at Gettysburg and likely would have remained one of the "unrecognized" were it not for a series of events that transpired in the days, weeks, and months after his death. The details of Amos Humiston's last hours at Gettysburg are fuzzy, but he likely died on July 1 after the New York 154th, outnumbered as part of Coster's Brigade, confronted a massive Confederate assault at Kuhn's brickyard.[73] According to one authoritative account, his body probably was discovered on July 5 or just after, inside a fenced lot on Judge Samuel Riddle Russell's property.[74] Mark Dunkelman, who has written a book detailing the life and death of Amos Humiston, notes, "The exact nature of Amos's mortal wound went unrecorded, as did a detailed description of his death pose."[75] What is known is that Humiston was found without his knapsack or any other materials with which he could easily be identified. He did have something in his hands, however. He apparently had died clutching an ambrotype of three small children.[76] Exactly who first found Humiston's body—and the ambrotype—is a fact of some disputation, but it was likely one of the daughters of Ben Schriver, a tavern keeper from nearby Graeffenburg Springs, who was in Gettysburg to help a pregnant sister.[77] Amos Humiston's body was interred near where he was found, in Judge Russell's lot, and the ambrotype ended up in the possession of Schriver, who put it on display in his tavern.

What happened next is well documented. Later that summer Dr. John Francis Bourns of Philadelphia stopped at the tavern with his traveling companions when their vehicle broke down. The group was on its way to Gettysburg to help in the hospitals there. As Dunkelman reports it, "Schriver showed the ambrotype of the three children to the men, and told them the story of its discovery. Dr. Bourns realized the photograph was a clue to the identity of the fallen father. He convinced Schriver to give him the ambrotype, explaining that . . . he would use the picture to discover who the children were."[78] Bourns left town with the ambrotype when his vehicle was fixed.

After Dr. Bourns finished work in Gettysburg, he returned home to Philadelphia, where he set about trying to identify the unknown soldier. He approached local newspapers in Philadelphia with the picture and the story behind it, inviting them to write about it to see if anyone who came forward would be able to identify the father. In addition, Bourns determined he would sell copies of the photograph to raise money to support war orphans and the children in the picture if he ever found out who they were.[79]

Newspapers did not have the capability to reproduce engravings in the manner of the large national magazines like *Harper's*. Thus Bourns had to rely on the newspapers to describe the photograph in enough detail so that readers might recognize something about the unknown soldier or the children in the picture. Like those who read the account of the Antietam exhibit in the *New York Times*, readers encountering the story of the unknown soldier's ambrotype had to rely solely on text to learn the photograph's story. On October 19, 1863, the *Philadelphia Inquirer* published a story on the ambrotype, observing, "The last object upon which the dying father looked was the image of his children, and as he silently gazed upon them his soul passed away. How touching! how solemn! What pen can describe the emotions of this patriot-father as he gazed upon these children, so soon to be orphans!"[80] Then, shifting dramatically from the past to the present tense, the author attempted to do just that, amplifying the story via an imagined death scene: "Wounded and alone, the din of battle still sounding in his ears, he lies down to die. His last thoughts and prayers are for his family. He has finished his work on earth; his last battle has been fought; he has freely given his life to his country; and now, while his life's blood is ebbing, he clasps in his hands the image of his children and, commending them to the God of the fatherless, rests his last lingering look upon them."[81] Note how the author conjures presence by placing the reader amid the sights and sounds of battle at Humiston's last moments. In the hands of the *Inquirer* writer, the photograph of the three children becomes an inventional resource for the construction of a narrative of what Drew Gilpin Faust has explained as "the Good Death": "The concept of the Good Death was central to mid-nineteenth-century America. . . . The hour of death had . . . to be witnessed, scrutinized, interpreted, narrated."[82] Dunkelman adds, "Death was most often an intimate family affair. Relatives and friends cared for the dead and dying, gathered by their bedsides, prepared their corpses for burial." In short, the Good Death required *presence*. The narrativization of the unknown soldier's death was thus done not merely for sentiment's or entertainment's sake, but to satisfy a societal need for the Good Death. If the soldier did not have a Good Death in real life, he could be granted one now. The apparent photographic

presence of the children at Humiston's moment of death offered the *Inquirer* writer a vehicle for publicly imagining a better death.

The article also had a more practical purpose. Noting that "the ambrotype was taken from his embrace, and has since been sent to this city for recognition," the author continued with a description that Bourns hoped would help someone recognize the children and thus identify the soldier.[83] The children and their apparent ages were described, as was the arrangement of bodies in the photograph and the children's clothing: "The youngest boy is sitting in a high chair, and on each side of him are his brother and sister. The eldest boy's jacket is made from the same material as his sister's dress."[84]

Initially two Philadelphia newspapers published the story of the ambrotype, but only the *Inquirer* described it in such detail as to make it possible to identify the children of the unknown soldier. Within a week newspapers in nearby cities also printed the story (several carrying the *Inquirer*'s version verbatim), including the Washington, D.C., *Daily National Intelligencer*; the Lowell, Massachusetts, *Citizen and News*; and even the Union-occupied Natchez, Mississippi, *Courier*.[85] Bourns also took the ambrotype to the offices of *American Presbyterian*, a religious newspaper published out of Philadelphia, and shared the image's story with its editor, who then wrote his own account and published it in *American Presbyterian*'s October 29, 1863, issue. Titled "The Dead Soldier and the Daguerreotype" (nice alliteration, though the image was not a daguerreotype), the story described the circumstances in which the photograph had been found and narrated its visual features, including a description of the frame, which earlier accounts had not offered.[86]

After the initial articles were published, several women wrote to Bourns asking for copies of the image, but a firm identification was not immediately forthcoming. In the meantime Bourns arranged for the public sale of copies of the image, which circulated under the title "The Soldier's Children"; proceeds were to be held by Bourns for the benefit of the children, when they were found.[87] No one recognized the children until Philinda Humiston, Amos's wife, was alerted by a friend in Portville, New York, who had read the *American Presbyterian* article. A letter was sent to Bourns in Philadelphia to request an image, a carte de visite was sent in reply, and by late November newspapers reported that the unknown soldier had been identified via recognition of the ambrotype of the children.[88] (In a noteworthy coincidence, the *American Presbyterian* publicized news of the identification of the ambrotype in its November 19, 1863, issue, the same day of the dedication of the cemetery at Gettysburg, where President Abraham Lincoln delivered a 272-word speech for the ages.[89])

After identification of the soldier as Humiston, public interest in the children and the photograph only increased. Copies of the photograph were sold to support wartime charitable efforts and became one of the most popular philanthropic images of the war, and songs and poems dedicated to Humiston and his children circulated widely.[90] Other stories featuring photographs of unknown soldiers continued to appear even years after the war ended. In its October 24, 1868, issue *Harper's Weekly* published a short announcement called "An Unknown Soldier."[91] Next to an engraving of a giant whale caught off the coast of Maine, the magazine published an engraving of a portrait of a bearded man reclining on a pillow, his eyes closed and his mouth fallen slightly open. The short piece that accompanied the engraving announced, "The Quarter-Master-General has requested us to publish the portrait of a soldier who died on the 28th of May 1864, in the Armory Square military hospital, in the city of Washington."[92] The announcement went on to say that when the soldier arrived at the hospital he was too ill to speak and carried no identification materials. When he died, however, it was discovered that he was carrying "a sum of money and the ambrotype or ferrotype of a child."[93] Unlike in the Humiston case, where the image of the children was used to identify the unknown soldier, this soldier was photographed postmortem "in the hope that it may lead to the restoration of his effects to his wife or child." The magazine invited viewers who recognized the man, or who sought to see the image of the child, to contact General H. W. Meigs, the quarter master general, with "proof of relationship."[94]

Of the response to Meigs's request, Drew Gilpin Faust writes, "Letters from women streamed into Meigs's office. While some may indeed have been fortune hunters seeking to claim the money, the great majority displayed what seems like such poignant desperation that it is difficult to doubt the sincerity of the wrenching tales they told." For example, "Mrs. Jenny McConkey of Illinois ...wrote suggesting the unidentified man might be her son," even though he had no children and she could not explain why he would carry a photograph of a child, except that "'he was very fond of children.'"[95] Other women wrote in wondering if he was their husband, claiming, "'Mistakes do often occur.'"[96] Unlike Amos Humiston, the soldier in *Harper's* was never identified. Yet Faust observes, "The unknown man had proved the catalyst for an outpouring of despair from women who represented the many thousands of loved ones left not just without their husbands, brothers, or sons but bereft of the kind of information that might enable them to mourn."[97] As Faust points out, what makes responses like these even more poignant is that these women were so

"An Unknown Soldier," *Harper's Weekly*, October 24, 1868.
Courtesy of the Rare Book and Manuscript Library, University
of Illinois at Urbana-Champaign.

desperate for resolution of their traumatic uncertainty that they imagined they could find it in the engraved face of a man who had been dead for four years.

Ultimately, viewing experiences such as these trained citizens how to negotiate their experience of war. Even when (or perhaps especially when) they were exposed not to photographs themselves but to verbal or visual translations of them, Americans learned what it meant to view war photographically. The thrilling and horrifying possibility of identifying individual dead soldiers at Antietam, or the drama of locating a dead soldier's family through a photograph of a soldier or his children, provided viewers with ways to communicate with one another about war, grief, loss, and trauma. Their close readings of such photographs illustrate how viewers tapped into photography's capacity

to produce presence as they negotiated the uncertainties of war and agonized over lost opportunities for a Good Death.

Holmes, War, and Spirit Photography

While biographers tend not to mention his interest in photography, Oliver Wendell Holmes Sr. holds a particularly important place in the rhetorical history of American photography.[98] He wrote three essays on photography, all of which were published in the *Atlantic Monthly*: "The Stereoscope and the Stereograph" (1859), "Sun-Painting and Sun Sculpture, with a Stereoscopic Trip across the Atlantic" (1861), and "Doings of the Sunbeam" (1863).[99] The essays stand as important early instances of sustained public engagement with photography as a popular technology, art, and science. In these pieces Holmes highlights various methods of photography, explains to the educated lay reader of the *Atlantic* how photographs are made, and explores the variety of contexts in which they are used. In all of the essays, but especially the two stereograph essays, Holmes assumes the persona of teacher and tour guide, instructing the reader/viewer how to consume stereoscopic images. It is notable that each of the essays is structured to highlight not so much photographs themselves but the modes of viewership they require or invite. That is, when Holmes describes an image he does so by foregrounding the viewer's experience of viewing it. For example, here is what he says about a stereograph of the Fountain of the Ogre at Bern, Switzerland, in which a woman in the picture moved before the second exposure was made: "In the right picture two women are chatting, with arms akimbo, over its basin; before the plate for the left picture is got ready, 'one shall be taken and the other left'; look! on the left side there is but one woman, and you may see the blur where the other is melting into thin air as she fades forever from your eyes."[100] By directing the viewer's eye ("look!"; "you may see"), Holmes functions as a kind of tour guide, enabling the reader to become a vicarious viewer of stereographs she cannot herself see.[101] Tapping into the photograph's capacity to conjure presence, Holmes creates for the reader an interpersonal interaction in which the reader joins Holmes in experiencing the contingent presence of the women at the fountain. Holmes celebrates photography in general by lauding the photograph's ability to have "fixed the most fleeting of our illusions."[102] More specifically, he praises the stereograph's ability to "produce an appearance of reality which cheats the senses with its seeming truth."[103] This "cheating of the senses" is possible because stereographs engage both viewers' eyes (with their binocular vision) and their imaginations.

Published two years later, in 1861, the second essay uses a similar persona to laud the glories of armchair travel. Stereographs, Holmes proclaims, make virtual travel possible: "It seemed to us that I might possibly awaken an interest in some of our readers, if we should carry them with us through a brief stereographic trip,—describing, not from places, but from the photographic pictures of them which we have in our own collection."[104] Emphasizing not the places themselves but "pictures of them," Holmes takes readers on a worldwide stereoscopic tour through his own images. Throughout the essay Holmes walks the reader through the images as if we were beside him, perhaps passing a handheld stereoscope back and forth. He starts with the United States and mentions Niagara Falls, Brady's views of Broadway, and Fort Sumter (the Civil War having begun earlier in the year). He then moves across the Atlantic to London, Shakespeare's Stratford-on-Avon, Scotland, Ireland, Paris, Switzerland, Italy, Spain, and Egypt. Through photography, space collapses and one becomes a tourist of the world's most wonderful sights. Importantly, that sense of presence is heightened by the three-dimensional nature of the images. Through virtual use of the stereoscope, the reader becomes immersed into each scene, which makes these images' capacity to produce presence that much more magical and palpable.

Holmes adopts a similar rhetorical stance but introduces a crucial moral dimension to the experience of photography in the third of his *Atlantic* photography essays, published in July 1863 as "Doings of the Sunbeam." Holmes devotes the first part of the long essay to explaining how photographs are made. He begins by taking the reader with him on a trip to Anthony's, a large business in New York City, where he explains how the gallery parses out to different employees the various parts of the laborious process.[105] Next, Holmes apprentices himself to a photographer named Black and walks the reader step-by-step through the process of making a photograph, from coating the plate with chemicals and exposing it to setting it onto the sunlit roof for printing. In the remaining sections of the essay, Holmes works through no fewer than ten different topics related to contemporary photography. He returns to his old love, stereography, to describe new views he has acquired, including Carleton Watkins's dramatic new landscape images of "Yo Semite."[106] He then goes on to explore the topic of portraiture and muses upon what it can reveal about the face, character, and family resemblance. In perhaps the most quoted portion of the essay, Holmes turns next to his experience of viewing photographs made at Antietam by Brady photographers. The topical organization continues with a discussion of aerial photographs made by photographers in balloons; astronomers' use of telescopes; microscopy and microscopic pho-

tography; enlarged portraits; the photographic copying of documents; and spirit photographs. Holmes concludes the long essay with an encomium to the fellowship that emerges among amateur photographers who share their photographs and their practices of photography with one another. The long essay is a tour de force narrative of the state of the art of photography in the eastern United States in 1863.

Of most interest to me are the sections of the essay that discuss war photography and spirit photography. As I noted at the outset of this chapter, while scholars have extensively engaged Holmes's discussion of the Antietam photographs, and fewer note his comments on spirit photography, nobody has addressed them together. Yet from the perspective of those navigating the national trauma of the Civil War, they are inextricably linked through viewers' rhetorical consciousness of the role of presence.

"The field of photography," Holmes writes, "is extending itself to embrace subjects of strange and fearful interest."[107] So begins his discussion of Gardner and Gibson's Antietam photographs. Writing not in the past tense of a battle many months past, but in the present tense of real-time viewership, Holmes states, "We have now before us a series of photographs showing the field of Antietam and the surrounding country, as they appeared after the great battle of the 17th of September."[108] Reminding readers of his earlier essay on the search for his son, Holmes explains that although he saw the battlefield just days after, he is not going to "bear witness to the fidelity of views which the truthful sunbeam has delineated in all their dread reality."[109] No, indeed, the opposite will happen: "The photographs bear witness to the accuracy of some of our own sketches in a paper published in the 'Atlantic Monthly' for December, 1862."[110] The remnants of battle Holmes described in that essay, he tells the reader, are still there in the pictures: "The 'ditch' is figured, still encumbered with the dead, and strewed, as we saw it and the neighboring fields, with fragments and tatters. The 'colonel's gray horse' is given in another picture, just as we saw him lying."[111] Holmes emphasizes that it is the photographs that authorize his own experience, not the other way around. In this way he grants authority to the images themselves and what they depict of the battlefield. Even more interesting, Holmes writes about the photographs in the present tense even though what they depict is not only months past but also in fact was photographed before Holmes himself ever visited the battlefield.[112] Consistent with his approach in the earlier stereograph essays, here too Holmes privileges the viewer's experience of encountering the images for the first time. For the viewer of the photographic series, Antietam is always in the present, both spatially and temporally.

Like the *New York Times* reporter writing of the Brady exhibit, Holmes argues that the photographs make eternally present the tragedy of war: "Let him who wishes to know what war is look at this series of illustrations. These wrecks of manhood, thrown together in careless heaps or ranged in ghastly rows for burial, were alive but yesterday. How dear to their little circles far away, most of them!—how little cared for here by the tired party whose office it is to consign them to the earth! An officer may here and there be recognized; but for the rest,—if enemies, they will be counted, and that is all."[113] As with the story of Amos Humiston, the anxiety of losing the opportunity to help a loved one achieve a Good Death is palpable. For Holmes, battlefield death ultimately takes away a man's chances for a Good Death; "their little circles far away" cannot care for them and those assigned to bury the dead cannot properly "recognize" most of them, especially if they are the enemy. Thus, for Holmes the tragedy of war is not so much death, but rather the photographs' visualization of what happens (or more to the point, what does not happen) to the dead. Holmes continues:

> Many people would not look through this series. Many, having seen it and dreamed of its horrors, would lock it up in some secret drawer, that it might not thrill or revolt those whose soul sickens at such sights. It was so nearly like visiting the battle-field to look over these views, that all the emotions excited by the actual sight of the stained and sordid scene, strewed with rags and wrecks, came back to us, and we buried them in the recesses of our cabinet as we would have buried the mutilated remains of the dead they too vividly represented.[114]

Commentators have noted the complex response to traumatic images presented by Holmes here.[115] Such images both "thrill" and "revolt"; they excite the emotions and sicken the soul. They make the viewer want to lock them up or bury them, to remove them from one's sight, or even not to look at all. In short, they offer *too much presence*. All of these responses have been described by other scholars as typical or representative responses to traumatic images; indeed, Holmes offers something like a narrative of posttraumatic stress disorder when he notes that the photographs made his "actual sight" of the battlefield come back to him "too vividly."[116] Yet coming directly on the heels of Holmes's concerns about the Good Death, we may also read this passage as a continuation of Holmes's anxiety about the bodies of the dead soldiers themselves. When he wishes to bury the photographs in "the recesses of our cabinet," he does so as he "would have buried the mutilated remains of the dead they too vividly represented." It is not that Holmes wishes to remove the

images of the dead from his view because they are too traumatic; rather, they are traumatic because the death they picture is anything but a Good Death: "the sight of these pictures is a commentary on civilization such as a savage might well triumph to show its missionaries." Such savagery may be necessary for war, and especially for this specific war, but "the contemplation of these sad scenes" exacerbates in the viewer trauma and grief.[117]

Unlike many of the photographs he describes in the stereograph essays and elsewhere in this one, here Holmes does not guide the viewer through specific photographs. Where elsewhere Holmes is the viewer's eager escort, here he guides the viewer away from them as quickly as possible. His account of the Antietam photographs is almost entirely about the experience of viewing them, not their specific content. They are too present; there is too much that is too vivid. At last he is relieved, he reports, to "soar away from the contemplation of these scenes, and fly in the balloon" of those who make aerial photographs, the decidedly more lighthearted next topic of the essay.[118]

The idea of too much presence reappears at the end of "Doings of the Sunbeam" when Holmes takes up spirit photography. It is useful to read this section of the essay in tandem with his discussion of Antietam, because there are important parallels. The very reasons Holmes disavows spirit photography are the same reasons he appreciates yet struggles with the Antietam photographs. Of the new practice of spirit photography, Holmes observes, "Some of our readers are aware that photographic operations are not confined to the delineation of material objects. There are certain establishments in which, for an extra consideration (on account of the *difficilis ascensus*, or other long journey they have to take), the spirits of the departed appear in the same picture which gives the surviving friends."[119] From the start, Holmes frames spirit photography as an economic concern, requiring for the enterprising photographer "extra consideration." Holmes then conjures up an imaginary customer, "Mrs. Brown," who "has lost her infant, and wishes to have its spirit-portrait taken with her own."[120] The fictional but representative Mrs. Brown pays to have such a photograph made. When it is completed, Holmes notes, the ghostly baby that appears is most certainly "unauthenticated" and nearly impossible to identify. Yet the mother seems to recognize something: "But it is enough for the poor mother, whose eyes are blinded with tears, that she sees a hint of drapery like an infant's dress, and a rounded something, like a foggy dumpling, which will stand for a face; she accepts the spirit-portrait as a revelation from the world of shadows."[121] Most surely referring to Boston's own recent celebrity, William Mumler, Holmes charges the photographer with preying upon mothers who have been "blinded" by grief. Their vision distorted by

trauma and tears, these mothers' imaginations take over, leading them to see hints of "drapery" as infants' clothing and "rounded somethings" and "foggy dumplings" as faces. Where Mumler jokingly noted his affinity for Barnum-like "drapery," here the term reads not in the comic but the tragic frame. The tendency of those who grieve to see what they want to see is too great, because the eyes of the "untaught" and grieving are easy to deceive. They reach for presence where there is none, and unfortunately photography as practiced by charlatans seems to offer them what they need. As Holmes writes wryly, in the form of a recipe, "First procure a bereaved subject with a mind 'sensitized' by long immersion in credulity. Find out the age, sex, and whatever else you can, about his or her departed relative. Select from your numerous negatives one that corresponds to the late lamented as nearly as may be."[122] For Holmes the presence conjured by those who exploit the grief and trauma of others is manipulative and cruel.

Note that Holmes does not blame those who want to believe, but rather those who exploit them. Indeed, we all imagine that we see things (recall Holmes's own tendency to see the face of his son in the profile of another hospitalized soldier): "Those who have seen shapes in the clouds, or remember Hamlet and Polonius or who have noticed how readily untaught eyes see a portrait of parent, spouse, or child in almost any daub intended for the same, will understand how easily the weak people who resort to these places are deluded."[123] For Holmes the problem with spirit photography is that its viewership depends too much (or perhaps entirely) on a recognition fueled by imaginary presence; that imagination, in turn, is grounded in desire, trauma, and grief rather than fact.

Of all the photographic practices Holmes writes about in "Doings of the Sunbeam," spirit photography is the only one to receive censure. Given what we know about his rhetorical purposes, such criticism makes sense. Holmes was a committed pedagogue; his photography essays are structured to teach readers how photographs are made and how to view them. The essays offer what Jordynn Jack has described as a "pedagogy of sight": "the explicit, didactic attempt to teach a new way of seeing to an audience."[124] Spirit photographs, by contrast, depend upon—even require—an uneducated eye. Where the employment of a magnifying glass might, in the case of the gallery visitor to the Antietam photographs, enhance the clarity of an image, spirit photographs do the opposite; no magnifying glass could ever clarify the "foggy dumplings" in the picture. Finally, spirit photographs re-mystify the practice of photography, which Holmes consistently seeks to demystify. Bringing readers along with him into the studio and darkroom and even onto the roof, Holmes explains

to lay viewers how the art works. By contrast, spirit photographers claim to introduce magic into a process that Holmes seeks to rationalize.

Ultimately, Holmes disdains spirit photography for the same reasons he is fascinated with yet troubled by the Antietam photographs: they offer too much presence. Both kinds of images are borne of grief and trauma, activating emotional experiences brought anew before the eyes of the viewer with each viewing of the image. In addition, both highlight the danger of looking too closely. Looking too closely at a war photograph leaves one in danger of seeing too much or recognizing someone. Looking too closely at a spirit photograph makes one desperate to turn any foggy dumpling into a face. Finally, in both spirit photographs and the Antietam images the viewer's emotions may be overdetermined. In the case of the former, one's emotions make one blind to what is there; in the case of the latter, one's emotions make one wish to put them away altogether. In short, what Holmes offers in his discussion of these two kinds of photographs is a complex discourse about the ethics of photography's capacity to produce presence. Whether they were imagining a Good Death for Amos Humiston and the "distinctive" but nameless boys who died at Antietam, or holding up the new practice of spirit photography as tragicomic drapery, Holmes and others mobilized presence to articulate an ethic of viewership that allowed them to negotiate death, trauma, and grief in and after wartime.

Spirit Photography on Trial

Before we leave the realm of presence, we need to finish the story of William H. Mumler, whose spirit photographs at the end of the decade gave presence a highly visible role in public conversations about photographic practice. In its May 8, 1869, issue, *Harper's Weekly* published a cartoon titled "Spirit Photography."[125] The image featured a portly gentleman having his portrait made at a studio called "Mumler's." In the first panel the man sits alone, posing assuredly for the camera. His female companion looks on approvingly from the background. The caption describes the scene: "Mr. Dobbs, at the request of his Affianced, sits for his Photograph. Unconsciously happens in at MUMLER'S." Turns out a visit to Mumler's was perhaps not the best choice for this groom-to-be. The resulting photograph reveals that Mr. Dobbs was not alone; the filmy figures of five women surround him. Dobbs's hair stands on end and the caption explains: "Result—Portrait of Dobbs, with his Five Deceased Wives in Spirituo!!!" Clearly, this "development" was unwelcome for a man with secrets to keep—five secrets, apparently. For readers taking

up that issue of *Harper's*, the cartoon was not only a farcical commentary on the continuing public interest in spirit photographs; it was also timely. That week the magazine featured on its cover the sensational trial in New York City of Mumler himself, who had relocated to New York from Boston and set up photographic shop. Some local photographers, fearing for their professional status, complained to the city about a charlatan in their midst. Mumler was arrested in early 1869 after a sting operation ordered by the mayor's office.[126] City marshal Joseph H. Tooker visited Mumler's studio (using a false name) and paid the exorbitant sum of ten dollars for a spirit portrait (a typical portrait sitting would have cost about three dollars). When Tooker protested that he had been cheated—he did not recognize the portrait as his deceased father-in-law, as he claimed he had been promised—Mumler was arrested and charged with two felonies and a misdemeanor for defrauding Tooker under "false pretenses," practicing "gross frauds and cheats . . . habitually upon the public," and "stealing" from Tooker by "trick or device."[127] The *Boston Daily Advertiser* noted of the trial, "The whole philosophy of spiritualism, the whole philosophy of optics, the whole science of photography, has been thrown open for proof and argument," and it noted, "The evidence of the eye and the ear, accepted

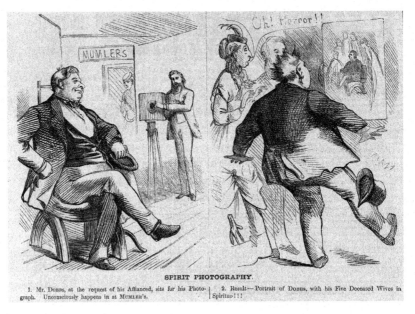

Spirit photography cartoon, *Harper's Weekly*, May 8, 1869. HarpWeek, LLC.

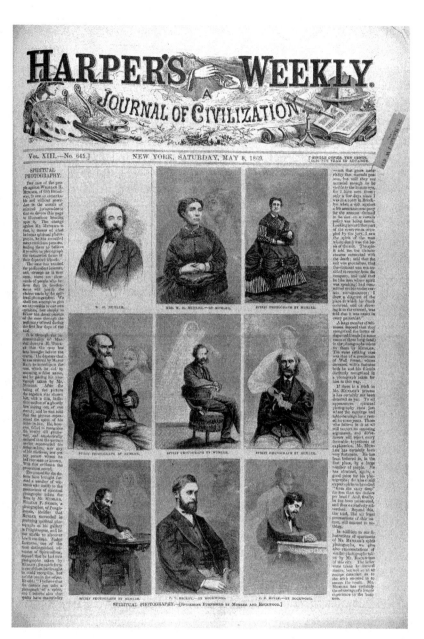

SPIRITUAL PHOTOGRAPHY.—[Specimens Furnished by Mumler and Rockwood.]

"Spiritual Photography," *Harper's Weekly*, May 8, 1869. Courtesy of the Rare Book and Manuscript Library, University of Illinois at Urbana-Champaign.

in all other cases, has been met in this by a bold denial of their power."[128] Six years earlier Oliver Wendell Holmes Sr. had concluded his dismissal of spirit photography by observing wryly, "If the penitentiary could be introduced, the hint would be salutary."[129] Though we have no record of his response to it, for Holmes the Mumler trial might seem to have offered the satisfaction of the successful prosecution of a practice he deemed unethical. But something quite different happened.

The three-day trial that followed Mumler's arrest was a public spectacle in its own right.[130] The courtroom was packed with onlookers, including much-mocked believers in spiritualism who worried that their belief system was also being put on trial. Transcripts of trial testimony in newspapers frequently insert responses of the crowd, "laughter" being the most frequent audience response. Newspapers in New York City covered the trial in disproportionate detail, as did those in Boston. The unusual event received extensive national exposure as well; newspapers from as far away as South Carolina, Wisconsin, and California reported on the trial and reproduced portions of trial testimony.[131]

The desire to communicate with spirits probably has always been a part of the human psyche. But Bret E. Carroll observes that this desire "became particularly intensified and culturally salient" in the antebellum United States.[132] Spiritualists tended to be politically progressive, active in movements such as abolition, temperance, and woman suffrage.[133] They were also interested in modern science and technology. Spiritualists believed in the materiality of the spirit world, subscribing to widely held nineteenth-century beliefs about the existence of ether, which supposedly held the order of the cosmos together. They frequently associated spirit communication with concepts such as electricity and magnetism and described spirit communication in terms of other modern modes of communication such as telegraphy.[134] John Durham Peters argues that spiritualism served as an influential metaphorical and conceptual force in the development of our contemporary ideas about communication.[135]

The Mumler case brought spirit photography and spiritualism to the public's attention, featuring the testimony of well-known spiritualists as well as average citizen-believers who had sat for many of the images in question and attested to their authenticity. The trial also educated the public about the practice of photography itself. Both the prosecution and the defense brought to the stand a series of photographers who testified in great detail as to how such photographs could be made by mechanical means. The primary strategy of the prosecution was to show that there existed "tricks" that any photographer could use to make spirit photographs and that Mumler, knowledgeable in photography, was able to use those tricks himself. In addition, master show-

man P. T. Barnum testified, to the great delight of the courtroom audience and newspaper readers across the country.[136] No slouch in the spectacle department himself, Barnum had famously debunked the practice of spirit photography in his recent book, *The Humbugs of the World*.[137] According to Michael Leja, the man who had introduced the Fiji Mermaid, George Washington's nurse, and other deceptive amusements to American popular culture "was able to speak in the confidence that his audience would recognize his falsehoods as such" because "everyone knew he was dissembling," yet no one minded.[138]

To illustrate how images like Mumler's might be made, witnesses for the prosecution sat for their own "spirit photographs." Barnum heartily agreed to sit. He noted, "I told [the photographer] I wanted a spirit photograph taken, but that I didn't want any humbug about it; [laughter;] I examined his operations thoroughly, but I could detect no fraud on his part, although I watched him closely; my photograph was taken, and on it was a spirit form, so-called; my photograph was that of Abraham Lincoln; I didn't feel any spiritual presence."[139]

The defense countered that Mumler did nothing deceitful in making the photographs, that the photographs could be explained by the mediumistic abilities of Mumler and his wife; that the fact that sometimes sitters did not get the spirit portrait they were looking for pointed to spiritual, rather than mechanical, intervention in the process; and, finally, that many satisfied customers had recognized their loved ones in the images. In the end the judge declared there was not enough evidence to move the case forward and it was dismissed. The defense had maintained throughout the trial that while it was certainly possible to fake spirit photographs, Mumler's photographs had not been faked. While the judge did not buy this argument—indeed, his final ruling suggests he did think that Mumler was engaging in a "humbug"—he ruled that prosecutor Elbridge T. Gerry had failed to establish that Mumler had used these methods himself.

The May 15, 1869, issue of *Harper's Weekly* reported the news of Mumler's acquittal. "In regard to the alleged likeness of the 'ghosts' to deceased friends," *Harper's* noted, "it was in evidence that persons had been honestly deceived by their imaginations."[140] This turn of phrase demands to be parsed. What might it mean to describe the viewers of spirit photographs as "honestly deceived" by their own "imaginations"? We get a clue if we attend to the testimony of one witness in particular and consider how presence was brought to bear on his viewing experience. On the second day of the trial the defense made its case. Defense attorney John D. Townsend called some of Mumler's former customers to the stand; one of them was Charles F. Livermore. In its account

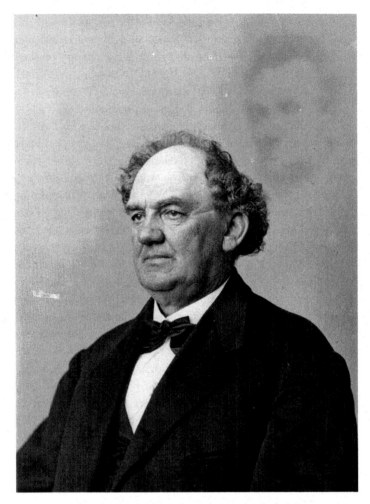

Spirit photograph of P. T. Barnum and Abraham Lincoln, ca. 1869.
Photograph by Abraham Bogardus. Courtesy of the Meserve-
Kunhardt Foundation.

of the trial, *Harper's* magazine described Livermore as a "gentleman of Wall
Street" and called his testimony "the most striking case" of the trial.[141] Liver-
more claimed on the stand that both "he and his friends distinctly recognized"
Livermore's deceased wife in a series of spirit portraits made in Mumler's stu-
dio.[142] Livermore's testimony was of interest for other reasons as well. Unlike
others who had testified in Mumler's defense, he was not an avowed spiritualist,

which left him largely immune from the prosecution's claims that Mumler's customers were delusionals who believed in the spirit world. In addition, he claimed to have approached his sittings with Mumler as a skeptic, claiming to have observed Mumler's entire process from start to finish and leaving satisfied that no manipulation of the plates, camera, or developing process had occurred. Unlike the grieving and untaught Mrs. Brown imagined by Holmes in "Doings of the Sunbeam," Livermore presented himself as a sophisticate and a skeptic, not likely to be deluded.[143]

Livermore testified that initially he went to Mumler's studio both to satisfy his own curiosity about spirit photography and to appease friends in England who had been sending him "earnest inquiries" about this new practice.[144] According to his testimony, upon arriving at the studio Livermore told Mumler he had "come to sit for my photograph to determine if there was anything in it." This phrase may be read in more than one way. Did Livermore mean he wanted to see if there would be "anything in" the portrait besides his own image—that is, a spirit—or, was he referring to spirit photography more generally? In other words, was there "anything in" this practice, or was it simply a hoax or parlor game? Either way, Livermore further testified in court that he "went there with my eyes open, but as a skeptic."[145] Whether out of embarrassment or skepticism, we cannot be sure, but the Wall Street gentleman was not entirely forthcoming with Mumler. He declined to give his name on that first visit and was recorded in Mumler's customer records as "Mr. 500."[146]

In his testimony Livermore offered a detailed account of his experience in the studio. He said he had observed Mumler throughout the entire process and had not discovered anything unusual in the photographer's practices. He also informed the *New York Sun* that initially he was so skeptical that he attempted during his sittings to "disconcert" Mumler, noting that between exposures he "suddenly changed my position so as to defeat any arrangement he might have made; in another I made him suddenly bring the camera three feet nearer to me." Livermore concluded of these strategies, "I was on the lookout all the while."[147] He testified that after this first sitting, he was dissatisfied with the results; he did not recognize the ghostly figure next to his own. According to Livermore, he then took the images home and showed them to a doctor friend, who "immediately recognized one of the pictures as a relative of his; then I recognized it myself."[148]

Livermore's first experience proved promising enough to encourage him to return to Mumler for a second sitting. He did not make an appointment, he said, because he wanted to achieve the element of surprise. At his second sitting he sat for five portraits. The first of these, Livermore noted, "amounted

to nothing but a shadowy background," but the latter three sittings provided pictures he recognized as that of his deceased wife. Two of these were later reproduced as engravings in the *Harper's* cover story on the trial. Showing him one of the images during cross-examination, prosecutor Gerry asked him, "Who is this figure in the picture?" Livermore replied, "It is my wife; she died eight years ago." Under questioning Livermore added, "I have a picture of her in my possession, and I may have seen the picture every day; it is hanging up in my bed room, . . . I have two portraits besides; I see them every day."[149] Livermore explained how he knew the spirit photographs were pictures of his wife. Although she had been dead for eight years, time had not caused his memory to fade, because he had other photographs of her. Simply put, Livermore remembered what his wife looked like. Furthermore, these images were not hidden away; one was hanging in his bedroom and he said twice that he saw it "every day." Because of the unique temporality of the photograph, Livermore continued to experience his wife in the present. He *sees* her *every day*, so of course he would know *what she looks like*. What makes the spirit image recognizable as his wife—what makes it authentic—is her presence in other photographs. Memory fades, but the photograph allows him to imagine that the spirit figure is her.

Prosecutor Gerry probed Livermore further, asking him to identify what *specific* features led him to recognize the indistinct figure as his wife. "Do you see anything to cause an identity except the faces?" he asked. "Nothing," Livermore observed, "except the general size." Gerry queried further, "Do you recognize any peculiar expression about the face?" Again, Livermore stated, "Nothing more than the general one."[150] Of the final picture, Gerry asked, "What do you recognize about this?"—again attempting to get Livermore to tell specifically *what* it was about the image that sparked recognition. But Livermore didn't respond by saying *what* he recognized; he only said *that* he recognized, observing firmly, "It is unmistakable; the recognition was perfect not only with myself, but with all my friends."[151]

In this exchange Gerry and Livermore are operating on two different registers. Gerry asks questions geared toward an identification, asking whether Livermore has seen "anything to cause an identity." He takes an analytical approach, asking Livermore to pull the image apart, to focus on specific elements, in order to explain his recognition. Livermore, in turn, offers only firm assertions, accompanied by adjectives of evaluation: the image is "unmistakable," and the recognition for him and his friends was "perfect." For Livermore recognition is not analytical, but holistic and communal. He knows what his wife looks like because he "sees" her "every day," and his friends back up his recognition with

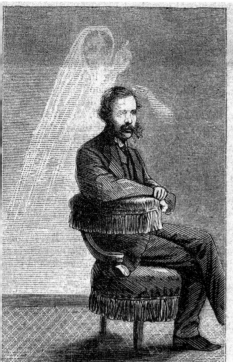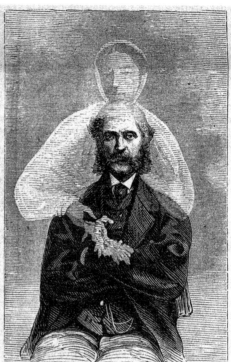

Detail of *Harper's Weekly* cover, featuring Mumler spirit photographs of Charles Livermore and his wife, *Harper's Weekly*, May 8, 1869. Courtesy of the Rare Book and Manuscript Library, University of Illinois at Urbana-Champaign.

their own. No dissection of the photograph is needed: he imagines he recognizes her, his friends imagine in kind, and so there is recognition.

The prosecution shared another view. In his closing arguments prosecutor Gerry discounted Livermore's claims and argued that Livermore had only a "mind prepared to believe."[152] Earlier in the prosecution's testimony, Livermore's spirit photographs were shown to photographer Charles W. Hull. Hull testified at the trial about a number of different ways that images like those Mumler produced could be made with mechanical means. Stating that anyone knowledgeable about photography could make such images, he boasted, "I can humbug anyone in my darkroom."[153] Writing shortly thereafter of the Mumler case for *Philadelphia Photographer*, Hull observed, "These miserable

photographs are so shadowy, so dim and indistinct . . . that imagination of the highest order is required to detect a likeness to any one, dead or alive."[154] What Livermore called "recognition," Gerry called "credulity" and Hull termed "imagination." While recognition could be produced by the photograph's capacity for presence, it could also be challenged as a stretch of the imagination by someone already prepared to believe. As Holmes argued about the fictional Mrs. Brown, too much presence could produce the wrong kind of recognition.

For Livermore recognition was not accomplished via the identification of the turn of a nose or the furrow of a brow; it was accomplished via presence and the visible memories of himself and his friends. The visible memories made available by Livermore's other photographs, the opportunity to "see" one's dead wife "every day," sanctioned Livermore's imagination and contextualized his arguments about the spirit portraits' authenticity. Like the hypothetical mother and her "foggy dumpling" spirit child in Holmes's essay, recognition for Livermore was produced by the combination of presence and an act of the imagination.

Prosecutor Gerry concluded in his closing arguments, "Those who went prepared to believe, of course, did believe on very slight proof. And that is all this evidence of the defense proves. It proves *the existence of a belief* . . . not *the truth* of [Mumler's] statements. There is no positive proof whatever of any spiritual agency, only evidence that certain persons *believe* it exists."[155] Ultimately the Mumler trial teaches us little about spirit photographs, but it tells us a lot about their viewers. The trial figured viewers of photographs as active, lively interlocutors with images; such citizens relied on experience, imagination, "fancy," and their recognition of photographs' capacity to produce presence to read the images. Such viewers were not experts in full command of technical knowledge; rather, they lived in a world where belief itself is contingent.

In light of the traumas of the decade, such images posed a reading problem for those who encountered them firsthand or by way of other authors' accounts. When *Harper's* or Holmes or Civil War widows' letters to the government offered evidence that "persons had been honestly deceived by their imaginations," perhaps this was the result of viewers' attempts to recover some kind of agency for themselves and their loved ones. To be *deceived by one's imagination* was perhaps inevitable in the increasingly complex world of appearances, where a photograph's capacity to produce presence mingled in messy ways with the desires of the imagination. Yet to call such persons "*honestly* deceived" to a certain extent sanctions that imagination, recognizing that viewing experiences often open a place for viewers to remake what they see. What

becomes important in the case of such photographs is thus not whether they are objectively truthful or deceptive, but rather how they invite viewers to engage in complex meaning-making practices.

After the case was dismissed the *New York Observer and Chronicle* declared, "The fools are not all dead," but did concede, "If people are such fools as to pay their money for pictures of departed spirits, why should our courts interfere to protect them?"[156] For its part, the *Saturday Evening Review* took a more sanguine stance: "Our own opinion is decidedly in favor of leaving those who wish to have 'spirit-photographs' at liberty to go and get them as they please."[157] As for the photographs themselves, they continued to function as touchstones for debate about spirits, spiritualism, and "humbug."[158] But their value, at least in a commercial sense, plummeted. The appearance right after the trial of ads for reproductions of spirit photographs, selling for twenty-five cents each rather than the ten dollars Mumler originally charged the sitters, suggests the aura of the images took a hit.

As for the photographer, Mumler reportedly retreated to Vermont for a time, where he was found by a newspaper there, working as an itinerant lecturer. According to the *Vermont Chronicle*, by July 1869 Mumler was "haranguing his audiences for an hour or more on the mysteries of the 'Summer Land' and then [opening] a valise and [dealing] out his trashy pictures at the rate of twenty five cents each. That he is being liberally patronized is but one more proof that the American people delight in being humbugged."[159]

Recognizing Lincoln

Portrait Photography and the Physiognomy of National Character

> People take awful liberties with Lincoln....
> It almost makes you wish that Lincoln had
> been copyrighted.
>
> —E.S.M., "Reproducing Lincoln,"
> *Life*, September 6, 1917

Thirty years after Abraham Lincoln's assassination, *McClure's* magazine published a newly discovered image that to this day remains the earliest known photograph of Lincoln. Revealed to the American public in 1895, nearly fifty years after its creation, the daguerreotype reproduction featured a Lincoln few had seen before: a thirty-something, well-groomed, middle-class gentleman.[1] Readers of the magazine greeted the image with delight. Brooklyn newspaper editor Murat Halstead rhapsodized, "This was the young man with whom the phantoms of romance dallied, the young man who recited poems and was fanciful and speculative, and in love and despair, but upon whose brow there already gleamed the illumination of intellect, the inspiration of patriotism. There were vast possibilities in this young man's face. He could have gone anywhere and done anything. He might have been a military chieftain, a novelist, a poet, a philosopher, ah! a hero, a martyr—and yes, this young man might have been—he even was Abraham Lincoln!"[2] General Francis A. Walker, president of the Massachusetts Institute of Technology, wrote similarly but more plainly of the photograph: "The present picture has distinctly helped me to understand the relation between Mr. Lincoln's face and his mind and

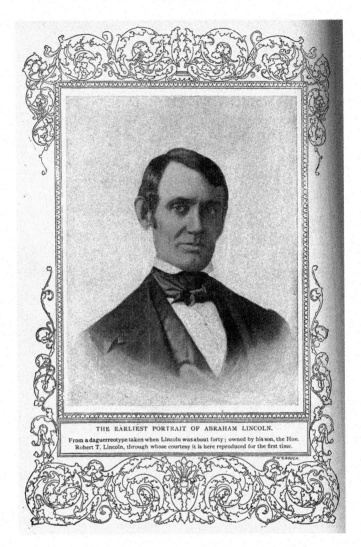

THE EARLIEST PORTRAIT OF ABRAHAM LINCOLN.

From a daguerreotype taken when Lincoln was about forty ; owned by his son, the Hon.
Robert T. Lincoln, through whose courtesy it is here reproduced for the first time.

"The Earliest Portrait of Abraham Lincoln."
McClure's, November 1895, 482.

character, as shown in his life's work. . . . To my eye it *explains* Mr. Lincoln far more than the most elaborate line-engraving which has been produced."[3]

The photograph itself hardly seems to inspire such broad claims or florid prose. Indeed, at first glance it is difficult to glean what exactly Walker thinks it might *explain* (in fact, he never tells us). The image is not particularly un-

usual save for the later fame of its subject. Cropped by *McClure's* to highlight Lincoln's head and shoulders, and reproduced in the pictorialist style of the era, the image nevertheless looks like a standard-issue early daguerreotype: its pose stiff and formal, body and head held firm to accommodate long exposure times of 1840s photography. Yet in this conventional image Halstead and Walker claim to see the seeds of Lincoln's greatness, to understand his "character."

Others who wrote letters to the magazine in response to the photograph responded similarly. In its December 1895 and January 1896 issues, *McClure's* published seven full pages of letters responding to the Lincoln daguerreotype. Analysis of these letters reveals that the image posed a reading problem for those who wrote in to the magazine. A few admitted they had trouble physically recognizing the iconic president as a younger man, while others wrestled with a seeming disjuncture between the well-dressed, conventional-looking man in the photograph and Lincoln's famed unconventional (even ugly) physicality. Still others had trouble locating in the image the affective qualities they had come to associate with Lincoln, such as his well-known melancholy. These late nineteenth-century viewers ultimately made sense of the Lincoln photograph by treating it as a vehicle for the exploration of its subject's character. Their responses show that they saw in the image not only a Lincoln they recognized physically but one whose psychology and morality they recognized as well. Those who composed responses to the *McClure's* photograph tapped into powerful myths about Lincoln that circulated during the late nineteenth century.

No figure carried more public weight in the late nineteenth century than Abraham Lincoln. Throughout his career, but particularly after his assassination, Lincoln was (and remains) a potent, contested icon.[4] Photographs of Lincoln are particularly fascinating because of the staggering force of the Lincoln mythos. Although there are fewer than 120 extant photographs of him (more than half of those made during his presidential years), Lincoln was one of the earliest and arguably the most photographed political figure of the middle nineteenth century.[5] By the close of the nineteenth century he had begun to surpass George Washington as the political icon of the republic.[6] Indeed, he probably was the only American whose visual image could generate the kind of public response found in *McClure's*.[7] Yet viewers' interpretations of Lincoln's iconicity have never been uniform. Sociologist Barry Schwartz argues that in the fifty or so years following his death, "Lincoln was not elevated . . . because the people had discovered new facts about him, but because they had discovered new facts about themselves, and regarded him as the perfect vehicle for giving these tangible expression."[8] In short, "Lincoln's portrait shifts depending on who is doing the remembering."[9]

How did *McClure's* readers in 1895 reconcile the reading problems posed by the new, yet older photograph? What shifting portrait of Lincoln did responses to the daguerreotype produce? Those who wrote letters recognized the photograph's capacity to communicate the *character* of Lincoln and, by extension, the character of the American nation. The concept of character is foundational to the study of rhetorical practice; indeed, as Thomas Farrell says, "The most powerful rhetorical proof, as Aristotle noted, is ēthos—the character of the speaker as it is manifested through the speech."[10] In traditional rhetorical understandings of character, speakers display or perform their good character through offering "practical wisdom, virtue, and goodwill" in their communications.[11] Yet ethos is not solely the responsibility of the speaker.

S. Michael Halloran observes that it is also about the audience and its character as a community. Ethos "indicates the importance of the orator's mastery of the cultural heritage; through the cogency of his logical and emotional appeals he became a kind of living embodiment of that heritage, a voice of such apparent authority that the word spoken by this man was the word of communal wisdom, a word to be trusted for the weight of the man who spoke it and the tradition he spoke for."[12] A rhetorical conception of character, then, oscillates between speaker and audience, between the individual and the social, such that ethos comes to constitute what Farrell calls "the heritage of our shared appearances."[13] As a "common dwelling place of both" audience and speaker, ethos constitutes a rhetorical space for conversations "where people can deliberate about and 'know together.'"[14]

Viewers seeking to make sense of the *McClure's* Lincoln recognized photography's capacity to communicate character. In the individual, subject-centered sense, photographs were understood to visualize the moral character of their subjects. Viewers of the *McClure's* Lincoln readily recognized the portrait as a vehicle for communicating evidence of Lincoln's moral character. In their arguments about the photograph, they relied upon this social knowledge about photography and portraiture and exhibited their comfort with "scientific" discourses of character such as physiognomy and phrenology. Yet the character revealed by photography was not understood only in an individual sense. By means of photographic study of the character of men of weight (to paraphrase Halloran) one might learn something about the community's character as well. Viewers of the *McClure's* Lincoln mobilized their responses to the photograph in ways that elaborated an ideal national type at a time when elites were consumed by anxiety about the fate of "American" identity. Through their close readings of the photograph, Lincoln the man became what Carl Sandburg marvelously termed the "national head." In fram-

ing Lincoln not only as the moral "savior of the Union" but also as the "first American," viewers used the *McClure's* Lincoln as a rhetorical resource for working out the anxieties of their age.

The *McClure's* Lincoln

McClure's published the daguerreotype to accompany the first in a series of articles on the life of Abraham Lincoln penned by Ida Tarbell.[15] Tarbell is best known today as the Progressive Era muckraking journalist who exposed corporate corruption at the Standard Oil Company.[16] Like many of her post–Civil War generation, Tarbell had a passing fascination with Lincoln; one of her most vivid childhood memories was witnessing her parents' grief upon his death.[17] For the foundation for her life of Lincoln Tarbell relied on the biographers who had known him most intimately.[18] But the selling point for Tarbell's series was that she went beyond the familiar tales. In her initial efforts she was frustrated by Lincoln's former secretary (and, later, fellow biographer) John Nicolay, who told her that her work was fruitless; there was "'nothing of importance' left to be printed on Lincoln's life."[19] Despite Nicolay's dismissiveness, Tarbell's series did in fact deliver new facts, documents, and images in an era when people had begun to share Nicolay's conclusion that Lincoln's full story had already been told. She traveled to Kentucky, Indiana, and Illinois, interviewing people who had known Lincoln in person and consulting court records, newspapers, and other archival resources that previous Lincoln biographers had neglected. Such legwork "cast a much brighter light upon Lincoln's parentage, childhood, and youth."[20] Judith Rice argues that Tarbell's series "marked a shift in the historiography of Lincoln literature" by depicting Lincoln's early life on the frontier in a positive light. Earlier biographers had "belittled the frontier environment in their works"; Lincoln's former law partner William Herndon, for example, had suggested that Lincoln came of age in "a 'stagnant, putrid pool.'"[21] Tarbell, by contrast, "emphasized the frontier as encouraging traits that led to [Lincoln's] success."[22] As we shall see, her emphasis on how the "ennobling" qualities of the frontier shaped Lincoln paralleled some viewers' responses to the daguerreotype.[23]

For *McClure's*, a middlebrow literary magazine barely three years old, the Tarbell series would pave the way to its early success. Publisher S. S. (Samuel Sidney) McClure founded the magazine in 1893 in the belief that a cheaper illustrated literary magazine could succeed.[24] Seeing a gap between the working-class populism of *People's Literary Companion* and the higher-end elitism of periodicals like *Century*, *Harper's*, and *Scribner's*, Sam McClure sought to

create an affordable mainstream periodical that was squarely positioned for the middle-class reader.[25] During college breaks McClure had worked as a traveling salesman; he noted in his autobiography that "the peddling experiences of those three summers had given me a very close acquaintance with the people of the small towns and the farming communities, the people who afterward bought *McClure's Magazine*."[26] McClure's desire to combine illustration with low cost was made easier by technical developments in image reproduction. The halftone process had been in what Ulrich Keller terms "experimental" use "since 1867 in weekly magazines and since 1880 in daily papers."[27] After some technical improvements, by the early 1890s it was in wide use by large newspapers and magazines.[28] Combined with the availability of cheaper glazed paper, halftone made it possible for publishers like McClure to provide an inexpensive yet lavishly illustrated product.[29]

McClure shared with Tarbell a deep interest in Lincoln; she noted that Lincoln "was one of Mr. McClure's steady enthusiasms."[30] Like Lincoln, McClure was a Westerner. Born in Ireland, McClure spent his formative years in the Midwest and graduated from Knox College in Galesburg, Illinois, in 1882.[31] In 1858 Knox was the site of the fifth Lincoln-Douglas debate; the campus still resonated with the memory of Lincoln when McClure was a student there twenty-five years later. Founded in the evangelical tradition and (legend has it) in a town with a stop on the Underground Railroad, Knox College encouraged students to be pious and embrace moral and political causes of the day, from temperance to abolition and woman suffrage.[32] Whether it was because of Lincoln's well-established popularity as a subject, or Sam McClure's longtime interest in Lincoln, or both, *McClure's* magazine featured Lincoln prominently: in its first ten years alone the magazine published thirty articles on Lincoln.[33]

McClure's promised of its Lincoln series, "We shall publish fully twice as many portraits of Lincoln as have ever appeared in any *Life*, and we shall illustrate the scenes of Lincoln's career on a scale never before attempted."[34] Between its first issue, in 1893, and the first installment of Tarbell's Lincoln series, in November 1895, the circulation of the magazine rose steadily from eight thousand to more than one hundred thousand readers per month, enabling it to compete with publications such as *Century* and *Scribner's*.[35] Sam McClure sought to raise sales even further by making a heavily publicized splash with one of the most vivid Tarbell discoveries: a previously unpublished photograph of the late president that had been made when he was a much younger man.

During the course of her research Tarbell met Robert Todd Lincoln, the only surviving child of the president. Robert Lincoln jealously guarded his father's legacy and famously battled with Lincoln's biographers. He did not provide Tarbell with much (his personal papers, which included a wealth of

hitherto unknown information related to his father, were not made available to researchers until 1947), but he did show her a daguerreotype that he said was the earliest known photograph of his father.[36] Tarbell was shocked at what she saw. The photograph looked like Lincoln, but one the public had never seen before. Previously known photographs of Lincoln dated only as far back as the late 1850s, well into Lincoln's public career and middle age. The most famous of these early images was made by photographer Alexander Hesler in 1857. Known as the "tousled hair" portrait, it portrayed a strong but rather disheveled Lincoln.[37] This new yet older image would allow *McClure's* readers to encounter Lincoln as a much younger and more dignified-looking man. While the 1857 "tousled hair" photograph figured Lincoln as a raw frontier lawyer having what can only be described as a bad hair day, this new image showed a youthful, dignified, reserved Lincoln. Tarbell recalled, "It was another Lincoln, and one that took me by storm."[38]

Access to the daguerreotype was quite a coup. McClure decided the image should be published as the frontispiece of Tarbell's first installment in November 1895. The magazine proudly (if convolutedly) trumpeted its find: "How Lincoln Looked When Young Can be learned by this generation for the first time from the only early portrait of Lincoln in existence, a daguerreotype owned by the Hon. Robert T. Lincoln and now first published, showing Lincoln as he appeared before his face had lost its youthful aspect."[39] While forgery of Lincolniana was common by the 1890s, this image was not a fake; coming from Lincoln's own son, readers would not doubt its authenticity.[40] McClure promoted the photograph for all it was worth.

The image is a cropped version of a quarter-plate, three-quarter-length-view daguerreotype most likely made in the mid to late 1840s. The *McClure's* version isolates Lincoln's head and shoulders and frames him in the rather fuzzy pictorialist haze that was common to magazine reproductions of portraits in the 1890s. Yet editors also used an elaborate Victorian line drawing to frame the image, perhaps attempting to signal to viewers its daguerreian origins. The differences between the two images should be of interest, for 1890s viewers were not only encountering an 1840s photograph, but they were also encountering it framed in a decidedly 1890s fashion.

To be specific, what *McClure's* readers encountered in the pages of the magazine was a halftone reproduction of a photograph of a daguerreotype. Most photographic reproductions of images, especially photographic reproductions of photographs, are viewed simply as transparent vehicles for communication of the earlier image. But Barbara Savedoff warns against the assumption of transparency: "We are encouraged to treat reproductions as more or less transparent documents. But of course, photographic reproductions are not re-

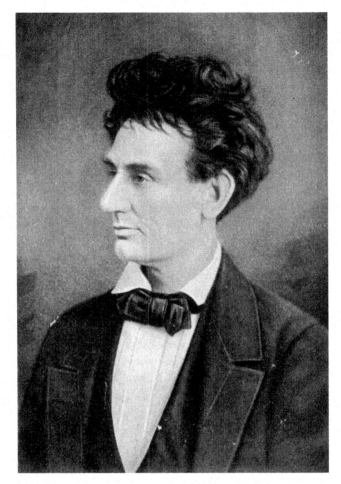

"Tousled hair" portrait of Abraham Lincoln. Based on photograph
by Alexander Hesler, 1857. Indiana Historical Society, P0406.

ally transparent. They transform the artworks they present."[41] Daguerreotypes,
in particular, are dramatically transformed in the process of reproduction.[42]
The daguerreotype process "produced a direct, camera-made positive, no
negative was available for later printing." As a result, daguerreotypes were not
reproducible but rather retained an aura of authenticity. As Richard Benson
puts it, "Every daguerreotype is a unique object that once sat in the camera
facing the subject of the picture."[43] In addition, the mirrored daguerreotype is
meant to be engaged directly and intimately by the individual viewer, literally

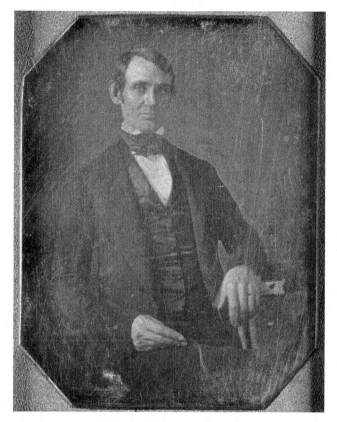

Abraham Lincoln, congressman-elect from Illinois.
Daguerreotype by Nicolas H. Shepherd, Springfield, Illinois,
ca. 1846–1847. Library of Congress.

manipulated by hand in order for the image to come into view.[44] Photographic
reproductions of daguerreotypes thus lose both their magical mirrored quality
as well as the visual depth of the original.[45] The *McClure's* reproduction of Lin-
coln by necessity removed the image from its association with daguerreotypy
(despite the editors' attempt to "frame" it) and transformed it into an image
that was more familiar to late nineteenth-century magazine readers. *McClure's*
viewers' experiences of the photograph were thus several steps removed from
an encounter with the "magical" aura of the Lincoln daguerreotype. This con-
ceptual distance makes viewers' effusive responses to the image initially all the
more surprising. What exactly was it about the photograph—no longer a magi-

cal daguerreotype, but a run-of-the-mill halftone magazine illustration—that produced such passionate rhetoric? As we shall see, the image's potency had a lot to do with cultural understandings of what portrait photographs were believed to communicate to viewers in 1895.

McClure was right that the photograph would draw immediate attention to Tarbell's series. Circulation swelled to 175,000 for the first of Tarbell's articles in the series and then catapulted to 250,000 for the second installment in December.[46] McClure later noted that "the years '95–'96 put *McClure's Magazine* on the map"; as a result of Tarbell's Lincoln series, the magazine's "prosperity and standing had been established."[47] Circulation numbers were not the only sign of interest in the series. Harold Wilson notes, "More letters on Lincoln arrived than all other editorial correspondence."[48] A number of readers responded specifically to the new daguerreotype. The December 1895 issue featured four pages of letters, the January 1896 issue three more. As noted earlier, *McClure's* was intended to be a lower-cost, middle-class magazine of letters, more affordable and "popular" than expensive magazines of the day such as *Scribner's* or *Harper's*. Yet curiously the majority of letters published in response to the photograph were not from these middle-class readers but from those who represented the era's intellectual elite: university professors, Supreme Court justices, and former associates of Lincoln.[49] Judging from the content of the letters and from the identity of the letter writers, it is likely that McClure sent advance copies of the photograph and its accompanying text to members of the Eastern political and scholarly establishment.[50] He probably had several motivations for doing so: to drum up interest in the upcoming Tarbell series, to show his confidence in the authenticity of the image itself by "testing it out" before "experts"—not photography experts but those who were in politics or who had known Lincoln in life—and to solicit elite responses in order to signal to *McClure's* readers the "proper" way to interpret the photograph. When I discuss the letters below it is important to keep in mind that those whose responses to the photograph were published in the pages of *McClure's* were not necessarily the same readers who would have purchased the magazine on the newsstand or subscribed to it at home. These expert letter writers solved the reading problems posed by the photograph by locating in it resources for making arguments about individual and national character.

"Valuable Evidence as to His Natural Traits . . ."

Overwhelmingly, letters discussed the Lincoln photograph not as a material object of history, nor as an artful example of a technology no longer in use, but in terms of the kind of evidence it offered about its subject. In interpreting

the photograph's significance, writers tapped into culturally available narratives about Lincoln in complex and fascinating ways. The letters are especially striking for the way they negotiate the complex temporality of the photograph. Lincoln had been dead for nearly thirty years, the photograph itself was nearly fifty years old, yet almost to a man the letters were written in the present tense: the image "*is Lincoln*," it "*explains*" Lincoln. The ontology of the photograph permits such a slippage, of course, for via the photograph Lincoln is persistently present despite his absence. Importantly, this temporal ambiguity enables readers to engage the image actively. Rather than simply noting the photograph's existence as a document of the past, *McClure's* readers activated the image in their own present. In doing so they did not assume that the photograph spoke for itself, but—as we saw in the previous chapter's discussions of war and spirit photography—transformed it into a playful space for interpretation.

For some the question of Lincoln's physical recognizability posed a reading problem. None of the writers overtly disputed the identity of the photograph as Lincoln, although a few did have trouble seeing a resemblance to the man they remembered from history. The Honorable David J. Brewer, associate justice of the Supreme Court of the United States, wrote, "The picture, if a likeness, must have been taken many years before I saw him and he became the central figure in our country's life. Indeed, I find it difficult to see in that face the features with which we are all so familiar."[51] Similarly, Charles Dudley Warner of Hartford had a hard time seeing his recollected Lincoln in the photograph: "The deep-set eyes and mouth belong to the historical Lincoln, and are recognizable as his features when we know that this is a portrait of him. But I confess that I should not have recognized his likeness. . . . The change from the Lincoln of this picture to the Lincoln of national fame is almost radical in character, and decidedly radical in expression."[52] For these letter writers, the Lincoln of history—the man from Springfield—clashed in their imaginations with the Lincoln of memory: the Lincoln of the presidency and "national fame."

Brewer's and Warner's difficulties mirrored Tarbell's own reported experience of first viewing the photograph—it *was* radical, a Lincoln no one had seen before. Yet most letter writers reported otherwise. A colleague from Lincoln's younger years wrote, "This portrait is Lincoln as I knew him best: his sad, dreamy eye, his pensive smile, his sad and delicate face, his pyramidal shoulders, are the characteristics which I best remember; . . . This is the Lincoln of Springfield, Decatur, Jacksonville, and Bloomington."[53] The Honorable Henry B. Brown, associate justice of the U.S. Supreme Court, noted of the *McClure's* Lincoln, "I recognized it at once, though I never saw Mr. Lincoln, and know him only from photographs of him while he was President." Knowing the subject in life apparently bore no correlation with recognition of the

man in the photograph. Brown continued, "From its resemblance to his later pictures I should judge the likeness must be an excellent one."[54] For Brown, as likely for the vast majority of *McClure's* readers, recognition of this different, early Lincoln did not require previous acquaintance with Lincoln the man, but with visual knowledge of other images that had circulated in public.

Perhaps concerned about the general tendency to equate virtue and wisdom with beauty, correspondents also dwelled on the pressing questions of Lincoln's purported ugliness and "vulgarity." Indeed, the photograph seemed to show a man who was much less physically awkward than many remembered. Henry C. Whitney, identified in the magazine as "an associate of Lincoln's on the circuit in Illinois," wrote of the daguerreotype, "It is without doubt authentic and accurate; and dispels the illusion so common (but never shared by me) that Mr. Lincoln was an ugly-looking man." Whitney continued, emphasizing Lincoln's distinctive masculinity: "In point of fact, Mr. Lincoln was always a noble-looking—always a highly intellectual looking man—not handsome, but no one of any force ever thought of that. All pictures, as well as the living man, show *manliness* in its highest tension—this as emphatically as the rest." Finally, implying perhaps the famed roughness of Lincoln's frontier habits, Whitney concluded bemusedly, "I never saw him with his hair combed before."[55] Thomas M. Cooley, thematically echoing Tarbell's interest in dispelling the myth of Lincoln's vulgar frontier upbringing, observed, "And what particularly pleases me is that there is nothing about the picture to indicate the low vulgarity that some persons who knew Mr. Lincoln in his early career would have us believe belonged to him at that time. The face is very far from being a coarse or brutal or sensuous face."[56]

Many of the correspondents in *McClure's* noted the absence of "melancholy" in Lincoln's face, which they took to be a characteristic of his later presidential-era portraits. John C. Ropes of New York City wrote, "It is most assuredly an interesting portrait. The expression, though serious and earnest, is devoid of the sadness which characterizes the later likenesses."[57] Woodrow Wilson, then a professor of finance and political economy at Princeton, noted, "The fine brows and forehead, and the pensive sweetness of the clear eyes, give to the noble face a peculiar charm. There is in the expression the dreaminess of the familiar face without its later sadness."[58] Similarly, Herbert B. Addams, professor of history at Johns Hopkins University wrote, "The portrait indicates the natural character, strength, insight, and humor of the man before the burdens of office and the sins of his people began to weigh upon him."[59]

Some readers saw in the photograph shades of Lincoln's future greatness, a man whose rise to prominence literally was prefigured in his visage. John

T. Morse, biographer of Lincoln, Jefferson, and Adams, among others, wrote to the magazine, "I have studied this portrait with very great interest. All the portraits with which we are familiar show us the man *as made*; this shows us the man *in the making*; and I think every one will admit that the making of Abraham Lincoln presents a more singular, puzzling, interesting study than the making of any other man known in human history."[60] Morse went on to note that he had shown the portrait to several people without telling them who it was: "Some say, a poet; others, a philosopher, a thinker, like Emerson. These comments also are interesting, for Lincoln had the raw material of both these characters very largely in his composition. . . . This picture, therefore, is valuable evidence as to his natural traits."[61]

Themes of character and expression dominate the letter writers' remarks—specifically, *character as revealed in expression*. The photograph almost universally is read as a locus of evidence about Lincoln's character. Lincoln's face is "noble," both his eyes and his smile are "pensive." His brow is "fine" and illuminated with "intellect"; his eyes are read alternately as "clear" and "dreamy." Several correspondents explicitly compared this early image of Lincoln with ones that were more familiar to them. While later images offered a "sad" Lincoln, this image avoided such melancholy; the younger Lincoln is merely "serious and earnest." In these accounts Lincoln is alternately a dreamy romantic and a strong patriot, a "pensive" intellectual and an insightful empath, a manly "military chieftain" and a feminized figure of "sweetness" and delicacy. Those writing about the photograph solved the reading problems it posed by constructing Lincoln as a man for all people. Regardless of the emotional valence of their readings, letter writers grounded their claims about the photograph in the assumption that there was a direct correspondence between Lincoln's image and his "natural traits"—between, as General Walker so tellingly put it, "Mr. Lincoln's face and his mind and character." In making such arguments *McClure's* readers activated their social knowledge of the relationship between photographic portraiture and popular nineteenth-century discourses of physiognomy and phrenology. Such implicit but powerful habits of viewing enabled them to read Lincoln's face and, oscillating between individual and communal conceptions of character, identify it as the face of the nation.

The Photographic Portrait as an Index of Character

Portraits in the nineteenth century were thought to reveal or "bring before the eyes" something vital and almost mysterious about their subjects.[62] It was assumed that the photographic portrait, in particular, did not merely "illustrate"

a person but also constituted an important locus of information about human character. Unlike the painted portrait, which would theoretically be created to "flatter," the photographic portrait was perceived as a more reliable index of character.[63] By mid century "the standard for a truly accurate likeness had become not merely to reproduce the subject's physical characteristics but to express the inner character as well."[64] Even after changes in photographic technology after the Civil War enabled more spontaneous images, the prevailing rhetoric of photography preferred a more formal style of portraiture that was thought to say something more general about human nature and society. David M. Lubin hints at the oscillating qualities of character when he observes, "Even though a portrait purports to allow us the close observation of a single, localized, individual, we discern meaning in it to the extent that it appears to *reveal* something about general human traits and social relationships."[65]

As loci of generalizable information about character, portraits educated viewers about the virtues of the elites and warned them against the danger of vice; thus they served as a way of educating the masses about what it meant to be a virtuous citizen. Images such as the large daguerreotypes made by Mathew Brady in his New York and Washington, D.C., studios at mid century provided visitors not only with an afternoon's stroll and entertainment but with "models for emulation."[66] Brady's galleries functioned as citizenship training of a sort, offering a democratic space for viewing a democratic art that paradoxically perpetuated elitist definitions of virtue: "Viewing portraits of the nation's elite could provide moral edification for all its citizens who needed to learn how to present themselves as good Americans in a quest for upward mobility."[67] Of Brady's gallery Alan Trachtenberg writes, "With its irresistibly compelling pictures of presidents, governors, poets, and preachers, 'Lecturers, Lions, Ladies and Learned Men,' the gallery served as a 'paragon of character.'"[68] *Gallery of Illustrious Americans*, a book featuring exquisite lithographs made from the Brady studio's daguerreotypes of national luminaries, constructed the story of national destiny by offering the reading and viewing public "a space for viewing men in the guise of republican virtue: *gravitas, dignitas, fides.*"[69]

Late nineteenth-century portraits often combined these traditional assumptions with modern production techniques. Consider, for example, a pair of wedding portraits featuring my great-grandparents Louisa and Lewis W. Chase. The photographs likely were made in 1887 in Kilbourne City, Wisconsin, to commemorate the couple's marriage. Relatively standard late nineteenth-century head-and-shoulders views, the photographs are neither remarkable nor all that different from the *McClure's* representation of Lincoln. The Chases wear the well-made, fashionable attire of the rising classes

along with the serious expressions demanded for portraits commemorating so auspicious an occasion. They appear to be middle-class and comfortable, "good citizens" likely well positioned in local society. Yet we most certainly understand the portraits differently if we know that the photographs are manipulated. In a process called "overpainting," the young couple's photographic portraits were superimposed on other, better-dressed bodies to create a hybrid that was common to photographic portraiture of the period.[70] Such photographic manipulation enabled the couple to project an image of themselves as they wanted to be rather than as they were. Embedded in a visual culture imbued with this complex rhetoric of the photographic portrait, the Chases implicitly would have understood the importance and the social necessity of such "manipulation." Yoking the available technologies of their own time to long-held beliefs about the relationship between photographic portraiture and human character, the Chases were able to accomplish visually what they would accomplish literally only many years later.[71]

Visual discourses of morality did not just emphasize the aspirations of the virtuous civic elite, however. As Allan Sekula reminds us, historians need to chart both the "honorific and repressive poles of portrait practice" if they are to understand the role of portrait photography in the nineteenth century.[72] Just a few years after photography appeared, the portrait was already being used for the purposes of criminal identification and classification.[73] Curiously, most traditional histories of photography ignore crime and police photography altogether, despite its social and political importance throughout the nineteenth century.[74] Yet even in the earliest years of photography, for every bourgeois portrait there could always be found a "lurking, objectifying inverse in the archives of the police."[75] By 1840 police departments already were using photography to identify and categorize crime suspects. By the early 1850s the mug shot was a standardized genre that could be taught to police photographers.[76] In the late 1850s "Rogues' Galleries" began to appear in the urban centers of the United States and Western Europe, in which the faces of known criminals were put forth in a kind of "municipal portrait show" displayed in police headquarters to help solve and prevent crime.[77] Mug shots were not only products of a visual order of surveillance but also served simultaneously as elements of spectacle and moral education.[78]

Such education was possible because of the connection between portrait photography and "scientific" discourses such as phrenology and physiognomy, which connected physical attributes to moral character and intellectual capacities. Sekula argues, "We understand the culture of the photographic portrait only dimly if we fail to recognize the enormous prestige and popularity of a

Louisa and Lewis Chase, overpainted wedding portraits, ca. 1887.
Unknown photographer, Wisconsin. Collection of Finnegan family.

general physiognomic paradigm in the 1840s and 1850s."[79] Throughout the
nineteenth century, "the practice of reading faces" was a key part of everyday
life and remained so well into the early twentieth century.[80] Whether it was
images like Brady's *Gallery of Illustrious Americans* or those of the Rogues'
Galleries, Americans were accustomed not only to reading the faces in photo-
graphs but to making judgments about the moral character of their subjects as
well. As we have already seen, viewers of the Lincoln photograph in *McClure's*
paid close attention to the face, arguing that Lincoln's face was the key to un-
derstanding his character. If we are to understand these readings, we need to
trace how the portrait photograph circulated in a fin-de-siècle visual culture
heavily influenced by the discourses of physiognomy.

Hermeneutics of the Face: Phrenology and Physiognomy

Scholars have documented extensively the nineteenth century's commitment
to the formation of character as well as the popularity and prevalence of the
"sciences" of phrenology and physiognomy. Karen Halttunen argues that
during the bulk of the nineteenth century character formation was incred-
ibly important to middle-class Americans, "the nineteenth-century version

of the Protestant work ethic."[81] Antebellum Americans, in particular, "asserted that all aspects of manner and appearance were visible outward signs of inner moral qualities." "Most importantly," Halttunen observes, "a man's inner character was believed to be imprinted upon his face and thus visible to anyone who understood the moral language of physiognomy."[82] The popular prominence of this language coincided with the birth of photography in the United States and Europe. Sekula notes, "Especially in the United States, the proliferation of photography and that of phrenology were quite coincident."[83] The first volume of the *American Phrenological Journal* (produced by the Fowler brothers, Lorenzo and Orson, who popularized phrenology in the United States), was published in 1839, the same year the daguerreotype was introduced to the public.[84] While phrenology and physiognomy predate photography by many years, the introduction of photography gave them modern relevance and vigor.[85]

Phrenology and physiognomy, which Allan Sekula calls "two tightly entwined branches" of the so-called moral sciences, were concerned with the knowledge of the internal through observation of the external.[86] Conceived in the late eighteenth century by Johann Caspar Lavater and popularized in the United States and Europe in the nineteenth century, physiognomy involved paying attention to "the minuteness and the particularity" of physical details and making analogies between those details and the character traits they were said to illustrate.[87] Physiognomy was framed as a science of reading character "in which an equation is posited between facial type and the moral and personal qualities of the individual."[88] Similarly, phrenology was founded upon the belief that "there was an observable concomitance between man's mind—his talents, disposition, and character—and the shape of his head. To ascertain the former, one need only examine the latter."[89] Both "sciences" were, as Stephen John Hartnett observes, "essentially *hermeneutic* activities."[90] These interpretive practices "fostered a wide-ranging 'self-help' industry that . . . blanketed the nation with magazines and manifestoes intended to guide confused Americans through the multiple minefields of their rapidly changing culture."[91] Employing a circular rhetoric, both practices "drew on the moral and social language of the day in order to guarantee the claims made about human nature."[92] While they could be harmless and entertaining, the practices of phrenology and physiognomy were not simple parlor game fun; indeed, not many more steps were necessary for a full-blown discourse of eugenics.[93] These sciences of moral character enabled anxious Americans, especially those of the middle and upper classes, to use a language that placed themselves (as well as marginalized others) in "proper relation."

Samuel R. Wells, a protégé (and brother-in-law) of the Fowler brothers, ran the publishing operation that helped to popularize their work. Wells believed that physiognomy, phrenology, and physiology constituted a tripartite "science of man."[94] Beginning in the 1860s, Wells wrote and published several books on physiognomy, including *New Physiognomy; or, Signs of Character, as Manifested through Temperament and External Forms, and Especially in "The Human Face Divine"* and the first of several volumes of *How to Read Character: A Handbook of Physiology, Phrenology, and Physiognomy, Illustrated with a Descriptive Chart.* Wells's primary argument in both texts was that while the brain "measures the absolute power of the mind," the face may be understood as "an index of its habitual activity."[95] Such claims echo ancient notions of ethos as habit or located within the habitual.[96] The books outline in exquisite detail how to read faces in order to ascertain temperament and character. There are chapters on every facial feature, including mouth, eyes, jaw, chin, and nose, as well as sections on hands and feet, neck and shoulders, movement, and even palmistry and handwriting analysis. For example, chapter 12, "All About Noses—With Illustrations," observes that the nose "tells the story of its wearer's rank and condition."[97] Describing two illustrations of Irish girls, one the "daughter of a noble house," the other "the offspring of some low 'bog trotter,'" Wells writes, "The one is elegant, refined, and beautiful; the other, gross, rude, and ugly. The one is fully symmetrically developed, the other is developed only in the direction of deformity." (No need for the reader to guess which is which.) Noses are not only individual, however; they are also national: "The more cultivated and advanced the race, the finer the nose."[98] The American nose, Wells explains, is an evolved nose that "agrees with our national character and national history."[99]

Phrenologists like Wells and Fowler were especially interested in exploring American character. In an 1869 essay published in the *American Phrenological Journal*, author D. H. Jacques lamented a recent magazine article that had criticized American faces as "'wholly devoid of poetry, of sentiment, of tenderness, of imagination.'"[100] Jacques disputed some specifics of this critique, but then observed, "We are too young as a nation to have fully developed and matured a national type of face; but we have it in process of formation, and the true physiognomist can see that it is destined to be one of the noblest that the world has produced."[101] Such rhetoric tied a hermeneutic of the face to broader conversations about national moral character and illustrated Americans' increased interest in the nature of American national identity. As we shall see, Lincoln's image played a large role in conversations about the "national face."

Of the cultural impact of this implicit physiognomic language, Madeleine Stern observes, "Often without knowing precisely what they were saying, people spoke phrenology in the 1860s as they would speak psychiatry in the 1930s and existentialism in the 1960s."[102] The practice of reading faces lasted well into the early twentieth century (and has never left us), guided by implicit but powerful assumptions about the relationship between appearance and character.[103] Perhaps nothing better sums up the ubiquity of such social knowledge than this rhetorical question of an anonymous writer in a 1909 issue of the *Methodist Review*: "The natural and customary use of language is to express one's thoughts, and, equally, the habit of the face is to reveal the spirit. The face no index to a man's nature, no indication of what may be expected from him? As well say that the appearance of the sky is no criterion of the weather. Everybody knows better."[104] "Knowing better" than to discount the "habit of the face," late nineteenth-century Americans understood the sciences of moral character as readily available rhetorical resources for arguing about human nature and American national identity. They knew, and they could count on others knowing, that "the general rule is that countenance and character correspond."[105]

"I think we can see in this face . . ."

Turning back now to the Lincoln letters, we may see how the *McClure's* letter writers addressed the reading problems posed by the photograph by recognizing photography's capacity to communicate character and mobilizing their social knowledge of the "hermeneutics of the face." The writers assume that the photograph's links to Lincoln's character are obvious; no one needs to make the case for reading Lincoln's face. The question for them is not whether the photograph shows a relationship between character and expression, but what specifically that relationship is. Descriptions of Lincoln's eyes as being "clear," for example, or his smile being "pensive," are characterological references that would resonate for viewers familiar with physiognomic discourse. Perhaps the most vivid example may be found in the letter of Thomas M. Cooley of Ann Arbor, Michigan, former chief justice of the Supreme Court of Michigan, who began, "I think it a charming likeness; more attractive than any other I have seen, principally perhaps because of the age at which it was taken. The same characteristics are seen in it which are found in all subsequent likenesses—the same pleasant and kindly eyes, through which you feel, as you look into them, that you are looking into a great heart. The same just purposes are also there;

and, as I think, the same unflinching determination to pursue to final success the course once deliberately entered upon."[106] Thus far Cooley's reading is similar to other correspondents' interpretations in its attention to physiognomic detail. Cooley, like other letter writers, claims to recognize much about Lincoln. His face reveals not only "pleasant and kindly eyes," but these eyes in fact signal a "great heart." His expression reveals "just purposes," as well as "unflinching determination." Here is a man, Cooley suggests, who can be relied upon to make the right decisions, a man who is thoughtful, determined, kind. Note, too, how the continuity of Lincoln is emphasized. Despite his youth in the photograph, Cooley emphasizes similarities to the Lincoln of today: the "same characteristics" are in later likenesses, including the "same" eyes; these eyes further point to the "same just purposes" and "the same unflinching determination." What the photograph reveals about Lincoln's ethos is its stability, its consistency.

The physiognomic frame thus mobilized to reveal Lincoln's stability and consistency, Cooley then goes on to elaborate in detail what specifically the photograph reveals about Lincoln's character. Transcending temporal boundaries in a way that only photographic interpretation can, Cooley reads the photograph in the present while speculating about a future that is already past. He constructs the meaning of the image in the conditional tense even though from his point of view fifty years later there is no uncertainty:

> It seems almost impossible to conceive of this as the face of a man to be at the head of affairs when one of the greatest wars known to history was in progress, and who could push unflinchingly the measures necessary to bring that war to a successful end. Had it been merely a war of conquest, I think we can see in this face qualities that would have been entirely inconsistent with such a course, and that would have rendered it to this man wholly impossible. It is not the face of a bloodthirsty man, or of a man ambitious to be successful as a mere ruler of men; but if a war should come involving issues of the very highest importance to our common humanity, and that appealed from the oppression and degradation of the human race to the higher instincts of our nature, we almost feel, as we look at this youthful picture of the great leader, that we can see in it as plainly as we saw in his administration of the government when it came to his hands that here was likely to be neither flinching nor shadow or turning until success should come.[107]

This passage is extraordinary for the way it oscillates between the specifics of the image and imaginative conclusions about Lincoln's character and behavior. The face that Cooley has read for us is not the face of someone who is

"bloodthirsty" or desirous of power; rather, this is the face of a man who will unflinchingly pursue a course of deliberate action. However (note the conditional tense), *if a war should come* (an echo of Lincoln's Second Inaugural: "and the war came"), then we can be assured that this man would go to war only for the right reasons; indeed, his face signals a character for which doing otherwise would be patently "impossible." This is not the face of a power-hungry, bloodthirsty "ruler of men," but of a benevolent, thoughtful, decisive leader: Lincoln, Savior of the Union.

Strikingly, Cooley goes a step beyond analysis of Lincoln's character to make quite another argument altogether: he actually argues that the war was not a war of conquest *precisely because the photograph does not reveal a man with such impulses*: "I think we can see in this face qualities that would have been entirely inconsistent with such a course."[108] Cooley not only uses the photograph to articulate a vision of Lincoln as the Savior of the Union, but he also mobilizes it in the service of arguments about the nature of the war itself. To "recognize" Lincoln's character in his face, then, is to imagine that the portrait photograph has the capacity to visualize moral claims.

Cooley is not alone in reading Lincoln's image in this way. Lincoln was the favored subject of physiognomists such as Samuel Wells. Wells's discussion of an engraved reproduction of a Lincoln photograph amounts to a near-complete physiognomic study of Lincoln and prefigures Cooley's own remarks nearly thirty years later:

> This photograph of 1860 shows, not the face of a great man, but of one whose elements were so molded that stormy and eventful times might easily stamp him with the seal of greatness. . . . The brow in the picture of 1860 is ample but smooth, and has no look of having grappled with vast difficult and complex political problems; the eyebrows are uniformly arched; the nose straight; the hair careless and inexpressive; the mouth, large, good natured, full of charity for all . . . but looking out from his deep-set and expressive eyes is an intellectual glance in the last degree clear and penetrating, and a soul *whiter* than is often found among the crowds of active and prominent wrestlers upon the arena of public life, and far more conscious than most public men of its final accountability at the great tribunal.[109]

Reading the past of the Civil War into the present of the picture, Wells, like Cooley, uses the discourse of physiognomy to predict the future: this man with the "white soul" is destined for greatness in the face of heavy burdens. Lest the reader of *New Physiognomy* be unclear about the implications of his reading, Wells sums up: "The lesson . . . is one of morals as well as of physiognomy.

Let any one meet the questions of his time as Mr. Lincoln met those of *his*, and bring to bear upon them his best faculties with the same conscientious fidelity that governed the Martyr-President, and he may be sure that the golden legend will be there in his features."[110] These ways of reading Lincoln persisted over time. As late as 1909 (the year of the Lincoln centenary) phrenological journals echoed Wells's earlier analysis of Lincoln's body, face, and character: "He was thus a true, sympathetic, tender-hearted, yet firm and positive man, and through his basilar faculties, which were actively developed, he manifested tragedic force, energy, and executive power."[111]

While neither Cooley nor the other correspondents in *McClure's* wrote of Lincoln with the precise detail found in physiognomic accounts, they still spoke in a language of moral pseudo-science that offered a potent framework for reading portraits. Those who read the photograph mobilized physiognomic recognition not only to honor Lincoln's individual ethos but also to proclaim him as a new "American type" in an age of anxiety about the fate of white national identity. In doing so, they found in the photograph rhetorical resources for a more communal sense of character as well, a national character constituted as the dwelling place of "the heritage of our shared appearances."[112]

"A new and interesting character": Lincoln as the National Head

Lincoln's physical appearance was a hugely popular topic in the Gilded Age. In the years following Lincoln's assassination, for example, Lincoln's law partner William Herndon gave a series of popular lectures on Lincoln. The first of these, delivered in two parts in Springfield, Illinois, on December 12 and 27, 1865, was titled "Analysis of the Character of Abraham Lincoln." Herndon began his study of Lincoln by observing, "Before I enter into an analysis of the mind—the character of Mr. Lincoln[—]it becomes necessary *first* to hold up before your minds the subject of analysis—the subject of such anatomy."[113] Following physiognomic convention, Herndon began with a detailed discussion of "the subject's" physical appearance, mentioning everything from Lincoln's hat size to his gait to the "lone mole on the right cheek."[114] Of the physical Lincoln Herndon observed, "His structure—his build was loose and leathery. . . . The whole man—body & mind worked slowly—creekingly [*sic*], as if it wanted oiling."[115] Only after this physical examination did Herndon turn to topics such as Lincoln's "perceptiveness," his "suggestiveness," his "judgments," and his "conscience." The arrangement of the speech suggests Herndon implicitly

understood that one must explore the subject's countenance before engaging the subject's character.

Popular magazines frequently printed personal recollections from those who had known Lincoln in life, "expert" commentary on Lincoln's appearance, or stories recounting the making of Lincoln photographs, life masks, or sculptures.[116] Writers sought to construct their preferred image of Lincoln in the public mind; in doing so, many of them tied that image to broader questions about the nature of American national identity at the turn of the twentieth century. In 1891 John G. Nicolay, Lincoln's former private secretary, published an essay in *Century* magazine called "Lincoln's Personal Appearance." Nicolay's stated goal in the essay was to dispel the persistent myth of Lincoln's ugliness.[117] Yet Nicolay was also interested in framing Lincoln as a new, distinctively "American" type. To accomplish this he quoted accounts that relied heavily on the kind of physiognomic detail we already have seen. Writing of his experience making a bust of Lincoln, sculptor Thomas D. Jones recalled in Nicolay's article that Lincoln's "great strength and height were well calculated to make him a peerless antagonist. . . . His head was neither Greek nor Roman, nor Celt, for his upper lip was too short for that, or a Low German. There are few such men in the world; where they came from originally is not positively known."[118] Nicolay constructed Lincoln as distinctly American, so much so that his ancestry was unimportant. Lincoln's American-ness could be found, Nicolay contended, in the frontier upbringing that gave him exposure to different kinds of people and situations: "It was this thirty years of life among the people that made and kept him a man of the people—which gave him the characteristics expressed in Lowell's poem: *New birth of our new soil; the first American.*"[119] Merrill D. Peterson observes that the discourse highlighting Lincoln as the first American "radiated everywhere" after the Civil War: "[James Russell] Lowell had discerned the archetype of a new national character, one long imagined but only now realized in a man who looked at things, who related to people, who bore himself in ways indigenous to the American continent."[120] The sheer reach of the trope of the first American may perhaps best be illustrated by its appearance in Southern discourse after the war. Even Henry Grady, in his conciliatory 1886 oration "The New South," spoke of Lincoln as "greater than Puritan, greater than Cavalier," describing him as the "first typical American" and noting that "in his homely form were first gathered the vast and thrilling forces of his ideal government."[121]

Viewers of the photograph in *McClure's* made similar arguments about Lincoln as the first American. Letter writers argued that the Lincoln photograph

revealed him as a distinctly American type, a "new man" whose physiognomy indicated a new stage in American characterological development. One of those who wrote to *McClure's* in response to the photograph was Truman H. (T. H.) Bartlett, identified by editors as an "eminent sculptor, who has for many years collected portraits of Lincoln, and has made a scientific study of Lincoln's physiognomy."[122] In his letter to *McClure's*, Bartlett observes that the photograph suggested the rise of a "new man": "It may to many suggest other heads, but a short study of it establishes its distinctive originality in every respect. It's priceless, every way, and copies of it ought to be in the gladsome possession of every lover of Lincoln. Handsome is not enough—it's great—not only of a great man, but the first picture representing the only new physiognomy of which we have any correct knowledge contributed by the New World to the ethnographic consideration of mankind."[123] Setting aside Bartlett's tortured prose, we see that for Bartlett (as for Nicolay), Lincoln's physical features signaled a marked shift in the moral makeup of American man. While some might be content to tie the image to other physiognomic types ("other heads," as Bartlett so wonderfully puts it), Bartlett suggests that the "distinctive originality" of Lincoln's features signaled something entirely new. Twelve years later Bartlett published in *McClure's* the study to which editors had alluded.[124] In "The Physiognomy of Lincoln," a highly detailed analysis of photographs and life masks of Lincoln's face and hands, Bartlett elaborated how Lincoln's physiognomy represented a distinct departure from those "other heads." Analyzing both facial expressions and bodily movement, Bartlett contended that both proved Lincoln was a new American type. The sculptor claimed to have shown the life masks and photographs to famous sculptors in France, including Auguste Rodin, who agreed with Bartlett that they illustrated "'a new and interesting character.... If it belongs to any type, and we know of none such, it must be a wonderful specimen of that type.'... 'It is a new man; he has tremendous character,' they said."[125] In all of these texts Lincoln is constituted not only in terms of his individual moral character but also in terms of his representativeness of a "new" kind of American character: "The utter individuality of Lincoln, which had impressed all who knew him, entered into the definition of his Americanness, to the point that his physiognomy blended into the representation of Uncle Sam."[126]

Such statements necessarily lead one to ask why it was so vital for *McClure's* readers—especially the elite letter writers—to connect Lincoln to this "new," uniquely American ideal. Why care about character in this communal, national, shared sense? Their desire can in large part be traced to racial and class anxieties about the changing character of American identity at the end of the

nineteenth century. I noted earlier that the majority of the letter writers were elite men—lawyers, judges, journalists, professors, and former acquaintances of Lincoln. Such professionals likely had a particular interest in specific ways of recognizing Lincoln. Elites existed in a perpetual state of anxiety during the Gilded Age. Many reasons have been posited for this cultural "neurasthenia,"[127] one of which was confusion about what it meant to be an American. Alan Trachtenberg writes that "America" was "a word whose meaning became the focus of controversy and struggle during an age in which the horrors of civil war remained vivid."[128] Robert Wiebe suggests that this struggle constituted nothing less than a national identity crisis: "The setting had altered beyond their [elites'] power to understand it and within an alien context they had lost themselves. In a democratic society who was master and who servant? In a land of opportunity what was success? In a Christian nation what were the rules and who kept them? The apparent leaders were as much adrift as their followers."[129] Attempts to grapple with these questions led white elites to define American identity by emphasizing both what Americans were and what they were not.

The white American cultural elite (I would put the *McClure's* letter writers in this category) believed they had good cause to be worried about the future of American identity. During these years the United States passed through a violent period of labor unrest, including most prominently the Haymarket events of 1886 and the bloody Pullman Strike of 1894. The voices of immigrants made themselves increasingly heard in these powerful labor movements, producing real fears of a violent class revolution. As T. J. Jackson Lears observes, "Worry about . . . destruction by an unleashed rabble, always a component of republican tradition, intensified in the face of unprecedented labor unrest, waves of strange new immigrants, and glittering industrial fortunes."[130] In the face of rising immigration, fears of miscegenation, and the threats to capital from labor, anxious elites sought rhetorically to dissociate certain citizens from the identity of "American." After the bombing at Haymarket Square in Chicago, one newspaper editorial pronounced, "'The enemy forces are not American [but] rag-tag and bob-tail cutthroats of Beelzebub from the Rhine, the Danube, the Vistula and the Elbe.'"[131] Jacob Riis's *How the Other Half Lives*, published in 1890, visualized similar anxieties. Beginning in the late 1880s Riis made photographs of New York's poor and their living conditions in the city's ghettos, sharing them in lantern slide lectures delivered to upper-class New York City audiences.[132] Writing of the cultural makeup of the New York tenements, Riis observed, "There was not a native-born individual in the court. . . . One may find for the asking an Italian, a German, a French, African, Spanish, Bohemian, Russian, Scandinavian, Jewish, and Chinese colony. . . . The

one thing you shall vainly ask for in the chief city of America is a distinctively American community. There is none; certainly not among the tenements."[133] The assumption grounding Riis's remarks is that there is, in fact, a "distinctively American community," but it is one by definition of which these poor immigrants cannot be a part.

Not surprisingly, these anxieties were also fueled by popular purveyors of the sciences of moral character, which provided a mechanism by which elites could construct a cohesive American identity through exclusion. Wiebe observes, "The most elaborate method—a compound of biology, pseudo-science, and hyperactive imaginations—divided the people of the world by race and located each group along a value scale according to its distinctive, inherent characteristics.... Bristling with the language of the laboratory, such doctrines impressed an era so respectful of science. At the same time, they remained loose enough to cover almost any choice of outcasts."[134] Physiognomy was thus well positioned rhetorically to both define those who were "real Americans" and those whose might be dangerous threats to a pure American identity. In *New Physiognomy* Wells included a lengthy discussion of "The Anglo-American." Emphasizing Americans' genetic connections to the Anglo-Saxon, Celtic, and Teutonic "races," Wells observed that contemporary Americans differed strikingly in temperament and character from their European counterparts: "The American is tall rather than short; has a well-developed frame-work, covered with only moderately full but very dense and wiry muscle; strongly marked if not prominent features; a Greco-Roman nose; rather high cheek-bones; strong jaws; a prominent chin; and a moderately large mouth."[135] As exemplars of this representative illustrious American, Wells offered up Abraham Lincoln and Cornelius Vanderbilt.[136]

Wells was not alone in arguing for the preservation of an American identity that was distinct from European ancestry. Wiebe notes, "On the surface Americans everywhere arrived at a common, unequivocal conclusion. Europe was old and tired and declining, America young and vigorous and rising.... America, on the contrary, joined virtue with youth, moral vision with power, imagination with thrust."[137] During these years, genealogical organizations such as the Daughters of the American Revolution rose in response to perceived threats to "American civilization," making available "the consolidation of a *seemingly* stable, embodied, and racialized national identity, one that conflated American borders with Anglo-Saxon bloodlines."[138] Eugenics discourse reached down from the rarified universe of science into the everyday lives of Americans, where it emphasized the importance of retaining a "pure" American identity in the face of the "threat" of the blending of the races. Such rhetoric was often

built on physiognomic principles. In "The Illumined Face," the same essay that equated reading faces with reading the weather, the anonymous author observed that one might conduct a kind of "before and after" experiment with a group of Native American children. "Put a group of Apache boys and girls before the camera," the author proposed, then "civilize" them with "Christian training" and see the inevitable changes in subsequent photographs: "The gentling of the savage is visibly reported in his face."[139] Even seemingly innocuous genealogical artifacts such as the baby book were developed as a cultural response to anxieties about the loss of American identity. Baby photographs, for example, served "as a testament to ancestry, inheritance, and continuity in family genealogies," and eugenicist Francis Galton promoted baby books to "'those who care to forecast the mental and bodily faculties of their children, and to further the science of heredity.'"[140]

At roughly the same time that *McClure's* was publishing letters in response to the Lincoln daguerreotype, W.E.B. Du Bois was beginning field research in Philadelphia, where he was exploring "the condition of the forty thousand or more people of Negro blood now living in the city of Philadelphia."[141] Mia Bay argues that Du Bois's groundbreaking study, published in 1899 as *The Philadelphia Negro*, should be understood as part of "a critical tradition of challenges to racism by minority authors."[142] In the 1890s "black racial thought was in flux," and while Du Bois's own "ideas about race were fluid in this period," Bay contends that *The Philadelphia Negro* marks Du Bois's turn toward social science as a way to argue against scientific claims about race.[143] As a result, though it does not directly critique the so-called sciences of character, its data-driven social science emphasized the structural constraints faced by African Americans, implicitly countering arguments about nature and biology while acknowledging their power. For example, writing of "prejudice against the Negro" in Philadelphia, Du Bois writes, "In the Negro's mind, color prejudice in Philadelphia is that widespread feeling of dislike for his blood, which keeps him and his children out of decent employment, from certain public conveniences and amusements, from hiring houses in many sections, and, in general, from being recognized as a man."[144] For Du Bois the "feeling of dislike for his blood" had profound consequences, blocking advancement of the race and prohibiting recognition of the African American's very humanity. When tied up with the hermeneutic of the face and the pseudo-sciences of moral character, dislike for the blood was "scientifically" rationalized to authorize marginalization and exclusion. Thus photography's recognized capacity to communicate character, in both the individual and communal senses, colluded with such rhetoric to participate in a circular discourse: one identifies groups

one wants to marginalize and exclude and then mobilizes the hermeneutic of the face to authorize the marginalization and exclusion.

During this period the need to fortify a usable (white) American national identity came to its apotheosis with the work of historian Frederick Jackson Turner. In 1893 at the World's Columbian Exposition in Chicago, Turner posited his highly influential "frontier thesis." Emphasizing the heroic, masculine traits of westward-moving pioneers, Turner argued that it was on the frontier that Americans had become Americans, forging a unique national identity apart from their European ancestry.[145] Alan Trachtenberg observes that the ethos of the frontier offered by Turner provided a coherent reading "of the American past at a time of disunity, of economic depression and labor strife, of immigrant urban workers and impoverished rural farmers challenging a predominantly Anglo-Saxon Protestant economic and social elite."[146] Turner's embracing of the frontier thus was not objective historical scholarship so much as it was "serviceable according to the needs of politics and culture: the needs of the nation at a moment of crisis."[147] Turner's frontier thesis gave white elites a narrative that acknowledged the dynamism of American cultural history while at the same time conveniently ignored or vilified difference and multiplicity. As Patricia Nelson Limerick observes, "In casting the frontier as the most important factor informing American character and democracy," Turner "paid little attention to Indians. [He] stressed the individualism and self-reliance of the pioneer and had correspondingly little to say about federal aid to expansion. . . . Perhaps most consequentially, [he] provided support for models of American exceptionalism by emphasizing the uniqueness of the American frontier experience."[148]

In a collection of essays later published together as *The Frontier in American History*, Turner sought to project "a national character, a type of person fit for the struggles and strategies of an urban future."[149] One of his strategies, not surprisingly, was to invoke the character of Abraham Lincoln as a synecdoche for the nation's character. Like the physiognomists and those who wrote to *McClure's* magazine, Turner found in Lincoln the ideal representative of what he termed "the frontier form."[150] Turner argued that the Midwest frontier's mixed populations of English, Scotch Irish, and Germans "promoted the formation of a composite nationality for the American people" and fostered an "American intellect."[151] Being raised among such "distinct people" gave Lincoln pioneer traits that he later used to the advantage of the nation.[152] The "great American West," Turner writes, "gave us Abraham Lincoln, whose gaunt frontier form and gnarled, massive hand told of the conflict with the forest, whose grasp of the ax-handle of the pioneer was no firmer than his grasp at the helm of the

ship of state as it breasted the seas of civil war."[153] If Lincoln's "frontier form" represented the frontier character, it did not take Turner too many more steps to link that frontier character to the glories of democracy itself: "It was not without significance that Abraham Lincoln became the very type of American pioneer democracy, the first adequate and elemental demonstration to the world that that democracy could produce a man who belonged to the ages."[154] Again we see Lincoln the first American, here not framed as an individual man of moral character but as a part of the national ethos, the heritage of shared appearances. In the hands of Turner, Lincoln is not just a representative of the American pioneer character; he is the product of democracy itself.

In an introduction to a 1944 book of photographs of Lincoln, Carl Sandburg concluded after reading late nineteenth-century accounts such as these that Lincoln "was a type foreshadowing democracy. The inventive Yankee, the Western frontiersman and pioneer, the Kentuckian of laughter and dreams, had found blend in one man who was the national head." At precisely the moment of Lincoln's Turnerian apotheosis, when Americans were being told there existed a uniquely American identity, this identity was declared to be threatened by the forces of social disorder and the closing of the frontier. The race- and class-infused physiognomic rhetoric constructing Lincoln as the national head—and thus the national ethos—dramatically reflected this tragic frame. Ironically, the Lincoln daguerreotype—no longer a mirror image itself—reflected these anxieties back at viewers. Those who responded to the photograph in *McClure's* recognized in that reflection a man whose high moral character and apparently "American" genes fulfilled their need for a "distinctive" American type that was capable of mitigating the anxieties of their age. In such accounts of Lincoln, Sandburg observed, "was the feel of something vague that ran deep in American hearts, that hovered close to a vision for which men would fight, struggle, and die, a grand tough blurred chance that Lincoln might be leading them toward something greater than they could have believed might come true."[155]

Reproducing, Recognizing, and Imagining Lincoln

In the 1917 epigraph with which I began this chapter, an author known only as "E.S.M." observes, "People take awful liberties with Lincoln. . . . It almost makes you wish that Lincoln had been copyrighted."[156] The title of E.S.M.'s essay is "Reproducing Lincoln." The writer wryly alludes to the frustrating impossibility of fixing Lincoln, of rhetorically managing him in ways that secure his cultural meanings within safe, familiar boundaries. Springfield's N. H.

Shepherd might fix an image of a young lawyer onto a plate, but that image would have the capacity, fifty years later, to exceed the boundaries of its reproduction in ways that were likely unimaginable to the image's creator or its subject. The responses to the *McClure's* Lincoln enable us to explore how late nineteenth-century viewers fixed Lincoln for their own purposes and in light of the concerns of their own interpretive communities. Recognizing in portrait photography resources for the production of arguments about individual and national character, the *McClure's* letter writers performed contemporary tensions about the nature of America and Americans, the uniqueness of national character, and the boundaries of national morality. While these choices might seem to be taking "awful liberties," perhaps they might more properly be termed "fair use." Alan Trachtenberg observes of Lincoln, "The most famous photographed face in American history may be the most overdetermined, the easiest, and at the same time, the most difficult to read as a person. The images are saturated with history. . . . Our readings depend on larger stories we tell (or hear) about the man and his history."[157] The stories told by the *McClure's* letter writers offer insight into the ways in which photography offered late nineteenth-century Americans resources for making sense not only of Lincoln the man and myth but of themselves as well.

Appropriating the Healthy Child

The Child That Toileth Not *and Progressive Era Child Labor Photography*

> Nowhere in the world is childhood
> loved and cherished more than in the
> United States.
>
> —"Constitution and Child Labor,"
> *Washington Post*, January 24, 1907

As the nineteenth century faded into the dawn of the twentieth, anxieties about the fate of the nation played out not only through the figure of Lincoln the "first American" but also through public deliberation about the fate of the youngest Americans. In earlier centuries Western children were conceived primarily as "faulty small adults, in need of correction and discipline"—and born in sin.[1] Over time, however, a shift occurred. T. J. Jackson Lears observes that by the middle of the nineteenth century, "middle-class children were no longer 'fostered out' to relatives or wet nurses. Unlike their colonial predecessors, they stayed increasingly at home, shielded by their mother from the market's corrupting influence."[2] Then, between 1890 and 1920, a profound transformation occurred. Contrary to scholars who trace the origins of "modern" childhood to the 1950s, Harvey J. Graff contends that the sweeping industrial, social, and political changes of the Progressive Era had a major influence on the construction of modern views of childhood and adolescence.[3] During this period, what David I. MacLeod has called the "age of the child," middle-class Americans became obsessed with the status and quality of childhood.[4] Childhood increasingly was framed as a preciously short time of innocence as

well as a psychologically important time of personal growth and development that easily could be disrupted by the "wrong" training, or no training at all. By the turn of the twentieth century, what Viviana A. Zelizer calls the "sacralization" of childhood was nearly complete. Where in the early nineteenth century the "usefulness" of children was emphasized, toward the end of the century children increasingly came to be understood paradoxically as "economically worthless" and simultaneously "priceless." Children became valuable for sentimental reasons, not utilitarian ones: "the new normative ideal of the child as an exclusively emotional and affective asset precluded instrumental or fiscal considerations."[5]

This "normative ideal of the child" did not appear or circulate in a vacuum. Anne Higgonet writes, "Precisely because the modern concept of childhood was an invented cultural idea, it required representations."[6] American visual media, especially photography, not only reflected modern ideologies of childhood; they also invented them. Higgonet continues, "Visual fictions played a special role in consolidating the modern definition of childhood, a role which became increasingly important over time."[7] While photography long had been a part of the home environment, the arrival of George Eastman's Kodak camera in 1888 cemented the relationship between photography and childhood, empowering a growing cadre of middle-class, camera-wielding parents to document every aspect of their precious children's lives. In her history of Kodak advertising, Nancy Martha West observes, "To no small extent, snapshot photography gained its cultural currency from the promise that children could demonstrate for the first time in photography history all the characteristics—spontaneity, playfulness, innocence—recently discovered as uniquely their own."[8] West observes that images of children did not begin to appear in Kodak advertisements until 1900. By the early decades of the twentieth century, however, about one-third of Kodak's advertising featured children. Many of these advertisements emphasized images of children in the home, outdoors, or at play, reinforcing the "leisured world of the middle- and upper-class family."[9] Art photographers also mobilized changing views of children and childhood in their work. Pictorialists such as Gertrude Käsebier and Clarence White emphasized a romantic, dreamy, painterly style, frequently using children as subjects—often their own or those of people they knew.[10] In embracing the normative vision of the sacred child, they put forth in their photographs an "ideologically powerful concept of young people . . . as being endowed with an emotional worth beyond all materialist reckoning."[11]

In *Photography on the Color Line*, Shawn Michelle Smith shows that middle- and upper-class African American families and photographers participated in

these same narratives. Smith studies photographic portraits made by Georgia photographer Thomas Askew and later displayed by W.E.B. Du Bois in his award-winning exhibit "The American Negro" at the 1900 Paris Exposition. In keeping with Du Bois's goal to visualize "the talented tenth" in ways that "challenged conventional American ideas" about race, the images reflected middle- and upper-class norms of photographic portraiture. They worked, as Smith puts it, "within a specific register of evaluation, one that is honorific, sentimental, and often familial."[12] In the context of competing racist images and murderous spectacles of lynching, such seemingly benign images of children functioned as an important "counter-archive" for Du Bois.

A family photograph of my grandmother Isabel Chase Finnegan and her younger sister, Edna Chase Lewis, illustrates well these visual fictions. (Their parents' overpainted wedding portraits made an appearance in chapter 2.) Undated but likely made at the turn of the twentieth century in a northern Minnesota frontier town, the studio portrait finds the Chase sisters engaged in a bit of cross-dressing and role-playing. Isabel and Edna are dressed identically in dark blouses and overalls, with white caps placed jauntily at an angle on heads full of carefully tended ringlets. The sisters share not only similar clothing but similar poses as well: each girl holds the brim of her hat and looks off to the right side of the frame, her smiling expression lit up by bright eyes. Apart from age and hair color, the only notable difference between the girls is little Edna's coquettish embrace of the pose (indeed, she seems to anticipate Shirley Temple by thirty years). Their costumed bodies offer the viewer two beloved little girls playing dress-up, masquerading to the camera as happy little worker boys. Clearly no one is fooling anyone; one would never mistake these girls for the laborers whose costumes they have put on. Not child laborers but children dressed as laborers, in this portrait the Chase girls are playfully yet squarely positioned within the sentimental frame of the sacred child.

Such visual fictions of childhood stood in marked contrast to actual child laborers' working bodies. In 1880 one million American children between the ages of ten and fifteen worked; this was one in every six children. By 1900 that number had nearly doubled to more than 1.75 million.[13] The reasons for the increase are well documented. Hugh Hindman notes that children had always worked, especially on the family farm.[14] But throughout the nineteenth century and especially after the Civil War, immigration and industrialization transformed the lives of American workers. The transformation of labor was perhaps most vivid in the New South, where industrial expansion occurred largely on the backs of white children who could work for low wages and had no power to organize. Between 1880 and 1890 the number of cotton mills in the South rose

Isabel and Edna Chase, ca. 1900. Cabinet card by Dunn and Drysdale,
Walker, Minnesota. Collection of Finnegan family.

from 180 to 412; during that same period the amount of capital invested in cotton manufacturing more than quadrupled. Labor in these mills was attractive to native whites. Walter Trattner writes, "It was easy to persuade vast numbers of impoverished white sharecroppers, tenants, and depressed farmers to abandon the exhausted, ruined land for the bright promise of the mill."[15] Once these

families arrived at the mills, it was often the children who worked; one-third of the workers in Southern mills were ten- to thirteen-year-old children.[16]

Economic necessity dovetailed with prevailing cultural ideologies of the day. Beliefs such as "idle hands are the devil's playground," combined with a deeply ingrained Protestant work ethic, produced a cultural tolerance for child labor that was often difficult to counter. While reformers in the North were somewhat successful at limiting the hours children could work by arguing for the importance of education, in the South, where there was little tradition of universal public education, such appeals often fell on deaf ears. Business leaders emphasized that poor children were better off working in the mills, canneries, and agricultural fields than they were living idly, where they might fall victim to temptation and get into trouble. Child labor laws in various states were often limited to certain manufacturing sectors, conditions, or ages of children. Furthermore, these laws often failed to have real impact: "The typical child labor law . . . often contained enough exceptions and loopholes to make it ineffective."[17]

Reformers sought to connect the issue of child labor to a broad constellation of Progressive Era questions about the health of the nation and the relatively new belief in the sacred status of the American child. Opponents of child labor argued for the importance of education rather than work. Freeing children from work would offset the short-term loss of the child's wages by providing long-term gains not only for the child but for the family and society as a whole. In addition, reformers argued that the labor in which children typically engaged was physically harmful (and in some cases deadly) and would keep children from growing into physically and morally healthy adults. As the arguments went, child labor produced "degenerate" white children (for most child laborers were white); degenerate children threatened the very future of national citizenship. As this chapter chronicles, visual representations of child labor became crucial participants in these arguments, providing important rhetorical resources both for reformers and for those who opposed them.[18]

Writing about child labor in the *North American Review* in 1911, Olivia Howard Dunbar observed, "For twenty-five years or more, whether as scientists, as artists or as sentimental amateurs, we have been more or less profitably engaged in 'studying the child.'"[19] Dunbar went on to claim that no one in her right mind would dare say publicly that childhood is unimportant: "The child question, as we have slowly come to see it, is not, like the 'woman question,' the labor question and other hard-used subjects of dispute, debatable. Or, at least, it will never be debated publicly. It is not conceivable that orators will ever mount platforms and contend that the soundness of a nation's children is an unimportant

matter—that it is even anything less than the supremely important matter."[20] By the time of Dunbar's writing, the status of the sacred child was so secure that she could not imagine rhetorical challenges to it. Indeed, she was largely right. Even those who argued that child labor was necessary made their arguments in the context of broader narratives about "the soundness of a nation's children."

This chapter examines one of those arguments, presented in a 1912 book called *The Child That Toileth Not: The Story of a Government Investigation* by Thomas Robinson Dawley Jr. The 490-page polemic, which contains more than one hundred photographs, was based on field investigations of child labor that Dawley conducted in Southern cotton mills while working for the U.S. Bureau of Labor.[21] Largely unexamined and barely remembered today, *The Child That Toileth Not* used both words and images to refute the rhetoric of child labor reform.[22] Dawley argued that children were better off working in the mills than staying on the hardscrabble mountain farms from which their families came. He contended that while life on the farm damaged children physically and morally, life in the textile mills offered children education, good health, positive moral development, and wages in exchange for what Dawley suggested was only light work. Contrary to what child labor reformers asserted at the time, Dawley argued that the mill saved children. While anti–child labor illustrations and photographs almost always depicted children at work or in the spaces of work, in *The Child That Toileth Not* Dawley assiduously avoids picturing children actually working. Visually emphasizing the mill town as a space of education, play, and patriotism, Dawley's book draws attention to the ways the mill town turns children into productive, healthy citizens.

While the previous chapter examined multiple responses to one photograph of Lincoln, in this chapter I examine one response—Dawley's—to a popular media narrative opposing child labor. That popular media narrative, circulated widely in relatively new national magazines with mass circulation, posed serious reading problems for Dawley. Those who so powerfully visualized an anti–child labor position synecdochically related the health of the child to the health of the nation, performing early twentieth-century anxieties about national identity, anarchy, and "race suicide." Such rhetoric tapped directly into the growing belief in the sacredness of the American child and the importance of childhood as a protected space where well-off, white proto-citizens could learn and play free from adult cares or concerns. Yet Dawley's political commitments required him to devise ways to visualize working-class white children as worthy of citizenship too. Dawley appropriated elements of these illustrated, widely circulated essays in order to construct his own, pro–child labor position. In responding to visual narratives about child labor produced

by Lewis Hine and others, Dawley is both a critical viewer of images and a cunning producer of them. Thus he constitutes something of a departure from photography's viewers as we have encountered them up to this point. In the previous two chapters, photography's viewers exercised their agency primarily through textual commentary. Dawley's book, by contrast, functions as a single, extended example of one polemical viewer's exercise of verbal and visual agency. By appropriating the structure, style, and strategies of a decade-old, multimodal narrative opposed to child labor, Dawley repositions the working child as the apotheosis of the values of citizenship rather than their denigration. Treating Dawley's book as a type of viewer response that qualitatively differs from others I take up in this project, this chapter offers an example of how the line between viewer of images and creator of them sometimes blurs.

The argument of *The Child That Toileth Not* is grounded in Dawley's recognition that photography and related media of visual culture offer powerful rhetorical resources for *appropriation*. While the term more frequently is invoked than defined, appropriation is recognized by scholars of rhetoric and literary studies as a key resource for communication.[23] Angela Ray defines appropriation as "the adaptation and reuse of forms originally produced and used by others" and observes that "its cultural valence varies depending on interpretations of the appropriated action." For Ray "appropriation is typically viewed as either direct quotation (re-citation) or creative transformation (parody), depending on the degree to which the original form is altered and the purposes to which this alteration is put."[24] As Ray points out, appropriation has a lot in common with parody, especially theories of parody that treat it as broader than ridicule or mocking.[25] For her discussion of appropriation, Ray relies in part on Linda Hutcheon's useful framing of parody as "repetition with a difference."[26] Like parody, appropriation is double-voiced in the Bakhtinian sense in that it invites simultaneous attention to the new work and to the work that has been appropriated.[27]

Appropriation operates on multiple levels, which we might describe as those of structure, style, and strategy. Hutcheon acknowledges the structural and stylistic levels of appropriation when she writes that parody is a "mode of thematic and formal structuring" that "marks the intersection of creation and re-creation, of invention and critique."[28] That is, one invents a new work by appropriating structural themes and conventions that are then put on display in order to facilitate what Robert Hariman calls "collective reflection."[29] Stylistic appropriation, for its part, operates by replicating or reproducing formal or aesthetic components of a work in the new work; examples that Hutcheon offers include composers' and painters' musical and visual quotation of the masters.[30]

Stylistic appropriation "replicates some prior form and thereby makes that form an object of one's attention rather than a transparent vehicle for some other message."[31] Finally, what we might term strategic appropriation operates in a narrower range; where structural appropriation happens at the level of conventions and social norms, and stylistic appropriation works in the middle space of the formal or aesthetic, strategic appropriation operates in a more situated and instrumental sense. Helene Shugart articulates this approach to appropriation when she defines appropriation as "any instance in which means commonly associated with and/or perceived as belonging to another are used to further one's own ends."[32] Two terms are key here: "means" and "ends." For Shugart and other scholars who emphasize strategic appropriation, it is best understood as an instrument used to further one's immediate persuasive goals.[33] When used strategically, Shugart writes, appropriation is a often a "means by which the referenced 'other' is challenged."[34] As I will show in this chapter, Dawley finds in visual representations of child labor more generally, and anti–child labor photography specifically, ample resources for structural, stylistic, and strategic appropriation. Such resources enable him to refute the visual rhetoric of child labor reform while at the same time advocating, in Dunbar's terms, for the supreme importance of "the soundness of a nation's children."

My argument in this chapter unfolds in the following manner. First, I explore early federal efforts in child labor reform in order to explain how T. R. Dawley came to conduct the fieldwork on child labor that led to his book. Then I elaborate the structural and stylistic features of the popularly circulated anti–child labor narratives that Dawley appropriated. The rest of the chapter then illustrates how *The Child That Toileth Not* activates appropriation to disrupt reformers' concerted attempts to contrast child labor with visual fictions of the sacred child. Dawley's appropriations of anti–child labor reform rhetoric invite the reader to contrast the working child not with the sacred child, but with the "mountain child," who lives an animal-like, unhealthy, uncivilized existence that only access to child labor can improve. While to twenty-first-century audiences such arguments may seem ethically dubious, to say the least, we shall see that they did have rhetorical traction in the early part of the previous century.

Early Child Labor Reform Efforts:
The NCLC and Beveridge's Bill

With child labor reform efforts already under way in several states, the National Child Labor Committee formed in 1904 to consolidate reform efforts taking

place in individual states. The NCLC was the first federal body dedicated to the issue of child labor.[35] Yet it is important to note that terms like "national" and "federal" do not mean governmental; the NCLC was what today we would term a nongovernmental organization, or NGO. In its statement of purpose the NCLC made clear its goals by declaring its desire to "be a great moral force for the protection of children."[36] The NCLC framed children as a special class of workers who needed zealous moral guardianship on the part of reformers: "It should be plainly said that whatever happens in the sacrifice of adult workers, the public conscience inexorably demands that the children under twelve years of age shall not be touched; that childhood shall be sacred; that industrialism and commercialism shall not be allowed beyond this point to degrade humanity."[37] The NCLC's purpose, in short, was to save children—indeed, childhood itself—from industrial capitalism.

NCLC leaders believed in the methods of social science grounded in the collecting and reporting of "social facts." The agency produced volumes of material for public distribution; in one year alone almost two million pages of printed material came out of the committee's offices.[38] Press coverage rose exponentially as a result of the committee's efforts; while few articles on child labor appeared before 1905, between 1905 and 1909 more than three hundred of them were indexed in the *Reader's Guide to Periodical Literature*.[39] Magazine coverage of child labor was particularly influential. When the federal child labor debate heated up in Congress in early 1907, several authors of these popularly circulated articles would find their work quoted directly.

That debate began in earnest on January 23, 1907, when forty-four-year-old senator Albert Beveridge of Indiana rose in the Senate chamber to present HR 17838, a bill passed by the House of Representatives that would regulate child labor in the District of Columbia.[40] While he supported the modest bill, Beveridge argued that the real problem of child labor lay far outside of the district; he offered an amendment to the bill that would address "the condition of the employment of young children in the factories, the mines, and the sweat shops of this country."[41] For the first time, federal legislation would address child labor on a national scale. Beveridge began his speech by noting that he did not oppose farmwork for children, for "where children are employed within their strength and in the open air there can be no better training."[42] He then offered a few statistics on child labor but noted that numbers were not necessarily the most persuasive evidence in this context: "if I were merely to say that so many children were employed, that would give no idea of what this evil is. Figures can not, of course, describe it." Instead of offering numbers to illustrate the extent of the child labor problem, Beveridge proclaimed he would "describe

it. I propose to show to the Senate and the country precisely what it [child labor] means, and I shall do this by the description of these children at work, of how their work is conducted, of its effect upon them, and in each instance by the testimony of eyewitnesses who have personally investigated this matter."[43] On January 23 and for several hours across two additional days thereafter, Beveridge did just that. Mobilizing a formidable array of evidence, including signed affidavits, charts, and photographs, Beveridge built a dramatic, seemingly never-ending case against the evils of child labor in the United States. Writing of the speech the following day, the *Washington Post* reported, "When the senior Indiana Senator rose to address the Senate the three desks immediately in front of him were piled high with books and exhibits to be used in his remarks. The array resembled a small improvised fort."[44] Other newspapers that reported on the speech similarly highlighted Beveridge's impressive array of evidence. The *Chicago Tribune* noted Beveridge's "photographs illustrative of the inhumanity of the child labor system."[45] The *Atlanta Georgian and News*, which called Beveridge's speech "brilliant" because it illustrated the threat of child labor to white Southerners' education and development, reproduced images it said were "copies of . . . pictures showing children who work in mines and mills" that "were submitted to the senate by Mr. Beveridge."[46] After the first day of Beveridge's speech, the *Washington Post* commended his dramatic and descriptive approach, opining, "Nowhere in the world is childhood loved and cherished more than in the United States. The people need only to be made aware of the injustice done to children in order to do away with it. Public opinion is particularly powerful in all that relates to family and to children."[47]

Beveridge built this fortress of evidence to support three primary claims. First he asserted that child labor of the sort he described was not unusual, but in fact typical in both the northern and southern sections of the United States. Responding to a colleague's objection to his narrative, Beveridge observed, "The Senator says—and I want his attention—that these are 'isolated' cases. On the contrary, they are *typical* cases." Offering statistics to illustrate the scope of the problem, Beveridge concluded, "Does the Senator think that 30,000, does he think that 60,000 child slaves are 'isolated' or 'occasional'?"[48] Beveridge supported his claims about typicality by quoting extensively, almost always verbatim, from published anti–child labor accounts and by producing charts that illustrated the scope of child labor.

Beveridge's second claim was that state laws currently in place did not go far enough, or often were flouted entirely, hence the need for federal action. Here, too, he relied extensively on published accounts, which he read into the record, especially those accounts that emphasized the gap between law and

practice. Manufacturers, parents, and local governments, Beveridge explained using several examples, had interest in skirting the laws in order to employ children, producing a situation of "universal nonenforcement of law."[49]

Beveridge's final argument highlighted the "American" character of child laborers, by which he meant primarily their race. Most child laborers were white. Beveridge argued that child labor was producing "a deterioration of the race" similar to what happened in Great Britain in the early 1800s: "The lowest estimate now is that we are pouring into American citizenship every year at least 200,000 London 'Hooligans,' boys and girls, who are broken in body and stunted in mind and soul, and who know it, and who are living engines of hatred toward society."[50] These broken and stunted "hooligans" were not merely lost citizens, Beveridge argued, they were the enemies of citizenship itself. The engine metaphor signaled that the very labor to which children had been made subject was transforming their bodies into dangerous machines: they would grow up and they would lash out. Offering up a classic early twentieth-century fear appeal—the threat of racial degeneration—he asked of his colleagues, "Had we not better do something to stop the production of that 'lower class,' that 'dangerous class'?"[51]

Beveridge used as his primary evidence a collectively constructed, multi-modal narrative about child labor that had been circulating in the American press since the turn of the century. That narrative, produced by social workers, labor activists, and crusading correspondents, trafficked in first-person accounts of child labor in the mines, mills, and factories and combined vivid textual description with the presentation of visual images in order to make child labor dramatically present to readers. Beveridge relied especially on accounts of child labor recently published in American magazines. Reflecting on the role of magazines in the anti–child labor effort, Beveridge observed that, unlike newspapers, "the magazines find it possible and profitable to take up one subject and keep hammering at it for months, and years. So the men and women who want to make the Nation better, and who have time for the work, have found in the magazines the means by which the people may be thoroughly educated upon any question of national interest." He added, "It was thus my own attention was first called to our terrible national sin of child slavery and child murder."[52]

Despite voluminous and vivid evidence, opponents of child labor did not unanimously support Beveridge's bill. When in late 1906 Beveridge began to speak of a federal child labor bill in Congress, he sought the support of the National Child Labor Committee. Up to this point the NCLC had focused on legislation at the state level.[53] Some in the NCLC feared angering Southern

reformers, who did not want federal intervention; indeed, when the NCLC eventually pledged its support for the bill, it lost some key Southern supporters.[54] Ultimately, while the Beveridge bill left many particulars unanswered, the NCLC saw the opportunity to expand discussion of child labor nationally and elected to support it.[55] But President Theodore Roosevelt recognized that neither Congress nor organized labor would support the bill, and he questioned its constitutionality.[56] In response to Roosevelt the NCLC shifted its own position, proposing instead "a large-scale federal study of the child labor problem."[57] Despite Beveridge's objections, in January 1907 Congress approved a federal study by the Bureau of Labor and appropriated three hundred thousand dollars for it.[58]

While ineffective in terms of accomplishing Beveridge's short-term goal of advancing federal child labor legislation, Beveridge's speech continued to resonate in public conversations about child labor. It was reintroduced to the public about five years later when one of those hired to conduct that Bureau of Labor study wrote a tell-all book about his experiences.

T. R. Dawley and Beveridge's Speech

T. R. Dawley was an unlikely child labor investigator. The exact circumstances that led him to take a job with the federal Bureau of Labor are unknown. He is more accurately described as a freelance journalist or foreign correspondent than a social worker or bureaucrat. Sixty-eight years old when he died, Dawley was described in a 1930 *New York Times* obituary as an "author, publicist, and war correspondent in the Spanish-American war."[59] The obituary briefly noted his work on *The Child That Toileth Not*—"in which he pointed out that the [child labor] situation was not as bad as had been anticipated"—but devoted the bulk of its space to describing Dawley's early years as a foreign correspondent.[60] The account describes a busy career, noting Dawley's "thrilling adventures" in Cuba at the end of the nineteenth century and describing him as a "close friend of President [Theodore] Roosevelt."[61]

Dawley's "thrilling adventures" in Cuba may be traced to the period just before the beginning of the Spanish-American War. In a series of stories published in *Harper's Weekly* and recirculated in other print outlets, Dawley presented firsthand accounts of meeting military leaders, described the arrival of Spanish soldiers in Havana, and told the tale of his own brief imprisonment in Cuba.[62] In a narrative strategy to be echoed later in *The Child That Toileth Not*, Dawley claimed to be beholden to no man nor institution. Yet his dispatches from Cuba during this period reveal him to be a willing, even driving partici-

pant in the coalescing ideology of empire that led to the Spanish-American War. Using both text and photographs, Dawley's dispatches valorized the Cuban "insurgents" and their "liberating army."[63] In hiring Dawley, then, the Bureau of Labor probably thought it was hiring an experienced (if crusading) correspondent with extensive experience gathering evidence and reporting it. What it got was something a bit more complex—and more vexing.

Topping out at nearly five hundred pages, *The Child That Toileth Not* is based upon two congressionally funded field investigations that Dawley conducted in Southern textile mills on behalf of the Bureau of Labor. Dawley's book opens with a chapter titled "Beveridge's Speech," in which Dawley produces a critical reading of Beveridge's speech in order to critique typical descriptions of child labor. Yet Dawley's critique is not so much of Beveridge, but of his "improvised fort" of sources. Dawley emphasized the powerful "word pictures" and "representations" created by magazine stories and reports that Beveridge quoted: "Little children were represented as working in dyehouses in vats of poisonous dyes"; "These child toilers, as represented, were the 'infant factory slaves'"; "It was represented that capitalists . . . were little less than human monsters"; children "were pictured as beginning their labors in the mills as young as four years." Beveridge and his child labor reform friends "presented a word picture of the children in the mills," Dawley concluded, that was seductive but skewed.[64]

Dawley reports early in the book that upon completion of his first field investigation, he encountered resistance to his findings in Washington: "I was told to write a report, but upon starting to write that report, my findings respecting child labor and the improvement of the families at the mills, were met with protests." Dawley suggests that the Bureau of Labor had launched its investigation with a set of assumptions firmly in place: "I was told that it was an established fact that factory employment was detrimental to the employed, that the captains of industry who employed the children, never worked a day in their lives and that they exploited the lives of the little children whom they employed, for their own personal gain."[65] In writing *The Child That Toileth Not*, Dawley sought to publicize what he believed to be his suppressed conclusions and to refute an activist narrative that he believed had been swallowed whole by the federal government.

The Anti–Child Labor Narrative in Popular Media

In 1912 the most potent rhetorical weapon in that narrative was photographer Lewis Hine.[66] From 1908 to 1918 Hine traveled the country as an investigator

for the NCLC. He documented working conditions of women and children, from the city streets to the cannery, coal mine, and cotton mill.[67] Working under the auspices of the NCLC, Hine made thousands of photographs, assembled them into lantern slide shows, wrote and illustrated reports, and created exhibit posters made up of what he termed "time-exposures," images paired persuasively with text.[68] His images circulated in NCLC publications and in magazine articles on child labor, many of which Hine wrote himself.[69] He mixed photographs with textual reports of his investigations because he knew that images alone would not be enough: "Sociologically, Hine learned that not truth but self-interest moved 'the authorities' and that only irrefutable truth, delivered in a package of photographic image and data [dates, places, names, ages, heights, hours of work, daily earnings] would appeal to the sole force capable of moving them: public opinion."[70] Of the impact of such work, Kate Sampsell-Willmann argues, "By the end of the 1910s, [Hine] was among the nation's leading social critics, and his expertise was such that he could testify directly to Congress about his work with the National Child Labor Committee (NCLC)."[71] Owen Lovejoy, who hired Hine at the NCLC, remarked years later in a letter to the photographer, "'In my judgment the work you did under my direction for the National Child Labor Committee was more responsible than any or all other efforts to bring the facts and conditions of child employment to public attention.'"[72]

No one mobilized and challenged the visual fictions of the sacred child better than Lewis Hine. But while the plainly composed, skillfully executed photographs produced by Hine served as poignant evidence in Progressive Era debates about citizenship, work, health, and the changing nature of childhood in the early twentieth century, Hine had important predecessors that scholars have largely ignored. The early twentieth century brought the rise of muckraking journalism, in which self-styled crusading journalists sought to expose large-scale corruption in economic, political, and social institutions. *The Child That Toileth Not* appropriated these structural conventions. Fueled by progressive fervor and supported by editors of popular magazines such as *McClure's* and *Cosmopolitan*, muckrakers typically aligned themselves with broad federal efforts at social reform.[73] What we remember today as the most famous muckraking efforts, Lincoln Steffens's "Shame of the Cities" series (1902–1903) and Ida Tarbell's exposure of the corruptions of the Standard Oil Company (1902), relied upon extensive field research as well as articulation of a moral dimension to reporting.[74]

Child labor was a common topic for magazines of the period; in fact, the first decade of the twentieth century was rife with magazine offerings on the

evils of child labor. Essays with titles such as "The Child at the Loom" and "Little Slaves of the Coal Mines" dramatically described the experiences of child laborers and utilized what became the patented muckraking style: vivid descriptions of conditions, emphasis on visual illustrations, direct address to the reader, and rhetoric designed to shame.[75] Matthew Schneirov describes such efforts: "This was the 'new realism,' which sought to 'speak not the pleasant but the true.' But speaking the truth did not mean separating facts from advocacy of a position. Instead, facts were to be exposed precisely to open the public's mind to the need for reform."[76]

Both popular and specialized magazines produced vivid, multimodal accounts of child labor, most of them negative. NCLC historian Walter Trattner describes such stories as "a series of well-meant but inaccurate magazine articles" and notes that some of the stories were built on exaggerations that embarrassed the NCLC, which preferred a more social scientific approach.[77] The magazine accounts published during the five years or so before Beveridge's speech are remarkably similar, constituting a set of structural conventions to which subsequent accounts needed to conform and which later opponents like Dawley appropriated. Child labor narratives of this period offered statistical information on the scope of the child labor problem across the United States, emphasized that the conditions described were not rare but in fact typical, challenged Americans to reject industry's excuses for child labor, proposed the need for national legislation to control and limit child labor, and often featured a focus on the laboring child's poor health and lack of education. As these stories circulated in popular media of the early twentieth century, and influenced others who came after—most notably Lewis Hine—they tended to mobilize a relatively stable set of stylistic strategies. First, child labor stories usually featured an author who offered firsthand observation and accounts of child labor. Second, the stories favored a multimodal approach combining textual and visual narratives. Finally, these multimodal, firsthand accounts relied heavily on vivid description to present the reader with dramatic details about child labor. Using examples from the same sources Beveridge cited in his 1907 speech (sources that, as we have seen, Dawley later criticized), I will examine each of these in turn.

In an era in which muckraking journalists rose to fame by offering firsthand accounts of complex economic and social conditions, those writing about child labor used similar tactics. Irene Ashby-Macfayden was a union operative who reported on child labor for Samuel Gompers and wrote about her experiences in periodicals such as *World's Work* and *American Federationist*.[78] Her essays emphasized her firsthand observations: "Only a few weeks ago I stood at 10.30

at night in a mill in Columbia, S.C., controlled and owned by northern capital, where children who did not know their own ages were working from 6 p.m. to 6 a.m. without a moment for rest or food or a single cessation of the maddening racket of the machinery, in an atmosphere unsanitary and clouded with humidity and lint."[79] Others worked similarly. In 1906 Bessie (known in print as "Mrs. John") van Vorst dramatized child labor in a multipart series published in the *Saturday Evening Post*.[80] In these essays the author's stance as a surrogate for the reader is paramount. As we saw with Oliver Wendell Holmes in chapter 1, here too such accounts constituted a pedagogy of sight as they purported to offer readers firsthand experience of the evils of child labor. Dawley later appropriated this stylistic convention in *The Child That Toileth Not*.

In these accounts the "truth" about child labor is uncovered not only through words but through images too. Thus a second convention of popular narratives opposed to child labor is their *multimodal approach*, in which authors combined the textual and the visual in their construction of dramatic narratives.[81] As we saw in chapter 2, beginning in the late nineteenth century with the rise of the halftone process, popular magazines and newspapers increasingly were able to reproduce a variety of visual images, and to do so cheaply. Magazines such as *McClure's, Cosmopolitan*, the *Saturday Evening Post*, and many others took advantage of this technology to illustrate their articles with images. Popular media representations of child labor were filled with a variety of visual images paired with texts to tell stories about child labor.

While today we tend to associate child labor reform imagery solely with photography, in the pre-Hine period it was common for magazines to use other modes of illustration. Child labor essays frequently were illustrated by well-known artists. For example, Bessie van Vorst's *Saturday Evening Post* treatment of child labor was published with drawings by Guernsey Moore, a well-known magazine and advertising illustrator who was often responsible for *Saturday Evening Post* covers.[82] Another multipart series published in the *Cosmopolitan* that same year used color-washed silhouettes by Warren Rockwell (no relation to Norman), a New York book and magazine illustrator, to illustrate articles by poet (and the magazine's associate editor) Edwin Markham.[83] Markham's essays, collectively called "The Hoe-Man in the Making" (after Markham's popular 1899 pro-labor poem "The Man with the Hoe"), were paired with silhouettes to track child labor across four industrial settings: textile mills, glass factories, coal mines, and what Markham termed "the grind behind the holidays," an exposé of holiday-season labor practices.[84]

Despite the heavy reliance on illustration, photography was present in early child labor narratives. Some photographs, such as those published in social-

ist writer John Spargo's *The Bitter Cry of the Children*, were similar to later photographs by Lewis Hine and others. These images depicted children in the poverty-stricken, dilapidated setting of their home or work environments. But other photographs sought to juxtapose visual fictions of the sacred child with images of child laborers. For example, union activist and writer Irene Ashby-Macfayden's 1902 account of child labor in *American Federationist* opens with a studio portrait made in Montgomery, Alabama. It features an adult woman (Ashby-Macfayden herself) and three child laborers, two girls and a boy. The studio setting of the formal portrait calls to mind the playful "laborer" photograph of the Chase girls that opens this chapter. But here any sense of visual fantasy is belied by the bodies and faces of the children. The girls wear threadbare dresses and the boy wears short pants, a dirty oversized shirt, and suspenders. All of the children have bare feet. Both girls stand with their hands folded politely in front of them. Removing the children from the economic space of the mill and placing them in the consumer space of the photography studio, Ashby-Macfayden strategically appropriates the family portrait to juxtapose the laboring child to the sacred child. Appropriation, as Linda Hutcheon puts it, entails "repetition with a difference."[85] Placing child laborers into the formal, familial setting of the conventional portrait studio, Ashby-Macfayden invites—perhaps even challenges—readers to see child laborers as valuable, significant, and worthy. In doing so she bluntly reworks the geography of childhood.

Finally, these firsthand, visual accounts operated using *enargia*, which rhetorical scholar Richard Lanham describes as "a generic term for visually powerful, vivid description, which recreates something or someone, as if they have appeared 'before your very eyes.'"[86] Poet Edwin Markham, whose multipart series in the *Cosmopolitan* mobilized so skillfully the silhouette imagery mentioned above, was particularly fond of dramatic amplification and accumulation of detail. Markham employed vivid language to invite readers to accompany him, as it were, into the literal spaces where the dramatic narrative of child labor plays out: "Let us glance into the weaving-rooms of the cotton mills and behold in the hot, damp, decaying atmosphere the little wan figures flying in hideous cotillion among looms and wheels—children choked and blinded by clouds of lint forever molting from the webs, children deafened by the jar and uproar of an eternal Niagara of machines, children silenced utterly in the desert desolation in the heart of never-ceasing clamor, children that seem like specter-shapes, doomed to silence and done with life, beckoning to one another across some thunder-shaken Inferno."[87] Such vivid language amplifies the drama and dangers of child labor and its effects on children's bodies in particular. The

"A Bit of Realism." Portrait of Irene Ashby-Macfayden and child laborers. *American Federationist*, May 1902, 214.

children move in "hideous cotillion" and are "choked," "blinded," "deafened," and, ultimately, "silenced."

Using a stable set of structural conventions that evolved through muckraking journalism, and deploying stylistic devices such as the presentation of firsthand accounts, multimodal communication, and vivid description, popular media

accounts of child labor narrated and dramatized the negative effects of child labor. As a result, they made available a variety of resources for appropriation. We have already seen such appropriation in the 1907 speech of Albert Beveridge, who mobilized these narratives directly in his "improvised fort" of evidence against child labor. This same narrative figures strongly in T. R. Dawley's refutation of child labor reform rhetoric.

Responding as a viewer to these representations of child labor, and creating polemical counter-representations of his own, Dawley appropriated the structural conventions and stylistic forms of the anti–child labor narrative. Throughout the book he emphasizes his firsthand experience doing fieldwork in the South, he combines text and image to build a detailed refutation of Beveridge and his ilk, and he deploys vivid description to tell a story of the laboring child citizen's good fortune. In addition, Dawley finds in child labor photography, especially in the work of Lewis Hine, resources for strategic appropriation. He strategically reproduces, or directly "quotes," several photographs by Lewis Hine in order to directly challenge what they purport to show.

The Child That Toileth Not:
"I would build them a cotton mill"

The Child That Toileth Not contains 121 photographs, a clue that the images are meant to be more than mere illustration.[88] Indeed, the opening pages of Dawley's book indicate that the photographic image will have a primary role and that firsthand observation will be a dominant trope of the text. The book itself opens with a photograph. Tellingly, it is not a photograph of the conditions Dawley encountered, but a photograph of the author himself: a full-page portrait of the author captioned, "THE AUTHOR AND HIS HORSE RUBBERNECK, as he appeared in the Mountains of North Carolina on his second investigation." The frontispiece functions as a visual epigraph, the caption situating the author within a particular space and time and hinting that he possesses firsthand experience of the conditions he will describe. Sporting the attire of a Teddy Roosevelt Rough Rider and sitting smartly astride his trusty horse, Dawley frames himself as a serious man of action. Although he is a government investigator, the frontispiece frames Dawley as the quintessential Rough Rider, evoking his earlier Cuban adventures by depicting himself as a muckraking loner seeking out the "truth."

The overall argument of the book is that while there are differences among labor practices at various mills, children are better off working in the mills than staying on the hardscrabble mountain farms from which their families came.

Such an argument was not new; indeed, supporters of child labor had made the same arguments years before Dawley's book appeared.[89] Dawley argues that life on the farm damages children both physically and morally; by contrast, life in the textile mills offers children education, good health, positive moral development, and wages in exchange for what Dawley suggests is only "light" work. Thus the mill saves children; it does not doom them. In addition to contrasting farm life with mill life, Dawley also explicitly contrasts the findings of his investigations with the reports of the NCLC, Lewis Hine, and other anti–child labor activists. Dawley argues that his investigations reveal that life in the mill is not nearly as detrimental to children as labor reformers suggest. In order to support these claims, he combines an exhaustive narrative discussion of his travels with a parallel visual argument constructed with photographs and captions scattered throughout the text. The book's chapters alternate between discussions of conditions Dawley observed in mills and mill towns and those he experienced while traveling in rural areas among farm and mountain people. The book concludes with a passionate, polemical indictment of child labor reform politics and wasteful government bureaucracy.

The photographs in the book generally are of two types: photographs of life on the mountain farms (featuring images of destitute, unhealthy-looking children and families struggling to live on inhospitable land) and photographs of life in the mill towns. Although photographers are not identified directly in the captions, the majority of the photographs appear to have been made by Dawley himself; Dawley mentions his photographic activities throughout the book.[90] As we shall see, Dawley's photographic response emphasizes that life in the mill town exerts a civilizing influence on children. His photographs are vital to his narrative, for they visualize the mill town as a positive influence in the lives of Southern children and thus constitute a deliberative challenge to reform narratives that would visualize children's experiences as the opposite. Dawley's heavy visual emphasis on the mountain farms adds something new to the debate. Most child labor reform rhetoric, especially what circulated in the popular press, emphasized the sites of industrial labor; it did not tend to picture conditions in the areas from which many child laborers came. As a result, Dawley's book sets up a contrast between farm life and mill town life that largely is invisible in other child labor narratives.

Dawley begins by contrasting child laborers not with images of the sacred child, but with mountain children. Indeed, the sacred child appears nowhere explicitly in Dawley's book, though it hovers like a ghost above the whole proceedings. The largest number of photographs in the book visualize the lives of the "mountain people." Dawley photographs the environment in which farm

families live and work, emphasizing the dilapidated buildings and hardscrabble land. The often sarcastic captions accompanying these photographs link the physical devastation of the land with the physical and moral "degeneration" of its people. Here is how Dawley captions a photograph of an abandoned farmer's shack: "GONE! GONE TO THE COTTON-MILL; It is from such productive farms that the special interests claim that our splendid mountain people go the mills to be ruined."[91] Dawley sarcastically uses the caption to suggest that the real life of mountain people is decidedly not "splendid," but something from which they need to be rescued. Indeed, Dawley's photographs of mountain people, along with their captions and Dawley's extensive documentation in his text, work to dismiss the myth of the healthy yeoman farmer and replace it with images of "decadent" people doomed to ill health and moral decay.

One photograph of a farming family in the mountain area is a multigenerational family portrait. Ten family members, including two young boys and a baby, stare into the camera, unsmiling. The caption reads: "PRODUCTS OF ISOLATION, IGNORANCE AND VICE. A poor family in Madison County without the advantages presented by a cotton-mill. Old Aunt Polly, some of her children and grandchildren. All were said to be illegitimate. At the time the picture was taken, another daughter was ill with pneumonia and was without medical attendance. Neighbors said their corn had given out and they had scarcely anything to eat. Such conditions as these existed in the hills of New England before the establishment of cotton-mills."[92] Dawley positions the family in explicit contrast to mill culture, for this family is "without the advantages" of the mill. The caption provides a context that is not locatable in the photograph itself, suggesting that the family is unhealthy both physically and morally. In both the text and the captions, Dawley emphasizes families with illegitimate children, implying that the people of the mountain farms are immoral and uncivilized. Dawley claims that this would change if they were living in the morally healthier culture of the mill.

It is also worth noting that "Old Aunt Polly's" family members in the picture are framed by Dawley as "products of isolation, ignorance and vice." The rhetoric of "product" is not accidental here. Dawley appropriates the term "product" from anti–child labor rhetoric that explicitly described sick or injured children as victims of an industry that was more committed to products than to those who produced them. Where Dawley's labeled "special interests" argued that the mills and industries produced bad products in the form of deformed and uneducated children, Dawley suggests that it is really uncivilized life on the farm, full of "isolation, ignorance and vice," that produces families like this one: poor, unhealthy, immoral—and, even animal-like. In a photograph

"Products of Isolation, Ignorance and Vice. A poor family in Madison County without the advantages presented by a cotton-mill." Dawley, *Child That Toileth Not*, 131.

captioned "A CHILD OF THE MOUNTAINS," Dawley features a small, squinting girl with long, wavy hair grown down to the middle of her back; she stands uncomfortably for the camera in front of a small mountain cabin. The caption quotes one of Dawley's informants, who observed of children like this one, "In the summer they live on berries like bears; in the winter they get nothing but corn meal. 'Thar ain't enough cotton-mills for them.'"[93] In contrast to the animal-like existence of this "wild child," Dawley suggests the potential salvation of the mill.

Dawley's captions often invite the viewer to look for evidence of degeneracy in the pictures themselves; in this way the photographs do not merely illustrate the claims made in the text, but become constituted as objects for analysis by the reader. For example, one photograph features a family of girls and women. While an older girl looks out the window of a dilapidated cabin directly at the photographer, a mother poses in front of the cabin with her family of five daughters, lined up in descending order of height, left to right. The caption is

"A Child of the Mountains." Dawley, *Child That Toileth Not*, 244.

headlined "FIVE LITTLE SISTERS ON THE FARM" and continues, "Note the fat and healthy appearance of the youngest one, the gradual deterioration of the others and finally the aged appearance of the mother at thirty-five."[94] Dawley invites the viewer to read the image in a way that suggests that, over time, life in the mountain areas breaks people down and eventually leads to their "deterioration." Furthermore, the deterioration is not just what happens when a woman becomes a mother and raises a family; rather, it is "gradual," and the only girl who is spared is the youngest, "fat and healthy" daughter, whose sealed fate is illustrated by the predictably deteriorating bodies of her sisters. The photograph itself, however, does not seem to show such a progression; indeed, the four youngest girls have healthy-looking, round faces quite similar to that of the youngest girl. In order to support his argument, however, Dawley needs to read this image and others like it as examples of the unhealthful effects of mountain life. The implication is that not only is life in the mountains unhealthy but also that it always has and always will be; the only way to avoid such physical and mental disabilities is to get to children early and remove them from the farm to the mill.

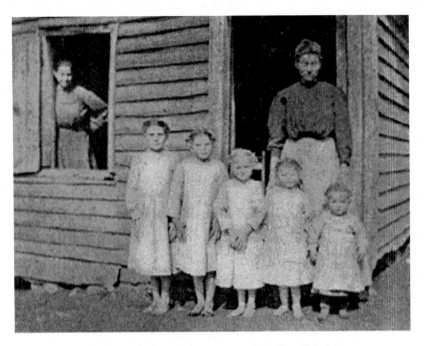

"Five Little Sisters on the Farm." Dawley, *Child That Toileth Not*, 449.

Dawley's verbal and visual depictions of the "mountain people" do not suggest that they are inherently degenerate so much as they are "products" of an environment that inevitably makes for degeneration. While Dawley frames adults as largely lost to health and civilization, those white children who leave the farms for the mill will gain "advantages" that those who stay behind lack. Thus for Dawley the farm families constitute an uncivilized citizenry needing redemption, not vilification; the wild child merely needs to be tamed. As descendants of white, Anglo-Saxon yeoman farmers of the century past, such families represent the foundation of the American nation. Describing an encounter with "Vicie," a divorced woman with children of questionable paternity, Dawley writes, "Like the oak that abounds in her forest, she was solid all the way through. How unlike the many expensively veneered creatures of our effete civilization, with all their advantages of wealth, culture and education. She presented that hardy type of our ancestral race that by its very rudeness and virility gave backbone to a nation."[95] Here Dawley's framing echoes the narrative of "the first American" we encountered in chapter 2, whose rude and rugged ways

formed the backbone of the pioneer nation's identity. By suggesting that such "hardy types" are more American than the "veneered creatures of our effete civilization," Dawley echoes the period's critiques of upper-class "civilized" culture that highlighted the psychological, physical, and moral weaknesses of the very wealthy.[96] In doing so, Dawley opens up a space between the abject poverty of the white mountain farmers and "effete civilization," a space into which the rising classes (such as the mill workers) may insert themselves. The mill town enables the uncivilized to rise while still upholding American values of work. As Dawley writes of the mountain people, "If I were a Carnegie or a Rockefeller seeking to improve the conditions of our poor mountain people, I would build them a cotton mill."[97] By suggesting that it is in fact through child labor that children may rise to a healthy, educated, middle-class existence, Dawley articulates a vision of the child-citizen that is not only purportedly healthy for the individual child but healthy for the nation as well. Child labor is thus redeemed from the hands of the reformers and their "exaggerated" claims.

Healthy Proto-Citizens: Dawley's Class Pictures of Mill Children

Throughout the book, photographs of life in the mill towns situate children's bodies in the contexts of school, play, and patriotism rather than work. In offering these alternative images of child laborers, Dawley attempts to replace the powerful visual narrative of Hine and his predecessors with one that dissociates the body of the child from the body of the laborer. Anti–child labor activists argued that if children were working long hours during the day, they could not possibly be receiving a proper education. In an attempt to refute this argument, Dawley includes photographs of life in the mill towns that show large groups of children gathered together in school settings. Adults are always nearby—not hovering threateningly, as in many of Hine's child labor images, but as figures of benevolence. Dawley's class pictures serve two functions. First, they are meant to counteract Hine's and others' often poignant images of individual child workers or small groups of children. By offering photographs of very large numbers of children, Dawley suggests that the majority of children in the mill towns are healthy and educated. Furthermore, the spaces in which groups of children are photographed highlight not the mind-and-body-numbing labor typically depicted in the narratives of those who are against child labor, but instead the benefits of education, exercise, and training in patriotism.

Dawley's images of a cotton mill in Pelzer, South Carolina, for example, seek to refute the idea that Pelzer is run by a despot. Dawley's photographs

frame this company town as a welcoming haven for children who would otherwise have little access to education or training. Where "special interests" have condemned Pelzer for exploiting the labor of women and children for profit, Dawley visualizes paternalistic beneficence. In a photograph of students in a cooking class, for example, a group of girls and their teachers pose in the school kitchen with the tools of their trade: bowls, brooms, stove, and pots and pans. The girls are clean and well dressed, if simply so; a few have fashionable bows in their hair. Dawley's image suggests that these girls have not been unsexed by mill culture; to the contrary, they are being taught the middle-class arts of domesticity. Dawley observes in the caption, "Children of mill operatives as they were with their teacher in their cooking class at the time of our investigation. Of course children thus trained make more efficient operatives, better housekeepers and better mothers."[98] Dawley assures the reader that these girls will be productive citizens in all of the ways expected of middle-class girls—and that they can do all of this while still functioning as "efficient" workers in the mill. The two jobs are not incommensurate.

Dawley observes that this cooking class is merely one example of the range of community activities available to children at such mills. It "was a part of the welfare work paid for and maintained by the corporation, as well as the lyceum, library, reading-room, park, swimming-pool, and everything else established for the improvement of the community."[99] All of these spaces in the company town, Dawley implies, enable children to develop themselves as healthy, educated citizens. Indeed, corporate-sponsored places of play figure prominently in Dawley's photographs. A photograph made in Georgia shows between thirty and forty small children gathered with their teachers outdoors in a fenced-in play area. The children display themselves for the photographer in a more or less orderly fashion, despite the fact that many of them are positioned somewhat uncomfortably on playground equipment. Two barefoot boys share a swing, while in the background little children are stacked like sardines on a slide, the boy at the bottom bracing his arms and legs as if to avoid being crushed by the flood of children behind and above him. Four teachers, all women, pose with the children, who appear clean and well-behaved despite their young ages. Trees are visible in the background of the image, as is a broader expanse of sky, suggesting something of the health of the outdoors. The photograph is a prototypical image of childhood, a "class picture" in both senses of the term. Children are gathered outdoors, under watchful but caring adult supervision, getting exercise and having fun. They are not working or suffering.[100] Suggesting that the "special interests" believe that such children really work in the mills, Dawley's caption observes, "The above was taken at the Eagle &

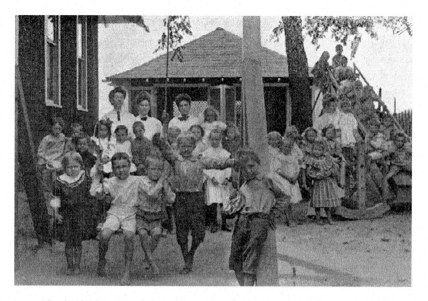

"Such Children Were Found in the Mill Kindergartens and Play Grounds."
Dawley, *Child That Toileth Not*, 290.

Phenix Mills, Columbus, Ga., where such children are represented by special interests, as marching in daily procession into the yawning mill."[101] The caption emphasizes that the playground photograph is a direct visual contradiction of evidence offered by "special interests." If there are children at the mills, Dawley implies, they are not hidden, but rather they are here, outdoors and in plain view in the healthy space of the playground.

In another photograph of play, Dawley presents a group of about a dozen young boys, perhaps nine to twelve years of age, posing outdoors amid tall pine trees. One of the boys holds what looks to be a long wooden bat. Dawley identifies the boys as "doffer boys who were playing ball between doffs" and suggests that boys like these "play two-thirds of the working day."[102] While the children in the playground or on the ball field may be current or future workers, Dawley suggests both in the text and with this image that their labor does not get in the way of healthy play. His emphasis on playground images may be understood in the context of early twentieth-century beliefs about childhood health. The playground movement, begun in the late nineteenth century in the United States and in full force by the time of Dawley's writing, argued that increasing urbanization made children of the industrial age par-

ticularly vulnerable to ill health and disease.[103] The construction of healthy play spaces, reformers argued, would enable exercise and foster good health, especially important in the confining spaces of industrial America. The existence of such spaces in the mill town implied that the corporation was both attentive to the health needs of the children and philanthropic in making these spaces available. Dawley's photographic emphasis on play is thus meant not only to counter images of children at work but also to tie corporate interests to progressive movements designed to help, not hurt, children.

In emphasizing school and play, Dawley did not deny that children worked, but he denied that this was all that they did and that it was difficult work that would damage their health. Furthermore, Dawley claims that even the labor children do is part of their education; throughout the book he offers examples of mill supervisors (all men) who started out as children and worked their way up into management positions.[104] Thus it was that Dawley would write of a mill in Tennessee, "There were sixty thousand spindles there. Sixty thousand educators for the poor children of the mountains."[105] Later, writing of another mill, he again personifies spindles as "child educators," emphasizing that the labor children were doing in the mill was teaching them the art of hard work and good citizenship.[106] Indeed, if life in the mills afforded children education and healthy exercise, as Dawley's images and text claim, then the mills were in effect creating just the kind of citizens early twentieth-century progressives desired. It was through child labor, not in spite of it, that lower-class whites would rise in society.

As we have seen, Dawley's book may be read as one excessively partisan viewer's extended rhetorical response to the child labor narratives circulating in the period. He appropriated child labor accounts' emphasis on firsthand observation; use of textual and visual evidence; and dramatic, vivid descriptions of conditions. In doing so, Dawley countered child labor reform critiques, especially those articulated by Beveridge and advocated by the NCLC and its investigators. Yet Dawley responded to this narrative not only by producing his own illustrated text with dozens of his own photographs but also by appropriating the photographs of others. In these moments of strategic appropriation, he mobilized these latter images in ways that enabled him to refute common anti–child labor arguments. George Dimock discusses a few appropriations of Hine in Dawley's book, describing Dawley's appropriations as "visual rebuttals" designed to ascribe "the sorry condition of the mill children not to the ruinous effects of wage labor but rather to the poverty, ignorance, malnutrition, and disease endemic to a prior rural life."[107] While Dimock is generally correct

in emphasizing the refutational qualities of Dawley's arguments, there is much more to say on this point. Dawley uses strategic appropriation to rebut quite specific claims about child labor made by his opposition. For starters, he uses strategic appropriation to refute claims to representativeness or typicality. At least three Hine images in the book are drawn from an article by the NCLC's Southern assistant secretary, Alexander McKelway. Published in the January 30, 1909, issue of *Charities and the Commons*, the piece was later lightly edited and released separately as an official publication of the NCLC called *Child Labor in the Carolinas*.[108] Twenty pages long and illustrated with twenty-six photographs made in the field by Lewis Hine, the pamphlet presented visual and textual evidence of conditions for child labor in the cotton mills of the Carolinas. The *Charities* piece and the pamphlet opened by describing Hine's work: "In November, 1908, he [Hine] went to Charlotte, North Carolina, the center of the cotton mill region of the South. Over 50 per cent of the cotton spindles and looms of the South are within a hundred miles of Charlotte. Mr. Hine visited 19 mill villages and investigated 17 Mills, taking 230 photographs of the conditions he discovered."[109]

Beveridge and the anti–child labor narrative from which he drew emphasized that the examples they offered were not unique or isolated, but in fact typical of child labor in both the North and the South. Hine's photos for the NCLC followed a similar rhetorical pattern. The captions accompanying his photographs in the Carolinas publications emphasized the typicality of the child workers pictured and sometimes described the children's ages, living and family situations, and typical work hours. For example, for one image of a young girl tending looms Hine offered this caption: "Spinner. A type of many in the mill. If they are children of widows or of disabled fathers, they may legally work until nine p.m., while other children must legally quit at eight p.m., but neither closing hour is enforced or regarded in the absence of all inspection."[110] Reproducing and appropriating the same Hine image in his own book, Dawley retitles the photograph "A CHILD SPINNER," the modifier added perhaps to de-emphasize the child's role as an employee of the mill corporation. Of the photograph Dawley writes, "Such as is represented as marching in daily procession into the mills, but I find that the employment of such a child is exceptional, and then she is only employed as a 'learner,' and not because of any adequate returns to the mill corporation."[111] Not a productive worker the corporation depends upon, but rather just a "learner" (a claim that may be at least partly true[112]), the girl is cast by Dawley as atypical of child labor practices. For Dawley she is singular, "exceptional," not at all represen-

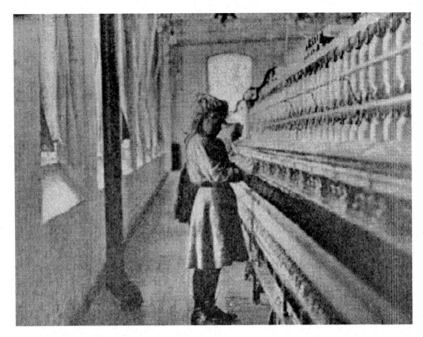

"A Child Spinner. Such as is represented as marching in daily procession into the mills." Photograph by Lewis Hine, reproduced in Dawley, *Child That Toileth Not*, 19.

tative. By appropriating the photograph of the spinner, Dawley urges readers to disrupt the visual synecdoche offered by Hine and others, who framed this young girl and others like her as representative of the whole class of spinners.

Dawley strategically appropriates another NCLC photograph published in the same pair of publications, this time to challenge an argument about what the subjects in the photograph are actually representative of. Reformers frequently argued that there was an available pool of adults who could fill the jobs occupied by child laborers if only the mills would hire them. Dawley reproduces a Hine photograph captioned in those publications as "Types of Adult Operatives."[113] Retitling the photograph "TYPES OF VILLAGE LOAFERS," Dawley writes in the caption, "Published by the National Child Labor Committee as types of Adult Operatives, but about the only thing they ever operate is boot-leg whiskey. It is not work that affects them, but keeping as far away from it as they can get."[114] If these men are representative of anything, Dawley

insinuates, it is vice and sloth. Throughout the book Dawley offers examples of the ways that adults shirk the responsibility of work, leaving the mills no choice but to hire children. Dawley appropriates the Hine image to refute the suggestion that there was a suitable adult labor pool from which the mill corporations might draw. In contrast to the training in citizenship and patriotism that Dawley argued the mill towns fostered, these adults who had not had the benefits of such an "education" were unreachable and therefore unemployable. It was thus best to begin with children, who could be "brought up" in the system and later perform well as adults.

In addition to challenging arguments about representativeness, Dawley also directly charges Hine with deception. He appropriates another Hine photograph, this one of a very small boy standing in the work space of the mill with a spool in his hand. Titling the photograph "HOW THE CAMERA LIES," Dawley writes in the caption, "Photographed by Lewis W. Hine and represented as a child worker in the mill. The child never worked and the photograph was obtained by deception."[115] In the publications from which Dawley likely drew the photograph, Hine and the NCLC did not explicitly represent the child as a worker. There, the photograph is identified as having been made at the Daniel Manufacturing Company of Lincolnton, North Carolina, and in both publications is captioned, "Six years old. Stays all day in the mill where his mother and sister work. Is beginning to 'help' a little and will probably soon be regularly at work, though his name may not appear on the payroll."[116] Contrary to Dawley's assertion, Hine and the NCLC did not claim the child worked, but rather pointed out that the child was in the mill because he accompanied family there. In their oral history of Southern mill towns, Jacquelyn Dowd Hall, James Leloudis, and their colleagues report that this was in fact a routine practice: "Adult women workers would sometimes bring their babies to the mill if there was no one else to care for them."[117] In addition to misrepresenting Hine and the NCLC's framing of the little boy, Dawley also fails to elaborate what he means when he says the photograph "was obtained by deception."[118] But simply retitling the picture "HOW THE CAMERA LIES" shifts readers' attention from the child to the camera as a tool of the photographer. By introducing the idea of deception and implying that the image cannot be trusted, Dawley's strategic appropriation encourages readers to question the practices of photography that produced the image and the evidence that the photograph purports to show.

In addition to appropriating Hine photographs, Dawley juxtaposes others' photographs with his own in order to intensify his attempts to contrast farm life with life at the mill. For example, he describes an encounter with the eldest daughter of a farm family of seven children living in poverty; Dawley is sur-

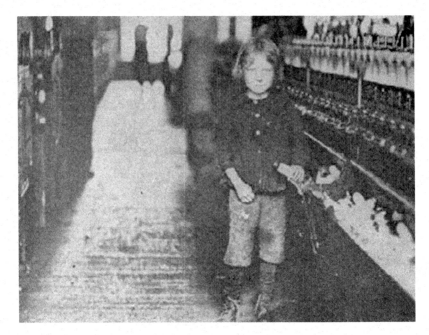

"How the Camera Lies." Photograph by Lewis Hine,
reproduced in Dawley, *Child That Toileth Not*, 113.

prised to learn that while the girl does not read very well, her younger sisters
do. When he asks her why the younger ones are better readers, she replies,
"'They learned down at the cotton-mill.'"[119] Dawley claims that because of new
laws barring young children from working, the family left the mill town after
ten months and returned to the farm. According to Dawley, when he paused
to make a photograph of the children for his report, he was informed by the
older girl that they had another family photograph from their time at the mill:

> The little girl brought forth the photograph, and there were the happy faces
> of those children, with their father and mother, and a relative, as they were,
> a united and happy family at the cotton mill.
>
> There was a story told on that bit of pasteboard. It needed no argument.
> Bright faces, good clothes, shoes and stockings, and a warm house to live
> in. These were the children at the mill to whom the law had said, 'Thou
> shalt not toil,' and as a consequence had driven them back to their miserable
> abode of hunger, ignorance, and squalor.[120]

Reproducing both photographs in the book, on consecutive pages, Dawley invites the reader to read the photograph explicitly in ways that project the family's cotton mill and mountain farm experiences into them. Claiming the photographs "needed no argument," Dawley instead invited readers to privilege narrative: to consider a story in which the family had moved from "hunger, ignorance and squalor" to "united and happy" and then descended back into squalor.

Dawley's comparison of the two photographs of the same family invites attention to health. While he claimed children were healthier at the mill, a common theme of anti–child labor discourse was "testimony from physicians on the physical effects of certain types of work."[121] In another strategic appropriation of a Hine photograph, Dawley invites his readers to attend to visual evidence of health in a picture of four hunched-over, unsmiling, forlorn girls and then juxtaposes it with one of his own.[122] It is likely that Dawley drew the Hine photograph from a 1911 NCLC publication called "A Great National Problem," which cropped off a fifth girl at the right, who was smiling, and captioned the photograph a bit differently: "You can see in these faces the serious effects of premature toil upon growing girls during this critical period of their lives. The wrinkled faces, the careworn expression, the stooped shoulders, and tired looks all tell the tale of overwork and loss of strength and vitality."[123] Highlighting the physical effects of toil visible in their faces, the caption encourages the viewer to read the photograph as evidence of the damage child labor does to the child's body at a crucial time of physical development.

Dawley retitles the photograph "HOOK-WORM SUSPECTS SUCH AS DR. STILES FOUND." He writes in the caption, "Reproduced from one of the National Child Labor Committee's publications in which such types are represented as products of the mill."[124] Dawley refers here to Dr. Charles W. Stiles, a public health researcher who had explored the effects of hookworm on the area's rural people through his work with the Rockefeller Hookworm Commission. Stiles found that many new arrivals to the mills came from the farm infected with hookworm. As a result, he argued for the continuation of child labor, because he believed the disease would be easier to treat if rural people continued to move to the mill towns.[125] As with the earlier image of the child spinner, Dawley does not challenge the fact that these girls work in the mill or that they may be ill. But by suggesting that these girls are like those studied by Stiles, he challenges the representation of them as specific "products" of the mill and suggests instead that they are recent, unhealthy arrivals from the farms.

To drive the point home even more forcefully, in his layout Dawley places the image of the girls with hookworm on a page opposite one of his own pho-

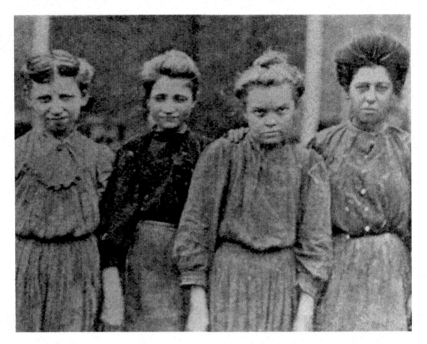

"Hook-Worm Suspects Such as Dr. Stiles Found" (photograph by Lewis Hine).
Dawley, *Child That Toileth Not*, 438.

tographs, which features a smiling, round-faced, apple-cheeked young girl
standing outdoors. She is drawing water from a faucet; her feet are barefoot,
but she is clean and smiling. The caption reads, "A TRUE PRODUCT OF THE
COTTON-MILL. She is a spinner at the Graniteville Mills. Note her robust form,
strong limbs and bright and smiling countenance. The cotton-mill has done
for her and her generation what it has done for hundreds of others from the
poor farms of the sterile sections."[126] In offering the girl at the water faucet as
a kind of celebratory "after" to the depressing, hookwormed "before" of the
previous page, Dawley uses juxtaposition to drive home the charge of decep-
tion and recontextualize the image of the hookworm-afflicted girls as illustra-
tive of the problems of the farm, not the mill.[127] Indeed, that the mill girl has
running water is not a minor visual detail in the context of a disease that results
from poor sanitation.

Ultimately, Dawley uses strategic appropriation to represent Hine's and
others' photographs as examples of the benefits of child labor rather than the

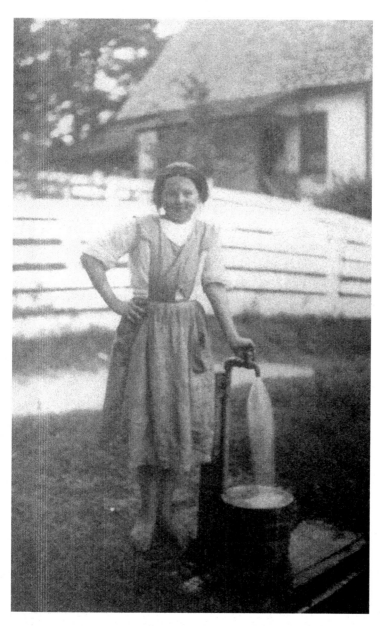

"A True Product of the Cotton-Mill. She is a spinner at the
Graniteville Mills." Dawley, *Child That Toileth Not*, 439.

ills. The family returned to the farm from the mill is depicted as clean, healthy, and well-dressed in the mill town. The mill girl at the water pump is the picture of youthful health. In these examples and throughout the book, Dawley encourages readers to scrutinize the photographs themselves for evidence of health. In this way he frames the photograph as a valuable, if contestable, form of documentary evidence. Advancing a body rhetoric that reflects the contemporary culture's valuing of child health, Dawley appropriates and rereads Hine's and others' photographs to suggest that the evidence they offer is in fact precisely the kind of healthy bodies reformers claim to want.

Child Health and the Healthy Citizen

The child labor debate was infused with the assumption that, in Olivia Howard Dunbar's terms, "the soundness of a nation's children" was of supreme importance because the health of the child constituted the health of the nation. Such discourse expressed a range of anxieties about children, citizenship, and the danger of "degeneracy." As we have seen, both those who opposed child labor and those who supported it made arguments about health. If the nation produced unhealthy children, as the argument went, then those children would grow up to be not only physically but also morally degenerate citizens. These rhetorics of national health, offered by elite reformers such as Theodore Roosevelt, Albert Beveridge, and NCLC president Felix Adler, and echoed in Dawley's refutations, all constructed children as "products" in needing of "right training" and equated physical "degeneracy" and moral "degeneracy" in order to support arguments that the telos of the American republic should be the achievement of a "pure" national "manhood" and "womanhood." For Roosevelt, Beveridge, and others child labor damaged those products; for Dawley it produced them. In both cases what was at stake was the future of white citizens of the nation.

In 1911 former president Theodore Roosevelt addressed a child labor conference in Birmingham, Alabama. The speech, titled "The Conservation of Childhood," argued that child labor was "one of the great, fundamental questions of our citizenship in this republic."[128] Ironically, Roosevelt used metaphors of the industrial age to argue that children should be protected from industry: "I want you to take pride in getting the very best machinery. . . . In the same way it is even more important to have the right kind of man behind the machine than it is to have the right machine. And you can not have the right kind of man unless you have the child trained in the right way, unless you have the child brought up amid right conditions."[129] For Roosevelt children were "products"

and child labor was a practice that damages the goods. After making a plea for the passage of specific legislation for working women and children, Roosevelt concluded by invoking another metaphor, that of "conservation," a term strongly associated in the public mind with his presidency: "Remember, that the human being is the most important of all products to turn out. . . . If you do not have the right kind of citizens in the future, you cannot make any use of the natural resources. Protect the children—protect the boys; still more, protect the girls; because the greatest duty of this generation is to see to it that the next generation is of the proper kind to continue the work of this nation."[130]

What kind of citizenship, exactly, was Roosevelt encouraging? A gendered one, certainly, as he urges "still more" protection of girls, who will be responsible for the "proper" production of the next generation. In addition, the language of "machinery," "product," and "natural resources" emphasizes the cultivation and training of future workers. But note further that Roosevelt uses "work" in another sense here, the "work of the nation." The "greatest duty" is for adults to see that children, the next generation, are "of the proper kind to continue the work of this nation." The telos of citizenship is in fact the production through "proper" means of the "right" kind of citizen.

A parallel case is made in a time exposure created by Lewis Hine, who invokes not the metaphors of industry but those of agriculture as he admonishes viewers, "We must not grind the seed corn." Children are the seeds of national citizenship; to "grind" them down is to ignore one's duty to turn out a good product. Not all children, of course, get to be seed corn; seed corn is made up of only the best seeds, those reserved for planting and producing future generations of good quality crops. Behind this rhetoric of product, whether industrial or agricultural, was intense anxiety about "degeneracy." Hine, the NCLC, and other reformers consistently emphasized the very real physical damage that child labor could do. Addressing the annual convention of the NCLC in December 1906, its president, Felix Adler, explicitly connected physical health to morality: "This premature toil . . . physically and mentally and morally . . . lowers the standard of civilization. . . . This next generation will become degenerate, and the standard of American civilization will be lowered."[131]

In his January 1907 speech before the Senate, Albert Beveridge mounted a vigorous challenge to child labor and emphasized its threat to white citizenship. In an earlier speech delivered during his Senate campaign, Beveridge stated that through child labor children's "bones are made crooked, their backs bent with the stoop of age, their minds stunted, their characters malformed."[132] Degeneracy was a moral problem that inevitably would produce what Beveridge called the "social and political poison" of criminality and anarchism. When

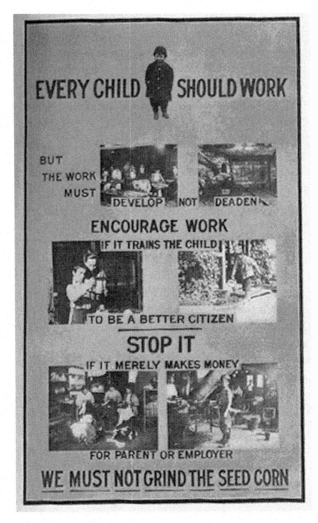

"Every Child Should Work . . . We Must Not Grind the Seed Corn." Lewis Hine, *Child Labor Bulletin*, February 1915, 41.

such children grow up "they feel that they have been robbed . . . of intellect, health, character, of life itself. And so they become, all over the land, living engines of wrath against human society itself. When the lords of gold tremble for the safety of their widespread investments, let them remember that child labor is daily creating an element in this republic more dangerous to their physical property itself than ever was packed in dynamiters' bombs."[133] Concluding

that "this making of possible anarchists and degenerates in America has got to be stopped," Beveridge explicitly tied the "degeneracy" of child laborers to that of society as a whole, using the threats of anarchism and "dynamiters' bombs" along with disease metaphors ("poison") to cultivate fear.[134]

The image of the physically and morally degenerate child contrasted with what many political elites believed should be the telos of American politics. Beveridge began his 1906 speech by invoking this telos: "The purpose of this republic is to make a better type of manhood and womanhood";[135] later he asked of American values such as liberty, "What do all these things mean, if they do not mean the making of a splendid race of clean, strong, happy, noble, exalted charactered men and women."[136] Similarly, the NCLC's Felix Adler echoed, "If we continue to sanction premature child labor we not only degrade and lower the standard of citizenship, but we prevent that future growth, that development of American civilization, that new type of manhood which we must give to the world in order to contribute to the world's riches. We prevent the evolution of that type; we cut off that dream."[137] As we saw in the previous chapter, the language of "race," "type," and "evolution" needs to be understood quite explicitly here; Beveridge and Adler are not speaking metaphorically. In a period when discourses of eugenics and racial purity dominated public conversations about national identity and morality, the rhetoric of child labor was not merely about social justice for children but also about a national morality that would degenerate if the "race" did not evolve "purely" and "cleanly."[138] T. J. Jackson Lears observes that the political and social upheaval of the period (immigration, labor disputes, anarchism) contributed to cultural anxiety about the potential "degeneracy" of the "Anglo-Saxon" race: statisticians warned that "Anglo-Saxons were being replaced by inferior immigrant stock"; immigration rhetoric was dominated by racist rhetoric of biological essentialism, and Theodore Roosevelt himself famously warned middle- and upper-class white Americans that they were committing "race suicide" if they chose to limit the size of their families.[139] Southern child labor historian Shelley Sallee argues that reformers' anxiety about "degeneracy" appeared to be about class but was also very much about race.[140] For example, in its story on Beveridge's 1907 speech the *Atlanta Georgian and News* published a related article with the headline "Negro Children, Senator Says, Are Being Strengthened."[141] While white children were heading off to work in the mills, the story stated, black children were instead going to school and getting educated. Fear that educated African Americans were "being strengthened" prompted whites to argue more vociferously for the end of child labor and to argue that the South in particular should support such efforts.

As a result, both Southern and Northern reformers invented "fictions of whiteness" to create solidarity among Southern whites and between Northerners and Southerners during a period when the "spirit of regional reconciliation" was deemed politically expedient and racial segregation was the law of the land.[142] This rhetoric separated the poor white child from identification with the white lower classes, the so-called cracker families: "Reformers removed children from categories such as *poor whites, mountain whites, low whites,* and *crackers*—terms that increasingly dubbed them inferior—and began referring to 'our pure Anglo-Saxon stock.'"[143] The image of the child played a crucial role in the construction of these fictions of whiteness. Such images indexed not merely the good or ill of child labor but the good or ill of civilization itself. As George Dimock and Stanley Mallach have observed of Lewis Hine's photographs, they enabled "middle-class viewers to look through unfamiliar and sometimes brutal activities and surroundings to see that the children of the poor were not unlike their own."[144]

Dawley occupies a fascinating place in the context of these arguments because he appropriates the same argument structure to argue the opposite conclusion. He brings poor Southern white children into the fold not by arguing they are like everyone's children, but by arguing that in fact they are different. For Dawley poor white children will never be the sacred children of the reformers' romantic imaginings, but they can become useful citizens. We see this most clearly in a final set of photographs from the book. The children of the mill, Dawley argues, are in fact the ideal future citizens that progressives wish to create. On this point Dawley is not subtle. In yet another class picture he depicts what looks to be more than one hundred children gathered outside the local school at the Pelzer mill. The large, modern-looking school building dominates the right-hand side of the frame, competing for the viewer's attention with an equally tall flagpole near the center of the image. An American flag waves in the breeze, fluttering over the large group of children and adults assembled below. Though they are not individually recognizable, the students appear well-behaved and orderly. They pose for the camera with their hands grasped firmly in front of them or held stiffly at their sides. Above all, this is an image of order, control, and tidiness, the upright stiffness of the children's bodies echoing the clean lines and rectangular linearity of the windows on the school building. Dawley's caption reads, "ONE OF THE RESULTS OF PELZER AND ITS DESPOTISM. In searching for the awful conditions of woman and child labor, we find the cotton-mill children going to school at the expense of the mill corporation. At the closing exercises for the day, they are preparing to sing our National Anthem around the flag."[145] Sarcastically refuting those who would

condemn the mill owners for their exploitation of workers, Dawley suggests that the mill cultivates in its youngest charges the positive values of patriotism. As if the image and its caption were not obvious enough, in the text he waxes eloquent about this scene: "As we stood looking at them, a group of younger ones went dancing around the pole which bore aloft that emblem of liberty which they never would have seen, perhaps, had those little doffer boys and child spinners of the previous generation been barred from the cotton-mill. As I, too, looked up at the flag, I thought what a cruel mockery of that liberty were those misrepresentations by paid agents seeking to bar children from coming down from their isolated mountain homes."[146] Dawley concludes his recounting of this patriotic scene by noting, "The childish voices burst forth singing our National anthem."[147] Life at the mill has not only saved these lucky children from the sure doom of illness and degeneracy borne of "isolated mountain homes"; it has also produced patriotic citizens. In contrast to what "paid agents" have described as the "'lint-laden atmosphere of the cotton-mill,'" Dawley finds "the living proof of the actual result, half a thousand ruddy-faced, well-dressed school-children performing their evening exercises before going home."[148] The "real" result of child labor? Healthy children spontaneously bursting forth in patriotic song.

Dawley further suggests that such patriotism, fostered in the worker-child by the benevolent corporation, will pay off for society later. Presenting a photograph of a rifle company of the South Carolina National Guard, Dawley tells the reader that this group, "made up of the very mill boys whom, the Socialistic reformers and labor committees tell us, are being stunted in growth and 'murdered,' present as fine a type of young manhood ready at their country's call as may be found anywhere, and I doubt whether many of our Northern cities present any better."[149] The photograph features maybe fifty or sixty older teenage boys, dressed in uniforms similar to those of the Rough Rider or the Boy Scout. They pose outdoors in an empty field, lined up as if for military review, each one standing with a rifle at his side. Dawley's caption says it all: these fine young men, so orderly and alert, so ready to work on behalf of their country, are "one of the results of child labor."[150]

Dawley appropriates the structural relationship between child health and the health of the nation to illustrate the ways child labor produces, not inhibits, good citizens. He writes:

Children who had toiled not, and who were growing up in idleness to become vagabonds of the future, arriving at the mills, in many instances bare-footed and in rags, were put to work spinning and doffing, learning to make money,

"One of the Results of Pelzer and Its Despotism." Dawley, *Child That Toileth Not*, 106.

and learning its value and what it would bring. They were given better houses to live in than they had ever seen; their parents were shown how to take care of them and keep them clean; they were provided with better food than they ever had before, and were provided with schools and churches. Ministers and teachers came in, whiskey and murder went out, and a great wave of industrial prosperity and education began sweeping over the entire country.[151]

Money. Housing. Hygiene. Food. Education. Religion. These are the things that produce good citizens, and these are the things Dawley argues child labor provides the children of poor white Americans.

Appropriating Visions of National Health

Perhaps predictably for such a polemical work, Dawley's book was both reviled and appreciated for offering an alternative to the dominant media narrative opposing child labor. The *New York Times* review of the book noted that its presentation of evidence tended to force its conclusions in only one direction, but granted the book some value, concluding that Dawley's arguments "are certainly worthy of close examination, and if they cannot be refuted, of frank acceptance by those interested in sociology."[152] Similarly, the *Washington Post*

praised Dawley for his "frankness" and argued that while children in general should be in school, those without access to education might be better off in the mills: "Mr. Dawley shows that the evils of idleness, drinking, and sloth in the mountains where most of the mill children were born were far worse than the employment of these same children in clean surroundings, at light work, and with facilities for education and a chance to earn money for their own support."[153] For this reviewer, at least, it seems as though Dawley's emphasis on the figure of the poor white mountain child was effective.

Not all reviews were positive. Though he did not mention Dawley's book specifically, Owen Lovejoy of the NCLC criticized the *New York Times* for giving space and attention to Dawley and other critics of child labor reform. According to Lovejoy, the issue was not whether the mill child was better off than the mountain child, but "whether the mill child is really in the way of the best possible preparation for life." Answering this question in the negative, Lovejoy challenged the rhetoric of "efficiency" and "product": "If the point is to make a perfect 'efficiency machine,' the cotton mill is a suitable school for efficiency in the mechanical dexterity of cotton-mill processes." "But our campaigns," Lovejoy insisted somewhat disingenuously, given the ongoing rhetoric of "product" proffered by Roosevelt, Beveridge, and others, "have been based on the principle that in a democracy mind and imagination must be trained, and that literacy is at least as important as dexterity."[154]

Concurring with Lovejoy but engaging Dawley's book more directly, *The Independent,* a weekly magazine published in New York, argued that "Dawley's "'facts' are not very convincing. . . . The book is largely a panegyric on the beneficence of the cotton mill as a civilizing agent. . . . The 'investigator' does not seem to have found a single fact or condition that could not be construed as ideal or at least favorable."[155] Writing in the *American Journal of Sociology,* Roy William Foley described the book as "an unjustifiable attack upon recent child labor legislation." Foley stated that the book was not worthy of attention by academics and observed that "its chief purpose seems to be to create public opinion in favor of child labor for cotton mills, and to thwart governmental action which may result in further prohibition of child labor."[156] Finally, perhaps embracing the truism that there is no such thing as bad publicity, Dawley's publisher took out an ad in the *New York Times* book review section that quoted from a hotly negative review by the *Hartford Courant.* Titled "That Amazing Book," the ad read, "Either the United States Secretary of Commerce and Labor and the conduct of his bureau should be put on examination at once, or Mr. Dawley should be prosecuted for libel and denounced as an unparalleled liar. He is, if untruthful, at least a fertile, ingenious, humorous writer of most

captivating fiction."[157] Faint praise, but perhaps sufficient for selling a contro-
versial book that Dawley's critics charged was embraced by Southern textile
interests, who invited him to speak at their annual meetings and, according to
the NCLC, hired him as a paid operative.[158]

Historians have tended to dismiss Dawley's efforts as merely "transparent"
propaganda designed to serve the interests of mill owners.[159] Certainly one
way to read *The Child That Toileth Not* is as the excessively partisan work of
a political gadfly. Yet Dawley's arguments about child labor offered not en-
tirely unreasonable challenges to the idea of child labor reform as well as to
the practice of social reform photography. Lewis Hine and the NCLC knew
that poignant images of child laborers would be interpreted by Progressive Era
audiences in the context of a visual culture that romanticized and idealized
childhood. Yet it certainly was not the case that all children "protected" from
child labor would be in any economic or social position to become those ide-
alized, precious citizens. Despite Lovejoy's assertions that literacy was valued
over dexterity, even NCLC historian Walter Trattner acknowledges that many
of the period's arguments in support of child labor were "plausible defenses"
of a system that seemed to many preferable to a difficult life of poverty on the
farm.[160] Dawley's attempt to reframe the norms of middle-class visual culture to
include the image of the child laborer offered an alternative, if problematic, view
that appropriated beliefs about childhood and "right training" to recognize
that for some children the mill might be the best they would get. Furthermore,
Dawley's challenges to Hine's photographic practices encouraged viewers of
Hine's photographs, and social documentary photography more generally, to
be critical and skeptical of what those images purported to illustrate.

I noted at the outset of this book that I am interested in exploring how
Americans constituted themselves as agents of photographic interpretation in
times of anxiety and crisis. Photographs shape citizens' experience of national
life and are routinely mobilized by citizens as resources for public argument.
As a critical consumer of the multimodal anti–child labor narrative, Dawley
found a way around the reading problems posed by that narrative: he acti-
vated photography's capacity for appropriation. In a time of industrialization
and rapid social change, Dawley sought to quell national anxieties about the
future of white citizenship by shifting the terms of the argument that equated
the health of the child to the health of the nation. Contesting the visual fictions
of the sacred child through the figure of the mountain child, Dawley rhetori-
cally situated the mill child in a middle space between these two extremes,
recognizing the value of appropriation for arguing for the value of child labor
in upholding "the soundness of a nation's children."

CHAPTER 4

Managing the Magnitude
of the Great Depression

Viewers Respond to FSA Photography

> "Photography good but hell of a
> subject for a salon."
>
> —Comment left by viewer of Farm
> Security Administration exhibit

The First International Photographic Exposition at New York City's Grand Central Palace ran from April 18 through 24, 1938.[1] According to a preview published in the *New York Times*, the exposition would feature "the work of both amateurs and professionals and more than 200 camera clubs," and would be comprised of "news pictures, pictorial views, portraits, industrial and scientific photographs, and a large collection of prints submitted by school children."[2] All told, the exposition would feature more than three thousand photographs representing all genres of photography. As the organizing committee wrote in its introduction to the catalog of exhibits and programs, "Photography today is the most catholic of the applied sciences and the livest of the arts. Lucid in its application, universal in its appeal, it is making America a picture-minded people—a people in whom the visual sense grows increasingly more dominant as an educational and emotional influence."[3]

The notion of a "picture-minded people" was a rhetorical commonplace by the mid-1930s. Changes in photographic technology made photography more accessible to the average person than ever. The rise of 35-mm photography in the 1920s, in particular, made professional cameras and film more

portable.[4] The way photographs circulated in media was also changing. As we have seen, beginning in the 1880s halftone technology made it possible to reproduce photographs in newspapers and magazines on a mass scale, helping to facilitate a lively, diverse, visual print culture. By the 1930s photographs circulated everywhere in print media. Sunday newspapers regularly featured photo-heavy rotogravure sections that tapped into readers' interest in pictures and picture stories. Most famously, *Life* magazine debuted in November 1936, but only after its founder, Henry Luce, had spent years looking for just the right coated paper on which to print high-quality photographs.[5] *Life* was soon joined by upstart, lower-brow competitors like *Coronet*, *Look*, and *Picture*, which collectively provided picture-minded Americans with plenty of images to feed their growing visual senses.[6]

Sometime between the eighteenth and twenty-fourth of April in 1938, one of those picture-minded people, Evelyn Glantz, visited the First International Photographic Exposition. Although we know little about what Glantz did there, we have evidence that she visited a small exhibit of photographs made by U.S. government photographers called "How American People Live." The exhibit featured the work of photographers of the Historical Section of the Farm Security Administration, or FSA, who for nearly three years had been chronicling the impact of the Great Depression and the New Deal on Americans.[7] The agency had received a special invitation to join the exposition. Run by Roy Stryker and employing photographers including Dorothea Lange, Walker Evans, and Arthur Rothstein, the FSA's Historical Section operated from 1935 to 1943 and during that time produced more than 250,000 photographs, including many of the most compelling and best-remembered images of the 1930s.[8]

We do not know for sure what Evelyn Glantz saw. A full record of the FSA's exhibit at Grand Central Palace does not exist. However, historians have pieced together information from available archival evidence, including seven badly overexposed photographs of the installation in the FSA's archive at the Library of Congress.[9] The exhibit likely included about seventy-five photographs, framed simply and hung in multiple sizes from 11 x 14 to 30 x 40 inches.[10] The organizers of the exposition emphasized the size and scope of the FSA's exhibit: "This all-inclusive picture exhibit will offer one of the most comprehensive studies in actual graphic illustration ever to be presented to the public."[11] Echoing the press release's emphasis on the show's comprehensiveness, a *Washington Post* article previewing the show called the FSA's exhibit "a complete documentary exhibit of agricultural and industrial activity in America."[12] This makes it seem as though the exhibition would feature

dry photographs of farm equipment and factories, yet that is not what was shown. In a letter to a friend a few days before the exposition was to open, FSA Historical Section chief Roy Stryker wrote, with only a bit more specificity, "Our theme is 'people'—people in various circumstances throughout the United States."[13] The evidence we do have makes clear that the tone of the photographs differed markedly from the slick, often commercial work shown throughout the rest of the exposition. Writing of the contents of the exhibit, John Raeburn observes that it "emphasized an America in the throes of the depression, with some of the Section's most biting images of it."[14] FSA photographer and muralist Ben Shahn reportedly said of the photos, in a paraphrase by Stryker, "It gave no one even a chance to catch their breath as they walked around."[15] Of these "biting" photographs that left viewers breathless, many of them are recognized today as some of the agency's most famous images, including Dorothea Lange's "Migrant Mother," Arthur Rothstein's "sharecropper's wife" and Oklahoma dust storm, Ben Shahn's West Virginia sheriff, and Walker Evans's Alabama sharecropper family. In the context of a lively, commercial spectacular, the FSA's photographs of poor, rural Americans in the South and West posed a reading problem for exhibit visitors: how should one respond to these photographs of fellow Americans, made more or less in real time, pictures that depicted the gravity of stark poverty and depression yet were displayed in a context emphasizing leisure, consumption, and fun?

The FSA produced the exhibit during a time of widespread budget cuts in Washington; it was organized on a shoestring and mounted by two FSA photographers, Arthur Rothstein and Russell Lee.[16] Drawing on practices he might have observed at other photographic salons, Rothstein put a box near the exit to the exhibit; it contained blank three-by-five cards on which visitors could write comments about what they had just seen. By the time the exposition closed just one week later, 540 comments had been left in that box, including one from Evelyn Glantz.[17] On that three-by-five card she wrote:

These are superb photographs for three reasons:

1. They are good pictures from the photographic viewpoint.
2. They give an accurate picture of conditions in various regions of the U.S.
3. They "demand" Congressional rehabilitation of certain areas in our country, namely:

 a. Sharecroppers [sic] regions
 b. Western drought areas

Installation image from FSA's exhibit at First International Photographic Exposition.
Arthur Rothstein, New York City, 1938. Library of Congress.

She then signed her name and left her address: "Evelyn Glantz, 2086 East Fourth St., Brooklyn."[18]

Writing to his assistant Edwin Locke just a few days after the close of the exposition, Roy Stryker wrote, "Arthur had the bright idea of getting a suggestion box put up in the booth. You will be amazed by the . . . cards that have been put into that box. They were good enough that [Rexford] Tugwell [former head of the Resettlement Administration and a member of Roosevelt's "Brains Trust"] suggested that they ought to go to the President."[19] In an oral history interview thirty years later, Stryker observed that, even with access to comments like those left at the First International Exposition, it was difficult to gauge in any concrete way the impact of the photographers' work: "We had no polls, we had no measures—unlike an advertising agency today, which is forever taking its pulse by having somebody make a test of how many people saw this, what they think." Of the FSA photographs' impact, he continued,

"I don't think we have any concrete hard facts that we were accepted by 10%, 30%, 40%—I think we have no answer. We seem to have been accepted, we did survive, we did get talked about."[20]

While we should take Stryker's own advice and not attempt to generalize from the experiences of some viewers to the experiences of all viewers of FSA photographs, or even all viewers of the FSA's exhibit at the exposition, the comments are an especially rich set of texts. Surprisingly, scholars of FSA photography have had little to say about them. While many (including me) mention the comments, and occasionally quote from them, no one yet has treated them as significant rhetorical texts in their own right.[21] However, there are several reasons to do so. First, the comments constitute some of the most complete discursive evidence of viewers' encounters with the FSA photographs. While by 1938 FSA photographs and photographers had received regular attention in the pages of newspapers and magazines, in museums, and from art critics, there is less evidence of how average Americans engaged or understood the photographs.[22] In addition, especially when compared to the kinds of viewer response I take up in the rest of this book, the corpus is unique in both its size and scope. The comment cards offer hundreds of brief, fragmented, yet rhetorically rich responses to what we now recognize as one of the most important bodies of photographic work of the era.

For these reasons alone the FSA comments are worth sustained critical attention. But they also offer insight into how viewers responded to the immediate reading problem posed by the photographs: how to make sense of images of want at a time of economic, political, and social crisis in the United States. In early 1938 Americans had lived through nearly a decade of depression (in the rural areas, nearly two) and newly reeled from a series of economic setbacks that came to be called the "Roosevelt Recession." As a result, they experienced a return of fear, perhaps more urgently than in the recent past. Not only had economic conditions stopped improving, but in fact they were getting worse, especially for those who were already the worst off. The comments left at the FSA exhibit offer evidence of how viewers of the photographs negotiated their understanding and experiences of recent economic and political developments in a time of fresh crisis.

Consider Glantz's own remarks left at the exit of the exhibit. First she offers a broad value claim about the exhibit overall: the photographs are "superb." Then, in a direct and quite linear fashion, she goes on to explain why they are superb by offering "three reasons." The reasons themselves constitute clearly stated claims of value, fact, and policy. She first comments on the photographs' aesthetic qualities: they are good "from the photographic viewpoint" (claim of

value). Next she states that the photographs accurately portray the conditions they depict in different parts of the United States (claim of fact). She concludes by arguing that a particular audience—Congress—needs to "rehabilitate" those in the "Western drought areas" and the "Sharecroppers [*sic*] regions" (claim of policy). Note further that in her policy claim about the need for congressional rehabilitation, Glantz states that the photographs themselves "demand" it (her word, in quotation marks). In just a few words, likely scrawled in pencil on an index card, Evelyn Glantz responds to the reading problems posed by the FSA photographs by advancing something like a theory of socially minded photography: according to her assessment, such photography is "superb" when it combines aesthetic appeal with "accurate" depiction of social conditions to create a "demand" for political action on behalf of those depicted. At a time when even the most engaged photographers were still defining for themselves the parameters of documentary photography, average viewers like Glantz seemed to understand photography's tenuous position at the intersection of aesthetics, documentation, and politics.

Yet Evelyn Glantz is only one viewer. There are hundreds of comments— many like hers, many others quite different—and it is impossible to offer close readings of each one here. Thus I approach this case by asking a broader question: how did the exhibit's large number of diverse viewers collectively navigate the reading problems posed by the FSA's contemporary documentary photographs of poor rural Americans? My analysis of this large corpus reveals that those who left comments collectively responded to the photographs' documentary demands by managing the photographs' *magnitude*. Thomas Farrell writes, "Magnitude has to do with the gravity, the enormity, the weightiness of what is enacted, a sense of significance that may be glimpsed and recognized by others."[23] In short, "magnitude says . . . 'Hey, look at this! This is important!'"[24] William Stott notes that documentary "gives information to the intellect" and "informs the emotions."[25] By virtue of its ability to confer visibility, significance, and weight, documentary photography constitutes a visual medium par excellence for enacting magnitude: *Look at this. This is important.* Yet in this case magnitude resides in more than the documentary demands of the photographs themselves. One encounters magnitude on all sides: in the contrast between the FSA's stark images of poverty and the vast commercial spectacle of the exposition; in the weighty ambitions of the FSA's multiyear visual chronicle of American life; in the vast scope and reach of mass media during the thirties; and in the gravity of the Great Depression itself. There is magnitude, too, in the size of the audiences for the exposition and in the hundreds of comments

left at the FSA's exhibit—comments whose own magnitude make my critical task in this chapter enormous as well.

Indeed, in shouting "look at this!" magnitude can become, well, too much for us. As Farrell puts it, "Something large can intimidate and overwhelm us to the point where we become lost, frustrated, perhaps diffident from desperation. Nothing may matter because everything matters too much."[26] In order to appreciate the magnitude of something without becoming lost or nihilistic, one needs to be able to put it in proper perspective, to *manage* magnitude. Farrell argues that this is precisely what Franklin Roosevelt did in his first inaugural address. While the speech "did nothing to solve the problem of the Depression," it did "reframe and represent the depression in a way that allowed demoralized citizenry to believe that it might be acted upon." Farrell contends that Roosevelt accomplished this task by rhetorically managing magnitude. That is, he presented the Depression as something grave and serious but of a proportion that could "be 'taken in'" by audiences. The Depression was still "a crisis, but never one so large as to be beyond the largesse of spirit in the American people."[27] I argue that the comments left by viewers at the exposition operate in much the same way. Viewers negotiated the magnitude of the crisis depicted in the photographs by treating them as "something important enough to be recognized, beheld, and reflected upon" by active agents of a national public.[28] As we shall see, viewers managed magnitude in four ways: by identifying with the photographs as "real," educational documents of social fact; by using a popular language of poverty grounded in dissociation, irony, and shame; by demanding public policy action; and by advocating for greater publicity and circulation of the photographs. Each of these ways of managing magnitude helped commenters make sense of the troubling images. They gave proportion to and inserted agency in a potentially overwhelming situation by imagining themselves as part of the stories the FSA photographs told.

1930s Photography and "Picture-Minded People"

Of the medium in the 1930s, Paul Hendrickson writes, "Photography wasn't a new American language in the middle of the Depression; it only felt like it."[29] Indeed, in 1938 photography was nearly one hundred years old, and few Americans could remember or even imagine a time when photographs did not loom large in public life. Less than forty years after the introduction of the Kodak Brownie, which had put photography into the hands of the masses, more than half of families in the United States kept a camera at home; they "made some

six hundred million pictures yearly, spending $100 million doing so."[30] By one estimate Americans owned one hundred thousand of the newer technology 35-mm cameras by the late 1930s.[31] Thus by the mid-1930s, for the first time in its history, photography was becoming a truly national mass medium: wide in its reach, easily accessible, readily consumable.

How precisely had Americans become that "picture-minded people" invoked by the exposition's organizers? Scholars of thirties photography have offered a number of overlapping explanations. One familiar narrative chronicles technological changes that made photography available to more people in more contexts. Changes in photographic reproduction, such as the introduction of halftone in the late nineteenth century (discussed in chapter 2), made reproduction of photographs more widely and cheaply available in books, newspapers, and magazines and led to the rise of the newspaper rotogravure sections and, later, picture magazines like *Life* and *Look*. In addition, changes in photographic production, such as the rise of the "miniature," or 35-mm, camera, introduced portability into high-quality photography and made it possible "to photograph people in candid poses, when they were clearly unaware of the presence of the camera."[32] Thus the camera could be taken into more settings and photographs could be published in more places.

But technological developments alone cannot explain the picture-mindedness of Americans during the thirties. In his outstanding, comprehensive history of thirties photography, John Raeburn posits his own set of worthwhile reasons: "Photography as an artistic and cultural enterprise reached this zenith in the thirties because of four complementary, mutually reinforcing developments. New venues for displaying pictures and pedagogical efforts to educate viewers about them collaborated to create a vast and informed audience whose voracious appetite for images stimulated gifted photographers—new and experienced—to create for it."[33] For Raeburn this combination of vibrant spaces, visual pedagogies, voracious and knowledgeable viewers, and the virtuosity of photographers constituted a "rebirth" of sorts for the medium as it approached its one hundredth birthday. But I contend there were two additional, related forces as well.

One is a set of explanations that Raeburn takes up but ultimately dismisses as too speculative: the affective elements of Americans' picture-mindedness. As Robert Hariman and John Lucaites remind us, photojournalistic or documentary photographs put "the viewer in an affective relationship with the people in the picture," which "activates available structures of feeling within the audience."[34] Raeburn locates a similar perspective in the work of Pete Daniel, Sally Stein, and Paul Hendrickson, who posit that the variety of private and public

emotions produced by the Depression itself may help to explain Americans' newfound "picture hunger" in the thirties.[35] According to this narrative, photographs' "capacity to evoke sensuous pleasure became especially compelling when people felt deprived of material goods."[36] The Depression also led Americans to become more curious about "themselves and their culture, which photographs could satisfy with exceptional vividness." And it may be that photographs' seeming realism made them "seem reliable when words no longer did."[37] Thus, the argument might go, photography's capacity to evoke pleasure in the midst of want, to vividly bring before the eyes previously hidden aspects of American life and culture, and to offer a seemingly certain realism in a time of great uncertainty, compelled Americans to attend to photography as never before. Yet Raeburn contends that these sorts of explanations, though they "are suggestive and likely true," can "never be more than speculation because they depend on the mostly undocumented feelings of viewers."[38] As we shall see in this chapter, however, some of the feelings of viewers are in fact documented in the comments left at the FSA exhibit, suggesting that arguments about the affective components of "picture-mindedness" may be well-founded. While the comments offer an understanding of viewers of photography in the thirties that is surely limited in scope, they nevertheless provide insight into the various ways that some viewers of some Depression-era photography affectively engaged it. Attention to viewer comments enables us to pick up the explanations dropped by Raeburn and explore the ways that seemingly less tangible emotions participated collectively in viewers' experiences of Depression-era photography.

A final explanation for Americans' picture-mindedness, one not engaged in much depth by scholars of the era's photography, is the rise of rhetorical-political vision during the era. As I have pointed out elsewhere, the rhetoric of President Franklin Roosevelt is saturated with visual language.[39] Indeed, Roosevelt speaks with what Ned O'Gorman has called "civic sight," a rhetoric grounded in a rhetorical vision that links seeing and knowing.[40] For example, Roosevelt's first inaugural address emphasizes the twin terms of "facing" and "recognizing," "exhorting Americans to confront their anxieties about the Depression head-on."[41] His second inaugural address, with its triadic declaration "I see one-third of a nation ill-housed, ill-clad, ill-nourished," repeatedly invokes notions of "seeing" and "painting" to offer its vision of the American political future.[42] Similarly, although they are typically studied as examples of political exploitation of the powerful medium of radio, Roosevelt's fireside chats are loaded with visual language as Roosevelt asks his listeners to imagine, to use their minds' eyes to follow his reasoning.[43] Of such language use Mary

Stuckey argues that Roosevelt's "ocular metaphors" helped to "underwrite radical shifts in political power by helping FDR persuade the mass public to accept a synoptic view of nationalism and governmental responsibility."[44]

By the late 1930s photography had taken on such a magnitude in the culture that it had created its own ideal audience of "picture-minded people." Through new technologies, venues for production and circulation, avenues for identification, and invitations to perform rhetorical-political vision, Americans like those attending the exposition learned to respond affectively and politically to the documentary demands of the camera in a mass-media age.

Picturing Photography at the First International Exposition

Acknowledging this new "picture-mindedness," exposition organizers (who included Willard Morgan of *Life* magazine and Roy Stryker of the FSA) presented photography broadly as an art, a science, and a business. On the "art" side the exposition featured awards for amateurs, professionals, and members of camera clubs; highlighted commercial, portrait, and color photography; honored historical examples of photographic art; and exhibited contemporary, well-known photographers such as Berenice Abbott, Edward Weston, Alfred Eisenstaedt, and Margaret Bourke-White. The art of photography commingled with its science. In addition to exhibiting aerial photography, microscopy, and the work of the Biological Photographic Association, the exposition offered a daily program of events. For example, visitors could attend lectures on the uses of "motion pictures in surgery" and access the latest technical information on flash photography, color photography, and the "optical principles of photo micrography."[45] All kinds of companies showcased their wares. NBC, General Electric, Bell and Howell (makers of motion picture equipment), Carl Zeiss, Inc. (maker of optical instruments, including microscopes), and other wholesalers and retail dealers of equipment offered exposition visitors the chance to see and try out the newest technological advances in photography and film. To help sell all of this there was also more than a little spectacle. Each evening the day's events ended with what was billed as a "Stage Show and Picture-Taking Free-for-All." The stage show was designed to give amateur photographers the chance to make "perfect" photographs on a professionally lit stage, a literally fool-proof opportunity to try to make the best photo that one could. The subject of the photos was female models in bathing suits.[46]

In this context the reading problem facing viewers at the FSA exhibit is clear: dozens of government photographs of poverty-stricken Americans in the rural United States likely seemed incompatible with and perhaps over-

whelmed by nearly everything else in the exposition. Indeed, FSA photographer Walker Evans complained to Stryker, "I must say the whole thing is so commercial it made me sick. I was not in much of a mood when I came to your show."[47] Yet while the FSA's show was different from much of what was shown at the exposition, a few other exhibits offered visitors related experiences in which they could encounter both historical and contemporary documentary or photojournalistic displays. Two exhibit spaces were explicitly devoted to what organizers termed "Publications."[48] Here visitors found work by photographers working for the Associated Press and the new picture magazines (such as *Life*, *Look*, and *Coronet*); the exhibit included the work of the era's top photojournalists, including Margaret Bourke-White, Peter Stackpole, Carl Mydans, Horace Bristol, and Alfred Eisenstaedt. By making visible the work of photographers who were publishing in the new camera magazines and visual periodicals, exposition organizers openly recognized the powerful role played by these publications in circulating contemporary photography. John Raeburn writes, "Among the distinctive features of thirties photography was the intermingling of the usually discrete realms of an art world and popular journalism to a degree unknown before or since."[49] Despite Evans's griping about commercialism, viewers probably were not surprised to encounter so many forms of photography commingling in one place.

Despite such a seemingly ecumenical orientation toward photography, the FSA's inclusion in the show came with a bit of controversy in the form of a complaint from the Oval Table Society, a group of photographers who embraced the largely outdated pictorial mode of photography.[50] Willard Morgan, who oversaw the exposition, recalled the event in a 1964 letter to Roy Stryker:

> The pictorial and Oval Table Society bunch were down on me and wanted to remove the FSA photos as not being worthy of the Show. . . . Yes, Mr. Bing, the father of the Oval Table Society threatened to pull out of the exhibition because I hung the FSA photos in the next gallery to his pictorial, mostly soft-focus pictures. He could see one of our big enlargements over the partition . . . so I smoothed out his feathers by lowering your photo so he couldn't see it from his booth. Even then he kept grumbling about the FSA photos not being worthy of showing.[51]

For at least some participating in the exposition, the FSA's subject matter and straight aesthetic seemed to clash with other approaches to photography as a fine or commercial art.

The exposition provided visitors with educational opportunities in the form of lectures and presentations. In addition to those already mentioned above, visitors on Saturday, April 23, could take advantage of an "illustrated" lecture

by Roy Stryker on "Documentary Photography," presumably sharing some of the FSA Historical Section's own images. Of the lecture Stryker wrote to James McCamy, a professor acquaintance at Bennington College, "I am going to talk at this photographic show in New York and propose to pay my respects to adults who persist playing around with cameras." Stryker continued, "I will probably make some people sore."[52] Why Stryker thought he might make people "sore" is unclear, although his reference to "adults who persist playing around with cameras" suggests he recognized the show's overwhelmingly commercial purposes and interest in appealing to amateurs. Perhaps he believed the section's work and his presentation would depart significantly from those norms. It is also possible that as a member of the exposition's organizing committee he had gotten wind of the Oval Table Society's disdain for the agency's featured spot in the exposition and expected resistance to his lecture on that front as well.

Despite its relatively steep admission charge of forty cents, the International Photographic Exposition proved instantly popular. The *New York Times* reported that such large crowds had gathered outside on the sidewalk on the first day—well before the planned opening time of 2:00 PM—that police demanded the exposition be opened early to clear the streets.[53] By 5:30 PM on its first day, 7,000 people had already entered. Overall, 110,000 visitors attended the exposition.[54] "Special trains" brought visitors from Pittsburgh, Washington, and Boston.[55]

The day after the exposition closed, Roy Stryker wrote to his assistant Edwin Locke, "Our part of the show went across in the big way. Arthur and Russell did a great job of hanging that set of pictures. It is not exaggerating a bit to [say] that we scooped the show."[56] To FSA photographer Dorothea Lange, Stryker wrote, "It was a corking exhibit."[57] Published reviews indicated that indeed one of most popular exhibits of the whole exposition was the one mounted by the FSA's Historical Section. Art critic Elizabeth McCausland wrote in a lengthy review that the FSA's photos "stood out as vivid and inescapable statements . . . a damning indictment." The photographs, McCausland elaborated, "are part of the inheritance of Americans, they are the reservoir of human beings and human experience which make our nation."[58] Rosa Reilly similarly emphasized the photographs' "American" qualities in her review in *Popular Photography*: "You will never beat these pictures anywhere. . . . They show American buildings. American homes. American life. American people. . . . American history rolled before your eyes."[59] Berenice Abbott, whose own work was also exhibited at the exposition, took a swipe at the pictorialists' critiques of the FSA in a comment she left at the exhibit: "Throw out all the

oval tables and have a million more photographs like these. Here photography is finding its real medium and expression. More and more power to the Farm Security Administration!"[60]

The FSA's exhibit also caught the eye of one of photography's giants, Edward Steichen. Stryker wrote to Locke, "Even Steichen went to the show in a perfunctory manner and got a surprise when he ran into our section."[61] That surprise turned into additional exposure for the project. On Steichen's recommendation the photography annual *U.S. Camera* devoted a special section to forty-one images from the FSA's exhibit in its 1939 volume. Edited by Steichen himself, the section opened with an encomium by Steichen to the Historical Section's work and paired specific photographs with captions drawn directly from the comments.[62] Writing in that issue of the FSA's exhibit at the exposition, Frank Crowninshield declared that the FSA's photographs were "the most interesting of all the modern galleries."[63] Nearly thirty years later, in an oral history interview, Stryker recalled that "Henry Wallace [then secretary of agriculture] took a copy of these comments with him and read part of them to a dinner."[64] And he boasted of the exhibit, "It made a great hit."[65] Despite the exhibit's humble footprint as part of the vast exposition as a whole, the intensity of responses lent the exhibit a magnitude it might not otherwise have had.

Look at This: Reconstructing the
FSA Exhibit at Grand Central Palace

Before turning to analysis of the comments, it is necessary to discuss the content and arrangement of the exhibit itself. Despite claims made in the exposition press release that the FSA's exhibit would be an "all-inclusive picture exhibit," the images that Raeburn terms "biting" and that McCausland termed an "indictment" belong to a narrative that elsewhere I have called the "tenancy story." As it developed in the work of the Historical Section photographers, the tenancy story came to involve "the two interrelated problems of farm tenancy and migrant labor."[66] Early FSA photography chronicled the lives of sharecroppers and farm tenants (mostly in the South) and documented the many Americans who left the American rural middle for the West and a tenuous life of migrant labor. Stryker repeatedly instructed photographers to "make pictures that related people to the land," which became a key theme of the tenancy story.[67] The emphasis on the relationship of people to land served the agency's project both affectively and pragmatically. Stryker contended that viewers of the photographs would better identify with migrant labor and farm tenancy issues emotionally if "the human factors" were clearly pictured.[68] The choice

to relate people to the land was pragmatic as well, for over time it would connect the agency's images to government efforts to resettle Americans to better land and reform land use.

Although we do not know for certain the final contents or arrangement of the entire exhibit, two key pieces of evidence exist. In the Roy Stryker papers one may find a list of eighty-one photographs compiled from "work sheets used by Russell Lee and Arthur Rothstein" to install the exhibit.[69] In addition, the FSA's photographic file contains seven installation photographs made by Rothstein. Taken together these materials provide sufficient detail to enable a discussion of the photographic themes that the exhibit's viewers would have encountered. However, these materials conceal as well as reveal. For example, Lee and Stryker's list of eighty-one photographs includes five listed as "no record," "killed," "same as" another photo in the list, or "not included."[70] These redactions would appear to leave seventy-six images in the exhibit. However, as John Raeburn points out, "the list, apparently put together at some later date from Lee's and Rothstein's work sheets," cannot be read as an accurate representation of what was shown. Because it does not use captions that are consistent with those in the file, it can be difficult to match photographs in the installation images with those on the list. In addition, in at least one case a photograph that was prominently visible in the installation photographs, Rothstein's famous dust storm photograph made in Oklahoma, does not appear on the list at all.[71] The installation photographs also vex; only sixty-one photographs are visible, even though the exhibit list indicates the display of many more.[72] Despite these gaps, however, a study of the content and arrangement of the exhibit—informed by the extant installation photographs—offers much to engage. In addition to discussing repeated topics, themes, and subjects, I have also combined three of the extant installation images in order to visually reconstruct one wall of the exhibit. This reconstruction enables me to analyze at least a few of the ways that Rothstein and Lee arranged photographs to punctuate particular themes and draw viewers' attention to individual images.

However vague it sounded, Roy Stryker was correct to tell James McCamy that the exhibit's theme was "people." The vast majority of the images visible in the installation photographs do feature people, most often situated in an environment that provides the viewer with some visual information about their living conditions. The photographs' subjects sit on the porches of worn houses, within the rugged interiors of their living spaces, and pose near or atop the vehicles taking them to their next job or place of residence. Most of the people depicted appear poor, if one may infer poverty from their surround-

ings, clothes, or apparent level of cleanliness. They gather together in small or large groups, in what look to be multigenerational families. Although the content of some of the photographs is difficult to discern in the badly over-exposed installation images, approximately one-third of them feature people pictured in isolation. Although these include photographs of both older and younger people, and variously depict men, women, and children, fully half of those pictured in isolation are adult men. Some of the most visually prominent photographs on the reconstructed installation wall I discuss below picture a mother with children, though only eight of the photographs visible in the installation photographs appear to feature an individual woman with a child or children. Finally, nearly all of the people pictured appear to be white; only three photographs obviously feature African Americans.[73] Stryker's "people," then, while largely white, rural, and poor, are a mix of old and young, male and female, and they are represented as both parts of larger group or family units and also as isolated individuals.

The photographs perform the agency's interest in visually relating people to the land. All of the photographs locate their subjects in rural geographic spaces of the South and West (their specific locations likely were designated on the captions mounted below each photo, though it is difficult to read them in the low-resolution images). The photographs feature people on farms, at dusty roadsides, near agricultural fields, and in rundown homes. Of the locations visible in the installation photographs, we see no photographs of people in cities or even on the streets of busy small towns. Indeed, the exhibit's "people" seem to exist apart from institutions of government, business, or education. They do not appear to participate in a community larger than that of the small group or family. (I discuss one compelling exception below.)

The photographs activate an ambivalent relationship between the subjects of the photographs and the spaces in which those subjects were photographed. On the one hand, the photographs are anchored by a sense of stasis: those pictured are most often at rest, immobile, seemingly idle. They stand in door-ways, sit still on porches, perch on the ground, or gather together in groups. Indeed, fewer than a handful of the extant photographs appear to picture anyone engaged in what looks like active work. Yet at the same time, hints of mobility punctuate many of the photographs. The presence of cars, trucks, tents, and roadsides in the photographs suggest a people on the move, or at least thinking about it.

Given my interest in the ways that viewers responded to the FSA exhibit in their comments, it is important not just to consider who or what is repre-sented, but also how the photographs construct their subjects' relationships

to the viewer: the exchanges of the gaze, the ways that subjects and viewers are positioned to interact. The photographs are a mix of what Gunther Kress and Theo van Leeuwen term "offer" and "demand" images.[74] In offer images, subjects do not gaze directly at the viewer, but rather elsewhere in the picture, in effect offering themselves and their surroundings to the viewer for her visual consumption. In a demand image, the photograph's subject meets the viewer's gaze, eye-to-eye. As a result of the combination of offer and demand images, the photographs invite viewer investigation and perhaps scrutiny of those pictured. In the offer images the viewer's eye is free to move around the image, to absorb its representations. At the same time, demand images interrupt that viewing experience to confront the viewer of the photograph directly. This dialectic of offer/demand creates a viewing experience in which the viewer both consumes the exhibit's people while at the same time being directly engaged with them. This mix of consumption and confrontation may at least partly account for Ben Shahn's supposed reaction to the images chosen for the exhibit, as recollected by Roy Stryker. Stryker claimed that Shahn said, "It gave no one even a chance to catch their breath as they walked around."[75]

I have been able to reconstruct what looks to be one complete wall of the exhibit by electronically stitching three of the installation images together.[76] The wall features twenty-six photographs. Not every individual photograph's content on the exhibit wall is visible; Rothstein likely took these overexposed flash images simply to document the fact of the exhibit for government higher-ups, not to depict the photographs themselves with sharpness or clarity. Even so, it is clear that exhibit designers Arthur Rothstein and Russell Lee arranged the images to punctuate the themes outlined above. The contents of this wall are not different from the rest of the images in the other installation photographs: men, women, and children isolated, in pairs, or in small groups; photographed in the contexts of their living environment, on the road, or in the fields; a mix of offer and demand images. The exhibit designers punctuate these themes by playing with the scale of some of the photographs and by arranging the photographs in ways that orchestrate the gazes of their subjects.

Photographic scale helps to direct the viewer's gaze. Rothstein and Lee located Dorothea Lange's famous "Migrant Mother" photograph dead center, printed it large (perhaps 30 x 40 inches), and positioned it directly underneath a sign announcing the exhibit as a "Collection of Pictures Loaned by the Farm Security Administration." Such a choice is not surprising. Even in early 1938 Lange's photograph was one of the agency's most recognized pictures, an image that successfully walked the line between social and aesthetic significance. Made by Lange in Nipomo, California, in February 1936, the photographs of

Florence Thompson and her children were first reproduced in the *San Francisco News*; later that year the iconic photograph that would come to be called "Migrant Mother" appeared in magazines such as *Survey Graphic, Midweek Pictorial*, and *U.S. Camera 1936*, the latter an annual publication honoring the best photographs of the year.[77] If any photograph of the Historical Section were its calling card, it would be this one. (The other, Arthur Rothstein's dust storm in Cimarron County, Oklahoma, was also printed large and put in a prominent place in another part of the exhibit.) Only two other photographs on the wall have the physical magnitude of Lange's "Migrant Mother": at the far left of the exhibit wall, an image by Arthur Rothstein featuring a profile of a pregnant woman and a child standing in a doorway (which had also been featured as one of the best of the year in *U.S. Camera 1936*); and just to the right of Lange's "Migrant Mother," one of Walker Evans's photographs of Alabama sharecropper Bud Fields, patriarch of one of the three families later featured by Evans and James Agee in *Let Us Now Praise Famous Men*.[78] These three large images—offer images, all—punctuate the wall and echo themes developed in the rest of the extant photographs: mothers with children, anxious faces, subjects' gazes focused on something beyond the viewer's reach, just past the edge of the frame.

Indeed, in their arrangement of the photographs Rothstein and Lee seem to have been playing with the organization of gazes. They position photographs so that the gazes of the subjects do not look inward, toward the other photographs on the wall, but outward, beyond the images on this single wall, beyond the edge of the wall entirely. Note the large Arthur Rothstein photograph of the pregnant mother at the far left; shot in profile, her gaze (a focused, penetrating one) leads the viewer's eye away from the wall, toward perhaps other images in the exhibit, or out back into the world beyond the exhibit. Similarly, the paired figures of Bud Fields and his smaller twin, a tightly cropped photograph of a Kentucky coal miner by Ben Shahn (second from the top right in both installation figures in this chapter), both shot in profile and looking rightward, invite the viewer to move to the right and away from the center of the image.[79] Rothstein and Lee's direction of these gazes suggests that the images on the wall should not be understood as a self-contained story or a world unto themselves. Rather, the arrangement invites attention to what is beyond the frame, beyond the wall, beyond perhaps the entire exposition. Consider for a moment how this wall might have been different. What if Rothstein's pregnant woman at the left had been placed at the far right instead, swapped with Evans's Bud Fields and Shahn's Kentucky coal miner? Even if all of the other images had been left the same, such an arrangement would direct the subjects' gazes toward the middle of the

Photomerge of installation images from FSA's exhibit at First International
Photographic Exposition. Photos by Arthur Rothstein, New York City, 1938.
Library of Congress. Photomerge by Cara Finnegan.

exhibit wall (and, indeed, highlighted the already famous "Migrant Mother"
even further, seemingly turning all gazes toward her). This alternative arrange-
ment would hint to the viewer that the story on that wall was a self-contained
one rather than one that invites us to consider what lies beyond the edges of
the wall. Not only does the overall content of the exhibit invite viewer attention
to the magnitude of a troubled world far removed from the exposition; the ar-
rangement of photographs on this particular wall does the same.

A final image bears discussion not only because it appears to be an outlier
but also because of its placement as a visual anchor on the right side of the
exhibit wall. Cropped closely to emphasize the girth of its subject, Shahn's

portrait of a Morgantown, West Virginia, deputy fills its photographic space, leaving the viewer with little information for contextualizing the presence of this man with the gun on his hip.[80] The photograph seems to function visually as either a joke or a threat: is Shahn being irreverent by highlighting this man's ample hindquarters, or is this really a photograph of his gun, and therefore a warning of some sort? The photograph itself is ambivalent. As it is situated on the wall with the other exhibit photographs, the photograph seems to invite the latter interpretation. Indeed, the twin men gazing to the right (especially the Kentucky coal miner positioned directly to the deputy's left) are positioned to regard the deputy with wariness. Yet that wariness may not be due so much to the threat of the gun (it is holstered, after all, and the deputy is in a posture of relaxation) as it is to the man's embodiment of a kind of faceless institutional authority. Indeed, this photograph of the deputy

is unique among the installation photographs' depictions of the exhibit. No other images obviously depict representatives of institutions. The exhibit's people therefore appear to be a people left largely on their own, with no recourse to institutions for help. The placement of the deputy as the object of some photographic subjects' gaze, combined with those subjects' obvious wariness, invites the viewer to see institutions as largely absent, disinterested, or, at worse, actively hostile (the gun) to the magnitude of the plight of the people in the pictures.

The FSA's exhibit at Grand Central Palace treated visitors not to a neutral or diverse depiction of "How American People Live," but to something perhaps more aptly termed "How Some of the Poorest Rural White Americans Live." The exhibit's people offered themselves for public consumption and demanded attention not as objects of pity, but as subjects in dire circumstances with few institutional resources to draw upon. The photographs powerfully depicted conditions in Roosevelt's America nearly in real time, transcending the limits of geography to make the absent rural poor loom large in midtown Manhattan. When Arthur Rothstein placed a box at the exit to the FSA's exhibit and invited visitors to leave comments in it, he invited them to respond to a picture of America that few had seen or, as some of the comments illustrate, wanted to see. While the comments should by no means be read as a unified statement on FSA photography, it is valuable to examine them as a group in order to discern how some viewers negotiated the reading problems posed by these striking images. Encountering the enormity and weightiness of the conditions the photographs depicted, viewers exercised agency by articulating hundreds of responses that collectively sought to manage the photographs' magnitude and put what they depicted into perspective.

The sheer number of comments presented me with a methodological challenge that was different from those I faced in the other case studies discussed in this book. Here, my goals were twofold: first, to get a handle on the themes of the corpus overall through a preliminary descriptive analysis, and, second, to build upon that foundation with a series of historically contextualized readings of the key intersecting themes identified in the initial description. The process thus began with a textual analysis of the corpus using an open coding approach.[81] I then explored the comments' themes and the complex interactions among them, building a critical interpretation that analyzes how commenters managed the magnitude of the FSA photographs in a time of national stress.

Claims made years later by Roy Stryker and others that viewers responded very favorably to the exhibit bear out in analysis of the comments. Commenters declared the FSA's photographs "admirable," "vital," "good," "remarkable,"

and, repeatedly, "excellent."[82] Visitors praised the images as "Best photography. Most living art in the show" and termed them "Easily the highlight of the exposition."[83] While some who left comments were content to offer a one- or two-word reaction, most exhibit visitors took the opportunity to share more, many going on at some length. Indeed, given that the space they were provided was a mere three by five inches, the detail in some of the comments is remarkable. The comments should not be read as a public opinion poll about attitudes toward Roosevelt, the New Deal, or the Great Depression, but we can examine them as a group in order to analyze how viewers negotiated the reading problems posed by these striking images. As we shall see, viewers managed magnitude by carving out a space for themselves as engaged agents in the stories the photographs told.

"Real Pictures of Real People": Managing Magnitude through Raised Awareness

Commenters emphasized over and over that the photographs taught them about the real, true, or accurate condition of rural Americans; that they depicted people who were "real"; and that the images helped them "realize" things of which they had been previously unaware. Recall, for example, Evelyn Glantz's statement that the photographs "give an accurate picture of conditions in various regions of the U.S." Others made similar remarks. For example, one commenter wrote, "Very good and representative of life in that part of the country."[84] Glantz and others like her invoked what Don Slater calls "ontological realism," "where the viewer knows that what appears in the photograph must have existed in order for it to have been captured by the camera."[85] Such comments suggested that viewers believed the photographs portrayed what actually existed; they were understood to be depictions of people and conditions that one would encounter in these places.

This perhaps more neutral realism contrasts with what might be termed a more political sense of realism found in comments that implicitly contrasted the photographs with something we might term "idealism," "nostalgia," or even "false consciousness." For these commenters, "real" equaled "life as it is," warts and all. One commenter wrote, "These pictures are remarkable. I have seen none which portray life as it is in our nation better than these." Another commenter stated, "These pictures impress one as real life of a vast section of the American people."[86] Implicit in these invocations of "real" is a sense that the FSA's photographs were not just ontologically factual but that they also told the blunt truth about conditions facing the nation. Two commenters

mobilized this more political or critical evaluation of realism most explicitly: "I am thankful to those artists who dared to show the miserable truth about the great suffering of our citizens"; "The awful truth. Real awful."[87]

A third sense of "real" and "true" emerges in comments that suggest something beyond factual accuracy or the revealing of the "awful truth." For these commenters to call the photographs "real" is to suggest that their communicative power lies in a kind of heightened significance produced by the authenticity of their subjects. As one commenter put it, using the emphasis of capital letters, "These pictures have something REAL. True life. They are meaningful and are of real social significance. More Power."[88] This sense of realism seems to reflect the critical orientation of realism described above, but in a way that highlights the power of photography to communicate. Terri Weissman explains that this approach to "the real" is not so much about objectivity, or fact, but about photography's capacity to construct "a *space* of communicative interaction."[89] This space provides the opportunity for the photograph, the photographer, and the viewer to interact. Thus when the FSA exhibit viewers state, "These are 'real' pictures" (note the use of the term in quotes) or "Real pictures of real people,"[90] they are acknowledging not *what* the photographs communicated, necessarily, but *that* they communicated, their power to do so.

Some commenters described the images not as "real," but as "realistic." Here, aesthetics came into play as commenters wrestled with the realism of the photographs in the context of the exposition overall. One commenter put it bluntly: "the only realistic photographs at the Exposition."[91] One commenter even argued the photographs were "too realistic."[92] References to the exposition itself, and to the photographs as "studies," suggest perhaps that viewers were noting a contrast with the commercialism of the exposition; recall Evans's complaint that the event made him "sick" or Stryker's wry comment about "adults playing with cameras." Yet such responses might also have been prompted by the traditional salon-style display of the photographs in a context seemingly more suited to the world of art: white exhibit space with simple frames and mats. As one commenter put it, "Your display of photographs is unique because it is human and realistic. It is the best expression of art applied to life."[93] For that commenter, and perhaps the others terming the photos "realistic," the images' presentation in a broader context that was seemingly more interested in artifice than in art made them "unique."

As an aesthetic movement of photography typically associated with straight photography—an approach that, as Terri Weissman puts it, "minimizes individual expression" and "represent[s] the facts of life with a kind of fidelity lacking in all other media"[94]—realism was most certainly in the air in the 1930s. Apart

from the ways that artists or activists might have conceptualized their work, a more vernacular, multimodal understanding of "the real" circulated as well. In his classic study of documentary in the thirties, William Stott observes that the public culture of the time valued personal experience and "*being there*" as "a criterion of authenticity."[95] Americans had "a consummate need" to "get the texture of reality, of America; to feel it and make it felt."[96] Newsreels, historical novels, photography magazines, and the ongoing rise of social science, among other developments, helped to fuel an interest in experience and a desire to get at "the texture of reality."[97] Added to that, Miles Orvell claims, was a paradoxical relationship to technology. On the one hand, technologies like photography (especially as applied in its straight aesthetic) seemed to offer a closer relationship to "the real" while at the same time mechanically distancing its users from experience itself: "a feeling emerged of a growing distance between the senses and the 'real world' whose physical structure seemed to defy our sensorium."[98] What Orvell terms "the machine-made world" of skyscrapers, the industrial arts, and photographic technologies embraced "the positive virtues of the machine."[99] Photography in this scenario became "a symbol of a kind of vision that is central to the culture of authenticity."[100] All of these developments, as William Stott concludes, served to foster "an imagination that seeks the texture of reality."[101] In framing their comments in terms of realism and authenticity, viewers drew upon their knowledge of the documentary camera's social and political goal to communicate with fidelity whatever entered its view.

The changing role of education in the thirties also reflected an interest in the real. John Dewey's early twentieth-century philosophy of education had begun to infiltrate the schools more fully by then; the idea that "learning should be lived, that direct experience was the best teacher" appeared not just in elite private schools but even in the most common public school settings.[102] Indeed, interwoven with the commenters' interest in "the real" are viewers' repeated declarations that the FSA's exhibit photographs are educational: they "bring home" to viewers a lived experience that they could not encounter themselves, but that thanks to the photographs they can now visualize. Commenters repeatedly called the photographs "educational" and "instructive."[103] One commenter wrote, "Important educational feature that should reach thousands of people who don't believe such conditions can possibly exist in the U.S."[104] The term "realize" emerged in some comments as viewers noted how the photographs raised their awareness of conditions of poverty across the country: "These pictures are fine. They serve to bring out some awful conditions that most of us people don't realize exist."[105] One viewer comment nicely condenses

these interrelated themes: "We had some vague idea about the hardships of these farmers, but not to the extent that has been depicted by these photographs. It has furthered our knowledge immensely and we realized that what we have read about is stark reality."[106] This language of "realization" implied a viewer's experiencing raised awareness of social and economic conditions far from home. Commenters writing along these lines sometimes explicitly referenced how the photographs made conditions present to them as urban-dwelling New Yorkers, who were far removed from the scenes depicted in the exhibit.[107] Indeed, the spatial sense of presence discussed in chapter 1 emerges here, too, as a key element in commenters' understandings of the photographs as "real" and "educational." This appears most vividly in the repeated idea that the photographs "brought home" the realities of rural poverty: "Reveals the terrible aspects of conditions in the farm areas. The truth is strikingly and forcibly brought home."[108] For these viewers the photographs fostered an affective response that collapsed not only literal but also emotional distance from the problem and made present the "real conditions" on which the public must be educated. In "bringing home" such information, the photographs provided not only "instructive" information but also created the conditions for identification between viewers and the subjects of the photographs.

Viewers understood the photographs as affectively powerful, educational documents of the "real" conditions facing many Americans. Their comments show that they managed the magnitude of the photographs by being open to their depictions of conditions and allowing themselves to be educated about them. In short, commenters reported that the photographs had raised their awareness. Discussions about the photographs' "instructional" capacity and their ability to "bring home" situations far away from the urban center of New York indicate that viewers believed the photographs to be directly addressing them as viewers. They managed the photographs' magnitude by inserting themselves into the photographs' stories as audiences who were capable of learning about and identifying with those pictured.

"Even They are of Our Land": Managing Magnitude through Dissociation, Irony, and Shame

Not all viewers managed magnitude through emphasizing a raised awareness, however. Others employed dissociation and irony to argue that the photographs depicted a poverty so contradictory to the American way of life that they should prompt national shame. To animate these claims, commenters appropriated a popular lexicon of poverty that offered a shorthand way to

reference conditions they found shameful. As we shall see, terms such as "one third of a nation," "how the other half lives," and "American standard of living" appear in the remarks of many of those who found in them a usable language for writing about their experience of viewing the exhibit photographs.

Surprisingly, given the content of the exhibit, the words "poor" and "poverty" appear infrequently in the comments, although commenters did articulate sympathy for the poor and referred to economic inequality. While viewers bemoaned the conditions pictured, poor people for the most part are treated sympathetically. One commenter wrote, "Indescribable poverty. No American should be able to claim these as his own." Similarly, a commenter named L. McLaughlin wrote, "It shows us the horrors of poverty. More work should be done to find work for these people."[109] One especially loquacious viewer found in the photographs a magnitude that invited an extended reflection on the idea of courage: "The pictures are more than merely interesting records—they represent vital drama, a page in our history—the living consciousness of a brave people facing terrible hazards and equally tremendous hardships—and instead of quitting are determinedly persevering forward toward civilization, toward progress, toward culture with the do or die spirit and it is my hope that the struggle not be in vain and that they will win that peace, security, and happiness which they so vividly have earned and deserve."[110] Here the emphasis is not so much on the bleak, "hopeless" conditions of poverty, but on the agency of those in the pictures: they are brave, they will not quit, they deserve not to have to struggle.

Most comments reflecting on the poverty that is depicted in the images involve an implicit logic of dissociation in which viewers express an inability to understand how such desperate conditions could exist in America: "It is almost unbelievable that these pictures are taken in our United States. I'll never regret paying taxes of any kind if these poor wretched people can be helped." Another wrote, "More power to the administration that they may help these poor people. These pictures make one heartsick." One viewer seemed sympathetic but still similarly distanced from the subjects of the photographs: "Even they are of our land and need our thoughts."[111] References to the subjects of the photographs as "these people" and arguments that "even they" are Americans perform what Chaim Perelman calls "dissociation," a mode of reasoning in which arguers contrast "reality" with "appearance."[112] Viewers frequently contrasted their perceptions of what was depicted in the photographs (reality) with the implicit belief that such conditions couldn't possibly exist in the United States (appearances).

Others managed the photographs' magnitude by taking a more negative approach to dissociation. A few comments, for example, explicitly blame the sub-

jects of the photographs for their situations. Birth control figures prominently as commenters construct a visual enthymeme from the photographs' depictions of parents and children: "How about practicing Birth Control?"[113] Similarly, other comments emphasize that the subjects of the photograph should use their own agency rather than relying on the help of outsiders or the government: "Anything to be able to help themselves should be done, but not thru direct relief"; "They could do better in building homes etc. Its [sic] partly their own fault."[114] If the more sympathetic, though still dissociative, comments speak to an environmental view of poverty in which it is recognized that people are poor because institutions, systems, and structures conspire to keep them that way, these fewer but potent comments perform a more hostile view of poverty that dissociated the viewer from the experiences of those pictured and treated "poverty as a moral flaw" that the subjects of the photographs could address by changes in individual behavior and character.[115]

Some of those who left comments appropriated popularly circulating language for talking about poverty; indeed, viewers who left comments seem to have had at hand a rhetorically sophisticated repertoire for making arguments about economic and social conditions. Four repeated phrases are of particular note: "one-third of a nation," the "other half," "land of plenty," and the "American standard of living." For audiences in the 1930s each of these terms cued specific ways of understanding poverty and economic depression. Such phrases, especially when appropriated and circulated over time, constituted a public language for talking about the magnitude of poverty that helped viewers rhetorically manage it. Such circulating language offered viewers like those at the FSA's exhibit a shorthand way for talking about economic depression and highlighting the irony that a nation seemingly so blessed with natural and economic resources could not take care of its own.

A handful of viewers invoked the popularly circulating phrase "one-third of a nation": "Excellent portraiture of how at least 'one third of the nation lives'"; "Would it be wrong to exhibit to members of organizations who support the movement to better the lives of the '⅓' of our people."[116] A few others who left comments emphasized the photographs' role as publicity, a theme I address in more detail below: "It is sad but instructive that this is the only way 'one-third of a nation' may receive publicity"; "Pictures are excellent publicity for President Roosevelts [sic] program to show why one third of nation must be relieved from ill-fed, ill-clothed, and ill-housed conditions."[117] In their use of the phrase "one-third of a nation," viewers appropriated (and, as we see in the first three examples above, placed in quotation marks) language from President Franklin Roosevelt's second inaugural address. Using visual lan-

guage to invite his audience to look with him at where the nation had been and where it was going, Roosevelt had spoken of "seeing" and "paint[ing] a picture" and famously observed, "I see one-third of a nation ill-housed, ill-clad, ill-nourished."[118] But the term did not only circulate via the inaugural address. Roosevelt himself repeated the phrase or versions of it at least eight times in speeches or press conferences between January 1937 and late April 1938.[119] In addition, the phrase was most certainly in the air in New York City in the spring of 1938. The Federal Theatre Project's "Living Newspaper" series, which dramatized current social and political issues of the day, produced a play on housing called "One Third of a Nation." It debuted in the summer of 1937 in Poughkeepsie, and during the period of the exposition it played at the Adelphi Theater on Broadway to strong reviews.[120] For these commenters Roosevelt's metaphorical claim that he had seen one-third of a nation appeared literalized in the FSA's photographs and played into other popularly circulating narratives about those in the United States who were "ill-housed, ill-clad, ill-nourished."

A second oft-repeated term, "the other half," likely had multiple resonances for viewers. The phrase itself derives from the old English proverb "One half of the world does not know how the other half lives."[121] Note, for example, this commenter: "Your pictures demonstrate clearly that one half the people do not know how the other half live." Another commenter seemed to question whether what the photographs depicted could even be called "living": "Something real—let's one half know how the other half (live?)." As we saw in the above discussion of how some viewers thought the photographs "brought home" the conditions in other parts of the country, one commenter invoked the phrase to highlight a similar idea: "The city people did not know how the other half lives."[122] Here these and the other largely urban viewers used the phrase to mark not just a resources gap (the half who have and the half who have not) but also a knowledge gap. When one viewer writes, "Marvelous. Give us some more, so people can see how the other half lives and wake them up," he or she is appropriating the phrase to support a claim about the power of the photographs to make present new knowledge, for the ways they help viewers to "wake up" and realize the extent of conditions in portions of the rural United States.[123]

While we cannot know for sure the extent of these commenters' familiarity with photography history (though given the exposition's purpose we might expect that it was greater than that of the average person), the phrase also carried with it the specific resonance of the work of photographer Jacob Riis, who famously titled his 1890 photographic exposé of New York slums *How*

the Other Half Lives.[124] In the book and in the lantern slide lectures he gave regularly around New York City, Riis used the phrase to highlight the need for real reform. But that reform was anything but a series of sober reflections on social conditions. Maren Stange writes that Riis combined humanitarianism with entertainment, "simultaneously titillating his audience with photographic versions of conventional urban subjects and exhorting them to take up tenement reform as a basis for class solidarity."[125] In this way Riis's invocation of "the other half" employed what Stange calls the "language of tourism," reassuring his audience "that they were the 'half' designated by progress and history to colonize and dominate."[126] For Riis and others after him, then, it is fair to say that the "other half" not only designated the poor but also implicitly framed a manageable space for the privileged, who, unlike the poor in urban slums, could appropriate Riis's vision and, from afar, safely move back and forth across the divide between one half and another.

As with "one-third of a nation," the "other half" functions dissociatively by marking out a distinction between the viewer, the "we" doing the viewing and commenting, and those depicted as subjects of the photographs. In cementing that dissociation, the phrase in a few instances seems to mark not only a resource or knowledge gap but also, more problematically, something we might term a "citizenship" gap. Indeed, a few comments invoking the term seem to imply that the "other half" represented in the pictures is neither a member of the public nor even "American." One commenter invoked the phrase in a way that dissociates "the other half" from "the public": "We ought to see more of this type of picture. Let the public realize what the other half is doing." In a similar vein, another commenter put it, "It's high time we Americans knew how the other half (the exploited negro and white) live."[127] The phrasing here is ambivalent; are "the exploited negro and white" also Americans as "we" are? Or are "we" (the viewer/commenter) the Americans while the other half (the exploited half) are something else entirely? It is unclear. Although other commenters made arguments about their ability to learn from the photographs and experience a raised awareness of conditions, here the invocation of "the other half" manages the magnitude of the photographs by dissociating the subjects of the photographs not just from the viewer but also from participation in the public—and by extension perhaps even from American citizenship itself.

While the terms "one-third of a nation" and "the other half" are probably recognizable to contemporary Americans, another batch of comments appropriated a ubiquitous phrase whose political resonances are largely lost to us today: "American Standard of Living." A viewer identified as H. Laudy wrote, "Wonderful. These pictures force your mind to ponder about a great social

problem which must be solved before we can be really proud of our so-called 'American Standard of Living.'" Another commenter said, "They are pitiful! A disgrace to our Eastern standard of living."[128] In these examples the term "standard of living" marks out a space of irony as these commenters argue that the photographs show disgraceful conditions that clash with our "pride" in the "so-called 'American Standard of Living.'" We are not, the comments imply, living up to our promise to America's citizens.

According to Marina Moskowitz, the idea of the standard of living "was one expression of the increasingly shared national culture that stemmed from the proliferation of both material culture and middle-class communities at the turn of the twentieth century."[129] The term itself began to appear in social science research just after the beginning of the twentieth century, and the language quickly filtered into the popular public lexicon as well.[130] Its precise definition has always been a "slippery one," but Moskowitz argues that the idea of the standard of living "retains a powerful hold on the culture and economy of the United States."[131] Less a quantitative measure than a qualitative feeling, in the early twentieth century "the standard of living was not a measure of how people lived, according to what they could afford—it was a measure of how people wanted to live, according to shared cultural minima."[132] When those commenting on the FSA's exhibit invoked the idea of "standard of living," then, viewers were tapping not merely into an economic idea but into a collective sense of community aspiration.

Yet apart from its broader links to early twentieth-century values and the rise of a national sense of a middle-class culture, the commenters' use of the phrase "American standard of living" also needs to be understood as the rhetorical product of an explicitly anti-Roosevelt politics. The term "standard of living" gained new and palpable currency in the later years of the Great Depression when the National Association of Manufacturers (NAM) launched an anti–New Deal, pro-business billboard campaign designed to convince Americans that the United States was not as bad off as Roosevelt claimed. According to James Guimond, "The NAM began to attack the New Deal in 1935" via a campaign that eventually came to include billboards, radio, films, and "educational" materials provided to schools.[133] Because billboards directly addressed people where they lived, worked, shopped, and moved, Americans around the country "were suddenly confronted by a giant tableau of a cheerful American family picnicking, greeting Dad at the end of a workday, or taking a Sunday drive with the family dog."[134] The billboards combined images of smiling, white, middle-class nuclear families with captions like "There's No Way Like the American Way," "World's Highest Standard of Living," and "World's Highest Wages."[135]

They appeared seemingly everywhere across the U.S. landscape. According to Stuart Ewan, "By 1938 every location in the country with a population of more than 2500 people had one of these billboards."[136] One scholar estimates that there were sixty thousand of them.[137]

FSA photographers paid attention to the NAM billboards when they discovered them in the field, finding in them a rhetorical resource for the communication of visual irony. Arthur Rothstein, for example, made at least four photographs of NAM billboards while in Birmingham, Alabama, in February 1937. The number of FSA photographs of the NAM billboards might suggest that viewers who left comments remarking upon the "standard of living" were directly referencing a billboard photograph they had seen in the exhibit. Yet neither the extant installation photographs nor the incomplete worksheets from the exhibit show photographs depicting NAM billboards; we do not know whether any were shown at the exhibit.[138] Because of their ubiquity, however, visitors to the exposition likely would have encountered the billboards in their own local contexts. It is also likely that they had encountered a photograph by Margaret Bourke-White, who famously took advantage of the visual irony the billboards offered the attentive photographer. One of Bourke-White's best-known photographs, "The Louisville Flood," was made in 1937 for *Life* magazine and originally published in its February 15, 1937, issue.[139] Bourke-White's image juxtaposes a group of African Americans in line for flood relief with a NAM billboard towering over them. The billboard features a smiling, well-off white family and their dog, traveling through a pastoral landscape, the text proclaiming, "World's Highest Standard of Living: There's No Way Like the American Way." As James Guimond writes, "Secure in their little car and in the American way of life, they appear to be totally oblivious to the depression all around them."[140] Indeed, in Bourke-White's composition the billboard's massive car seems poised to run over the very real, tired, and weary people waiting in line at the bottom of the photograph. While the photograph as published in *Life* was meant to illustrate a specific news event (Ohio River flooding that had killed nearly four hundred people and left nearly one million homeless), Bourke-White's juxtaposition of displaced African Americans with NAM's pro-business message skillfully performed the irony of proclaiming plenty in a time when so many were in crisis.[141]

Given the wide circulation of both the billboards and *Life* magazine (its circulation would reach 1.5 million per week by the end of 1937), it is reasonable to assume that the visual ironies noted by the viewers in their comments reflected the public visibility of the billboards.[142] Indeed, viewer comments echo the visual irony communicated by Bourke-White and the FSA photog-

raphers. One commenter, for example, observed that the FSA's photographs "ably refuted" the "oft heard phrase 'The Highest Standard of Living.'" Another asked, "Is this typical of the American standard I hear so much of?"[143] In each of these cases the commenter contrasts what the pictures showed and what business culture sought to communicate. Viewers emphasized how the photographs talked back in ways that challenged the pro-business ideology proffered by the New Deal's opponents. To them the photographs collectively offered evidence that the imagined middle-class world the NAM sought to conjure visually was a sham.

Viewer comments that the United States is a "land of plenty" similarly invoked irony. With its biblical undertones and links to the civil religion of American exceptionalism, the phrase itself long predates the Great Depression, of course.[144] Jackson Lears writes that "Utopian visions of abundance" have always existed, in which "the enduring myth of an earthly paradise melded material abundance with the spiritual abundance of salvation, celebrating eternal ease in a nurturant land of plenty."[145] Such myths have held particular sway in the history of the United States. David Morris Potter writes that for generations of immigrants, America's lure was its imagined identity as "the land of plenty, the land of promise, where they could 'dwell like kings in fairyland, lord of the soil.'"[146] Some viewers used the term in precisely these ways, offering interpretations of the photographs through the lens of a national self-concept of the nation as a chosen, mythical land with abundant resources. Harold Finkelstein wrote, "These photos are among the most interesting at the first International Exposition. They picture life as we here little realize it can be in this land of plenty." Others similarly contrasted what they seem to have believed was empirically true about the nation (we are a country of plenty) with what the photographs appeared to show. In recognizing the apparent magnitude of that contrast, viewers amplified it with an affective tone that articulated their professed feelings of shame and disgust. For example, one commenter wrote, "Disgraceful state of things in this country of plenty"; another, "What galling shame that in this land of plenty there should be this misery, and this impoverishment."[147] As we shall see below, such comments also participate more broadly in an evaluative rhetoric that challenged the very nature of the nation's moral character.

By the time of the Great Depression, the myth of the land of plenty seemed to contrast even more openly with reality. Novelist and social critic Robert Cantwell published a novel with that title in 1934 and citizens who wrote letters to President Roosevelt used the term as well. One wrote, "Now, Mr. President, we are in the land of plenty but I see that good many of us are starving."[148] Yet it is interesting to note that the phrase "land of plenty" appears in Franklin

Roosevelt's presidential rhetoric only once, and when it does it is not offered as a platitude or upheld as a suitable national aspiration. Instead, Roosevelt offers what might best be described as a realist take on the land of plenty. Speaking via radio to the Young Democratic Clubs of America in 1935, Roosevelt said:

> Party or professional leaders who talked to us twenty-five or thirty years ago almost inevitably spoke in a mood of achievement and of exultation. They addressed us with the air of those who had won the secret of success for themselves and of permanence of achievement for their country for all generations to come. They assumed that there was a guarantee of final accomplishment for the people of this country and that the grim specter of insecurity and want among the great masses would never haunt this land of plenty as it had widely visited other portions of the world. And so the elders of that day used to tell us, in effect, that the job of youth was merely to copy them and thereby to preserve the great things they had won for us.[149]

Yet "insecurity" and "want" not only came but had in fact existed all along. Roosevelt continued, "While my elders were talking to me about the perfection of America, I did not know then of the lack of opportunity, the lack of education, the lack of many of the essential needs of civilization which existed among millions of our people who lived not alone in the slums of the great cities and in the forgotten corners of rural America but even under the very noses of those who had the advantages and the power of Government of those days."[150] For Roosevelt the myth of the "land of plenty" was not something to aspire to, because it existed only if one hid or ignored conditions "which existed among millions of our people." Some viewers of the FSA's exhibit invoked "land of plenty" with a similar tone. One commenter said, "These were such realistic pictures of what conditions a land of plenty should immediately strive to improve. Where are our high American standards of living?"; another stated simply, "Our land of plenty? I am ashamed."[151] Here dissociation and irony emerge again as commenters manage the photographs' magnitude by highlighting the gulf between national myth and the conditions visualized by the FSA. Perelman tells us that dissociation "aims at separating elements which language or a recognized tradition have previously tied together."[152] Commenters use pointed rhetorical questions and an ironic tone to pull apart the threads of a recognized tradition, the myth that the United States is a land of plenty. For these viewers the photographs at the FSA exhibit prompted them to articulate a way of reading the photographs as challenges to these conventional myths.

The use of dissociation and irony connects to a broader claim among viewers that the photographs revealed conditions that should prompt national

shame. If "one third of a nation" is not housed, fed, or clothed properly, if the "World's Highest Standard of Living" is a propagandistic sham, if the "land of plenty" is a flawed myth, then the only response is one that indicts the moral compass of America itself. Many commenters said that "we" as a nation should be ashamed: "I think it deplorable that such conditions exist in this fine country of ours. We should be ashamed"; "Our land of plenty? I am ashamed."[153] Such statements of blame suggest that some who left comments interpreted the photographs as much more than straightforward visual evidence of "real" economic conditions in the rural United States. They understood them, rather, as evidence of a kind of moral hypocrisy: what, they asked, does it say about us that such conditions exist within our borders?

Sara Ahmed explains that shame is tied to human agency; that is, to feel shame entails the recognition that one might have done something different. Furthermore, "In shame, more than my action is at stake: *the badness of an action is transferred to me*, such that I feel myself to be bad and to have been 'found' or 'found out' as bad by others."[154] Ahmed notes that the etymology of shame involves the idea of hiding or covering; when we feel shame, we wish to cover and hide, not to make things visible.[155] Aristotle, who famously engaged shame as a key emotion in his discussion of rhetoric and the emotions, connects shame to vision, noting that people "feel more shame at things done before these people's eyes and in the open; hence, too the proverb 'Shame is in the eyes.'"[156] Shame thus shares a connection to visibility and witnessing. Yet note, too, that the FSA exhibit comments that express shame have more of a communal than an individual focus. *We* should be ashamed, commenters write. It is a "galling shame" that there should be such struggle in *our* "land of plenty." Even the commenter who writes in the singular—"I am ashamed"—ties that shame to a communal question about *our* land of plenty. In each case shame appears as part of a broader, collective sense of national shame. Ahmed argues that one type of national shame is one in which "the nation may bring shame 'on itself' by its treatment of others."[157] Those who left comments articulating feelings of disgrace and shame indicted their fellow citizens—and the nation itself—for its treatment of people like those in the photographs. Conditions that were a "blot" on the country and its character implicated all citizens.

Dissociation, irony, and shame allowed some viewers to manage the magnitude of the FSA photographs by serving as a vehicle by which we judge what Ahmed calls "the success or failure of subjects to live up to ideals."[158] When the FSA exhibit commenters called out the conditions pictured in the photographs as a disgrace, when they pointed out the ironies of investing in the "American standard of living" or the myth of the "land of plenty," they both

implicated themselves and invited other citizens to recognize or feel national shame. Commenters argued that the photographs indexed a moral dissociation between what Americans are and what they should aspire to be. In doing so they highlighted their own agency as viewers, recognizing themselves and their fellow citizens as implicated in the country's moral failings at large.

"Do Something": Managing Magnitude
by Demanding Action

Many viewers who left comments explicitly took up the question of what should be done to alleviate the conditions depicted in the photographs, some going beyond general calls for government intervention to make explicit policy recommendations about what should be done to ameliorate such conditions. These viewers thus managed the magnitude of the photographs by calling for action. One commenter wrote, "A very sad sight. Something should be done about it. I mean the conditions." Similarly, another viewer commented, "They're so moving and dramatic they make you want to do something about such conditions and for such courageous people." Other comments took the form of rhetorical questions, such as "What is being done about it?" and, more plaintively, "God, can't they be helped?"[159] In comments such as these, viewers articulate a desire that the subjects of the photographs receive aid, though they do not specify exactly how. Who or what should be responsible for accomplishing these changes is a question that is largely absent from this group of comments, this despite the frequent demand among them to "Do something." Indeed, the explicit call to "do something" is repeated frequently in the comments: "Excellent. Something should be done." A few comments suggested that the "something" needed to be more than acts of communication, photographic or otherwise: "Do something about it instead of talking about it"; "Poor peoples [*sic*] plight should not be exhibited, but help rendered instead"; "A few words written here don't matter. Do something."[160] Such comments are ambivalent in ways that suggest viewers struggled with the magnitude of what was depicted in the photographs. First, what precisely is that "something" that should be done? Commenters suggest that "help" and improvement of "conditions" are that something, but this group of comments does not get more specific than that. Second, there is ambivalence not only in the *what should be done* but also in the *who should do it*. If the question "What is being done about it?" is seemingly addressed to the exhibit organizers, or possibly to the president or the state, then are those the audiences that should

also do something other than put on an exhibit? To whom are these demands for social action being directed?

It is tempting to conclude from such comments that those who visited the FSA's exhibit were simply responding to the photographs by offering vague correctives, the kinds of things one is supposed to say when confronted with documentary imagery of this magnitude. Yet the demand to "do something" is more specific than it seems. Exhortations to "do something" echo Franklin Roosevelt's arguments about the value of social experimentation in the face of massive crisis. Roosevelt's rhetoric was dominated by the idea that to survive the Great Depression, the United States had to be willing to be bold and experimental. Speaking to the Baltimore Young Democratic Club in April 1936, the president said, "In regard to all these problems, in regard to every problem that arises, there are counselors these days who say: 'Do nothing'; other counselors who say: 'Do everything.' Common sense dictates an avoidance of both extremes. I say to you: 'Do something'; and when you have done that something, if it works, do it some more; and if it does not work, then do something else."[161] Even viewer demands to "do something" carry with them a kind of implied agency, one that avoids the extremes of paralysis or unfocused overaction. The Rooseveltian mantra "do something" advocates for action and flexibility in the face of challenging and contingent conditions and thus becomes a way for viewers to manage magnitude.

Those who articulated more specific suggestions for addressing the conditions pictured in the photographs tended to argue for the importance of government intervention; furthermore, the comments are clear that we should read "government" not as a local or state entity, but as the United States federal government. While it is not always made explicit what specifically the federal government should do, commenters were clear that the agency should lie with the government: "Very good. Depicts human life on the farm. U.S. government should try to better these conditions"; "I believe that your show is an example of the excellent use that can be made of photography to depicture the terrible living conditions of the farming sections and show the need for reform and relief." The rhetorical question appears in these types of comments as well, where viewers seem to assume the government is or should be addressing the problems illustrated by the photographs: "If these pictures represent American life in the rural sections of our country, then something should be done to ameliorate those conditions. What is the Government doing about it?"[162]

During the Great Depression and New Deal era, Americans experienced an unprecedented change in the role of the federal government in their daily

lives. David Kennedy reminds us that for more than two decades before the Depression, progressives had sought to "use government as an agency of human welfare."[163] Yet the most consequential element of the New Deal was that "ever after, Americans assumed that the federal government had not merely a role, but a major responsibility, in ensuring the health of the economy and the welfare of citizens."[164] Michael Katz states that the New Deal marked the moment "in which the national government created the infrastructure of the national state."[165] "Before the Great Depression," Katz writes, "the government lacked the means to coordinate increasingly complex, national business."[166] Yet just one year into Roosevelt's first term that was changing dramatically. In February 1934 alone 22.2 percent of Americans received assistance from just three agencies: the Federal Employment Relief Administration (FERA), the Civil Works Administration (CWA), and the Civilian Conservation Corps (CCC).[167] It did not take long for Americans in all parts of the country to become increasingly comfortable with the expanded role of the federal government in their lives.

Roughly six weeks after Nazi Germany annexed Austria, in a period when isolationism still largely influenced the public mind, some commenters argued that the federal government needed to abandon other policy goals in order to "help Americans first."[168] One commenter wrote, "After seeing these they still want to bring others from the other side—help those here first." Similarly, another viewer wrote, "The U.S. as a whole ought to be ashamed to have such conditions existing. Instead of sending money to help Jews and other foreigners they should stop societys [sic] from sending money out of the country. I say help America first." Another commenter ended a lengthy meditation on how we have "abused our lands and prostituted our resources" by writing, "This is all one can say: Instead of the present baiting of so-called aliens, instead of spouting about a so-called alien menace let us turn attention to care for our deplorable needy human beings. And let us do it with dispatch, lest the clamor rise and deluge the nation with its cry." Yet another commenter concluded more succinctly, "Good food for reflection that the U.S.A. has plenty to do at home before it can with self respect dream of its mission to reform the world outside."[169] These commenters frame help for the "other side" or "outside" as direct economic competition with those in the photographs; the assumption is that there is not enough U.S. government support to go around, so the United States should help those inside its borders first.

Many of those whose comments demanded action highlighted the need for particular policies or advocated on behalf of particular New Deal agencies. Evelyn Glantz, whose visit to the exhibit opened this chapter, argued

that congressional attention to "rehabilitation" was necessary; this is a direct reference to New Deal agencies like the FSA and its predecessor, the Resettlement Administration, that were charged with rehabilitating (and in some cases resettling) farmers to better land. Although by 1938 large-scale schemes of resettlement had been abandoned, echoes of the years of bigger-scale thinking emerge in the comments.[170] Others who left comments offered specific support for the continuation or expansion of New Deal programs: "Shows clearly the need to extend FSA and WPA etc."; "Show need for enlargement of T.V.A. program thruout [sic] South west."[171]

Critics of President Roosevelt and the New Deal also found in the photographs resources for arguing their positions. While a few were critical of FDR and the New Deal entirely—"Typical of the New Deal bunk at taxpayers [sic] expense. However, F.D.R. and the whole gang is about washed up Thank God"—some commenters recognized what the nation faced economically but expressed doubts that the New Deal was the answer. For them the photographs seemed to show that the New Deal was not working: "It is a sad state of affairs that such conditions exist in America. However, the 'New Deal' administration cure will prove worse than the disease"; "I think that these pictures show how Mr. Roosevelt's attempts at getting rid of the depression are not so hot."[172] Perhaps anticipating these and other critiques, some viewers used their experience of viewing the photographs to refute Roosevelt's or the New Deal's critics and assert that the actions taken thus far had been correct ones: "Heart-breaking revelations. Perhaps they will serve as a rebuke to critics of further spending for relief and rehabilitation"; "Startling. Every American who thinks Rural Resettlement is a waste of taxpayer money should see these."[173]

These commenters read the FSA's pictures in light of their sense of the economic challenges currently facing the nation. And they were correct to be nervous. The First International Photographic Exposition occurred in the midst of what came to be known as the Roosevelt Recession, and some of those who had supported Roosevelt in the past now found themselves disagreeing with his policy choices. In 1937, as the United States continued a very slow but steady economic recovery, President Roosevelt and Congress began to shift attention to the need to balance the federal budget, which meant cutting back on government spending. Although the economy had not returned to its pre-1929 state, national income was running almost double what it had been in 1932 during the depths of the Depression. By 1936 unemployment had dropped to 17 percent (down from nearly 25 percent in 1933).[174] The administration even began talking about "proposing a balanced federal budget for fiscal year 1938."[175] In early 1937 Roosevelt "directed that the rolls of the WPA [Works

Progress Administration, a federal work relief program] be cut about in half."[176] By the end of 1937, however, as these changes took effect, the Roosevelt Recession had settled in. Earlier gains that seemed to signal a broader recovery had been but a blip. By March 1938 "two-thirds of the economic gains achieved since 1933 had been lost." Unemployment zoomed back up to 19 percent.[177] On April 14, 1938, just four days before the exposition opened, Roosevelt delivered his twelfth fireside chat. Timed to coincide with a budget proposal he had just forwarded to Congress, the speech noted a continued interest in reducing the federal deficit but highlighted the administration's new plan to reinstate and increase public works spending, asking for additional money for the WPA and the FSA, among others. "These appropriations," Roosevelt noted in an uncharacteristic choice of passive voice sentence construction, were "made necessary by increased unemployment."[178]

Some exposition visitors who left comments read the photographs as evidence against the policy choices made by Roosevelt before the April 1938 fireside chat. For them the FSA's exhibit constituted a visual refutation of claims that the worst was past. "Pictures are great challenge to those who curtail public relief," wrote one viewer. The need for a balanced federal budget came under specific criticism: "If more pictures such as these were shown to greater groups of people maybe these [sic] wouldn't be such a hue and cry of Balance the budget"; "But all you hear in the papers is: Balance the budget!!!"; the FSA's pictures "should be sufficient answers to all arguments for budget balancing."[179] Responding not just with vague pro- or anti-Roosevelt sentiment, these commenters stated explicitly that the photographs answered in the negative the question of whether the worst was over. In their view the magnitude of what the photographs depicted should outweigh concerns about government spending.

Not all commenters urging action to alleviate conditions invoked the federal government as the locus of solutions; several urged more individualized solutions of birth control and education, and one rare commenter suggested that "spiritual uplift" was as "necessary as material betterment."[180] Yet for the most part those viewers who demanded action did so by arguing that the responsibility for helping those in the photographs lay primarily with the federal government. Writing in an especially vulnerable economic time, and clinging to an isolationism that urged Americans to protect Americans "first," viewers of the exhibit expressed their relatively newfound confidence that the government would address (or was already addressing) the social conditions depicted in the FSA's photographs. Viewers thus managed the magnitude of the photographs by treating the invitation to share comments as an opportunity to talk directly to the federal government, to urge it to "do something."

"Take More Pictures": Managing Magnitude
through Publicity and Circulation

For some viewers the mass medium of photography itself took center stage as commenters advocated for more production of such photographs and wider circulation of them. Thus they revealed themselves to be knowledgeable consumers of photography in a period when photography increasingly was becoming a national mass medium of communication. Viewers managed the magnitude of the photographs by arguing that their very weightiness merited circulation: if more photographs were seen by more people in more contexts, then perhaps something might be done to transform the conditions themselves. One commenter put it succinctly, "Show more and people will understand more."[181]

Several of those who left comments urged that the FSA's work specifically be allowed to continue and expand: "I think that the FSA has performed a truly remarkable and also humane deed in photographing these pictures. Their efforts should be continued"; "Excellent work. Enlarge the project and take more pictures. Very fine use of public funds." Others seemed to believe more broadly that increased production of documentary photographs would be good for photography itself. One viewer wrote, "Government agencies should encourage more work of this sort. It is of very great value to the photographer who learns to do it, to any progressive government and to the entire population. But with the limited amount being done at present, its usefulness is necessarily much more limited than it should be."[182]

Other commenters tapped into ideas already discussed above, urging that such photographs should continue to be produced because they were educational, because they brought home rural problems to urban viewers, and because they illuminated information about America's poor standard of living.[183] They argued that such photographs should continue to be produced so that Americans could "wake up" and understand what was really happening in the country: "Wake up smug America! Give them more of these pictures." A viewer who identified himself as Samuel Kaplan of Brooklyn reported not only his own reaction but one overheard by another exhibit visitor as well: "Highly educational. Very interesting and remarkable photographic endeavor. Let's have more of this[;] one person just commented that the scenes make you sick."[184] Urging "us" to "have more of this" and, in the same breath (note even the absence of punctuation between the two thoughts) acknowledging the difficult scenes, Kaplan encapsulates many viewers' response to the magnitude of the photographs: more of these would be better, because more people would be "sick" and perhaps "wake up."

In addition to arguing for more production of such photographs, across their comments dozens of viewers argued that the FSA photographs needed to be seen by more people, in more venues, throughout the United States. Viewers repeatedly called for greater publicity for the pictures, arguing that to limit them to those passing through the exposition was a waste of their power. One commenter wrote, "These pictures impress one as real life of a vast section of the American people. They should be made available to many more people than could be expected at an amateurs [sic] exposition with a forty cent admission," while another noted, "I think these pictures are very fine—but I believe a greater attempt should be made to publicize them." Over and over again those who left comments argued that the photographs should be publicized widely.[185] While one viewer worried about lack of circulation of the photographs—"I hope these pictures are not filed away in some government archives"—others explicitly encouraged more of it. Commenter John Scott contrasted the FSA's exhibit with the rest of the exposition when he wrote, "Amid expensive gadgets of this show these pictures are heartrending. They should be seen by every one. Thank you."[186]

Although largely used in positive terms in the comments, "publicity" could have its dark side as well. A smaller group of commenters employed the notion of "propaganda" to describe their reactions to the FSA's exhibit—a term those who worked for the FSA or the Resettlement Administration were quite familiar with.[187] They did not advocate for greater publicity and circulation of the images; indeed, they seemed to see in the photographs a hidden purpose of being produced simply for publicity. Commenters called the photographs "Subversive propaganda"; "Magnificent propaganda," and "Dirty propaganda." They claimed the photographs were "New Deal propaganda pure and simple" and "Purely propaganda for Communism."[188]

As we saw above, a number of those who commented on New Deal policies specifically invoked the image of an opposition to Roosevelt in their comments. Some argued that circulation of the FSA's photographs to that opposition would refute anti-Roosevelt claims: "Every comfortable person who objects to the present administrations [sic] efforts to help the poor in city or country should be made to look at these splendid pictures until they see daylight"; "Show these to Anti-Roosevelts!"[189] These viewers and others like them framed a particular imagined audience who needed to see the pictures: "comfortable" people, anti-Roosevelts. They read the FSA photographs as having the power to make documentary demands on imagined strangers not present.

Calls for production, publicity, and circulation reflect viewers' implicit understanding that 1930s photography circulated in a lively mass culture of print.

As I noted in the introduction to this chapter, photography in this period benefited from new locations for display, new pedagogies, and new audiences. The rise in the "picture-mindedness" of these audiences, as we have seen, influenced the ways they argued about production, publicity, and circulation of the exhibit's photographs. It is especially noteworthy that many of those who submitted comments made specific suggestions about *where* the photos should circulate. "Put more of them in more public places," argued one commenter, while another exclaimed with great specificity, "Hang this exhibit in the halls of Congress!" A few viewers commented that the photographs "should travel as an exhibit" or to schools, where "copies should be made available for class room use in the Public Schools";[190] "These are sensational and enlightening. Important educational feature that should reach thousands of people who don't believe such conditions can possibly exist in the U.S. Exhibits should be opened to the public. Free of Charge."[191]

The majority of those who left comments about circulation suggested print-based homes for the pictures, recognizing the wider reach such venues would have for the agency's work: "I wish that these pictures could be more widely published. There are millions of people who would be interested and influenced by them."[192] Viewers mentioned books, magazines, and newspapers specifically: "Very educational, more of these photos should be printed especially in magazines and news papers [*sic*] to show city people how the other ½ live"; "These pictures should be published in a low priced (10¢) picture book with a running commentary"; "I should like to see them published by some national magazine, like LIFE"; "Grand shots! We hope that they are issued in some more permanent form, like a book."[193] Calls to publish the photographs in newspapers and magazines illustrate that the exhibit's viewers recognized well the cultural value of these venues for the circulation of photography. Despite its many competitors, by 1938 *Life* magazine was the gold standard of picture magazines, and it would only cement that position over time.[194] Calls to publish the photographs in books recognize the relatively recent rise of popular, best-selling "photobooks" such as Margaret Bourke-White and Erskine Caldwell's problematic but popular *You Have Seen Their Faces*, published in 1937 to chronicle sharecropping in the American South.[195] Archibald Mac-Leish's prose poem *The Land of the Free*, featuring FSA photographs (the first of many photobooks to do so), would be published later in the year.[196] The photobook would indeed become a key site for the reproduction and circulation of documentary photography by the FSA and others.[197] Such comments show that the exhibit's viewers were (not surprisingly, given the exposition's purposes) savvy consumers of visual culture and that they knew the kinds of

outlets where documentary photographs like those of the FSA might circulate and achieve greater visibility.

Implicit in these comments about circulation in exhibits, books, and magazines is the idea, expressed more explicitly by other viewers, that the magnitude of the photographs necessitated a specifically *national* circulation: "The necessity for farm relief would be brought home more forcefully if these pictures were made available to a greater majority of the public throughout the nation"; "That they should be shown all over the country is obvious"; "should be exhibited thruout [*sic*] the country."[198] The call to circulate them to a national public suggests that viewers thought of the photographs as potential participants in a broader national conversation about the issues they depicted. Recall the discussion above in which viewers contended the photographs "brought home" conditions in other parts of the country. If such images made the rural depression more present to New York viewers, the argument goes, then they might do the same for other members of the national public, strangers who were not present at the exposition. Such an assumption likely reflects viewers' sense of the rising power of a national media. William Uricchio and Marja Roholl argue that 1930s documentary efforts such as that of the FSA "helped to establish a new vocabulary for describing the nation, redefining it in a way that had not been previously seen in either photojournalism or film." They contend that during this period, technological transformations in film, radio, and photography encouraged thinking about "the role of nation" at once in terms of "body politic (the Roosevelt administration), as land mass bound together by media networks (radio, photojournalistic endeavors such as *Life*, and the cinema distribution circuit) and as cultural force (regional images, stories, and melodies)."[199] In this view what made 1930s culture "national" was the power of media to circulate ideas publicly to the whole country. Media themselves, then, possessed magnitude. Increased circulation of the FSA photographs, by extension, would produce the capacity for more and better public conversations about the poverty and economic inequality visualized in the photographs. It is striking that the comments about publicity do not call for the photographs to reach a broader "audience"; rather, the call is for circulation to "the public," the need to "publicize." I have argued elsewhere that circulation "does important cultural work, including creating interpretive communities and constituting publics."[200] Calls for circulation to a national public thus signaled viewers' implicit recognition of the role of circulation in creating a public that was capable of responding to the documentary demands of the photographs. Ultimately, viewers who left comments about production, publicity, and circulation managed magnitude by expressing a profound faith in the power of documentary photography to

move through public culture with political purpose. Such a faith might seem naïve to us today, and indeed it did to a few commenters who wondered how mere photographs could actually effect change in the world.[201] Yet it is clear from the comments that viewers—schooled in the workings of late 1930s print culture—imagined that circulation of the photographs to a national public would amplify the photographs' messages and potentially constitute other viewers as being capable of responding to the magnitude of the photographs' documentary demands. These viewers thus constructed themselves as rhetorical agents of that message, urging exhibit organizers to share the images widely.

The Weight of Picture-Minded People

Nearly thirty years after the FSA's exhibit at the First International Photographic Exposition, Roy Stryker recalled the exhibit and the comments to oral history interviewer Richard Doud:

> We had one show, one exhibit that I think we could place much weight on. That was a show that was done in New York, at the International Photographic Show exhibit in 1938 at Grand Central Palace. . . . It was a tough show, it was a pretty brutal statement of—by the kind of pictures we selected. . . . And the only index we could possibly have had of that show, that we could place any credence in at all, was a box that Rothstein conceived and the blank 3 x 5 cards. And we wound up with some almost 500 comments. And they were extremely varied—from calling us "Communists" (although Communism wasn't very well know [sic] then, it wasn't the word everybody used) to an enormous number of the people who answered said [sic], "Why isn't something done about it? Why don't we do something about these people?" On the whole, the comments were sympathetic, understanding, and even to the point of being distressed about these conditions; why couldn't something be done.[202]

Stryker was always careful to avoid claiming that the comments constituted any kind of scientific poll on the impact of the FSA's photography. But note how he locates in the comments—in both their sheer numbers and their largely "sympathetic" yet questioning tone—a "weight," a magnitude, that lends them a certain rhetorical force. For Stryker the value of the comments lay in their ability to lend "credence" to the FSA's project, to make it seem more credible to those in power holding the purse strings.

Yet my analysis of the comments has shown that they indexed another weight as well. Confronted with the fear and uncertainty of the times pictured

so bluntly in the photographs, viewers made sense of the reading problems posed by the images one three-by-five card at a time. They explained how the photographs raised their awareness of social conditions they previously had not known existed. They mobilized popular languages of poverty to show how they, and others across the nation, should feel ashamed by what the photographs pictured. They demanded public policy action by speaking directly to those capable of acting. And they advocated for greater publicity and circulation of the photographs so that others might see the pictures in the future. In doing so, they took up the invitation to respond to the exhibit's photographs by doing more than simply looking. They interpreted the FSA's photographs as a narrative addressed directly to them as well as to others across the nation. Viewers managed the photographs' magnitude by inserting themselves as active agents in the stories the photographs had to tell.

Photography's Viewers, Photography's Histories

Photography helps us learn to see as members of interpretive communities. I have shown one way this works by studying how viewer engagement with photography happens at the local, historically specific level. By closely reading traces of viewers' encounters with photography, I have written a rhetorical history of photographic viewership showing that viewers were active agents who used their experiences of photography to deliberate about issues of common concern. In this final chapter I explore the value of such a project for those of us invested in studying the role of photography in public life. Specifically, I reflect on what the project tells us about the nature of the viewer, consider how it challenges our definitions of what a photograph is, and elaborate how the rhetorical study of viewership enriches our histories of photography.

I noted at the outset of this book that studying photography's historical viewers is not easy. We cannot survey them, we cannot observe them interacting with photographs in real time, and we cannot ask them what they think about what they see. My solution to this dilemma has been to use my training as a scholar of rhetoric to locate historical viewers through the traces of their engagement with photographs. As we have seen, studying such encounters revealed that historical viewers possessed a rhetorical consciousness about photography that enabled them to navigate the dominant anxieties and crises of their age. This rhetorical consciousness—a way of thinking about the possibilities for persuasion, belief, and judgment—manifested itself through the

use of an implicit but sophisticated repertoire mobilized by viewers and put to work in their arguments about public issues of the day.

One result of this project, then, is that it recovers the viewer as a key participant in the event of photography. By itself this is a valuable contribution. Yet in doing so this project has implicitly done something else as well. The case studies in this book have shown that the rhetorical practices of viewers are not uniform; the texts I engaged here cut across multiple genres, from magazine and newspaper articles to letters, books, trial testimony, and exhibit comments. They also showed that viewers themselves are not uniform either; that is, contrary to what some scholarship in visual culture studies seems to assume, there is no one prototypical viewer. From the singular, polemical consumer of child labor imagery T. R. Dawley, to the handful of elite commentators on Lincoln, to the hundreds of nearly anonymous visitors to the FSA's exhibit, each case study offered a different answer to the question "Who is the viewer?" Answering this question required an eclectic critical methodology that balanced the interpretive precision of close reading with a more flexible framework that was able to account for both the variety and the scope of viewer responses to photographs. In one sense, then, this project models a suitable critical approach for the study of a wide breadth of historical viewers across multiple contexts. But, more important, it reminds us that any study of historically situated viewers is going to offer its own unique challenges and demands. The critic who is interested in taking up those challenges will need to be flexible in addressing them.

If the encounter between viewers and photographs is shaped by different answers to the question "Who is the viewer?" this study has also shown that the question of what the viewer is looking at is also more complex than it might initially seem; that is, what constitutes "viewing a photograph" changes, in some cases dramatically, across photography's history. We saw this most vividly in chapter 1's discussion of Civil War and spirit photographs, where viewers' encounters with photographs took place primarily through the process of virtual witnessing. Writers on photography such as Oliver Wendell Holmes translated their viewing experiences for viewers with no direct access to the photographs, and engravings such as those published in *Harper's Weekly* illustrated but only approximated the horrors of war. Here viewers' encounters with photographs can hardly be understood to be encounters with photographs at all. Other case studies offered similarly complex understandings of the photograph. Chapter 2's viewers wrestling with the *McClure's* Lincoln encountered a halftone reproduction of a daguerreotype that forced them to reconcile an older, materially unique technology with more contemporary, highly reproducible images.

Early twentieth-century viewers such as Dawley in chapter 3 and FSA viewers in chapter 4 encountered photographs that were designed (and in Dawley's case also produced) to serve an information function as documentary evidence about pressing social and political issues; changes in technology enabled those images to circulate widely in an increasingly mass culture of print. What constituted an encounter with photographs, then, radically differed across time, space, and technology during the medium's first one hundred years. Thus the technology of the camera and evolving mechanisms for producing, reproducing, and circulating photographs need to be recognized as key components of the photographic encounter. When viewers responded to photographs, what precisely they were responding to was always changing over time.

Overall we have seen that viewers of late nineteenth- and early twentieth-century photographs were more than passive spectators. Whether they were interrogating the accuracy of spirit photography, mourning with the nation over images of the battlefield dead, performing their anxieties about citizenship and national identity in response to images of Lincoln and child laborers, or challenging the public to "do something" to address the Great Depression, photography's viewers above all constituted themselves as active agents, readers, and critics of photographs that were diverse in subject matter and technology. In their responses to photographs of death, war, citizenship, and poverty, viewers engaged them, questioned them, reworked them, and appropriated them. And they used their viewing experiences to make ethical and political arguments that went far beyond the boundaries of the photographic frame. How precisely did viewers do all of these things? As we have seen, they put their rhetorical consciousness to work, inventing "possibilities for persuasion, conviction, action, and judgment."[1] These invented possibilities included the mobilization of a rhetorical repertoire of presence, character, appropriation, and magnitude.

Presence emerged as a way to address the reading problems that arose from Civil War and spirit photography in a time of national trauma. It came to matter in a moment when anxieties could be alleviated, however fleetingly, by the collapsing of distance afforded by photography. Yet as we saw, presence was not always embraced positively. As Holmes attested, there can be too much presence: photography is capable of bringing things too close, which can overwhelm, and the unethical manipulation of presence may confuse the understanding. Yet whether embraced or contested, presence became a kind of a navigational tool for making sense of grief and trauma in times of crisis.

Character emerged to help viewers address anxieties about the fate of American identity at the dawn of the age of empire, coming into play when

the emergence of a seemingly "new" Lincoln clashed with later iconic visions. Character thus operated as a shorthand way to stake claims about who was or was not an "ideal American" and ultimately served the ends of both those who sought to elevate the high moral character of the nation and those who sought to limit who counted as American.

Appropriation took on an important role in contested conversations about child labor and disputes about the "right" way to raise good citizens. As an individual, polemical viewer with highly instrumental goals, Dawley recognized the ways structural, stylistic, and strategic appropriation might be activated to further those goals. Emerging in a context of refutation and activated in order to argue that photographic evidence is not self-evident, appropriation came to matter as a way for Dawley to rework the terrain of the debate without overturning core beliefs about the value of "healthy" children.

Magnitude came into play as viewers recognized the enormity of the conditions their fellow citizens faced and sought through their comments to put those conditions into proper proportion. It facilitated arguments about what should be considered important or unimportant and what should be valued or dismissed. Magnitude spoke to viewers' anxieties about an intimidating and overwhelming national situation; viewers managed magnitude by turning the crisis into one over which they might have some control and agency.

Identification and elaboration of this repertoire makes concrete the specific ways that photography fostered in viewers a rhetorical consciousness that enabled them to negotiate the various crises of public life during this period. Thinking in terms of the basic elements of argument—defined loosely as a claim linked to evidence by some warrant or principle of reasoning—we can see that presence, character, appropriation, and magnitude served as a series of connecting principles that grounded the claims viewers made about the photographs they saw. This repertoire emerged out of their understandings of photography's communicative capacities and their participation in particular interpretive communities of culture and experience. Studying the rhetorical practices of photography's viewers, as I have shown here, allows us to get at the important but largely implicit modes of reasoning used by viewers to make sense of the reading problems posed by encounters with particular photographs.

Of that repertoire overall, two concluding points seem in order. First, while one can imagine other cases where elements of this repertoire—say, presence or character—might emerge as key elements of other photographic encounters, I am not interested in arguing about whether any of these elements is "universal" to photographic encounters in general. Rather, my interest is in identifying them when and where they emerge and discerning how they function as rhe-

torical solutions to particular reading problems. In short, I want to insist on photography's *eventfulness*—on the ways that specific viewers in particular times and places creatively sought to make photography matter.

My second point is that this repertoire should not be understood as housed solely in the interaction between photograph and viewer. Responding to an earlier draft of this manuscript, one reviewer asked whether I was claiming the elements of this repertoire as inherent qualities *of photographs*, or was I claiming instead that these are ideas that *viewers bring to* photographs? That is a proverbial "chicken or the egg" question, to be sure. My only answer to this question is to point out that it may be the wrong question. If, as I argued in the introduction, we conceive of photography as an event, a visual habit that endlessly animates relations among its component parts (camera, photographer, subject, photograph, viewer), then the appropriate question is not where precisely presence or whatnot resides (the chicken or the egg), but rather how we account for the encounter between the (always technologically changing) photograph and the (non-monolithic) viewer in that historically specific space of eventful exchange.

In terms of what the project tells us about photographic viewership more broadly, we have learned that viewers are rhetorically conscious agents who invent sophisticated arguments about photographs. Thus photographic viewership is profoundly rhetorical in ways that many histories of photography do not account for. Each of the case studies I have explored here has implicitly shown us that viewership is not the same in all places and situations; rather, it emerges from the photographic encounter in ways that are simultaneously contextual, communal, contestable, and contingent. Photographic viewership is *contextual* in that it is grounded in the historically specific times and places where viewers encounter photographs. What we call "context" are the circumstances that form or shape the setting for an event or situation and within which that situation or event needs to be processed in terms of its potential meanings. In the case of photographs of the war dead and spirit photography, we saw these contextual components in the period's obsession with the idea of the "Good Death" and in the spiritualist desire for the return of spirits to comfort the living. In the case of the FSA photographs at the exposition, we found relevant context in viewers' critiques of the administration's handling of the Roosevelt Recession and their concern that the worst of the Great Depression had not yet passed. Understanding viewership as contextual means acknowledging that photography's viewers do not exist in a vacuum; they live in particular times and places and interact with photographs in the midst of their historically situated social and political experiences.

Photographic viewership is also *communal* in the sense that photography's viewers are socially situated beings with beliefs derived from the common sense of the communities with which they identify. Photography's viewers thus need to be understood not as discrete individuals responding idiosyncratically to images, but instead as participants in interpretive communities that shape and guide those responses. We saw viewership's communal aspects in the ways viewers of the Lincoln photograph tapped into the well-worn and often problematic beliefs in the so-called moral sciences of phrenology and physiognomy. We also encountered a critique of viewership's communal qualities in Dawley's refutation of anti–child labor reform narratives. In critiquing what these narratives of child labor purported to show, Dawley challenged the social knowledge that such forces seemed to take for granted. Understanding photographic viewership as communal means acknowledging the power and influence of particular interpretive communities on the photographic encounter.

Photographic viewership is *contestable* in that it is vulnerable to critique and open to dispute. As the Dawley example illustrates, photography's viewers do not always agree with one another; their interpretations often diverge from or contradict other readings. Dawley mobilized the contestable qualities of viewership most clearly in his strategic appropriation of the photographs of Lewis Hine, where he contested what Hine's images purported to show and offered instead his own readings of them. We also saw viewership's contestable aspects in the hundreds of FSA comments about photographs from the First International Photographic Exposition, where what some viewers called "pure propaganda" was for others a "realistic" social fact requiring immediate policy response. If understanding viewership as communal means recognizing the power of the social, understanding viewership as contestable means leaving room for diverging opinions and debate among them.

Finally, photographic viewership is *contingent* in that it takes place in the realm of what is undecided, uncertain, or up for debate. We tend to think of contingency as marking things perilously beyond the realm of human control; yet, in a world where so much is contingent, to call viewership contingent is also to highlight it as a space for human action, a scene of agency and invention. During the Civil War, photographs of unknown soldiers invited readers and viewers to actively identify, and in some cases imagine, loved ones in the pictures. And viewers of the Lincoln photograph sought to articulate the seeming stability of Lincoln's character in a context of dramatically shifting social demographics that caused uncertainty. Considering viewership as contingent means recognizing that the space of encounter between viewer and photograph opens up opportunities for human agency rather than closing them off.

From the Civil War to the Great Depression, photography shaped a collective consciousness that enabled viewers to negotiate anxieties of the period, from war, poverty, and economic depression to national identity and citizenship. Privileging the agency of viewers invites us to think anew about photography's eventfulness as a historically situated visual habit that is grounded in particular interpretive communities, regularly transformed by technological change, and made rhetorically significant through the engaged creative communication of its viewers. Above all, it invites us to value those historical viewers who made photography matter.

Notes

Introduction

1. In their study of *National Geographic*, Catherine A. Lutz and Jane L. Collins offer a comprehensive approach that studies the history and contemporary production of the magazine, critically analyzes reproductions of photographers' work within the magazine, accounts for the circulation of the magazine, and engages responses to the magazine's images via interviews with contemporary readers and viewers. See Lutz and Collins, *Reading National Geographic* (Chicago: University of Chicago Press, 1993).

Thomas Struth offers a visual response, of sorts, to this dilemma in his large-scale photographic studies of visitors to museums and famous churches. On Struth's work, see Michael Fried, *Why Photography Matters as Art as Never Before* (New Haven, CT: Yale University Press, 2008), 115–42.

2. David Freedberg, *The Power of Images: Studies in the History and Theory of Response* (Chicago: University of Chicago Press, 1989), 39. Freedberg's own answer to this question involves turning to a more general theory of response. By contrast, here I seek to discern historical response (and the broader political implications of that response) by looking for specific textual traces of viewers' encounters with historical photographs.

3. Thomas B. Farrell, *Norms of Rhetorical Culture* (New Haven, CT: Yale University Press, 1993), 16.

4. "Republic of suffering" is Drew Gilpin Faust's term; see Faust, *This Republic of Suffering: Death and the American Civil War* (New York: Vintage Books, 2008).

5. David Zarefsky defines the various ways to understand rhetorical history in "Four Senses of Rhetorical History," in *Doing Rhetorical History: Concepts and Cases*, ed. Kathleen J. Turner (Tuscaloosa: University of Alabama Press, 1998), 19–32.

6. Cara A. Finnegan, "The Naturalistic Enthymeme and Visual Argument: Photographic Representation in the 'Skull Controversy,'" *Argumentation and Advocacy* 37 (2001): 133–49.

7. G. Thomas Goodnight, "Controversy," in *Argument in Controversy: Proceedings of the Seventh Conference on Argumentation*, ed. Donn Parson (Washington, DC: National Communication Association/American Forensic Association, 1991), 1–13.

8. Cara A. Finnegan, *Picturing Poverty: Print Culture and FSA Photographs* (Washington, DC: Smithsonian Books, 2003), xii, xiv–xviii.

9. Ariella Azoulay, *Civil Imagination: A Political Ontology of Photography*, trans. Louise Bethlehem (London: Verso, 2012), 26.

10. Alan Trachtenberg, *Reading American Photographs: Images as History from Mathew Brady to Walker Evans* (New York: Hill and Wang, 1989), 6, 20.

11. Alan Trachtenberg, "Photography: The Emergence of a Keyword," in *Photography in Nineteenth Century America*, ed. Martha A. Sandweiss (Fort Worth: Amon Carter Museum, 1991), 22.

12. Ibid.

13. Barbie Zelizer, *About to Die: How News Images Move the Public* (New York: Oxford University Press, 2010), 6–7.

14. Ibid., 11–12.

15. Robert Hariman and John Louis Lucaites, *No Caption Needed: Iconic Photographs, Public Culture, and Liberal Democracy* (Chicago: University of Chicago Press, 2007), 5.

16. Ibid., 14. On iconoclasm in theories of the public, see Cara A. Finnegan and Jiyeon Kang, "'Sighting' the Public: Iconoclasm and Public Sphere Theory," *Quarterly Journal of Speech* 90, no. 4 (2004): 377–402; Jiyeon Kang and Cara A. Finnegan, "Gross Iconoclasm," *Argumentation and Advocacy* (Spring 2013): 228–30.

17. On social knowledge and the enthymematic functions of photography, see Cara A. Finnegan, "The Naturalistic Enthymeme"; and Cara A. Finnegan, "Recognizing Lincoln: Image Vernaculars in Nineteenth-Century Visual Culture," *Rhetoric & Public Affairs* 8 (Spring 2005): 31–58.

18. Trachtenberg, *Reading American Photographs*, xiv.

19. Trachtenberg does address the reception of the daguerreotype in his "Mirror in the Marketplace: American Responses to the Daguerreotype," in *The Daguerreo-*

type: A Sesquicentennial Celebration, ed. John Wood (Iowa City: University of Iowa Press, 1989), 60–73.

20. Leah Ceccarelli, *Shaping Science with Rhetoric: The Cases of Dobzhansky, Schrödinger, and Wilson* (Chicago: University of Chicago Press, 2001), 8. In the tradition of reader-response theory, scholars have addressed similar questions and issues regarding reading. See, for example, Jane P. Tompkins, ed., *Reader-Response Criticism: From Formalism to Post-Structuralism* (Baltimore: Johns Hopkins University Press, 1980); and Andrew Bennett, ed., *Readers and Reading* (New York: Longman, 1995).

21. Bonnie J. Dow, "Response Criticism and Authority in the Artistic Mode," *Western Journal of Communication* 65, no. 3 (2001): 344.

22. Alan Trachtenberg, "Response from an Adjacent Field," in James Elkins, ed., *Photography Theory* (London: Routledge, 2007), 363.

23. David Freedberg articulates a similar concern about "the failure of art history to deal with the extraordinarily abundant evidence for the ways in which people of all classes and cultures have responded to images," adding, "I did not believe the material (nor indeed the whole matter of response) to be too idiosyncratic or too anecdotal to transcend analysis." See Freedberg, *Power of Images*, xix.

Despite their acknowledgment that viewers' meaning-making practices are complex and varied, many conceptions of visual culture tend to frame viewers as spectators whose experiences of the visual are more or less determined by the overwhelming force of institutions, technologies, or ideologies. For example, in *Practices of Looking: An Introduction to Visual Culture*, Marita Sturken and Lisa Cartwright acknowledge that meaning-making begins with viewers' consumption of images. Yet their chapters on viewership focus on traditional cultural studies frameworks of ideology, interpellation, surveillance, spectatorship, and the gaze to explain how viewers' meaning-making practices are constrained, if not confined, by discourses of power and ideology. While such approaches illuminate much about the conditions for consumption of images in general, they typically have little interest in attending to the experiences of actual viewers in specific historical contexts. Marita Sturken and Lisa Cartwright, *Practices of Looking: An Introduction to Visual Culture* (New York: Oxford University Press, 2001).

24. W. J. T. Mitchell, *Picture Theory* (Chicago: University of Chicago Press, 1994), 21. Mitchell writes here in direct response to Jonathan Crary. Crary argues for the construction of a history of vision that includes attention to the role of the "observing subject" and explicitly eschews the term "spectator" because it suggests the idea of a "passive onlooker at a spectacle" rather than active engagement. However, Mitchell argues that Crary's "observer" is instead inevitably interpolated into a "'dominant model' . . . extracted from physiological optics and optical technology" (21). As a

result, Crary's observer possesses little agency, and Crary, as he himself admits, is uninterested in the empirical specifics of viewership. See also Crary, *Techniques of the Observer: On Visions and Modernity in the Nineteenth Century* (Cambridge: MIT Press, 1990), 5, 7.

25. Karlyn Kohrs Campbell, "Agency: Promiscuous and Protean," *Communication and Critical/Cultural Studies* 2 (2005): 2.

26. Jacques Rancière, *The Emancipated Spectator*, trans. Gregory Elliott (London: Verso, 2009), 12, 103.

27. Ariella Azoulay, *The Civil Contract of Photography*, trans. Rela Mazali and Ruvik Danieli (New York: Zone Books, 2008), 125.

28. As Thomas Farrell has theorized it (via Aristotle), social knowledge is the tacit knowledge that we use to negotiate our historically specific, contingent, everyday experiences. It is not the knowledge of the expert, but rather the shared knowledge of public life that we all use to "get by." See Thomas B. Farrell, "Knowledge, Consensus, and Rhetorical Theory," in John Lucaites, Celeste Condit, and Sally Caudill, eds., *Contemporary Rhetorical Theory: A Reader* (New York: Guilford, 1999), 140–52.

29. Michael Ann Holly, *Past Looking: Historical Imagination and the Rhetoric of the Image* (Ithaca, NY: Cornell University Press, 1996), 26.

30. Thomas B. Farrell, "Sizing Things Up: Colloquial Reflection as Practical Wisdom," *Argumentation* 12 (1998): 1.

Chapter 1. The Presence of Unknown
Soldiers and Imaginary Spirits

1. Peter Gibian describes Holmes as "The mid-century's best-known doctor," "one of the fathers of modern American medicine," as well as "one of America's preeminent literary figures for more than a century." Peter Gibian, *Oliver Wendell Holmes and the Culture of Conversation* (Cambridge: Cambridge University Press, 2001), 2.

2. James McPherson, *Crossroads of Freedom: Antietam* (New York: Oxford University Press, 2002), 3. See also Stephen Sears, *Landscape Turned Red: The Battle of Antietam* (New York: Mariner Books, 1983).

3. Holmes biographer Eleanor Tilton summarizes this incident in *Amiable Aristocrat: A Biography of Dr. Oliver Wendell Holmes* (New York: Henry Schuman, 1947), 269–70. Eliza Richards writes of Holmes's response to the Antietam battlefield in "'Death's Surprise, Stamped Visible': Emily Dickinson, Oliver Wendell Holmes, and Civil War Photography," *Amerikastudien* 54, no. 1 (2009): 13–33.

4. Oliver Wendell Holmes, "My Hunt After the Captain," in *Soundings from* The Atlantic (Boston: Ticknor and Fields, 1864), 64–65. Originally published in the *Atlantic* in December 1862.

5. "The Atlantic Monthly," *Boston Investigator,* December 10, 1862, 253, Gale Digital Collections, 19th-Century U.S. Newspapers database, http://gdc.gale.com/products/19th-century-u.s.-newspapers.

6. "Spirit Photographs: A New and Interesting Development," *Herald of Progress,* November 1, 1862, 4.

7. Ibid.

8. William H. Mumler, *The Personal Experiences of William H. Mumler in Spirit-Photography, Written by Himself* (Boston: Colby and Rich, 1875), 5.

9. "Spirit Photographs," 4. Richard Benson defines a *carte de visite* as "a small photographic portrait, approximately 2¼ by 3½ inches . . . that was mounted on a card similar in size to a calling card." Benson, *The Printed Picture* (New York: Museum of Modern Art, 2008), 316; see also 116–17. Cartes de visite were incredibly popular during the Civil War. Timothy Sweet notes that during the war one large firm, New York's E. and H. T. Anthony and Co., produced upward of thirty-six hundred of them per day. See Sweet, *Traces of War: Poetry, Photography, and the Crisis of the Union* (Baltimore: Johns Hopkins University Press, 1990), 81.

10. "Spirit Photographs," 4.

11. "Pictures of Dead Men," *Daily Evening Bulletin* (San Francisco, CA), January 1, 1863, issue 72, col. B; "Spiritual Photographs," *Daily Cleveland Herald,* November 24, 1862, issue 277, col. C, 19th-Century U.S. Newspapers Database.

12. A. B. Child, "A New Spiritual Phase," *Banner of Light,* November 1, 1862, 4. Reprinted in Louis Kaplan, *The Strange Case of William Mumler, Spirit Photographer* (Minneapolis: University of Minnesota Press, 2008), 39.

13. See, for example, articles published in the *Boston Investigator* on December 3, 10, 17, and 24, 1862; criticism continued into 1863.

14. "Another 'Spiritual' Humbug," *Boston Investigator,* November 12, 1862, issue 28, col. A, 19th-Century U.S. Newspapers database.

15. "Superstition—Spirit Photographs," *Boston Investigator,* December 10, 1862, 253, 19th-Century U.S. Newspapers database.

16. Alan Trachtenberg, *Reading American Photographs: Images as History from Mathew Brady to Walker Evans* (New York: Noonday Press, 1989), 90–93; Trachtenberg, "Photography: The Emergence of a Keyword," in *Photography in Nineteenth-Century America,* ed. Martha A. Sandweiss (Fort Worth: Amon Carter Museum, 1991), 37–45; Sweet, *Traces of War,* 119–20; Shirley Samuels, *Facing America: Iconography and the Civil War* (New York: Oxford University Press, 2004), 75; Richards, "'Death's Surprise, Stamped Visible.'" Of these sources, only Trachtenberg mentions Holmes's commentary on spirit photography, and it is only a passing reference. *Reading American Photographs,* 93.

17. "Virtual witnessing" was coined by Shapin and Schaffer to describe the process by which an author uses techniques to invite readers to imagine themselves at the site

of actual witnessing (as in reports of a scientific experiment). See Steven Shapin and Simon Schaffer, *Leviathan and the Air-Pump: Hobbes, Boyle, and the Experimental Life* (Princeton, NJ: Princeton University Press, 1985). See also Richard Cunningham, *"Virtual Witnessing* and the Role of the Reader in New Natural Philosophy," *Philosophy and Rhetoric* 34 (2001): 207–24; and Jordynn Jack, "A Pedagogy of Sight: Microscopic Vision in Robert Hooke's *Micrographia*," *Quarterly Journal of Speech* 95 (2009): 192–209. For a substantive history of how Americans similarly experienced the daguerreotype through written descriptions, see Marcy J. Dinius, *The Camera and the Press: American Visual Culture and Print Culture in the Age of the Daguerreotype* (Philadelphia: University of Pennsylvania Press, 2012).

18. Chaim Perelman and Lucie Olbrechts-Tyteca, *The New Rhetoric: A Treatise on Argumentation* (Notre Dame, IN: University of Notre Dame Press, 1969), 17. Rhetorical scholarship on presence includes Louise A. Karon, "Presence in *The New Rhetoric*," *Philosophy and Rhetoric* 9 (1976): 96–111; John M. Murphy, "Presence, Analogy, and *Earth in the Balance*," *Argumentation and Advocacy* 31 (1994): 1–16; Robert E. Tucker, "Figure, Ground, and Presence: A Phenomenology of Meaning in Rhetoric," *Quarterly Journal of Speech* 87 (2001): 396–414; and Alan A. Gross, "Presence as Argument in the Public Sphere," *Rhetoric Society Quarterly* 35 (2005): 5–21.

19. Karon, "Presence in *The New Rhetoric*," 97.

20. Ibid.

21. Murphy, "Presence, Analogy, and Earth," 5.

22. Chaim Perelman, *The Realm of Rhetoric* (Notre Dame, IN: University of Notre Dame Press, 1982), 35–38. Similarly, Alan Gross observes that presence may be "created by the manipulation of figure and ground, space, and time." Alan A. Gross, "Presence as Argument," 7. On visual aspects of presence, see Gross, "Presence as Argument" and Alan A. Gross, "Presence as a Consequence of Verbal-Visual Interaction: A Theoretical Approach," *Rhetoric Review* 28, no. 3 (2009): 265–84.

23. Perelman, *Realm of Rhetoric*, 35.

24. Roland Barthes, *Camera Lucida: Reflections on Photography* (New York: Macmillan, 1994), 87.

25. I draw this term from Drew Gilpin Faust, *This Republic of Suffering: Death and the American Civil War* (New York: Vintage Books, 2008).

26. Jackson Lears, *Rebirth of a Nation: The Making of Modern America, 1877–1920* (New York: Harper Collins, 2009), 12.

27. Martha Sandweiss tracks the work of daguerreotypists during the Mexican-American war in *Print the Legend: Photography and the American West* (New Haven, CT: Yale University Press, 2002), 15–45. William A. Frassanito notes that it was not until the Crimean War of the 1850s that there would be "any photographic coverage of a military conflict that can be termed extensive." See William A. Frassanito,

Antietam: The Photographic Legacy of America's Bloodiest Day (New York: Charles Scribner's Sons, 1978), 20.

28. Frassanito, *Antietam*, 17.

29. "Brady's Photographs of the War," *New York Times*, September 26, 1862, 5.

30. Robert Wilson, *Mathew Brady: Portraits of a Nation* (New York: Bloomsbury, 2013), 5.

31. Trachtenberg, *Reading American Photographs*, 33. See also Wilson, *Mathew Brady*, 19–62.

32. Trachtenberg, *Lincoln's Smile and Other Enigmas* (New York: Hill and Wang, 2007), 11.

33. Trachtenberg, *Reading American Photographs*, 33.

34. Ibid., 42.

35. D. Mark Katz, *Witness to an Era: The Life and Photographs of Alexander Gardner* (Nashville: Rutledge Hill Press, 1991), 25.

36. Trachtenberg, *Reading American Photographs,* 73. A valuable record of the full variety of Civil War–era photography may be found in Jeff L. Rosenheim, *Photography and the American Civil War* (New York: Metropolitan Museum of Art, 2013), which is the catalog for the MOMA exhibit of the same name.

37. Keith F. Davis, "'A Terrible Distinctness': Photography of the Civil War Era," in *Photography in Nineteenth Century America*, ed. Martha A. Sandweiss (Fort Worth: Amon Carter Museum, 1991), 135.

38. Katz, *Witness to an Era,* 31. See also Wilson, *Mathew Brady*, 2–5, 121–22.

39. Harry Stout, *Upon the Altar of the Nation: A Moral History of the Civil War* (New York: Viking, 2006), 157. On Gardner and Brady's early relationship, see Katz, *Witness to an Era*, 14–16.

40. Katz, *Witness to an Era*, 28.

41. Frassanito, *Antietam*, 51–52. See also Wilson, *Mathew Brady*, 131–33.

42. Frassanito, *Antietam*, 53.

43. On stereo cards, see Benson, *Printed Picture*, 114–15. On Holmes Sr. and the stereoscope, see Nancy M. West, "Fantasy, Photography, and the Marketplace: Oliver Wendell Holmes and the Stereoscope," *Nineteenth-Century Contexts* 19 (1996): 231–58. Of the stereoscope Holmes invented himself, West writes that he "marketed it without a patent so as to encourage its widespread popularity" (238). On Holmes's interest in stereoscopic photography, see also Miles Orvell, *The Real Thing: Imitation and Authenticity in American Culture, 1880–1940* (Chapel Hill: University of North Carolina Press, 1989), 75–77. Emily Godbey discusses death in Civil War stereographs in Godbey, "'Terrible Fascination': Civil War Stereographs of the Dead," *History of Photography* 36, no. 2 (2012): 265–74. Brent Malin examines how early twentieth-century producers of stereographic photography framed stereoscopy as a white, middle-class practice; see Malin, "Looking White and Middle Class: Ste-

reoscopic Imagery and Technology in the Early Twentieth-Century United States," *Quarterly Journal of Speech* 93, no. 4 (2007): 403–24; and Brenton J. Malin, *Feeling Mediated: A History of Media Technology and Emotion in America* (New York: NYU Press, 2014), 71–105.

44. Frassanito, *Antietam*, 26.

45. Ibid., 203.

46. Ibid., 17.

47. McPherson, *Crossroads of Freedom*, 7.

48. Joshua Brown, *Beyond the Lines: Pictorial Reporting, Everyday Life, and the Crisis of Gilded Age America* (Berkeley: University of California Press, 2002), 45.

49. "The Battle of Antietam," *Harper's Weekly*, October 18, 1862, 663. HarpWeek database, http://www.harpweek.com.

50. Ibid. Frassanito reproduces the photographs on which the engraving is based. He suggests that the buried body is likely a Union soldier, while the remaining one is a Confederate. Frassanito, *Antietam*, 180–81.

51. "Battle of Antietam," 663.

52. Davis, "'Terrible Distinctness,'" 152.

53. "Brady's Photographs: Pictures of the Dead at Antietam," *New York Times,* October 20, 1862, 5. A number of scholars quote from this review. Among them, see Trachtenberg, *Reading American Photographs*, 74; Stout, *Upon the Altar*, 159; Davis, "'Terrible Distinctness,'" 150, 152; Rosenheim, *Photography and the American Civil War*, 8–9; and Godbey, "'Terrible Fascination,'" 269.

54. "Brady's Photographs," 5.

55. Ibid.

56. Ibid. William Frassanito reproduces a large chunk of this article in his book, but omits the portions I quote here. Frassanito, *Antietam*, 15–17. Robert Wilson says that viewers at the gallery would have studied "the stereo images on the sort of box stereograph viewer that Brady also had in his Washington studio," so they would have been seeing them in 3D. Wilson, *Mathew Brady*, 137.

57. "Brady's Photographs," 5.

58. Photography historian Robert Taft notes that stereoscopic negatives were usually 3½ by 7 inches in size; each photo would thus have been 3½ inches square. Robert Taft, *Photography and the American Scene* (Mineola, NY: Dover, 1938), 171.

59. Oliver Wendell Holmes, "The Stereoscope and the Stereograph," in *Classic Essays on Photography*, ed. Alan Trachtenberg (New Haven, CT: Leete's Island Books, 1980), 78.

60. "Brady's Photographs," 5.

61. Ibid.

62. Karon, "Presence in *The New Rhetoric*," 97.

63. Holmes, "My Hunt," 29.

64. Frassanito, *Antietam*, 286.

65. Katz, *Witness to an Era*, 63.

66. Frassanito, *Antietam*, 285. See also William A. Frassanito, *Gettysburg: A Journey in Time* (Gettysburg, PA: Thomas Publications, 1975), 27.

67. Wilson, *Mathew Brady*, 142.

68. The Christian Commission, an outgrowth of the YMCA, operated from 1861 to 1866. Volunteer "delegates" traveled to camps, battlefields, and hospitals to evangelize Union soldiers and support their spiritual and material needs. In addition to distributing Bibles and other religious tracts, delegates of the Christian Commission provided food and clothing, worked at hospitals, helped soldiers write letters home, and even helped to bury the dead after battle. See David Alan Raney, "In the Lord's Army: The United States Christian Commission in the Civil War," PhD diss., University of Illinois at Urbana-Champaign, 2001. See also Rev. Edward P. Smith, *Incidents of the United States Christian Commission* (Philadelphia: J. P. Lippincott, 1869).

69. "City Affairs: A Christian Commission Delegate's Story," *North American and United States Gazette*, June 15, 1864, 215, 19th-Century U.S. Newspapers database.

70. For a discussion of the cultural beliefs about death that framed the construction of the Gettysburg cemetery, see Garry Wills, *Lincoln at Gettysburg: The Words That Remade America* (New York: Simon and Schuster, 1992), 63–89.

71. "The National Cemetery at Gettysburg," *Boston Daily Advertiser*, March 18, 1864, issue 66 column F, 19th-Century U.S. Newspapers database.

72. The most complete treatment of the Humiston case is Mark Dunkelman, *Gettysburg's Unknown Soldier: The Life, Death, and Celebrity of Amos Humiston* (Westport, CT: Praeger, 1999). More recently, filmmaker Errol Morris relied on the accounts of Dunkelman and others in a five-part essay published first on his *New York Times* blog, "Zoom," and later in his book *Believing Is Seeing: Observations on the Mysteries of Photography* (New York: Penguin, 2011), 221–71. See also Drew Gilpin Faust, *Republic of Suffering*, 11–12; Rosenheim, *Photography and the American Civil War*, 162–63. On the use of the ambrotype for fund-raising, see Kathleen Collins, "Photographic Fundraising: Civil War Philanthropy," *History of Photography* 11, no. 3 (1987): 173–87. A contemporaneous source that mentions the Humiston story is E. Smith, *Incidents of the United States Christian Commission*, 175–76.

73. Stephen W. Sears, *Gettysburg* (Boston: Houghton-Mifflin, 2003), 221; Dunkelman, *Gettysburg's Unknown Soldier*, 118–20. Several members of the 154th were shot or captured. Dunkelman states that Amos Humiston "survived the firestorm at the brickyard" but was likely shot and killed while trying to escape to safety (120).

74. Dunkelman, *Gettysburg's Unknown Soldier*, 130.

75. Ibid.

76. The ambrotype was the next generation of wet-plate photographs to follow

the daguerreotype. Richard Benson defines it as "a lightly exposed wet-plate glass negative that appears as a positive when placed on a black backing." Benson, *Printed Picture*, 314. Beaumont Newhall writes that ambrotypes "lack the brilliancy of daguerreotypes, but they were easier to produce, and to professionals the fact that they could be finished and delivered at the time of the sitting was their most attractive feature." By 1863, Newhall notes, the ambrotype was already becoming obsolete. Newhall, *The History of Photography* (New York: Museum of Modern Art, 5th ed., 1994), 63.

77. Dunkelman, *Gettysburg's Unknown Soldier*, 132.

78. Ibid., 133.

79. Ibid., 138.

80. Ibid., 140.

81. Ibid.

82. Faust, *Republic of Suffering*, 8–9.

83. Dunkelman, *Gettysburg's Unknown Soldier*, 140.

84. Ibid.

85. "Whose Father Was He?" *Washington Daily National Intelligencer*, October 23, 1863, issue 15, 968, col. B; "Whose Father Was He?" *Natchez (MS) Courier*, November 3, 1863, issue 10, col. B.; "Whose Father Was He?" *Lowell (MA) Daily Citizen and News*, November 4, 1863, issue 2304, col. E; "Whose Father Was He?" *Boston Investigator,* November 11, 1863, 214, issue 27, col. A., 19th-Century U.S. Newspapers database. Dunkelman mentions several New York state newspapers in which the article appeared. Though these papers would have been more likely to reach the Humistons in New York, they were not the vehicles by which Humiston was identified (142).

86. Dunkelman, *Gettysburg's Unknown Soldier*, 143.

87. Ibid., 149.

88. Ibid., 150.

89. Ibid., 155.

90. Dunkelman narrates in detail the experiences of the Humiston family after the photograph was identified and they became celebrities; see Dunkelman, *Gettysburg's Unknown Soldier*, 151–98. Kathleen Collins notes that the Humiston children's photograph was one of the best-selling philanthropic images of the war; see Collins, "Photographic Fundraising," 181–85; see also Dunkelman, *Gettysburg's Unknown Soldier*, 163. *Frank Leslie's Illustrated Newspaper* visually imagined Humiston's dying moments in an engraving published in its January 2, 1864, issue. Dunkelman, *Gettysburg's Unknown Soldier*, 161–62; Faust, *Republic of Suffering*, 12. Not soon after, songs and poems dedicated to the children and to Amos Humiston appeared.

Dunkelman, *Gettysburg's Unknown Soldier*, 167–72; Collins, "Photographic Fundraising," 183.

91. "An Unknown Soldier," *Harper's Weekly*, October 24, 1868, 679, 684, Harp-Week database. See also Faust, *Republic of Suffering*, 130–31.

92. "Unknown Soldier," 679.

93. Faust states the sum was quite large: $360. Faust, *Republic of Suffering*, 130.

94. "Unknown Soldier," 679. Faust explains that Meigs was "responsible for executing federal policy on graves and interments" (238).

95. Faust, *Republic of Suffering*, 130.

96. Ibid.

97. Ibid.

98. Key biographies and critical studies include E. M. Tilton, *Amiable Aristocrat*; Gibian, *Oliver Wendell Holmes and the Culture of Conversation*; and Michael A. Weinstein, *The Imaginative Prose of Oliver Wendell Holmes* (Columbia: University of Missouri Press, 2006).

99. Alan Trachtenberg reprints an abridged version of "The Stereoscope and the Stereograph" in his edited *Classic Essays on Photography* (Stony Creek, CT: Leete's Island Books, 1980), 71–82. All three are collected together in *Soundings of* The Atlantic, an anthology of Holmes's *Atlantic* writings. On these Holmes essays and the relationship of stereoscopy to touch, see John Plunkett, "'Feeling Seeing': Touch, Vision and the Stereoscope," *History of Photography* 37, no. 4 (2013): 389–96.

100. Holmes, "Stereoscope and Stereograph," 153.

101. On this point, see also Orvell, *Real Thing*, 75–76.

102. Holmes, "Stereoscope and Stereograph," 126.

103. Ibid., 140.

104. Oliver Wendell Holmes Sr., "Sun-Painting and Sun-Sculpture," *Soundings of* The Atlantic, 178.

105. Of the importance of Anthony's, Taft writes, "This firm for nearly half a century was the principal photographic supply house in this country." *Photography and the American Scene*, 54.

106. Holmes, "Doings of the Sunbeam," *Soundings of* The Atlantic, 252. Anne Teresa Demo and Kevin DeLuca write about Watkins's Yosemite photographs, although they do not mention that they were stereographs. Demo and DeLuca, "Imaging Nature: Watkins, Yosemite, and the Birth of Environmentalism," *Critical Studies in Media Communication* 17 (2000): 241–60.

107. Holmes, "Doings of the Sunbeam," 265.

108. Ibid., 266.

109. Ibid.

110. Ibid.

111. Ibid.

112. Holmes states that he was there "the Sunday following the Wednesday when the battle took place." "Doings of the Sunbeam," 266. Frassanito explains that evidence shows that photographers Garner and Gibson were likely in the battlefield area on September 18, the day after the battle, which means their battlefield dead photographs were made between September 19 and 22. If Holmes Sr.'s statement is accurate, then he would have been on the battlefield on the 21st. Frassanito, *Antietam*, 51–52. While it's possible that Holmes saw unburied bodies during his visit, it seems more likely that he saw other remnants of the battle, the things he mentions in "My Hunt After the Captain."

113. Holmes, "Doings of the Sunbeam," 267.

114. Ibid.

115. See, for example, Sweet, *Traces of War*, 119–20; Trachtenberg, *Reading American Photographs*, 90–93.

116. On photographs of trauma, pain, and death, see Elaine Scarry, *The Body in Pain: The Making and Unmaking of the World* (New York: Oxford University Press, 1987); Susan Sontag, *Regarding the Pain of Others* (New York: Farrar, Strauss, and Giroux, 2002); Barbie Zelizer, *About to Die: How News Images Move the Public* (New York: Oxford University Press, 2010); Susie Linfield, *The Cruel Radiance: Photography and Political Violence* (Chicago: University of Chicago Press, 2010).

117. Holmes, "Doings of the Sunbeam," 268.

118. Ibid., 269.

119. Ibid., 276.

120. Ibid., 277.

121. Ibid.

122. Ibid., 278.

123. Ibid., 277.

124. Jack, "Pedagogy of Sight," 193.

125. *Harper's Weekly*, May 8, 1869, 304.

126. A number of sources suggest that the mayor's office was alerted to Mumler's activities by P. V. Hickey of the *New York World*, who was a member of a local and influential photographers' group called the Photographic Section of the American Institute. See Michael Leja, *Looking Askance: Skepticism and American Art from Eakins to Duchamp* (Berkeley: University of California Press, 2004), 24; Elbridge T. Gerry, *The Mumler 'Spirit' Photograph Case: Argument of Mr. Elbridge T. Gerry, of Counsel for the People, before Justice Dowling, on the Preliminary Examination of Wm. H. Mumler, Charged with Obtaining Money by Pretended 'Spirit' Photographs; Reported by Andrew Devine* (New York: Barker, Voorhis, and Co., Law Publishers, 1869), 4; Charles W. Hull, "New York Correspondence," *Philadelphia Photographer*

6 (1869): 199–203; Cloutier, "Mumler's Ghosts: The Trials and Tribulations of Spirit Photography," MA thesis, Arizona State University, 1998.

127. Gerry, "Mumler 'Spirit' Photograph Case," 5. Gerry's closing argument is also anthologized in Kaplan, *Strange Case of William Mumler*, 140–79. Mumler's wife (who claimed to be a spirit medium) and his business partner, William Guay, participated in the spirit photography business as well but were never charged.

128. "The next time the news is dull . . .," *Boston Daily Advertiser*, May 5, 1869, col. A, 19th-Century U.S. Newspapers database.

129. Holmes, "Doings of the Sunbeam," 278.

130. For years the Mumler trial remained nearly unknown, an amusing (and perhaps embarrassing) footnote in mainstream scholarly discussions of U.S. photographic history and spiritualism. Notably, the key histories of the American spiritualist movement do not mention the trial or spirit photography at all; see, for example, Ann Braude, *Radical Spirits: Spiritualism and Women's Rights in Nineteenth Century America*, 2nd ed. (Bloomington: Indiana University Press, 2001) and Bret E. Carroll, *Spiritualism in Antebellum America* (Bloomington: Indiana University Press, 1997). But scholarship on the Mumler trial has blossomed in the last decade or so as historians and critics began to view the trial and the events surrounding it as a compelling lens through which to explore a variety of aspects of nineteenth-century science, law, and visual culture. For example, Jennifer Tucker situates the trial in the context of science in the late nineteenth century; see Tucker, "Photography as Witness, Detective, and Impostor: Visual Representation in Victorian Science," *Victorian Science in Context*, ed. Bernard Lightman (Chicago: University of Chicago Press, 1997), 378–408. Jennifer Mnookin and Heinz and Bridget Henisch examine the trial as an important moment in the history of the use of photographs as legal evidence in U.S. courts; see Mnookin, "The Image of Truth: Photographic Evidence and the Power of Analogy," *Yale Journal of Law and the Humanities* (Winter 1998): 1–57 (Lexis Nexis pagination); and Heinz K. Henisch and Bridget A. Henisch, *The Photographic Experience, 1839–1914: Images and Attitudes* (University Park: Pennsylvania State University Press, 1994), 309–10.

Tom Gunning features Mumler in his discussion of the practice of spirit photography as an art of the "uncanny," one in which the world of spirits, death, and the afterlife merged with modern discourses of technology and public spectacle; see Gunning, "Phantom Images and Modern Manifestations," *Fugitive Images: From Photography to Video*, ed. Patrice Petro (Bloomington: Indiana University Press, 1995), 42–71. See also Gunning, "Ghosts, Photography and the Modern Body," in *The Disembodied Spirit*, ed. Alison Ferris (Bowdoin, ME: Bowdoin College Museum of Art, 2003), 8–19. Art historians interested in the occult see in Mumler's work the origins of a genre of spirit or ghost photography that persists to today; see Clem-

ent Cheroux, Andreas Fischer, Pierre Apraxine, Denis Canguilhem, and Sophie Schmit, eds., *The Perfect Medium: Photography and the Occult* (New Haven, CT: Yale University Press, 2005), the catalog for an exhibit of the same name. See also the 2003 special issue of *Art Journal* on spirit photography, including Alison Ferris, "Disembodied Spirits: Spirit Photography and Rachel Whiteread's 'Ghost,'" *Art Journal* 62 (2003): 44–55; Louis Kaplan, "Where the Paranoid Meets the Paranormal: Speculations on Spirit Photography," *Art Journal* 62 (2003): 18–29; and Karl Schoonover, "Ectoplasms, Evanescence, and Photography," *Art Journal* 62 (2003): 30–43. Finally, Michael Leja suggests that the trial be understood as an example of the growth of a visual culture that would demand of viewers a more modern sense of irony. Leja, *Looking Askance.*

Beyond the scholarship cited above, a number of other sources offer details surrounding Mumler's arrest and trial in New York; not all details are consistent across sources, but most offer a common general outline of events. See James Coates, *Photographing the Invisible: Practical Studies in Spirit Photography, Spirit Portraiture, and Other Rare but Allied Phenomena* (1911; New York: Arno Press, 1973), 4–11; Cloutier, "Mumler's Ghosts"; Kristy Sharpe, "A Stupendous Fraud: The Rise and Fall of William Mumler, Spirit Photographer," MA thesis, Simmons College, 2006; Martyn Jolly, *Faces of the Living Dead* (West New York, NJ: Mark Batty, 2006). A helpful volume of primary sources about the Mumler trial, which includes two critical essays by the editor, is Kaplan, *Strange Case of William Mumler.*

131. See, for example, "Letter from New York," *Daily Evening Bulletin* (San Francisco), May 11, 1869, col. B; "Spiritual Photography," *Milwaukee Daily Sentinel*, May 1, 1869, col. C; *Charleston (SC) Courier*, "Our New York Correspondence," May 1, 1869, col. B, 19th-Century U. S. Newspapers database.

132. Carroll, *Spiritualism in Antebellum America*, 1.

133. See ibid., 4; Braude, *Radical Spirits*, 3–4.

134. On metaphors of electricity in spiritualism, see Braude, *Radical Spirits*, 23–24; Carroll, *Spiritualism in Antebellum America*, 68–69. Carroll observes that a popular spiritualist newspaper was called *The Spiritual Telegraph.*

135. John Durham Peters, *Speaking into the Air: A History of the Idea of Communication* (Chicago: University of Chicago Press, 1999), 100. On spiritualism and communication, see also Joshua Gunn, *Modern Occult Rhetoric: Mass Media and the Drama of Secrecy in the Twentieth Century* (Tuscaloosa: University of Alabama Press, 2005), 62–65.

136. On Barnum, see James W. Cook, *The Arts of Deception: Playing with Fraud in the Age of Barnum* (Cambridge: Harvard University Press, 2001).

137. P. T. Barnum, *The Humbugs of the World* (1865; Detroit: Singing Tree Press, 1970). Barnum discusses spirit photography, making veiled reference to Mumler's discovery of spirit photographs, on 77–85.

138. Leja, *Looking Askance*, 53. For primary texts illustrating Barnum's various hoaxes and amusements, see James W. Cook, ed., *The Colossal P. T. Barnum Reader: Nothing Else Like It in the Universe* (Urbana: University of Illinois Press, 2005).

139. "Spiritual Photography," *Milwaukee Daily Sentinel*, May 4, 1869, col. C., 19th-Century U.S. Newspapers database; brackets on "laughter" in original.

140. "Home and Foreign Gossip," 315.

141. "Spiritual Photography," *Harper's*, May 8, 1869, 289, HarpWeek database.

142. Ibid.

143. Livermore's account appears in Mumler's *Personal Experiences*, 24–25; see also Kaplan, *Strange Case of William Mumler*, 87–88. Prosecutor Gerry also mentioned Livermore in his closing argument. Gerry, "The Mumler 'Spirit' Photograph Case," 18, 34, 36–37, 50; and Kaplan, *Strange Case of William Mumler*, 152, 164, 166–67, 175. A reproduction of the spirit photograph in question may be found in Kaplan, *Strange Case of William Mumler*, 167.

144. "Ghostly Portraits," *Daily Cleveland Herald*, April 26, 1869, issue 99, col. D., 19th-Century U.S. Newspapers database. News accounts offer slightly differing stories of Livermore's testimony on the stand, but let's set the scene using Mumler's own description, years later in his 1875 autobiography, of Livermore's visit to his studio in New York City:

> Mr. Livermore sat three times, and I did not succeed in getting a spirit form. Mr. L. remarked that he had a severe headache, and did not think I would be successful. I however proposed to make one more trial, which he acceded to, and this time appeared on the plate the form of a lady standing behind him, with one hand on his forehead, and the other resting on his breast, holding a bunch of lilacs. The negative was shown him, when he desired me to make another trial, which I did; and this time I succeeded in getting the same face, but in a different attitude.... [more times this happens].... On receiving the pictures, he exclaimed, 'I shall never doubt any more.' I asked him if he recognized the likeness, and he replied, 'It is my wife.' Here, then, is a test that is simply unanswerable—the unmistakable likeness of this gentleman's wife appearing in three different positions, totally unlike any that she had taken during life. Mr. Livermore testified to the above facts, under oath, at my trial; and when the Judge asked him if he recognized these pictures as likenesses of his wife, his answer was, 'Unmistakably.'

Mumler, *Personal Experiences of William H. Mumler*, 24.

145. "Ghostly Portraits."

146. Mumler, *Personal Experiences of William H. Mumler*, 24.

147. Livermore qtd. in Leja, *Looking Askance*, 30–31.

148. "Ghostly Portraits."

149. Ibid.

150. Ibid.

151. Ibid.

152. Gerry, "Mumler 'Spirit' Photograph Case," 18.

153. "Spirit Photography," *New York Times*, April 27, 1869, 8.

154. Hull, "New York Correspondence," 199–203.

155. Gerry, "Mumler 'Spirit' Photograph Case," 19; emphasis in original.

156. "The Fools Not All Dead," *New York Observer and Chronicle*, May 6, 1869, 142, American Periodicals Series database, ProQuest, http://www.proquest.com/products-services/aps.html.

157. "Spirit-Photographs," *Saturday Evening Review*, May 15, 1869, 2, American Periodicals Series database.

158. Some time after the trial Mumler returned to Boston and resumed his photography business there. In March 1872, Boston newspapers reported that a certain famous widow had visited Mumler's studio; she used the name "Mrs. Tyndall" and hid her face under a veil until it was time for the photograph to be made. Mumler wrote, "Subsequent events have proved the lady to be Mrs. Lincoln. Who the 'ghost-like image' looks like I leave to you to judge and draw your own inferences. Suffice it to say the lady fully recognized the picture." See "Mrs. Abraham Lincoln Sits for a Spiritpicture [*sic*]," *Daily Central City (CO) Register*, March 16, 1872, col. D, 19th-Century U.S. Newspapers database.

159. "That Prince of Spiritualist Humbugs . . . ," *Vermont Chronicle* (Bellows Falls), July 10, 1869, 3, 19th-Century U.S. Newspapers database.

Chapter 2. Recognizing Lincoln

1. The photograph was most likely made in 1846 or 1847 in Springfield, Illinois, by local photographer N. H. Shepherd. See Charles Hamilton and Lloyd Ostendorf, *Lincoln in Photographs: An Album of Every Known Pose* (Norman: University of Oklahoma Press, 1963), 4–5. It was given to the Library of Congress in 1937 by Robert Todd Lincoln's daughter Mary Lincoln Isham. Gibson William Harris, who read law in Lincoln's Springfield office in the mid-1840s, identified the photographer as Shepherd in a 1903 magazine article. He claimed that he and Shepherd roomed together at a local boardinghouse and recalled that Shepherd was "among the very first of his line [photographers] to come as far west as Illinois" (11). See Gibson William Harris, "My Recollections of Abraham Lincoln," *Woman's Home Companion*, November 1903, 9–11. Parts of Harris's reflections are reprinted in Rufus Rockwell Wilson, *Lincoln in Portraiture* (New York: Press of the Pioneers, 1935), 21–22.

2. "Miss Tarbell's Life of Lincoln," *McClure's*, January 1896, 208.

3. "The Earliest Portrait of Lincoln: Letters in Regard to the Frontispiece of the November McClure's," *McClure's*, December 1896, 112.

4. Scholars of rhetoric have examined primarily Lincoln's oratory. See, for ex-

ample, Marie Hochmuth Nichols, "Lincoln's First Inaugural," in *American Speeches*, ed. Wayland Maxfield Parrish and Marie Hochmuth Nichols (New York: David McKay, 1954), 60–100; Michael C. Leff and Gerald P. Mohrmann, "Lincoln at Cooper Union: A Rhetorical Analysis of the Text," *Quarterly Journal of Speech* 60, no. 3 (1974): 346–58; Michael C. Leff, "Dimensions of Temporality in Lincoln's Second Inaugural," *Communication Reports* 1 (1988): 26–31; David Zarefsky, *Lincoln, Douglas, and Slavery: In the Crucible of Public Debate* (Chicago: University of Chicago Press, 1993); Amy Slagell, "Anatomy of a Masterpiece: A Close Textual Analysis of Abraham Lincoln's Second Inaugural Address," *Communication Studies* 42, no. 2 (1991): 155–71; and Lloyd Bitzer, "Gettysburg and Silence," *Quarterly Journal of Speech* 80 (1994): 21–36. See also "Lincoln's Rhetorical Worlds," a 2010 special issue of *Rhetoric & Public Affairs* edited by Cara A. Finnegan and John M. Murphy and featuring essays on Lincoln's rhetoric by David Zarefsky, Angela Ray, Kirt Wilson, and Susan Zaeske.

Rhetoric scholars' attention to Lincoln in public memory is increasing. On the post-assassination genre of Lincoln reminiscences, see Shawn J. Parry-Giles and David S. Kaufer, "Lincoln Reminiscences and Nineteenth-Century Portraiture: The Private Virtues of Presidential Character," *Rhetoric & Public Affairs* 15, no. 2 (2012): 199–234. Greg Goodale describes how early twentieth-century audio recordings created the false impression of Lincoln as a manly baritone because the new sound era of presidential speech emphasized "manliness." See Goodale, "The Presidential Sound: From Orotund to Instructional Speech, 1892–1912," *Quarterly Journal of Speech* 96, no. 2 (2010): 178; and Goodale, *Sonic Persuasion: Reading Sound in the Recorded Age* (Urbana: University of Illinois Press, 2011), 45. On the use of Lincoln as a rhetorical touchstone for national memory, see Bradford Vivian, *Public Forgetting: The Rhetoric and Politics of Beginning Again* (University Park: Pennsylvania State University Press, 2010), in particular chapters 3 and 6. Especially important is the work of Charles E. Morris III on Lincoln, sexuality, and public memory. See Morris, "My Old Kentucky Homo: Lincoln and the Politics of Queer Public Memory," in *Framing Public Memory*, ed. Kendall R. Phillips (Tuscaloosa: University of Alabama Press, 2004), 89–114; Morris, "Hard Evidence: The Vexations of Lincoln's Queer Corpus," in *Rhetoric, Materiality, and Politics*, ed. Barbara Biesecker and John Lucaites (New York: Peter Lang, 2009), 185–214; and Morris, "Sunder the Children: Abraham Lincoln's Queer Rhetorical Pedagogy," *Quarterly Journal of Speech* 99, no. 4 (2013): 395–422.

5. I will admit to hedging on offering a specific number here. In 1963 Charles Hamilton and Lloyd Ostendorf noted that there are more than 100 extant photographs of Lincoln. See Hamilton and Ostendorf, *Lincoln in Photographs*, ix–x. The number 114 is offered in the more recent calculations of Philip B. Kunhardt III, Peter W. Kunhardt, and Peter W. Kunhardt Jr., eds., *Looking for Lincoln: The Making of*

an American Icon (New York: Alfred A. Knopf, 2008), 461–74. Since 2007 at least two photographs surfaced that experts believe likely include Lincoln. The Kunhardts include one of these in their count. See "Images of Lincoln at Gettysburg," *USA Today*, November 15, 2007, http://www.usatoday.com/news/nation/2007-11-15 -gettysburg-images_N.htm; "Photo May Be Only One of Lincoln in Front of White House," *New York Times*, March 10, 2009, http://www.nytimes.com/2009/03/11/ arts/design/11abe.html.

6. Barry Schwartz traced references to both Lincoln and Washington in newspapers and in the *Congressional Record* from roughly 1865 to 1920. He found that references to Lincoln markedly increased after 1900 and soon thereafter surpassed references to Washington. See Barry Schwartz, *Abraham Lincoln and the Forge of National Memory* (Chicago: University of Chicago Press, 2000), 57–58, 78, 110–13. See also Marcus Cunliffe, "The Doubled Images of Lincoln and Washington," in *Gettysburg College*, 26th Annual Robert Fortenbaugh Memorial Lecture (Gettysburg, PA: Gettysburg College, 1988), 7–34; and Merrill D. Peterson, *Lincoln in American Memory* (New York: Oxford University Press, 1994), 27–29.

7. Harold Holzer is the foremost scholar of the visual iconography of Lincoln. See Harold Holzer, *Lincoln Seen and Heard* (Lawrence: University Press of Kansas, 2000); Harold Holzer, Gabor S. Boritt, and Mark E. Neely Jr., *The Lincoln Image: Abraham Lincoln and the Popular Print* (Urbana: University of Illinois Press, 2001); and Harold Holzer, Gabor S. Boritt, and Mark E. Neely Jr., *Changing the Lincoln Image* (Fort Wayne: Louis A. Warren/Lincoln Library and Museum, 1985). On popular twenty-first century photographs of Lincoln, see Elizabeth Young, "Lincoln and the Civil War in Twenty-First Century Photography," in *Remixing the Civil War: Meditations on the Sesquicentennial*, ed. Thomas J. Brown (Baltimore: Johns Hopkins University Press, 2011), 112–36.

8. Barry Schwartz, "The Reconstruction of Abraham Lincoln," in *Collective Remembering*, ed. David Middleton and Derek Edwards (London: Sage, 1990), 101.

9. Kunhardt, Kunhardt, and Kunhardt, *Looking for Lincoln*, xi.

10. Thomas B. Farrell, *Norms of Rhetorical Culture* (New Haven, CT: Yale University Press, 1993), 41.

11. Craig R. Smith, "*Ethos* Dwells Pervasively: A Hermeneutic Reading of Aristotle on Credibility," in *The Ethos of Rhetoric*, ed. Michael J. Hyde (Columbia: University of South Carolina Press, 2004), 3.

12. S. Michael Halloran, "On the End of Rhetoric, Classical and Modern," *College English* 36 (1975): 621.

13. Farrell, *Norms of Rhetorical Culture*, 84. On the communal quality of ethos, see also S. Michael Halloran, "Doing Public Business in Public," in *Form and Genre: Shaping Rhetorical Action*, ed. Karlyn Kohrs Campbell and Kathleen Hall Jamieson (Falls Church, VA: Speech Communication Association, 1978), 123; essays in Hyde,

Ethos of Rhetoric; Risa Applegarth, "Genre, Location, and Mary Austin's Ethos," *Rhetoric Society Quarterly* 41 (2011): 41–63.

14. Dale Sullivan, "The Ethos of Epideictic Encounter," *Philosophy and Rhetoric* 26 (1993): 127; Michael Hyde, "Introduction: Rhetorically, We Dwell," in *Ethos of Rhetoric*, xiii.

15. The *McClure's* series is discussed in M. Peterson, *Lincoln in American Memory*, 148–55; and in Kunhardt, Kunhardt, and Kunhardt, *Looking for Lincoln*, 334–36.

16. Tarbell was already a veteran writer for *McClure's*; during its first year she wrote a popular series, "Life of Napoleon," for the magazine. On Tarbell, see Kathleen Brady, *Ida Tarbell: Portrait of a Muckraker* (New York: Seaview/Putnam, 1984); see also Tarbell's autobiography, *All in a Day's Work* (New York: Macmillan, 1939).

17. M. Peterson, *Lincoln in American Memory*, 149.

18. In particular, Tarbell relied heavily on the work of Lincoln's former secretaries, John Nicolay and John Hay. See John G. Nicolay and John Hay, *Abraham Lincoln: A History* (New York: Century Co., 1890); *Century* magazine serialized this book in the late 1880s.

19. Judith A. Rice, "Ida M. Tarbell: A Progressive Look at Lincoln," *Journal of the Abraham Lincoln Association* 19 (1998):59.

20. Brady, *Ida Tarbell*, 96–98; M. Peterson, *Lincoln in American Memory*, 150–52; quotation 153.

21. Rice, "Ida M. Tarbell," 61; Herndon qtd. in Kunhardt, Kunhardt, and Kunhardt, *Looking for Lincoln*, 336.

22. Rice, "Ida M. Tarbell," 62.

23. Kunhardt, Kunhardt, and Kunhardt, *Looking for Lincoln*, 336.

24. At the time he founded *McClure's*, S. S. McClure had about a decade of experience in the magazine business and was founder and head of one of the first publishing syndicates, the Associated Literary Press (also known as the McClure Syndicate), which began in 1884. See Harold S. Wilson, *McClure's Magazine and the Muckrakers* (Princeton, NJ: Princeton University Press, 1970), 40.

25. The monthly magazine first sold for fifteen cents an issue (most similar magazines sold for twenty-five to thirty-five cents). McClure later cut the price to ten cents. See Theodore Peterson, *Magazines in the Twentieth Century* (Urbana: University of Illinois Press, 1964), 6–7, 9–10. On *McClure's* and its early readership, see also Richard Ohmann, *Selling Culture: Magazines, Markets, and Class at the Turn of the Century* (New York: Verso, 1996), 227–30.

26. S. S. McClure, *My Autobiography* (New York: Frederick A. Stokes Co., 1914), 130.

27. Ulrich Keller, "Early Photojournalism," *Communication in History: Technology, Culture, and Society*, ed. David Crowley and Paul Heyer (Boston: Allyn and Bacon, 2003), 172.

28. On the importance of halftone to the circulation of photographs in print culture, see Robert Taft, *Photography and the American Scene* (Mineola, NY: Dover, 1938), 427–41, 446. On the technology of "photography in ink," including early halftone technologies, see Richard Benson, *The Printed Picture* (New York: Museum of Modern Art, 2008), 220–23.

29. Brady, *Ida Tarbell*, 92.

30. Wilson, *McClure's Magazine*, 73. This interest was made material in more ways than one; according to Wilson, McClure later sponsored "Lincoln scholarships at Knox" (74).

31. McClure, *My Autobiography*, 141; see also Rice, "Ida M. Tarbell," 59.

32. Wilson, *McClure's Magazine*, 7, 10–12.

33. Ibid., 109.

34. "Editorial Announcement," *McClure's*, November 1895, 483–84.

35. T. Peterson, *Magazines in Twentieth Century*, 10; McClure, *My Autobiography*, 222.

36. Brady, *Ida Tarbell*, 98–99; M. Peterson, *Lincoln in American Memory*, 151.

37. The "tousled hair" photograph circulated widely after Lincoln's senate nomination. Lincoln later wrote to a friend that he thought it was "a very true one; though my wife and many others do not. My impression is that their objection arises from the disordered condition of the hair." Hamilton and Ostendorf, *Lincoln in Photographs*, 6–7.

38. Quoted in M. Peterson, *Lincoln in American Memory*, 152; see also Tarbell, *All in a Day's Work*, 165–68.

39. "*McClure's* Magazine for 1895–6: How Lincoln Looked When Young," *McClure's*, November 1895, 3.

40. Legend has it that despite its excellent provenance and strong resemblance to Lincoln, the family later was required to authenticate the image three times. See Harold Holzer, "Is This the First Photograph of Abraham Lincoln?" *American Heritage*, February–March 1994, 39–42. The daguerreotype eventually was donated by Robert Todd Lincoln's daughter to the Library of Congress. On forgery of Lincolniana in general, see M. Peterson, *Lincoln in American Memory*, 144–55, 291–98, 341; see also Harold Holzer, ed., *Lincoln and Lincolniana* (Providence, RI: Brown University Press, 1985).

41. Barbara Savedoff, *Transforming Images: How Photography Complicates the Picture* (Ithaca, NY: Cornell University Press, 2000), 152.

42. On the history of daguerreotypes, see Beaumont Newhall, *The Daguerreotype in America*, 3rd rev. ed. (New York: Dover Publications, 1976); Taft, *Photography and the American Scene*, 2–101; and Marcy J. Dinius, *The Camera and the Press: American Visual and Print Culture in the Age of the Daguerreotype* (Philadelphia: University of Pennsylvania Press, 2012).

43. Benson, *Photography in Print*, 100.

44. See Alan Trachtenberg, "Photography: The Emergence of a Keyword," in *Photography in Nineteenth-Century America*, ed. Martha A. Sandweiss (Fort Worth: Amon Carter Museum, 1991), 20; Susan S. Williams, *Confounding Images: Photography and Portraiture in Antebellum Fiction* (Philadelphia: University of Pennsylvania Press, 1997), 52; and Alan Trachtenberg, "Likeness as Identity: Reflections on the Daguerrean Mystique," in *The Portrait in Photography*, ed. Graham Clarke (London: Reaktion Books, 1992), 177. Because they are mirrors, most daguerreotypes are also reverse images. Robert Taft observes that this aspect of daguerreotypy produced some comic moments: "One weary operator commented indirectly on this reversal when he complained about the lovesick swains who in sitting for their portraits would persist in placing a huge paw over the region of the heart and after a few days would return with the daguerreotype for repairs because the heart was on the *wrong side*." Taft, *Photography and the American Scene*, 100; emphasis in original.

45. Savedoff, *Transforming Images*, 174.

46. T. Peterson, *Magazines in the Twentieth Century*, 10; see also McClure, *My Autobiography*, 222.

47. McClure, *My Autobiography*, 222–23. Tarbell's series was later published as a book in 1900, which went into several editions by 1920. Rice, "Ida M. Tarbell," 64.

48. Wilson, *McClure's Magazine*, 110.

49. Of the first set of twelve letters published in the December 1895 issue of *McClure's*, four are from members of the legal profession (including Supreme Court justices), five are from academics, and two are from newspaper editors.

50. Many correspondents began their letters by thanking McClure for sending an advance copy of the image; for example, C. R. Miller, editor of the *New York Times*, wrote on October 24, "I thank you for the privilege you have given me of looking over some of the text and illustrations of your new Life of Lincoln." "Earliest Portrait," 111. Another letter writer, J. W. Powell, noted he was "delighted with the proof of the portrait of Lincoln from a daguerreotype"; his use of the term "proof" suggests he received a prepublication version. "Earliest Portrait," 110. Murat Halstead similarly thanked the editors for the "artist's proof of the engraving" of Lincoln. "Earliest Portrait," 112. In her study of Tarbell's series, Judith Rice notes, "The McClure offices solicited opinions of the portrait that were then printed in the magazine along with the second and third installments of Tarbell's series." Rice, "Ida M. Tarbell," 63.

51. "Earliest Portrait," 111.

52. Ibid., 112.

53. Ibid., 110.

54. Ibid.

55. Ibid.; emphasis in original.

56. Ibid., 109.

57. Ibid., 111.

58. Ibid.

59. Ibid., 109.

60. "Miss Tarbell's," 206–7; emphasis in original.

61. Ibid., 207. Others noted the resemblance to Emerson as well: "I think you will be interested to know that in showing the early portrait of Lincoln to two young people of intelligence, each of them asked if it were not a portrait of Waldo Emerson." "Miss Tarbell's," 207.

62. On the rhetoric of portrait photographs, see Graham Clarke, ed., *The Portrait in Photography* (London: Reaktion Books, 1992). On the notion of "bringing-before-the-eyes," see Sara Newman, "Aristotle's Notion of 'Bringing-Before-the-Eyes': Its Contributions to Aristotelian and Contemporary Conceptualizations of Metaphor, Style, and Audience," *Rhetorica* 20, no. 1 (2002): 1–23; Debra Hawhee, "Looking into Aristotle's Eyes: Toward a Theory of Rhetorical Vision," *Advances in the History of Rhetoric* 14 (2011): 139–65.

63. Trachtenberg, "Photography," 33.

64. Barbara McCandless, "The Portrait Studio and the Celebrity," in *Photography in the Nineteenth Century*, ed. Martha A. Sandweiss (Fort Worth: Amon Carter Museum, 1991), 55.

65. David M. Lubin, *Act of Portrayal: Eakins, Sargent, James* (New Haven, CT: Yale University Press, 1985), 3; emphasis in original.

66. Trachtenberg, "Photography," 33.

67. McCandless, "Portrait Studio and the Celebrity," 49. See also Williams, *Confounding Images*, 19.

68. Alan Trachtenberg, *Lincoln's Smile and Other Enigmas* (New York: Hill and Wang, 2007), 11.

69. Alan Trachtenberg, *Reading American Photographs: Images as History from Mathew Brady to Walker Evans* (New York: Noonday Press, 1989), 48. Stephen Hartnett reads Brady's *Gallery* in light of the politics of the era—particularly debates about slavery—and argues the images are examples of the "new genre of the daguerreotype as politician's tool." See Stephen John Hartnett, *Democratic Dissent and the Cultural Fictions of Antebellum America* (Urbana: University of Illinois Press, 2002), 152. See also Robert Wilson, *Mathew Brady: Portraits of a Nation* (New York: Bloomsbury, 2013), 29–30.

70. On overpainting, see Heinz K. Henisch and Bridget A. Henisch, *The Photographic Experience, 1839–1934: Images and Attitudes* (University Park: Pennsylvania State University Press, 1994), 93–95.

71. The Chases moved from Wisconsin to the lumber frontier of northern Minnesota a few years later, where they became the proprietors of three hotels in the tourist

community of Walker. See John R. Finnegan Sr. and Cara A. Finnegan, "The Chase Hotel and the Rise of Lakeside Tourism," *Minnesota History* 61 (2009): 272–83.

72. Allan Sekula, "The Body and the Archive," *October* 39 (1986): 7.

73. John Tagg, *The Burden of Representation: Essays on Photographies and Histories* (Minneapolis: University of Minnesota Press, 1988), 74.

74. Beaumont Newhall's oft-cited *History of Photography* does not mention crime photography at all, though it does have chapters on portraits, news photography, and documentary. Similarly, Robert Taft's *Photography and the American Scene* offers no discussion of crime photography. See Beaumont Newhall, *The History of Photography from 1839 to the Present*, 5th ed. (New York: Metropolitan Museum of Modern Art, 1994); Taft, *Photography and the American Scene*. One recent exception is Liz Wells, ed., *Photography: A Critical Introduction*, 3rd ed. (New York: Routledge, 2004). On the role of photography as an instrument of the state, see also Suren Lalvani, *Photography, Vision, and the Production of Modern Bodies* (Albany: SUNY Press, 1996), 87–137; Tagg, *Burden of Representation*, 60–116.

75. Sekula, "Body and the Archive," 7.

76. Harry Soderman and John J. O'Connell, *Modern Criminal Investigation*, 5th ed. (New York: Funk and Wagnall's, 1962), 71.

77. Martha Merrill Umphrey, "'The Sun Has Been Too Quick for Them': Criminal Portraiture and the Police in the Late Nineteenth Century," *Studies in Law, Politics, and Society* 16 (1997): 144. See also Trachtenberg, *Reading*, 28–29.

78. Umphrey argues that one of the most popular late nineteenth-century texts on criminality, Thomas Byrne's *Professional Criminals of America* (1886), functioned as an ambivalent moral warning against criminal behavior, because it both condemned and celebrated the most sensational forms of criminal activity. Umphrey, "'The Sun,'"142. See also Sekula, "Body and the Archive," 37–38.

79. Sekula, "Body and the Archive," 12.

80. Miles Orvell, *The Real Thing: Imitation and Authenticity in American Culture, 1880–1940* (Chapel Hill: University of North Carolina Press, 1989), 16.

81. Karen Halttunen, *Confidence Men and Painted Women: A Study of Middle-Class Culture in America, 1830–1870* (New Haven, CT: Yale University Press, 1982), 28.

82. Ibid., 40–41.

83. Sekula, "Body and the Archive," 12.

84. On the Fowlers, see Madeleine B. Stern, *Heads and Headlines: The Phrenological Fowlers* (Norman: University of Oklahoma Press, 1971); see also O. S. Fowler, *Fowler's Practical Phrenology* (New York: Edward Kearney, 1840).

85. On relationships between phrenology/physiognomy and photography, see also Allan Sekula, "The Traffic in Photographs," *Art Journal* 41, no. 1 (1981): 18–19; Sekula, "Body and the Archive," 10–16; and Hartnett, *Democratic Dissent*, 156–59.

86. Sekula, "Body and the Archive," 11; Lucy Hartley, *Physiognomy and the Mean-

ing of Expression in Nineteenth-Century Culture (Cambridge: Cambridge University Press, 2001), 2.

87. Hartley, *Physiognomy,* 127.

88. Orvell, *Real Thing,* 14.

89. Stern, *Heads and Headlines,* x.

90. Stephen Hartnett, "'It Is Terrible to Possess Such Power!' The Critique of Phrenology, Class, and Gender in Hawthorne's 'The Birth-Mark,'" *Prospero* 5 (1998): 6; emphasis in original.

91. Ibid., 6.

92. Hartley, *Physiognomy,* 12.

93. Beginning in the late 1870s, Francis Galton made composite photographs that relied heavily on discourses of phrenology and physiognomy to construct typologies of criminality and deviance. Allan Sekula points out that Galton's "career was suspended between the triumph of his cousin Charles Darwin's evolutionary paradigm in the late 1860s and the belated discovery in 1899 of Gregor Mendel's work on the genetic ratio underlying inheritance." Sekula, "Body and the Archive," 42. See also Orvell, *Real Thing,* 92–94. On the rhetoric of eugenics in the twentieth century, see Marouf Arif Hasian Jr., *The Rhetoric of Eugenics in Anglo-American Thought* (Athens: University of Georgia Press, 1996).

94. Stern, *Heads and Headlines,* 212.

95. Samuel R. Wells, *How to Read Character: A Handbook of Physiology, Phrenology, and Physiognomy, Illustrated with a Descriptive Chart* (New York: Fowler, Wells, and Co., 1888), 127.

96. See, for example, Applegarth, "Genre, Location," 48; Nedra Reynolds, "Ethos as Location: New Sites for Understanding Discursive Authority," *Rhetoric Review* 11 (1993): 192–214.

97. Samuel R. Wells, *New Physiognomy; or, Signs of Character, as Manifested through Temperament and External Forms, and Especially in "the Human Face Divine"* (New York: Fowler and Wells, 1866), 189.

98. Ibid., 188–89.

99. Ibid., 216.

100. Quoted in D. H. Jacques, "American Faces," *American Phrenological Journal* 49 (January 1869): 12.

101. Ibid.

102. Stern, *Heads and Headlines,* 214.

103. For example, Lisa Nakamura analyzes alllooksame.com, a website that invites visitors to "test" their ability to recognize whether faces in photographs are Chinese, Korean, or Japanese. The exam and the comments resulting from it suggest a variety of complex assumptions about the ability to "see" race and ethnicity in faces. See

Nakamura, *Digitizing Race: Visual Cultures of the Internet* (Minneapolis: University of Minnesota Press, 2008), 70–94.

104. "The Illumined Face," *Methodist Review* (July 1909): 622. American Periodicals Series (APS) Online. ProQuest, http://www.proquest.com/products-services/aps.html.

105. Ibid.

106. "Earliest Portrait," 109.

107. Ibid.

108. Ibid., 108.

109. Wells, *New Physiognomy*, 550–51; emphasis in original. Lincoln's Second Inaugural haunts Wells's text, too: "charity for all."

110. Ibid., 552; emphasis in original.

111. "The Centenary of Abraham Lincoln," *Phrenological Journal and Science of Health* (February 1909): 52.

112. Farrell, *Norms of Rhetorical Culture*, 84.

113. William Herndon, "Analysis of the Character of Abraham Lincoln: A Lecture," *Abraham Lincoln Quarterly* 1, no. 7 (1941): 356. The lectures were transcribed from his notes and published for the first time by the *Abraham Lincoln Quarterly* in 1941.

114. Ibid., 359.

115. Ibid., 357; see also Herndon qtd. in Kunhardt, Kunhardt, and Kunhardt, *Looking for Lincoln*, 126.

116. For just a few examples published over the course of approximately twenty years (in addition to those I discuss in the text), see "Personal Reminiscences of Lincoln," *Scribner's Monthly*, February 1878, 561–69; "The Lincoln Life-Mask and How It Was Made," *Century Illustrated Magazine*, December 1881, 223; "Two Portraits of Lincoln," *Century Illustrated Magazine*, October 1882, 852; and "Some Great Portraits of Lincoln," *McClure's*, February 1898, 339–47. On the rhetoric of Lincoln reminiscences in the late nineteenth and early twentieth centuries, see Parry-Giles and Kaufer, "Lincoln Reminiscences and Nineteenth-Century Portraiture."

117. John G. Nicolay, "Lincoln's Personal Appearance," *Century*, October 1891, 932.

118. Quoted in ibid., 933.

119. Nicolay, "Lincoln's Personal Appearance," 935; emphasis mine. Nicolay is quoting the final line of James Russell Lowell's "Commemoration Ode," written for Harvard's graduation in the summer of 1865. See M. Peterson, *Lincoln in American Memory*, 32–33.

120. M. Peterson, *Lincoln in American Memory*, 386.

121. Henry W. Grady, "The New South," in Ronald F. Reid and James F. Klumpp,

eds., *American Rhetorical Discourse*, 3rd ed. (Long Grove, IL: Waveland Press, 2005), 495.

122. "Miss Tarbell's," 207.

123. Ibid.

124. Truman H. Bartlett, "The Physiognomy of Lincoln," *McClure's*, August 1907, 390–407.

125. Rodin quoted in ibid., 399, 405.

126. M. Peterson, *Lincoln in American Memory*, 387.

127. On neurasthenia, see T. J. Jackson Lears, *No Place of Grace: Antimodernism and the Transformation of American Culture, 1880–1920* (1981; Chicago: University of Chicago Press, 1994), 47–54; Alan Trachtenberg, *The Incorporation of America: Culture and Society in the Gilded Age* (New York: Hill and Wang, 1982), 47–48.

128. Trachtenberg, *Incorporation of America*, 7.

129. Robert Wiebe, *The Search for Order, 1877–1920* (New York: Hill and Wang, 1967), 43.

130. Lears, *No Place of Grace*, 28.

131. Quoted in ibid., 29.

132. Jacob Riis, *How the Other Half Lives: Studies among the Tenements of New York* (1890; New York: Dover, 1971); see also Wiebe, *Search for Order*, 88.

133. Riis, *How the Other Half Lives*, 19.

134. Wiebe, *Search for Order*, 156.

135. Wells, *New Physiognomy*, 408.

136. Ibid., 409.

137. Wiebe, *Search for Order*, 226.

138. Shawn Michelle Smith, *American Archives: Gender, Race, and Class in Visual Culture* (Princeton, NJ: Princeton University Press, 1999), 136.

139. "Illumined Face," 629.

140. Quoted in Smith, *American Archives*, 125.

141. W.E.B. Du Bois, *The Philadelphia Negro: A Social Study* (Philadelphia: University of Pennsylvania, 1899), 1.

142. Mia Bay, "'The World Was Thinking Wrong about Race': The Philadelphia Negro and Nineteenth-Century Science, in *W.E.B. Du Bois, Race, and the City: The Philadelphia Negro and Its Legacy*, ed. Michael B. Katz and Thomas J. Sugrue (Philadelphia: University of Pennsylvania Press, 1997), 42.

143. Ibid., 43.

144. Du Bois, *Philadelphia Negro*, 322.

145. Trachtenberg, *Incorporation of America*, 14; see also Wiebe, *Search for Order*, 66.

146. Trachtenberg, *Incorporation of America*, 16.

147. Ibid., 13.

148. Patricia Nelson Limerick, "Turnerians All: The Dream of a Helpful History in an Intelligible World," *American Historical Review* 100 (1995): 699-700.

149. Trachtenberg, *Incorporation of America*, 16.

150. Frederick Jackson Turner, *The Frontier in American History* (New York: Henry Holt, 1920), 268.

151. Ibid., 22, 37.

152. Ibid., 206.

153. Ibid., 267-68.

154. Ibid., 304-5.

155. Frederick Hill Meserve and Carl Sandburg, *The Photographs of Abraham Lincoln* (New York: Harcourt, Brace, and Co., 1944), 16.

156. E.S.M., "Reproducing Lincoln," *Life,* September 6, 1917, 370.

157. Trachtenberg, "Lincoln's Smile," 75-76.

Chapter 3. Appropriating the Healthy Child

1. Anne Higonnet, *Pictures of Innocence: The History and Crisis of Ideal Childhood* (London: Thames and Hudson, 1998), 8.

2. T. J. Jackson Lears, *No Place of Grace: Antimodernism and the Transformation of American Culture* (1981; Chicago: University of Chicago Press, 1994), 145-46.

3. Harvey J. Graff, *Conflicting Paths: Growing Up in America* (Cambridge: Harvard University Press, 1995), 303.

4. David I. MacLeod, *The Age of the Child: Children in America, 1890-1920* (New York: Twayne, 1998).

5. Viviana A. Zelizer, *Pricing the Priceless Child: The Changing Social Value of Children* (Princeton, NJ: Princeton Paperbacks, 1994), 5, 11.

6. Higonnet, *Pictures of Innocence*, 8. For a discussion of nineteenth-century photography and children, see Lindsay Smith, *The Politics of Focus: Women, Children, and Nineteenth-Century Photography* (Manchester: Manchester University Press, 1998).

7. Higonnet, *Pictures of Innocence*, 8.

8. Nancy Martha West, *Kodak and the Lens of Nostalgia* (Charlottesville: University of Virginia Press, 2000), 78.

9. Ibid., 80.

10. On pictorialism, see Beaumont Newhall, *The History of Photography from 1939 to the Present*, 5th ed. (New York: Metropolitan Museum of Modern Art, 1994), 140-65. Some pictorialist photographers, including Lewis Carroll, produced romanticized photographs of children that were also highly sexualized. See Carol Mavor, "Dream-Rushes: Lewis Carroll's Photographs of the Little Girl," in *The Girl's Own: Cultural Histories of the Anglo-American Girl, 1830-1915*, ed. Claudia Nelson and

Lynne Vallone (Athens: University of Georgia Press, 1994), 156–93; Higonnet, *Pictures of Innocence*, 108–32. Founded in 1903, Alfred Stieglitz's important photography journal, *Camera Work*, often published high-art photographs of children; see Ute Kieseyer, Julia Krumhauer, and Simone Phillipi, eds., *Stieglitz: Camera Work* (Cologne, Germany: Taschen, 2008).

11. George Dimock, "Priceless Children: Child Labor and the Pictorialist Ideal," in Weatherspoon Art Museum, *Priceless Children: Child Labor and the Pictorialist Ideal* (Greensboro: University of North Carolina at Greensboro, 2001), 7. See also Dimock, "Children of the Mills: Re-Reading Lewis Hine's Child Labour Photographs," *Oxford Art Journal* 16, no. 2 (1993): 37–54. On Käsebier's pictorialist photography, particularly her images of women, see Judith Fryer Davidov, *Women's Camera Work: Self/Body/Other in American Visual Culture* (Durham, NC: Duke University Press, 1998), 45–101.

12. Shawn Michelle Smith, *Photography on the Color Line: W.E.B. Du Bois, Race, and Visual Culture* (Durham, NC: Duke University Press, 2004), 6, 69.

13. Walter I. Trattner, *Crusade for the Children: A History of the National Child Labor Committee and Child Labor Reform in America* (Chicago: Quadrangle Books, 1970), 32, 41.

14. Hugh Hindman, *Child Labor: An American History* (Armonk, NY: M.E. Sharpe, 2002), 5.

15. Trattner, *Crusade for the Children*, 37.

16. V. Zelizer, *Pricing the Priceless Child*, 60.

17. Ibid., 64.

18. Rhetorical studies scholars largely have ignored early twentieth-century debates about child labor in the United States. Exceptions include J. Robert Cox, "The Rhetoric of Child Labor Reform: An Efficacy-Utility Analysis," *Quarterly Journal of Speech* 60 (1974): 359–70; A. Cheree Carlson, "Albert J. Beveridge as Imperialist and Progressive: The Means Justify the End," *Western Journal of Speech Communication* 52 (1988): 46–62; Cara A. Finnegan, "'Liars May Photograph': Image Vernaculars and Progressive Era Child Labor Rhetoric," *POROI: An Interdisciplinary Journal of Rhetorical Analysis and Invention* 5, no. 2 (2008): 94–139; and Mari Boor Tonn, "'From the Eye to the Soul': Industrial Labor's Mary Harris 'Mother' Jones and the Rhetorics of Display," *Rhetoric Society Quarterly* 41 (2011): 231–49.

19. Olivia Howard Dunbar, "A Crusade for the Child," *North American Review* (January 1911): 91.

20. Ibid., 92.

21. Thomas Robinson Dawley Jr., *The Child That Toileth Not: The Story of a Government Investigation* (New York: Gracia Publishing, 1912).

22. Trattner's history of child labor and the NCLC, *Crusade for the Children*, mentions the book by name but does not explicitly name Dawley, who is described as

"a disgruntled investigator" who "attacked both the NCLC and the Department of Labor" (103). Hugh Hindman's *Child Labor: An American History* briefly mentions Dawley's book and describes it as one of the more robust and logical rebuttals to the NCLC's arguments about child labor; see Hindman, *Child Labor*, 56–57. Art historian George Dimock examines Dawley's appropriations of a few Hine photographs (which I discuss later in this chapter) in Dimock, "Children of the Mills," 44–45.

23. An important literature on "cultural appropriation" exists in the fields of communication and rhetorical studies as well. While less relevant for my immediate purposes here, this work draws attention to the ways that forms, structures, and discursive resources of cultural identity are appropriated, domesticated, or reworked, with various (often negative) effects. See, for example, Kent Ono and Darren Buescher, "Deciphering Pocahontas: Unpackaging the Commodification of a Native American Woman," *Critical Studies in Media Communication* 18 (2001): 23–43; Richard A. Rogers, "From Cultural Exchange to Transculturation: A Review and Reconceptualization of Cultural Appropriation," *Communication Theory* 16 (2006): 474–503.

24. Angela Ray, "The Rhetorical Ritual of Citizenship: Women's Voting as Public Performance," *Quarterly Journal of Speech* 93 (2007): 3.

25. I share Ray's affinity for Linda Hutcheon's work, which theorizes parody as something more akin to appropriation, broader than the ways in which it typically is invoked in both popular and scholarly representations. Hutcheon writes, "What I am calling parody here is not just that ridiculing imitation mentioned in the standard dictionary definitions" (5). While parody "is a form of imitation," such imitation is "not always at the expense of the parodied text" (6). Hutcheon argues that what we typically term "parody" may be more correctly described as "satire." See Linda Hutcheon, *A Theory of Parody: The Teachings of Twentieth-Century Art Forms* (Urbana: University of Illinois Press, 2000).

26. Hutcheon, *Theory of Parody*, 101.

27. Mikhail Bakhtin, *Problems of Dostoevsky's Poetics*, ed. and trans. Caryl Emerson (Minneapolis: University of Minnesota Press, 1984). On Bakhtin and rhetorical studies, see John M. Murphy, "Mikhail Bakhtin and the Rhetorical Tradition," *Quarterly Journal of Speech* 87 (2001): 259–77; see also Robert Hariman, "Political Parody and Public Culture," *Quarterly Journal of Speech* 94 (2008): 247–72.

28. Hutcheon, *Theory of Parody*, 101.

29. Hariman, "Political Parody," 251; see also Hutcheon, *Theory of Parody*, 13.

30. Hutcheon, *Theory of Parody*, 12–13.

31. Hariman, "Political Parody," 253. Anne Demo explores how such appropriation works in her discussion of the Guerrilla Girls' stylistic appropriation of canonical works of art; see Demo, "The Guerrilla Girls' Comic Politics of Subversion," *Women's Studies in Communication* 23 (2000): 133–56.

32. Helene Shugart, "Counterhegemonic Acts: Appropriation as a Feminist Rhetorical Strategy," *Quarterly Journal of Speech* 83 (1997): 211.

33. See, for example, Helene Shugart, Catherine Egley Waggoner, and D. Lynn O'Brien Hallstein, "Mediating Third-Wave Feminism: Appropriation as Post-Modern Media Practice," *Critical Studies in Media Communication* 18 (2001): 194–210.

34. Shugart, "Counterhegemonic Acts," 211.

35. Trattner, *Crusade for the Children*, 58. By the turn of the century there were a number of child labor committees organized at the state level. On the origins of the NCLC, see also Hindman, *Child Labor*, 50–53.

36. Trattner, *Crusade for the Children*, 58.

37. Ibid., 59.

38. Ibid., 75.

39. V. Zelizer, *Pricing the Priceless Child*, 61.

40. A. Cheree Carlson examines this speech in a study of Beveridge's imperialist and progressive rhetoric. She argues that Beveridge took similar rhetorical approaches in addressing both movements: "Beveridge never abandoned his imperialistic goal of establishing an American empire ruled by an Anglo-American 'master race.' . . . He maintained rhetorical consistency by redefining racial superiority as a product of environment as well as breeding, and cast progressivism as the means of safeguarding Americans at home, better fitting them to rule abroad." See Carlson, "Albert J. Beveridge as Imperialist and Progressive," 47.

41. 60th Cong. Rec. S1552 (January 23, 1907) (statement of Senator Beveridge).

42. Ibid.

43. Beveridge, Cong. Rec., S1553.

44. "Child Labor Assailed," *Washington Post*, January 24, 1907, 4.

45. "Child Labor Evil Shown to Senate," *Chicago Tribune*, January 24, 1907, 11.

46. "Beveridge Warns the White People of South against Killing Race by Working Children in Factories," *Atlanta Georgian and News*, January 24, 1907, 2.

47. "Constitution and Child Labor," *Washington Post*, January 24, 1907, 6.

48. 60th Cong. Rec. S1799 (January 28, 1907) (statement of Senator Beveridge); emphasis in original.

49. Beveridge, Cong. Rec., S1817.

50. Beveridge, Cong. Rec., S1805.

51. Beveridge, Cong. Rec., S1805. On this point, see Carlson, "Albert J. Beveridge," 57.

52. Albert J. Beveridge, "Introduction," in Mrs. John Van Vorst, *The Cry of the Children* (New York: Moffat, Yard, and Company, 1908), xi. While Beveridge was sincere in his passion for citizenship and his hatred of child labor, he had multiple motives. Beveridge biographer John Braeman notes that "while campaigning in the fall of 1906, Beveridge found the loudest applause when he called for the adoption

of a national child labor law." Worried that a Democrat would beat him to the punch for "leadership of the fight against child labor," Beveridge especially feared media mogul and congressman William Randolph Hearst, whose magazines' muckraking journalism Beveridge himself used to inform his own anti-child labor position. See John Braeman, *Albert J. Beveridge, American Nationalist* (Chicago: University of Chicago Press, 1971), 112–13.

53. Hindman, *Child Labor*, 64. See also Trattner, *Crusade for the Children*, 58. By the turn of the century there were a number of child labor committees organized at the state level. On the origins of the NCLC, see Hindman, *Child Labor*, 50–53.

54. Hindman, *Child Labor*, 64.

55. Trattner, *Crusade for the Children*, 88.

56. Braeman, *Albert J. Beveridge*, 116.

57. Hindman, *Child Labor*, 65.

58. Trattner, *Crusade for the Children*, 89.

59. "T. R. Dawley, Jr., Publicist, Is Dead," *New York Times*, June 2, 1930, 27.

60. Ibid.

61. Ibid.

62. Throughout 1896 and 1897 Dawley filed dispatches from Cuba, both textual and photographic. Dawley's Cuba dispatches for *Harper's Weekly* included "Our Correspondent in Cuba," *Harper's Weekly*, March 7, 1896, 220–22; "The Arrival of Spanish Troops in Havana," *Harper's Weekly*, March 28, 1896, 295; and a three-part series in which Dawley reported on and photographed the Cuban military efforts: "With the Cuban Insurgents, I. In Search of Gomez," *Harper's Weekly*, May 15, 1897, 491; "With the Cuban Insurgents, II. Camp Life with Gomez," *Harper's Weekly*, May 22, 1897, 518; and "With the Cuban Insurgents, III. Breakfast with Gomez," *Harper's Weekly*, May 29, 1897, 534. HarpWeek database, http://www.harpweek.com.

63. Dawley, "With the Cuban Insurgents, I," 491.

64. Dawley, *Child That Toileth Not*, 2, 4, 2.

65. Ibid., 280.

66. On Hine and his photography, see Kate Sampsell-Willmann, *Lewis Hine as Social Critic* (Oxford: University Press of Mississippi, 2009); Alan Trachtenberg, *Reading American Photographs: Images as History from Mathew Brady to Walker Evans* (New York: Noonday Press, 1989), 164–230; Maren Stange, *Symbols of Ideal Life: Social Documentary Photography in America, 1890–1950* (Oxford: Cambridge University Press, 1989), 47–87; Judith Mara Gutman, *Lewis W. Hine and the American Social Conscience* (New York: Walker and Company, 1967); Verna Posever Curtis and Stanley Mallach, *Photography and Reform: Lewis Hine and the National Child Labor Committee* (Milwaukee, WI: Milwaukee Art Museum, 1984); Weatherspoon Art Museum, *Priceless Children*; James Guimond, *American Photography and the American Dream* (Chapel Hill: University of North Carolina Press, 1991), chapter

3; and Kathy A. Quick, "The Narrative Document: Lewis Hine and 'Social Photography,'" PhD diss., Brown University, 2010. The popular narrative about Hine is that his early twentieth-century work was "forgotten" until it was "rediscovered" by art critic Elizabeth McCausland during the 1930s. See, for example, Elizabeth McCausland, "Portrait of a Photographer," *Survey Graphic* (October 1938): 502–5; McCausland, "Documentary Photography," *Photo Notes*, January 1939, available at http://newdeal.feri.org/texts/337.htm.

67. Hine's creative strategies for gaining access to industrial spaces are well documented by Hine scholars, to the point of becoming iconic. As the stories go, Hine would often pose as a factory inspector or equipment salesman: "Using any pretext he could get away with, he entered factories, sheds, mines, and homes by night or day, to photograph and interview working children." Trattner, *Crusade for the Children*, 105. In order to accurately represent what he saw in the spaces he infiltrated, he "measured children's height according to the buttons on his coat, and scribbled notes while keeping his hands in his pockets." Trattner, *Crusade for the Children*, 106. When Hine could not get inside the workspaces, he would photograph child workers coming and going from the area or on their lunch breaks. See also Alan Trachtenberg, "Ever—The Human Document," in *America and Lewis Hine*, ed. Walter Rosenblum and Naomi Rosenblum (Millerton, NY: Aperture, 1977), 129.

68. I discuss Hine's time exposures in Cara A. Finnegan, "Studying Visual Modes of Public Address: Lewis Hine's Progressive Era Child Labor Rhetoric," in *The Handbook of Rhetoric and Public Address*, ed. Shawn Parry-Giles and Michael Hogan (London: Wiley-Blackwell, 2010), 26. See also Trachtenberg, "Ever—The Human Document," 130; Daile Kaplan, *Photo Story: Selected Letters and Photographs of Lewis W. Hine* (Washington, DC: Smithsonian Institution Press, 1992), xxviii.

69. For just a few examples of the way Hine combined social photography with an ethnographic, social science style of reportage, see Lewis W. Hine, "Child Labor in Gulf Coast Canneries: Photographic Investigation Made February, 1911," *Annals of the American Academy of Political and Social Science* 38 (July 1911): 118–22; Lewis W. Hine, "Baltimore to Biloxi and Back," *Survey*, May 3, 1913, 167–72.

70. Trachtenberg, "Ever—The Human Document," 128.

71. Sampsell-Willmann, *Lewis Hine*, 56.

72. Quoted in Stange, *Symbols of Ideal Life*, 66.

73. On magazines' role in muckraking, see Matthew Schneirov, *The Dream of a New Social Order: Popular Magazines in America, 1893–1914* (New York: Columbia University Press, 1994).

74. Ibid., 213.

75. Ibid., 232–34.

76. Ibid., 239.

77. Trattner, *Crusade for the Children*, 99. For example, Trattner notes that in

his *Cosmopolitan* article "Child at the Loom," Edwin Markham claimed that fifty thousand children worked at Southern looms, where most children in cotton mills did not work at looms but at other jobs.

78. *American Federationist* was the official publication of the American Federation of Labor, or AFL. *World's Work* was a monthly magazine intended for a more popular audience. See Irene M. Ashby, "Child-Labor in Southern Cotton Mills," *World's Work*, October 1901, 1290–95; Irene Ashby-Macfayden, "Child Life vs. Dividends," *American Federationist*, May 1902, 215–23.

79. Ashby-Macfayden, "Child Life vs. Dividends," 217.

80. Van Vorst's stories were published as a book in 1908, which featured an introduction written by Sen. Albert Beveridge. See Mrs. John van Vorst, *The Cry of the Children: A Study of Child-Labor* (New York: Moffett, Yard and Company, 1908). Available at http://www.archive.org/stream/cryofchildrenstu00vanv#page/n5/mode/2up. Van Vorst was a pioneer of the genre. In 1902 she and her sister-in-law Marie van Vorst took temporary jobs as factory workers in order to report on conditions for working women. In a series of articles published in 1902 in *Everybody's Magazine*, and then later in a book, the women described conditions in New York, Chicago, Pittsburgh, and in the Southern cotton mills where they labored to make clothing, textiles, and shoes. See Mrs. John van Vorst and Marie van Vorst, *The Woman Who Toils: Being the Experiences of Two Gentlewomen as Factory Girls* (New York: Doubleday, Page, and Co., 1903).

81. On multimodal rhetoric, see Gunther Kress and Theo Van Leeuwen, *Multimodal Discourse: The Modes and Meaning of Contemporary Communication* (New York: Oxford University Press, 2001).

82. Moore is perhaps most famous for designing the *Saturday Evening Post*'s typeface, known as "Post Old Style." See his obituary, "Guernsey Moore, Artist," *New York Times*, January 7, 1925, 25. Moore's illustrations, which combined influences of Art Nouveau and early pictorial modernism, were accompanied in the series by smaller, impressionistic sketches by William Glackens, a magazine illustrator in New York who later became one of the founders of the Ashcan School. On Glackens, see M. Sue Kendall, "Glackens, William J.," in *Grove Art Online: Oxford Art Online*, e-reference (accessed May 30, 2011). On pictorial modernism, see Philip B. Meggs and Alston W. Purvis, *Meggs' History of Graphic Design*, 4th ed. (Hoboken, NJ: John Wiley and Sons, 2005), 269–86.

83. Rockwell, born Maxwell Warren Rockwell, served in the Spanish-American War and then studied illustration in New York and Paris before developing a career in book and magazine illustration. He died at the age of thirty-four in 1911. See Yale University, *Obituary Record of Graduates of Yale University* (deceased during the year ending June 1, 1911) (New Haven, CT: Yale University, 1911), 273. Google Books.

In 1914 Markham and his coauthors published *Children in Bondage: A Complete*

and Careful Presentation of the Anxious Problem of Child Labor. The book used photographs, sketches, and other renderings as well as the Warren Rockwell silhouettes that dominated the 1906 series in the *Cosmopolitan.* See Edwin Markham, Benjamin B. Lindsey, and George Creel, *Children in Bondage: A Complete and Careful Presentation of the Anxious Problem of Child Labor* (New York: Hearst's International Library, 1914).

84. Rockwell's images appear in two of the four articles in the series; the other two articles feature, respectively, photographs of child laborers by an unidentified photographer and sketches by B. Cory Kilvert. Kilvert, a Canadian, studied at the Art Students' League in New York City and worked as an illustrator for magazines from the early 1900s until the 1930s. See his obituary, "B. S. Cory Kilvert," *New York Times,* March 31, 1946, 46.

85. Hutcheon, *Theory of Parody,* 101.

86. Richard Lanham, *A Handlist of Rhetorical Terms,* 2nd ed. (Berkeley: University of California Press, 1991), 64.

87. Edwin Markham, "Child at the Loom," *Cosmopolitan,* September 1906, 482.

88. The book might be described as a "photobook," which photography historians Martin Parr and Gerry Badger define as books that advance their case primarily through images or images mixed with text. See Martin Parr and Gerry Badger, *The Photobook: A History,* vol. 1 (London: Phaidon Press, 2004), 6. Photobooks are largely underexplored artifacts of photographic circulation, even though the genre is nearly as old as photography itself. In the late nineteenth and early twentieth centuries, photobooks like J. Thomson and Adolphe Smith's *Street Life in London* (London: Sampson Low, Marston, Searle, and Rivington,1877) and Jacob A. Riis's *How the Other Half Lives* (New York: Scribner's, 1890) collected images of the poor and the immigrant in order to document and classify the changing urban landscape. Parr and Badger, *Photobook,* 48, 53. See also Robert Hirsch, *Seizing the Light: A History of Photography* (Boston: McGraw Hill, 2000), 146.

89. See, for example, Julia Magruder, "The Child-Labor Problem: Fact Versus Sentimentality," *North American Review,* October 1907, 245–56. American Periodicals Series Online. ProQuest, http://www.proquest.com/products-services/aps .html. Like Dawley and others, Magruder suggests that there are few alternatives to child labor for children in the South and notes that children in mill towns are better educated, fed, and more civilized than children on the farm. She also specifically critiques the "superexcited pictures" accompanying magazine articles about child labor; Magruder claims that such illustrations always make child laborers look "misshapen" and "diseased." As for photographs, Magruder claims they are often at odds with the text, picturing "healthy, fat, and jolly-looking" children while the text depicts them as suffering ill health.

90. As we shall see later in the chapter, Dawley also reproduces a few photographs

given to him by those he interviewed and reproduces images most likely made by Lewis Hine for the NCLC.

91. Dawley, *Child That Toileth Not*, 382.

92. Ibid., 131.

93. Ibid., 244.

94. Ibid., 449.

95. Ibid., 180.

96. On critiques of middle-class and elite U.S. society as effete or weak, see especially Lears, *No Place of Grace*, 117–24; Jackson Lears, *Rebirth of a Nation: The Making of Modern America, 1877–1920* (New York: Harper, 2009), 26–31, 92.

97. Dawley, *Child That Toileth Not*, 140.

98. Ibid., 100.

99. Ibid., 109.

100. The NCLC digitized collection at the Library of Congress includes four photographs made by Hine at Pelzer; all feature children outside of the mill before or after a workday. Hine's captions emphasize that the children depicted, all of whom look to be under twelve years old, are not the youngest children he saw at the mill. See NCLC Collection, Library of Congress Prints and Photographs Division, http://www.loc.gov/pictures/collection/nclc.

101. Dawley, *Child That Toileth Not,* 290.

102. Ibid., 285. "Doffers" were young boys who would be on hand in the mills to remove full bobbins from the giant mechanized spinning frame and replace them with empty ones.

103. On the history of the playground movement in the late nineteenth and early twentieth centuries, see Dominic Cavallo, *Muscles and Morals: Organized Playgrounds and Urban Reform, 1880–1920* (Philadelphia: University of Pennsylvania Press, 1981).

104. See, for example, Dawley, *Child That Toileth Not*, 227.

105. Ibid.

106. Ibid., 448.

107. Dimock, "Children of the Mills," 44.

108. Alexander McKelway, "Child Labor in the Carolinas," *Charities and the Commons*, January 30, 1909, 743–57; National Child Labor Committee, *Child Labor in the Carolinas* (New York: NCLC, 1909).

109. NCLC, *Child Labor in the Carolinas*, 3.

110. McKelway, "Child Labor in the Carolinas," 746. See also NCLC, *Child Labor in the Carolinas*, 17. As published in the pamphlet, the last clause about enforcement does not appear, likely because an inspection law was passed by the time the pamphlet was published. McKelway noted, "Since the above written, the South Carolina Legislature has passed a law providing for factory inspection. The substance of this

article, published in 'Charities,' with the photographs, had something to do with the result in both the Carolinas" (19).

111. Dawley, *Child That Toileth Not*, 19.

112. On young girls as "learners," Hall, Leloudis, et al. explain, "Most children first learned about factory labor when they tagged along with a parent or sibling, carried hot meals to the mill at dinnertime, or stopped by after school." Often during these visits the younger children would learn how to operate the machinery in "a form of apprenticeship by which basic skills and habits were transmitted to each new generation" (61). See Jacquelyn Dowd Hall, James Leloudis, et al., *Like a Family: The Making of a Southern Cotton Mill World* (Chapel Hill: University of North Carolina Press, 2000); see also Dimock, "Children of the Mills," 46.

113. NCLC, *Child Labor in the Carolinas*, 15. See also McKelway, "Child Labor," 752.

114. Dawley, *Child That Toileth Not*, 79.

115. Ibid., 113.

116. NCLC, *Child Labor in the Carolinas*, 8. See also McKelway, "Child Labor," 750.

117. One of their oral history interviewees reported that a neighbor who was still nursing her baby would "'take a quilt and lay that baby in her roping box while she worked. And she'd bring her baby down and keep it in the mill all day long.'" Hall, Leloudis, et al., 60.

118. Without an explanation of what Dawley means by "deception," it is hard to know what he intends by his use of the term. One reading is that Hine simply lied that this child was a worker; the NCLC report seems to show that he did not claim the child worked. Another interpretation is that Hine was known to use deception (posing as a machine inspector or other job) in order to access the inside of the mill. However, the NCLC's pamphlet claims that only two Carolina mills explicitly prohibited Hine from entering (he managed to enter and make photographs anyway); the mill in Lincolnton, North Carolina, was not one of them. See NCLC, *Child Labor in the Carolinas*, 3.

119. Dawley, *Child That Toileth Not*, 230.

120. Ibid., 234.

121. Carol Squiers, *The Body at Risk: Photography of Disorder, Illness, and Healing* (New York: International Center of Photography), 30.

122. The photograph was first published in the *Survey* in October 1909, in a photo essay on child laborers ominously titled "Southerners of Tomorrow." See Lewis W. Hine, "Southerners of Tomorrow," *Survey*, October 1909, unpaginated insert. There the photograph features five girls, not four—the one on the right was cropped out later by the NCLC. The latter is the photo Dawley likely used.

123. Quoted in Squiers, *Body at Risk*, 30. Squiers notes that the photograph was

reproduced, in cropped and uncropped fashion, in a number of NCLC publications and exhibits.

124. Dawley, *Child That Toileth Not,* 438.

125. Trattner, *Crusade for the Children,* 103–4. Hindman also mentions Dr. Stiles's work on hookworm but mistakenly calls him "George W. Stiles." See Hindman, *Child Labor,* 56–57.

126. Dawley, *Child That Toileth Not,* 439.

127. George Dimock suggests this photograph be read as a "visual rebuttal" to Hine's more famous spinner photographs, but in the context of Dawley's book the "hookworm" girls and the water pump girl are placed on facing pages, suggesting that a direct juxtaposition of health is perhaps a better interpretation. See Dimock, "Children of the Mills," 44.

128. Colonel Theodore Roosevelt, "The Conservation of Childhood," *Annals of the American Academy of Political and Social Science* (New York: National Child Labor Committee, 1911), 2.

129. Ibid., 4.

130. Ibid., 8.

131. Felix Adler, "The Attitude of Society toward the Child as an Index of Civilization," in National Child Labor Committee, *Child Labor and the Republic* (New York: American Academy of Political and Social Science, 1907), 139.

132. Albert Beveridge, "Child Labor and the Nation," in ibid., 116.

133. Ibid.

134. Ibid., 117. On the late nineteenth- and early twentieth-century rhetorical habit of "bomb talking" and other rhetorical uses of the new technology of dynamite, see Ian Edward Jackson Hill, "The Malthusian Paradox: Weapons Rhetoric before the Bomb," PhD diss., University of Illinois, 2012.

135. Beveridge, "Child Labor and the Nation," 115.

136. Ibid., 119.

137. Adler, "Attitude of Society," 140.

138. On the rhetoric of eugenics, see Marouf Arif Hasian Jr., *The Rhetoric of Eugenics in Anglo-American Thought* (Athens: University of Georgia Press, 1996).

139. Lears, *No Place of Grace,* 29–30. See also Shawn Michelle Smith, *American Archives: Gender, Race, and Class in Visual Culture* (Princeton, NJ: Princeton University Press, 1999), 116–17. Roosevelt's famous comments about "race suicide" were republished as a "prefatory letter" to the Van Vorst sisters' book described above, *The Woman Who Toils.* In the letter, Roosevelt observes to the authors, "You touch upon what is fundamentally infinitely more important than any other question in this country—that is, the question of race suicide, complete or partial." Roosevelt noted here that "a desire to be 'independent'" was not a substitute "for the practice of the strong, racial qualities without which there can be no strong races." Van Vorst

and Van Vorst, *The Woman Who Toils*, vii. He concluded, "If the men of the nation are not anxious to work in many different ways, with all their might and strength, and ready and able to fight at need, and anxious to be fathers of families, and if the women do not recognize that the greatest thing for any woman is to be a good wife and mother, why, that nation has cause to be alarmed about its future" (viii).

140. Shelley Sallee, *The Whiteness of Child Labor Reform in the New South* (Athens: University of Georgia Press, 2004), 2.

141. "Negro Children, Senator Says, Are Being Strengthened," *Atlanta Georgian and News*, January 24, 1907, 2.

142. Sallee, *Whiteness of Child Labor Reform*, 2.

143. Ibid., 4.

144. Stanley Mallach, "Child Labor Reform and Lewis Hine," in Mallach, *Photography and Reform*, 25.

145. Dawley, *Child That Toileth Not*, 106.

146. Ibid., 111.

147. Ibid., 113.

148. Ibid., 111.

149. Ibid., 113–14.

150. Ibid., 112.

151. Ibid., 408–9.

152. "Defending Child Labor," *New York Times*, January 26, 1913, BR36.

153. "The Child-Labor Problem," *Washington Post*, February 11, 1913, 6.

154. Owen R. Lovejoy, "The Child Workers," *New York Times*, February 12, 1913, 14.

155. "Children of Toil," *Independent* (New York), March 27, 1913, 701. American Periodicals Series Online.

156. Roy William Foley, "The Child That Toileth Not," *American Journal of Sociology* 19 (July 1913): 94.

157. "That Amazing Book," *New York Times*, June 5, 1913, BR 19.

158. Dawley was well known to NCLC activists even before his book was published. Alexander McKelway, NCLC Secretary for the Southern States, wrote to the *New York Times*, "After his separation from the service [the Bureau of Labor] Mr. Dawley occupied himself with addressing Southern cotton mill associations, telling the members of these associations how humane and kind-hearted they were, while at one of the conventions suitable financial arrangements were made for the publication of his articles." See A. J. McKelway, "Mr. Dawley's Charges," *New York Times*, January 25, 1912, 10. Hugh Hindman reports that Dawley's work was well received by corporate interests in the mill communities. *Child Labor*, 57. The NCLC's Owen Lovejoy claimed that copies of Dawley's book had been sent by two cotton manufacturers in the South "to every member of the Legislatures in North and South

Carolina." "Child Workers," 14. A search of the *Southern Textile Bulletin*, the main print organ of the mill owners, turned up no specific references to Dawley or his book for the period 1913–1914.

159. Sallee, *Whiteness of Child Labor Reform*, 13; see also Trattner, *Crusade for the Children*, 103; Hindman, *Child Labor*, 57.

160. Trattner, *Crusade for the Children*, 102.

Chapter 4. Managing the Magnitude of the Great Depression

1. Epigraph from "Farm Security Administration Picture Comments," Comment 3, Roy Emerson Stryker papers, photographic archive, University of Louisville, Louisville, Kentucky, microfilm, reel 6; hereafter cited as "RES Papers." Subsequent citation of the comments will be by number only.

2. "Camera Men to Exhibit," *New York Times*, April 17, 1938, 36.

3. First International Photographic Exposition, *Catalog of Exhibits, Program of Events* (New York, 1938), 1.

4. I describe these changes in Cara A. Finnegan, *Picturing Poverty: FSA Photographs and Print Culture* (Washington, DC: Smithsonian Books, 2003), 170–75.

5. Ibid., 175.

6. "More Picture Magazines Bob Up," *Business Week,* December 4, 1937, 28. On the rise of picture magazines in the thirties, see also John Raeburn, *A Staggering Revolution: A Cultural History of Thirties Photography* (Urbana: University of Illinois Press, 2006), 93–113, 194–218.

7. "Editor's Check List of Special Features," press release for First International Photographic Exposition, April 18–24, 1938, RES papers, reel 6.

8. For more on the origins and history of the FSA project, see Finnegan, *Picturing Poverty*. The Historical Section's project is well-trod scholarly territory; key sources that address the project include F. Jack Hurley, *Portrait of a Decade: Roy Stryker and the Development of Documentary Photography in the Thirties* (Cambridge, MA: Da Capo, 1977); Pete Daniel, Merry A. Foresta, Maren Stange, and Sally Stein, eds., *Official Images: New Deal Photography* (Washington, DC: Smithsonian Institution Press, 1987); Carl Fleischhauer and Beverly Brannan, eds., *Documenting America, 1935–1943* (Berkeley: University of California Press, 1988); James Curtis, *Mind's Eye, Mind's Truth: FSA Photography Reconsidered* (Philadelphia: Temple University Press, 1991); Nicholas Natanson, *The Black Image in the New Deal: The Politics of FSA Photography* (Knoxville: University of Tennessee Press, 1992); Maren Stange, *Symbols of Ideal Life: Social Documentary Photography in America* (Cambridge: Cambridge University Press, 1992); Colleen McDannell, *Picturing Faith: Photography and the Great Depression* (New Haven, CT: Yale University Press, 2004); Anne Whiston Spirn, *Daring to Look: Dorothea Lange's Photographs and Reports from*

the Field (Chicago: University of Chicago Press, 2009); John Raeburn, *Staggering Revolution*; and Jan Goggans, *California on the Breadlines: Dorothea Lange, Paul Taylor, and the Making of a New Deal Narrative* (Berkeley: University of California Press, 2010).

9. The full FSA-OWI (Farm Security Administration–Office of War Information) archive is housed in the Prints and Photographs Division at the Library of Congress; most of it is available at http://www.loc.gov/pictures/collection/fsa.

10. Raeburn, *Staggering Revolution*, 187, 339n39; letter from Roy Stryker to James McCamy, April 12, 1938, RES papers, reel 2.

11. "'How American People Live': Shown in Pictures at First International Photographic Exposition," undated but after April 1938, RES papers, reel 6.

12. Arthur Ellis, "Camera Angles," *Washington Post*, April 17, 1938, TT9.

13. Letter from Roy Stryker to James McCamy, April 12, 1938, RES papers, reel 2.

14. Raeburn, *Staggering Revolution*, 191.

15. Roy E. Stryker, oral history interviews, 1963–1965, Archives of American Art, Smithsonian Institution. Available at http://www.aaa.si.edu/collections/interviews/oral-history-interview-roy-emerson-stryker-12480; hereafter cited as "AAA."

16. In a Smithsonian Institution oral history recorded nearly thirty years later, Stryker recalled, "Arthur and Russell had designed it" and confessed that in order to protect the photographers from interference from higher-ups concerned about excessive spending, he waited to put in a travel authorization for the two men to drive the photographs to New York City: "So just about an hour before—we had the pictures in little bunches so the boys could put them together—I got them a travel order. They had the printed pictures in the back of their car. They were ready to take off in about—they weren't in the car yet—but they were going to leave in about four hours. I said to Mr. Fisher [the "higher-up" in question], 'You'd better come over and take a look at these because we're going to New York.' He thought they were wonderful." Roy E. Stryker, oral history interview, AAA.

17. There is no way of knowing whether the 540 comments were left by 540 separate individuals, or whether visitors saw the exhibit multiple times and/or left more than one comment. Thus it is best to quantify the response by emphasizing the number of comments rather than assuming that each comment represents one separate visitor. At some point the comment cards were transcribed into a typewritten list, with each comment numbered. This list may be found in RES papers, reel 6.

18. Comment 73. A search of the 1940 census reveals that two years after the exposition, Evelyn Glantz was living with her mother and brother at that same address. According to that record, she would have been about twenty-seven years old at the time of the 1938 exposition.

19. Roy E. Stryker, letter to Edwin Locke, April 25, 1938, RES papers, reel 1.

20. Stryker, oral history interview, AAA.

21. For example, John Raeburn mentions them and quotes from a few in *Staggering Revolution*, 280–81. In *Picturing Poverty* I describe how some comments left at the 1938 exposition evinced a "hostile view" of poverty; see Finnegan, *Picturing Poverty*, 18–19. Elsewhere in that book, I show how some comments were used as captions for FSA photographs featured in a special section of the photography annual *U.S. Camera 1939*; see Finnegan, *Picturing Poverty*, 150–51. See also James Guimond, *American Photography and the American Dream* (Chapel Hill: University of North Carolina Press, 1991), 99–100.

22. A comprehensive bibliography of period sources on the FSA project may be found in Penelope Dixon, *Photographers of the Farm Security Administration: An Annotated Bibliography, 1930–1980* (New York: Garland, 1983). See also Finnegan, *Picturing Poverty*.

23. Thomas B. Farrell, "Sizing Things Up: Colloquial Reflection as Practical Wisdom," *Argumentation* 12 (1998): 6.

24. Thomas B. Farrell, "The Weight of Rhetoric: Studies in Cultural Delirium," *Philosophy & Rhetoric* 41 (2008): 484.

25. William Stott, *Documentary Expression and Thirties America* (Chicago: University of Chicago Press, 1973), 12.

26. Farrell, "Weight of Rhetoric," 483.

27. Farrell, "Sizing Up," 11.

28. Ibid., 7.

29. Paul Hendrickson, *Looking for the Light: The Hidden Life and Art of Marion Post Wolcott* (New York: Alfred A. Knopf, 1992), 47.

30. Raeburn, *Staggering Revolution*, 9.

31. Hendrickson, *Looking for the Light*, 47.

32. Finnegan, *Picturing Poverty*, 173. I discuss the technological changes of photographic reproduction and production in *Picturing Poverty*, 170–75.

33. Raeburn, *Staggering Revolution*, 2.

34. Robert Hariman and John Louis Lucaites, *No Caption Needed: Iconic Photographs, Public Culture, and Liberal Democracy* (Chicago: University of Chicago Press, 2007), 35.

35. The phrase is James McCamy's, quoted in Raeburn, *Staggering Revolution*, 7.

36. Raeburn, *A Staggering Revolution*, 7.

37. Ibid. On Americans' increasing interest in what constituted "authentic" American culture in the 1930s, see also Cara A. Finnegan, "FSA Photography and New Deal Visual Culture," in Thomas Benson, ed., *American Rhetoric in the New Deal Era* (East Lansing: Michigan State University Press, 2006), 115–55.

38. Raeburn, *Staggering Revolution*, 7.

39. Finnegan, *Picturing Poverty*, x-xi. See also Cara A. Finnegan, "FSA Photogra-

phy and New Deal Visual Culture"; Mary E. Stuckey, "FDR, the Rhetoric of Vision, and the Creation of a National Synoptic State," *Quarterly Journal of Speech* 98, no. 3 (2012): 237–319.

40. Ned O'Gorman, "Aristotle's *Phantasia* in the *Rhetoric*: *Lexis*, Appearance, and the Epideictic Function of Discourse," *Philosophy & Rhetoric* 38, no. 1 (2005): 16–40. For a broader discussion of Aristotle's notion of rhetorical vision, see also Debra Hawhee, "Looking into Aristotle's Eyes: Toward a Theory of Rhetorical Vision," *Advances in the History of Rhetoric* 14 (2011): 139–65.

41. Finnegan, *Picturing Poverty*, x.

42. There are ten references to "see" or "seeing" and three references to "painting" a "picture" in the speech. See Franklin D. Roosevelt, "Inaugural Address," January 20, 1937. Available online by Gerhard Peters and John T. Woolley, American Presidency Project, http://www.presidency.ucsb.edu/ws/?pid=15349. See also Stuckey, "FDR, Rhetoric of Vision," 301.

43. On Roosevelt's fireside chats, see Russell D. Buhite and David W. Levy, *FDR's Fireside Chats* (New York: Penguin Books, 1992); Amos Kiewe, *FDR's First Fireside Chat: Public Confidence and the Banking Crisis* (College Station: Texas A&M University Press, 2007). On the ways Americans responded to FDR's fireside chats, see Lawrence R. Levine and Cornelia R. Levine, *The Fireside Conversations: America Responds to FDR during the Great Depression* (Berkeley: University of California Press, 2002).

44. Stuckey, "FDR, the Rhetoric of Vision," 299.

45. First International Photographic Exposition, *Catalog*, 3, 5, 15, 18.

46. "Eager Crowd Opens Photo Show Early," *New York Times*, April 19, 1938, 23.

47. Letter from Walker Evans to Roy Stryker, April 21, 1938, RES papers, reel 2.

48. First International Photographic Exposition, *Catalog*, 3.

49. Raeburn, *Staggering Revolution*, 195.

50. Pictorialist ideals included valuing the individual photographer as artist, eschewing an industrial look for images in favor of a painterly aesthetic, and "moving away from faithful depiction toward more evocative and expressive photographs." See Mary Warner Marien, *Photography: A Cultural History*, 3rd ed. (Upper Saddle River, NJ: Prentice Hall, 2011), 172.

51. Willard Morgan, letter to Roy Stryker, February 25, 1964, RES papers.

52. Roy E. Stryker, letter to James McCamy, April 12, 1938, RES papers, reel 1.

53. "Eager Crowd," 23.

54. Raeburn, *Staggering Revolution*, 279.

55. "Eager Crowd," 23; see also Raeburn, *Staggering Revolution*, 279.

56. Roy E. Stryker, letter to Edwin Locke, April 25, 1938, RES papers, reel 1.

57. Roy E. Stryker, letter to Dorothea Lange, May 17, 1938, RES papers, reel 1.

58. Elizabeth McCausland, "First International Show of Photography," *Springfield Sunday Union and Republican*, April 24, 1938, 6E.

59. Quoted in Raeburn, *Staggering Revolution*, 280.

60. Comment 539.

61. Roy E. Stryker, letter to Edwin Locke, April 25, 1938, RES papers, reel 1.

62. For a full discussion of the ways that *U.S. Camera* used exposition photographs and comments, see Finnegan, *Picturing Poverty*, 150–67.

63. Quoted in Finnegan, "FSA Photography and New Deal Visual Culture," 147.

64. Roy E. Stryker, oral history interview, AAA.

65. Ibid.

66. Finnegan, *Picturing Poverty*, 43.

67. Ibid.

68. Roy E. Stryker, quoted in Finnegan, *Picturing Poverty*, 43.

69. "The list of photographs appearing on these two pages . . .," RES papers, reel 6.

70. Ibid.

71. Raeburn, *Staggering Revolution*, 339n39.

72. Raeburn claims that only fifty-nine photographs are visible; it is possible that he elected not to count two photographs, each of which are less than half visible in the installation image at http://lcweb2.loc.gov/service/pnp/fsa/8b16000/8b16900/8b16975v.jpg.

73. Race is difficult to judge visually, of course. The most iconic photograph of the period, Dorothea Lange's "Migrant Mother," features Florence Thompson, who though she was Cherokee was "misrecognized" as white. See Sally Stein, "Passing Likeness: Dorothea Lange's 'Migrant Mother' and the Paradox of Iconicity," in *Only Skin Deep: Changing Visions of the American Self,* ed. Coco Fusco and Brian Wallis (New York: Harry N. Abrams, 2003).

74. Gunther Kress and Theo van Leeuwen, *Reading Images: The Grammar of Visual Design* (New York: Routledge, 2006), 123–30.

75. Roy E. Stryker, oral history interview, AAA.

76. Using the "photomerge" function of Adobe Photoshop, it is possible to combine these three images: lcweb2.loc.gov/service/pnp/fsa/8b16000/8b16900/8b16971v.jpg (left), lcweb2.loc.gov/service/pnp/fsa/8b16000/8b16900/8b16974v.jpg (middle), and lcweb2.loc.gov/service/pnp/fsa/8b16000/8b16900/8b16972v.jpg (right).

77. On "Migrant Mother" as an "iconic photograph," see Hariman and Lucaites, *No Caption Needed*, 49–67. On the photograph's appearance in magazines of the period, see Finnegan, *Picturing Poverty*, 98–102, 141–44; Hariman and Lucaites, *No Caption Needed*, 327n14.

78. On the featuring of Rothstein's and Lange's photographs in *U.S. Camera 1936*, see Finnegan, *Picturing Poverty*, 136–44. The Bud Fields photograph, captioned "Bud Fields in his cotton patch," may be found in the FSA-OWI archive at http://www.loc.gov/pictures/collection/fsa/item/fsa1998020958/PP.

79. A differently cropped version of Ben Shahn's photograph of the Kentucky coal miner may be found at the FSA-OWI archive at http://www.loc.gov/pictures/collection/fsa/item/fsa1997016891/PP.

80. Ben Shahn's photograph of the deputy may be found in the FSA-OWI archive at http://www.loc.gov/pictures/collection/fsa/item/fsa1997016556/PP.

81. University of Illinois doctoral student Julius Riles and I separately reviewed the comments and generated our own lists of the major themes we identified in the corpus. Next we met and agreed upon fifty-two themes to use for coding the complete corpus. Riles then coded each comment in light of these themes. Comments were coded for any of the themes that they spoke to; thus many comments were coded for multiple themes. The goal of the first phase was to provide a detailed descriptive framework upon which to build my critical interpretation.

82. See, for example, comments 285, 314, 398, 432, 437, 444, 527, 531, 534.

83. Comments 337, 316.

84. Comment 83. See also comments 149, 191.

85. Cara A. Finnegan, "The Naturalistic Enthymeme and Visual Argument: Photographic Representation in the 'Skull Controversy,'" *Argumentation and Advocacy* 37 (2001): 142. See also Don Slater, "Photography and Modern Vision: The Spectacle of 'Natural Magic,'" *Visual Culture*, ed. Chris Jenks (London: Routledge, 1995), 218–37.

86. Comments 383, 9. See also comments 192, 233.

87. Comments 327, 477.

88. Comment 124.

89. Terri Weissman, *The Realisms of Berenice Abbott: Documentary Photography and Political Action* (Berkeley: University of California Press, 2011), 18; emphasis in original.

90. Comments 136, 486.

91. Comment 39. See also comments 118, 531.

92. Comment 146.

93. Comment 183.

94. Weissman, *Realisms of Berenice Abbott*, 13.

95. Stott, *Documentary Expression*, 36, 38; emphasis in original. Stott notes that even advertising reflected this value, as evidenced in the rise of the testimonial advertisement (40).

96. Stott, *Documentary Expression*, 128.

97. Ibid., 128–32.

98. Miles Orvell, *The Real Thing: Imitation and Authenticity in American Culture, 1880–1940* (Chapel Hill: University of North Carolina Press, 1989), 148.

99. Ibid., 155.

100. Ibid., 199. On the FSA project's relationship to the culture of authenticity, see Finnegan, "FSA Photography and New Deal Visual Culture," 120.

101. Stott, *Documentary Expression*, 132.

102. Ibid., 131–32.

103. See, for example, comments 14, 48, 85, 128, 189, 262.

104. Comment 304.

105. Comment 28.

106. Comment 178.

107. See, for example, comments 16, 289.

108. Comment 41. See also comments 15, 62, 299.

109. Comments 215, 484.

110. Comment 116.

111. Comments 310, 419, 212.

112. Chaim Perelman, *The Realm of Rhetoric* (Notre Dame, IN: University of Notre Dame Press, 1982), 134.

113. Comment 78 (capitalization in the original). See also comments 134, 244.

114. Comments 111, 159.

115. Finnegan, *Picturing Poverty*, 10.

116. Comments 470, 9.

117. Comments 56, 381.

118. Roosevelt, "Inaugural Address," January 20, 1937.

119. See Franklin Roosevelt, "Address at the Democratic Victory Dinner, Washington, D.C., March 4, 1937"; the fireside chat of March 9, 1937; May 1937 "Message to Congress," a June 1937 press conference; a radio address in November 1937; a March 1938 letter to the U.S. governors on housing policy; a March 1938 address at Gainesville, Georgia; and an April 1938 message to Congress on curbing monopolies. All texts available at American Presidency Project, http://www.presidency.ucsb.edu.

120. One reviewer called it the "most sensational story on the New York stage at the moment"; see Brooks Atkinson, "Saga of the Slums: The Openings," *New York Times*, January 30, 1938, 151. See also "New WPA Play Opened: 'One-Third of the Nation,' Story of Slums, in Poughkeepsie Debut," *New York Times*, July 31, 1937, 6; and Brooks Atkinson, "The Play; Living Newspaper of the Federal Theatre Reports the Housing Situation," *New York Times*, January 18, 1938, 27. Thanks to Mary Stuckey for reminding me of this play.

121. The phrase likely originated in Europe but was popularized in the United States via Benjamin Franklin's *Poor Richard's Almanack*.

122. Comments 8, 142, 81.

123. Comment 172.

124. Jacob Riis, *How the Other Half Lives: Studies among the Tenements of New York* (Boston: Bedford Books, 1996).

125. Stange, *Symbols of Ideal Life*, xv.

126. Ibid., 16, 18.

127. Comments 471, 294.

128. Comments 4, 49. See also comment 98.

129. Marina Moskowitz, *Standard of Living: The Measure of the Middle Class in Modern America* (Baltimore: Johns Hopkins University Press, 2004), 2.

130. Ibid., 278, 279.

131. Ibid., 3.

132. Ibid., 5.

133. Guimond, *American Photography*, 114, 115–16.

134. Wendy L. Wall, *Inventing the "American Way": The Politics of Consensus from the New Deal to the Civil Rights Movement* (New York: Oxford University Press, 2008), 34.

135. Ibid.

136. Stuart Ewen, *PR! The Social History of Spin* (New York: Basic Books, 1996), 240. See also Finnegan, "FSA Photography and New Deal Visual Culture," 133.

137. Guimond, *American Photography*, 116.

138. In an interview with Arthur Rothstein, James Guimond reports that Rothstein said the FSA photographers "considered the Manufacturers' clichés about the American standard of living so absurd . . . that they treated the billboards as fair game for visual ironies." Guimond, *American Photography*, 112.

139. For a reading of this photograph, see John Walker, "Reflections on a Photograph by Margaret Bourke-White," *Creative Camera* 167 (May 1978): 148–49. See also Raeburn, *Staggering Revolution*, 210–11.

140. Guimond, *American Photography*, 113.

141. For a history of Bourke-White's photograph, see "Behind the Picture: 'The American Way' and the Flood of '37," life.time.com, available at http://life.time .com/behind-the-picture/the-american-way-photos-from-the-great-ohio-river-flood -of-1937.

142. On *Life*'s circulation numbers, see Loudon Wainwright, *The Great American Magazine: An Inside History of "Life"* (New York: Knopf, 1986), 81.

143. Comments 105, 352. See also comments 328, 373.

144. See Genesis 41:53, which chronicles the end of seven years of "plenty" and the beginning of seven years of famine under the reign of Pharaoh.

145. Jackson Lears, *Fables of Abundance: A Cultural History of Advertising in America* (New York: Basic Books, 1994), 17–18.

146. David Morris Potter, *People of Plenty: Economic Abundance and the American Character* (Chicago: University of Chicago Press, 1954), 80.

147. Comments 103, 104, 270.

148. Robert Cantwell, *Land of Plenty* (New York: Farrar and Rinehart, 1934); letter to Roosevelt reproduced in Robert S. McElvaine, *Down and Out in the Great Depression: Letters from the Forgotten Man* (Chapel Hill: University of North Carolina Press, 1983), 170.

149. Franklin D. Roosevelt, "Radio Address to the Young Democratic Clubs of America," August 24, 1935. Available online by Gerhard Peters and John T. Woolley, American Presidency Project. http://www.presidency.ucsb.edu/ws/?pid=14925.

150. Ibid.

151. Comments 373, 434.

152. Perelman, *Realm of Rhetoric*, 49.

153. Comments 375, 434.

154. Sara Ahmed, *The Cultural Politics of Emotion* (New York: Routledge, 2004), 105; emphasis in original.

155. Ibid., 104.

156. Aristotle, *On Rhetoric: A Theory of Civic Discourse*, trans. George A. Kennedy (New York: Oxford University Press, 1991), 146 (II.6.14).

157. Ahmed, *Cultural Politics of Emotion*, 108.

158. Ibid., 102 (emphasis in original), 109. Other scholars recently have argued similarly that shame should not be understood entirely as a negative emotion; see Julian A. Deonna, Raffaele Rodogno, and Fabrice Teroni, *In Defense of Shame: The Faces of an Emotion* (New York: Oxford University Press, 2011).

159. Comments 247, 21, 137, 125. See also comments 269, 370.

160. Comments 239, 437, 64, 306. See also comments 36, 216, 365.

161. Franklin D. Roosevelt, "Address to the Young Democratic Club, Baltimore, Md.," April 13, 1936. Available online by Gerhard Peters and John T. Woolley, American Presidency Project. http://www.presidency.ucsb.edu/ws/?pid=15280.

162. Comments 430, 438, 345. See also comments 232, 384.

163. David M. Kennedy, *Freedom from Fear: The American People in Depression and War, 1929–1945* (New York: Oxford University Press, 1999), 32.

164. Ibid., 377.

165. Michael B. Katz, *In the Shadow of the Poorhouse: A Social History of Welfare in America*, 2nd ed. (New York: Basic Books, 1996), 226.

166. Ibid., 214.

167. Ibid., 234.

168. David Kennedy writes that "the idea of isolation was as old as America itself," but that it grew increasingly stronger in the twenties, as Americans came to under-

stand the First World War as a problematic "departure" from "its historic policy of isolation" (387). Perhaps shockingly to today's eyes, Hitler is referenced twice in the corpus, both times in a positive light. One commenter wrote, "I think we need a Hitler" (Comment 465). Another elaborated, "We sure need a Hitler. If he comes over I know a plenty who would vote for him" (Comment 466). Such comments may reflect the common belief that Hitler had improved the German economy, as well as recall public conversations from early in the Roosevelt presidency in which it was argued that Roosevelt sought dictatorial powers. For more on favorable responses from citizens to the idea of a Roosevelt dictatorship, see Davis W. Houck and Mihaela Nicosian, "FDR's First Inaugural Address: Text, Context, and Reception," *Rhetoric & Public Affairs* 5, no. 4 (2002): 649–78.

169. Comments 303, 504, 270, 362. See also comment 145.

170. For more on the history of the RA/FSA, see Finnegan, *Picturing Poverty*, 27–35; see also Sidney Baldwin, *Poverty and Politics: The Rise and Decline of the Farm Security Administration* (Chapel Hill: University of North Carolina Press, 1968).

171. Comments 498, 200. See also comments 42, 44.

172. Comments 206, 208, 346. See also comment 284.

173. Comment 152, 440.

174. Nick Taylor, *American Made: The Enduring Legacy of the WPA* (New York: Bantam, 2008), 315.

175. Michael Hiltzik, *The New Deal: A Modern History* (New York: Free Press, 2011), 377.

176. Buhite and Levy, *FDR's Fireside Chats*, 111.

177. Taylor, *American Made*, 356.

178. Buhite and Levy, *FDR's Fireside Chats*, 116–17.

179. Comments 203, 46, 99, 67.

180. Comment 344.

181. Comment 525.

182. Comments 89, 180, 69. See also comment 47.

183. See, for example, comments 91, 98, 214, 394.

184. Comments 72, 396.

185. Comments 9, 22. See also comments 474, 249, 487, 11, 379.

186. Comments 67, 305. See also comments 100, 317, 519.

187. For discussion of the agency's experiences with charges of "propaganda," see Baldwin, *Poverty and Politics*, 85–125.

188. Comments 340, 156, 436, 393, 94.

189. Comments 296, 325. See also comments 359, 391.

190. Comments 264, 441, 25, 38.

191. Comment 304. In fact the exhibit did travel; after the exposition in New York it appeared in a department store in Philadelphia and in the Department of Agriculture (its home agency) in Washington, D.C. What Raeburn describes as a "reduced version" of the exposition exhibit later traveled the United States under the auspices of the Museum of Modern Art in 1939–1940. See Raeburn, *Staggering Revolution*, 188.

192. Comment 512.

193. Comments 276, 472, 445, 533. See also comment 516.

194. On the role of picture magazines in circulating the FSA's photographs, see Finnegan, *Picturing Poverty*, 168–219.

195. Erskine Caldwell and Margaret Bourke-White, *You Have Seen Their Faces* (1937; Athens: University of Georgia Press, 1995).

196. Archibald MacLeish, *Land of the Free* (Cambridge, MA: Da Capo Press, 1977). Later books based on FSA photographs include Dorothea Lange and Paul Taylor, *American Exodus: A Record of Human Erosion* (1939; Paris: Jean Michel Place, 2000) and Richard Wright, *12 Million Black Voices* (1941; New York: Thunder's Mouth Press, 2000).

197. For example, Raeburn notes that "about one quarter" of the content of the FSA's First International Exposition exhibit was from its forthcoming collaboration with Archibald MacLeish, *Land of the Free* (New York: Harcourt Brace, 1938). See Raeburn, *Staggering Revolution*, 187.

198. Comments 24, 110, 128. See also comments 241, 535.

199. William Uricchio and Marja Roholl, "From New Deal Propaganda to National Vernacular: Pare Lorentz and the Construction of American Public Culture," manuscript available at http://web.mit.edu/uricchio/Public/pdfs/pdfs/stuttgart.pdf, 8.

200. Cara A. Finnegan, "Studying Visual Modes of Public Address: Lewis Hine's Progressive-Era Child Labor Rhetoric," in *The Handbook of Rhetoric and Public Address*, ed. Shawn Parry-Giles and Michael Hogan (London: Wiley-Blackwell, 2010), 258.

201. See, for example, comments 64 and 202. The latter reads, "Pictures are very interesting, but what are you going to do about the conditions. Certainly more than take snapshots!"

202. Roy E. Stryker, oral history interview, AAA.

Conclusion

1. Thomas B. Farrell, *Norms of Rhetorical Culture* (New Haven, CT: Yale University Press, 1993), 16.

Selected Bibliography

Azoulay, Ariella. *Civil Imagination: A Political Ontology of Photography*. Translated by Louise Bethlehem. London: Verso, 2012.

Benson, Richard. *The Printed Picture*. New York: Museum of Modern Art, 2008.

Brown, Joshua. *Beyond the Lines: Pictorial Reporting, Everyday Life, and the Crisis of Gilded Age America*. Berkeley: University of California Press, 2002.

Clarke, Graham, ed. *The Portrait in Photography*. London: Reaktion Books, 1992.

Dunkelman, Mark. *Gettysburg's Unknown Soldier: The Life, Death, and Celebrity of Amos Humiston*. Westport, CT: Praeger, 1999.

Farrell, Thomas B. *Norms of Rhetorical Culture*. New Haven, CT: Yale University Press, 1993.

Faust, Drew Gilpin. *This Republic of Suffering: Death and the American Civil War*. New York: Vintage Books, 2008.

Finnegan, Cara A. *Picturing Poverty: FSA Photographs and Print Culture*. Washington, DC: Smithsonian Books, 2003.

Frassanito, William. *Antietam: The Photographic Legacy of America's Bloodiest Day*. New York: Charles Scribner's Sons, 1978.

Freedberg, David. *The Power of Images: Studies in the History and Theory of Response*. Chicago: University of Chicago Press, 1989.

Guimond, James. *American Photography and the American Dream*. Chapel Hill: University of North Carolina Press, 1991.

Hariman, Robert, and John Louis Lucaites. *No Caption Needed: Iconic Photographs, Public Culture, and Liberal Democracy*. Chicago: University of Chicago Press, 2007.

Henisch, Heinz K., and Bridget A. Henisch. *The Photographic Experience, 1839–1934: Images and Attitudes*. University Park: Pennsylvania State University Press, 1994.

Higonnet, Anne. *Pictures of Innocence: The History and Crisis of Ideal Childhood*. London: Thames and Hudson, 1998.

Holly, Michael Ann. *Past Looking: Historical Imagination and the Rhetoric of the Image*. Ithaca, NY: Cornell University Press, 1996.

Hutcheon, Linda. *A Theory of Parody: The Teachings of Twentieth-Century Art Forms*. Urbana: University of Illinois Press, 2000.

Kaplan, Louis. *The Strange Case of William Mumler, Spirit Photographer*. Minneapolis: University of Minnesota Press, 2008.

Kennedy, David M. *Freedom from Fear: The American People in Depression and War, 1929–1945*. New York: Oxford University Press, 1999.

Kress, Gunther, and Theo van Leeuwen. *Reading Images: The Grammar of Visual Design*. New York: Routledge, 2006.

Kunhardt, Philip B., III, Peter W. Kunhardt, and Peter W. Kunhardt Jr., eds. *Looking for Lincoln: The Making of an American Icon*. New York: Alfred A. Knopf, 2008.

Lears, Jackson. *Rebirth of a Nation: The Making of Modern America, 1877–1920*. New York: Harper Collins, 2009.

Lears, T. J. Jackson. *No Place of Grace: Antimodernism and the Transformation of American Culture, 1880–1920*. 1981; Chicago: University of Chicago Press, 1994.

Leja, Michael. *Looking Askance: Skepticism and American Art from Eakins to Duchamp*. Berkeley: University of California Press, 2004.

Mitchell, W. J. T. *Picture Theory*. Chicago: University of Chicago Press, 1994.

Orvell, Miles. *The Real Thing: Imitation and Authenticity in American Culture, 1880–1940*. Chapel Hill: University of North Carolina Press, 1989.

Perelman, Chaim. *The Realm of Rhetoric*. Notre Dame, IN: University of Notre Dame Press, 1982.

Perelman, Chaim, and Lucie Olbrechts-Tyteca. *The New Rhetoric: A Treatise on Argumentation*. Notre Dame, IN: University of Notre Dame Press, 1969.

Peterson, Merrill D. *Lincoln in American Memory*. New York: Oxford University Press, 1994.

Peterson, Theodore. *Magazines in the Twentieth Century*. Urbana: University of Illinois Press, 1964.

Raeburn, John. *A Staggering Revolution: A Cultural History of Thirties Photography*. Urbana: University of Illinois Press, 2006.

Rosenheim, Jeff L. *Photography and the American Civil War*. New York: Metropolitan Museum of Art, 2013.

Sampsell-Willmann, Kate. *Lewis Hine as Social Critic*. Oxford: University Press of Mississippi, 2009.

Sandweiss, Martha, ed. *Photography in Nineteenth Century America*. Fort Worth: Amon Carter Museum, 1991.

Schwartz, Barry. *Abraham Lincoln and the Forge of National Memory*. Chicago: University of Chicago Press, 2000.

Smith, Shawn Michelle. *American Archives: Gender, Race and Class in Visual Culture*. Princeton, NJ: Princeton University Press, 1999.

———. *Photography on the Color Line: W.E.B. Du Bois, Race, and Visual Culture*. Durham, NC: Duke University Press, 2004.

Stange, Maren. *Symbols of Ideal Life: Social Documentary Photography in America*. Cambridge: Cambridge University Press, 1992.

Stott, William. *Documentary Expression and Thirties America*. Chicago: University of Chicago Press, 1973.

Taft, Robert. *Photography and the American Scene*. Mineola, NY: Dover, 1938.

Trachtenberg, Alan. *Reading American Photographs: Images as History from Mathew Brady to Walker Evans*. New York: Hill and Wang, 1989.

———, ed. *Classic Essays on Photography*. New Haven, CT: Leete's Island Books, 1980.

West, Nancy Martha. *Kodak and the Lens of Nostalgia*. Charlottesville: University of Virginia Press, 2000.

Zelizer, Barbie. *About to Die: How News Images Move the Public*. New York: Oxford University Press, 2010.

Zelizer, Viviana A. *Pricing the Priceless Child: The Changing Social Value of Children*. Princeton, NJ: Princeton Paperbacks, 1985.

Index

CARA A. FINNEGAN is a professor of communication at the University of Illinois at Urbana-Champaign. She is the author of *Picturing Poverty: Print Culture and FSA Photographs*.

The University of Illinois Press
is a founding member of the
Association of American University Presses.

———————————————————————

University of Illinois Press
1325 South Oak Street
Champaign, IL 61820-6903
www.press.uillinois.edu